THE LIVES OF STONE TOOLS

KATHRYN WEEDMAN ARTHUR

THE LIVES
OF STONE TOOLS

Crafting the Status, Skill, and Identity of Flintknappers

THE UNIVERSITY OF
ARIZONA PRESS
TUCSON

The University of Arizona Press
www.uapress.arizona.edu

ISBN-13: 978-0-8165-3713-6 (cloth)

Cover design by Leigh McDonald
Cover photo by Kathryn Weedman Arthur

Unless otherwise noted, all photos are by the author.

Library of Congress Cataloging-in-Publication Data
Names: Arthur, Kathryn Weedman.
Title: The lives of stone tools : crafting the status, skill, and identity of flintknappers / Kathryn Weedman
 Arthur.
Description: Tucson : The University of Arizona Press, 2017. | Includes bibliographical references and index.
Identifiers: LCCN 2017035690 | ISBN 9780816537136 (cloth : alk. paper)
Subjects: LCSH: Flintknapping—Social aspects—Ethiopia. | Tools—Social aspects—Ethiopia. | Gamo
 (African people)
Classification: LCC TT293 .A78 2017 | DDC 745.58/4—dc23 LC record available at https://lccn.loc.gov/
 2017035690

Printed in the United States of America
♾ This paper meets the requirements of ANSI/NISO Z39.48-1992 (Permanence of Paper).

CONTENTS

ACKNOWLEDGMENTS

T HE STORY OF my interest in African people and indebtedness to my many mentors in life begins with a poet, my parents, and a priest. At the end of many school days, Afrocentric poet Tom Elias Weatherly guided me through global issues while riding bicycles through Buffalo, New York. It was the mid-1970s, a period when boxed food covered the tables of most working-class families, who watched television variety shows that tried to bring humor into an era filled with tensions over civil rights, women's rights, and the Vietnam War. As the oldest daughter of graduate students, who were studying African American literature and urban anthropology, conversations about lived experiences with conflict permeated my household. By the age of twelve the confluence of school, parents, and an Afrocentric poet culminated in my future path to Africa. At a Catholic private school on scholarship (we were neither wealthy nor Catholic), it was a priest who introduced me to the rich heritage and accomplishments exposed in Egyptian archaeology. But it was Tom Weatherly who in a quiet way corrected my education and relocated Egypt in Africa for me. He gently teased me for my insular knowledge and articulated quite clearly the present-day and historic experiences of many African Americans. Tom revealed to me the racism that was all around me fostered by a history of exploitation and violence hinged on disinformation and misrepresentation of African culture and peoples. It was from this point on that my life took on an agenda to meet African peoples to know them as they are, rather than through the predominate American lens.

Next, I would attend university, where many well-known scholars broadened and challenged me and to whom I express deep gratitude. At the University of Texas at Austin, early mentors Joseph Carter, Jeremiah Epstein, John E. Lamphear, David

Brown, and Jon Morter encouraged me and kept me on the path to graduate school. I continued at UT Austin as a graduate student of James Denbow, who brought me to the Kalahari and introduced me to Ed Wilmsen. Together they revealed to me that archaeology could be so much more than just digging! Every day in Africa with them was a lesson about how present-day politics, land use, and culture are entwined with history making. Thomas Hester was a patient teacher, who guided me through the history and methods of lithic technology and encouraged reflection on the relationship between material culture and identity. After a master's thesis that analyzed lithic technology at archaeological sites in the Kalahari from the Later Stone Age (LSA) to historic periods, I was interested in pursuing a career in ethnoarchaeology. A phone call from Steve Brandt at the University of Florida (UF) offering to introduce me to people who made and used stone tools in southern Ethiopia led to the next phase in my graduate studies. I will always be grateful to Brandt, who served as my advisor and whose ethnoarchaeological survey in 1995 provided me with the amazing opportunity to travel throughout southern Ethiopia to meet stone-tool-using leatherworkers. I am also thankful for Melanie Brandt who provided wonderful illustrations and maps for my research, some of which are reproduced in this book. Seminars, debates, and discussions led by Kathleen Deagan, Steven Feierman, Abe Goldman, Michael Moseley, Sue Rosser, Kenneth Sassaman, and Anita Spring, as well as my UF cohorts, were so engaging and fulfilling that they nearly derailed me into other historical/anthropological pursuits. I also was fortunate enough to participate in Russell Bernard's research-methods seminar, which I am sure largely contributes to my success in writing and earning federal research awards. Peter Schmidt is still a force in my life, encouraging me to share my ideas more broadly and introducing me to new scholars who also like to listen. His seminars were magical and essential in forming my ideas about proper ethnoarchaeological practice and the importance of incorporating descendant peoples' perspectives into the writing of their history.

In the late 1990s, my husband, who had been working in the American Southwest, decided to switch his focus to African studies; and together we have continued over the last twenty years to cross the Atlantic, ending up in the Horn of Africa learning from the Gamo people. I am indebted to many Ethiopians for their graciousness, assistance, and friendship. Yohannes Ethiopia Tocha for the last ten years has shared his amazing linguistic and cultural knowledge concerning Omotic peoples and has walked all the footpaths with me toward building knowledge of and collaborations with Gamo communities. Berhano Wolde, Getacho Girma, and Paulos Dena worked with me as field assistants and translators during my earlier studies. I also thank Bizuayehu Lakew of the Southern Nations, Nationalities, and Peoples' Region (SNNPR), who has tenaciously supported and facilitated my research since 2005 and for whose vast knowledge of southern Ethiopian peoples I appreciate. Heartfelt

thanks go toward Gezahegn Alemayehu and his family, Father John Skinnader, Father Paddy Moran, Woro Tsentany, Sara Shanko, Tsechay Yekay, Napa Mangasah, Masay Girma, Marcos Aseray, and Wagay Yanda, who provided companionship, ensuring that my stay in Chencha was not just a research base but a home.

I would like to thank the program officers and reviewers at the National Science Foundation, the National Endowment for the Humanities, the University of South Florida St. Petersburg, the University of South Florida System, the Leakey Foundation, and Fulbright for their generous funding supporting my research since 1996. Furthermore, I was able to successfully complete my research thanks largely to the very professional administrative personnel at Ethiopia's Ministry of Culture and Information's Authority for Research and Conservation of Cultural Heritage (ARCCH, formerly CRCCH), the National Museum of Ethiopia, the National Herbarium, and the Southern Nations, Nationalities, and Peoples Region's Bureau of Culture and Information in Awassa, Arba Minch, and through many local district offices.

This book is filled with the conversations I had with Gamo men and women who openly shared their lives with me. I hope that this book brings them future pride and prestige. *Hashu Hashu*!

THE LIVES OF STONE TOOLS

INTRODUCTION

O N A MIDDAY IN 1997, the Gamo highland cool breezes bolstered my eager-
ness to descend the escarpment toward the stone quarry in the Ethiopian Rift
Valley (figure 1). The sounds of children chattering, dogs barking at baboons in the
fields, and cattle and donkeys lowing wafted in the wind and escorted us down the
mountain. We trekked for two long hours along winding clay-cracked mountain paths
that shifted to scree, cascading into the heat of the lowlands toward Lake Abaya. The
steep and at times slippery trail challenged my knees and breath, as I struggled to keep
upright. Though my guide (figure 2) was thirty years my senior, he glided along the
footpath. As an elder leatherworker, he produced and used stone hidescrapers almost
daily to process cattlehides for bedding and agricultural bags.

Arriving at the quarry, we sat in the shadow of an old fig tree, where I mindfully
watched him produce several hidescraper blanks. His knapping appeared effortless,
and I had the bravado to believe that I could make a hidescraper. I requested his per-
mission to use the raw materials to produce my own hidescraper. The corner of his
mouth twisted up in a half smile, and he furrowed his brow. I contemplated how
I elicited this expression—was I an intruding foreigner, a woman enacting a man's
technology, or both? Then he smiled and motioned for me to proceed. Like many
archaeologists, I thought that I could make a hidescraper and that if I produced one
that looked like his tool, it would be sufficient enough to receive his approval. With
a look of exasperation, he said "*t'unna*," which means worthless. I was disappointed.
"Why?" I asked him. He smiled and scoffed, "You should have learned from me."
Over the next twenty years of studying with the Gamo, I would eventually learn that
producing a viable hidescraper among the Gamo requires more than observations and

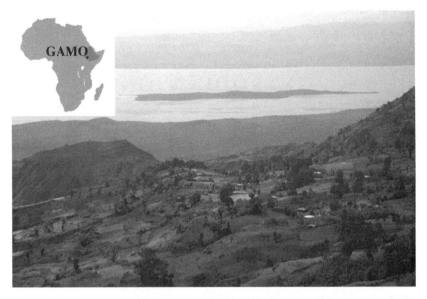

FIGURE 1 View from the Ethiopian Gamo highlands looking toward the Rift Valley and Lake Abaya with a map insert locating the Gamo highlands in Ethiopia and Africa.

attempts to copy a final product. A skilled flintknapper[1] must embody the correct status, practices, and reverence of the nonhuman world.

The Gamo flintknappers are lithic practitioners[2] who are enculturated with technological knowledge associated with skilled stone hidescraper production, which is imparted from lineage elders to individuals recognized as social full adults. When I first studied with the Gamo in the late 1990s and tried to produce a stone hidescraper, I was a married woman with no children. I was not yet a full adult human being in the minds of many Gamo people, particularly elders. The wives of many of the leather-workers would admonish me for sleeping in my tent instead of with my husband. They often sent me away with blessings for a child. The absence of a child signaled that I had not completed my ritual transformation to a mature adult. Particularly in the past, elders transferred technological knowledge, including knapping and leatherworking, to youth during rites of passage. The most intensive period of technological education for men occurred during seclusion associated with puberty rites and for women during seclusion for marriage and childbirth rites. I had most obviously not birthed a child, and thus it was assumed that, like that stone hidescraper I made, I was not fully developed; the stone tool I made and I were both *t'unna*—infertile and not full beings.

When I returned in 2006, I had with me my three-year-old daughter. She followed me slowly to a Gamo community as mud from rains weighed down her little boots.

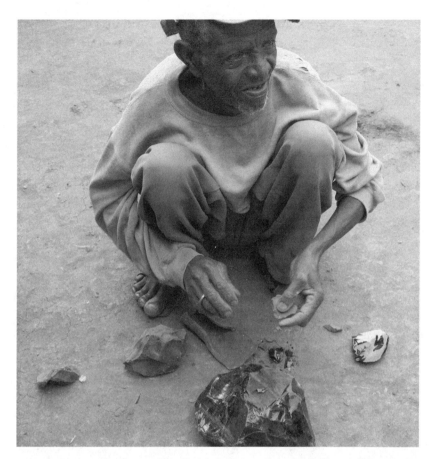

FIGURE 2 Hanicha Harengo knapping chalcedony and obsidian hidescrapers from cores.

The day we arrived just happened to be the first rain to break a drought that year. The greetings were warm and overwhelming: *Bless you, Kati, you are a full woman now; there is rain; you have a child!* The connection between the presence of the rain and my child is not lost on any of us. I returned with my daughter and the rain, both symbols of fertility. I had become a full fertile adult woman, a *mischer*, who would be allowed access to adult wisdom that entwined technological knowledge with the tenets of their Indigenous perspective of the world, *Woga*.

For many Gamo in the past and for some today, *Woga* is their Indigenous religion, their philosophy, and their view of the world. *Woga* is referred to as *Etta Woga* (Fig Tree Culture/Law) among the Boreda Gamo with whom I worked, though in other Gamo districts it is also known as *Bene Woga* (Old Culture/Law) or *Ogay Woga* (Path of the Culture/Law).[3] A majority of Gamo state they adhered to *Woga* beliefs and

practices prior to the coup d'état in 1974 followed by national rule by the Derg, a militant Marxist-Leninist regime (1974–91). Although Orthodox churches and mosques were present prior to the Derg,[4] many Gamo farmers and craftspeople lament that the Derg forced them through beatings, fines, and imprisonment to abandon their Indigenous religion and convert to Protestantism, Orthodox Christianity, or Islam and with increased vigor built religious structures on their sacred forests and burial grounds. Elders frequently offer that they practiced their Indigenous religion in secret at their sacred forests (figure 3) during the Derg and are trying to revitalize their religion today. Currently, many Gamo are active in promoting their position as Indigenous peoples to protect their culture and sacred lands from state and religious development schemes.[5] A handful of Gamo elders and youth adhere to the tenets of *Woga* and the way it shapes the identities of people and other earthly entities.

The Boreda Gamo indigenous religion *Etta Woga* is a unique African philosophy and prescribes that all matter, including stone, comes into being through a reproductive process and exhibits a light, essence, or spirit (*Tsalahay*); that all beings are gendered; and that all demonstrate a change in their status throughout their respective life-cycles (*Deetha*). Some spirit beings, such as trees and snakes, are infused with a spirit derived from deceased human ancestors, a form of animism.[6] Other beings, such as stones, river water, and rainbows, generate essence through the interactive forces of the earth and have power, tendency, and agency and experience a life cycle detached

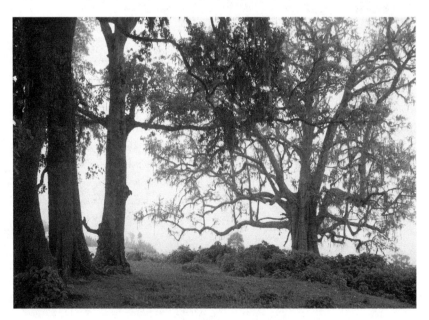

FIGURE 3 Boreda Barena sacred forest.

from human involvement; they are vital beings.[7] Knappable stone begins life through the interaction of male rains penetrating the female womb of the earth, achieving life without human interference. Some knappable stones then enter a reciprocal relationship with humans and begin to take part in human social life by experiencing rites of passage and life courses that mirror that of the knappers expressing a relational theory of reality.[8] Knappable stones are male; and among the Boreda, gender is ascribed based on the way in which entities are perceived to participate in reproduction. Cryptocrystalline stones are circumcised through knapping and become male hidescraper youths shedding their wasteful material, and then they rest in the house. The circumcised male hidescraper is inserted into a female wood haft to create a viable mature composite tool through marriage. The male stone hidescraper matures through his activities scraping hides in the house. A hidescraper's activities wane, and he becomes an elder resting near the hearth in the house. Eventually, he dies and is buried in a household garden to be reincorporated into the earth.

Etta Woga governs not only the life status, gender, and life course of knappable stone, but also the knapper. Men with the unique knowledge of stone hidescraper technology are members of an inherited occupational group that hold a very low status in Boreda society. Lithic technological knowledge and skills are transmitted from father to son within the inherited occupational group *hilancha katchea*, who represent fewer than 1 percent of the Gamo population. Knappers typically live secluded on the edge of their community in small houses on steep slopes with poor agricultural soils. For nearly twenty years, Boreda lithic practitioners have generously shared their knowledge and skills with me. When I asked Hanicha Harengo, an elder knapper, once again to produce a stone hidescraper for me, he shook his head with amusement, as he shuffled over to the door and reached up above the lintel to grab a large core. Deftly, as if the hard stone were butter, he cut the stone, removing one flake, and then shaped the flake into a hidescraper in less than a minute. When he finished, he inquired with an earnest voice: "Kati, why do you always want me to make hidescrapers, and what are you going to do with what I tell you?" I replied: "Hanicha, not everyone knows how to make stone tools. We just do not know how, and we want to learn." He smiled and said, "Of course, I am the elder, and the best, and my father taught me." Then he proceeded in a more serious tone: "Kati, tell the people where you come from and the people in other parts of Ethiopia and even my neighbors that my work is important. It is difficult and requires many years of hard work and apprenticeship. I am worthy of respect." Hanicha's statement brings to the forefront the difference between our Western academic perception of male knappers and his life experience in which men are not valued for their stone tool technology.

In the Gamo highlands, a lithic practitioner's daily stone tool practices result in negative consequences for the status and identity of the male skilled knapper.

Patriarchal control of lithic technology under the tenets of the Boreda Gamo Indigenous religion, *Etta Woga*, is a transgression. A craftsman's birthing of stone serves as justification for his membership in a low-status hereditary endogamous caste group. Some Boreda oral traditions offer that sometime between the seventeenth and nineteenth centuries, men began to act alone without women and birth stone for knapping and iron smelting. As punishment for their transgressions in appropriating women's roles in birth, the Boreda restrict craftsmen and their families from social and economic prosperity, which ensures their segregation from others in community space and life. In turn, knappers generally practice their craft inside their homes, marry only the daughters of other knappers, and speak an argot or ritual language to protect their trade secrets.

Today, there are fewer and fewer knapping leatherworkers, and beliefs in the tenets of *Etta Woga* are waning. Still, their daily practices embody the perception that stone is a living, gendered, and statused being, and lithic practitioners continue to occupy the same low-status hereditary group in their communities. In addition to regime and religious change, the Boreda increasingly participate in national and international economic spheres that affect their trade. The Ethiopian government encourages the export of hides for industrial manufacturers, and industrial clothing, bedding, and bags are replacing local leather goods. With a decrease in demand for locally made leather goods, sons of leatherworkers are pursuing other occupations, reducing the frequency with which knowledge of lithic technology is transmitted. Hanicha Harengo and other elders still maintain this knowledge and enculturate willing sons and grandsons in the trade.

Twenty years ago, Hanicha did not admonish me for producing a hidescraper because I was a foreigner or a woman, but for producing a tool without being properly enculturated and for not being in an appropriate stage or status in my life for practicing this technology. Once I became a recognized adult, my true education commenced. Men and women began to disclose to me their religious philosophies and practices that brought to the foreground a deeper understanding of the connection between lithic technology and their Indigenous theory of reality.

INDIGENOUS ONTOLOGIES

In the *Lives of Stone Tools*, I honor and forward the Indigenous[9] Boreda Gamo ways of being and knowing the world—their ontology, *Etta Woga*—as a valid theory of reality for explaining how human and stone exist and interact. *Etta Woga* shapes the life course of the human being as a male low-status craft-specialist, who is born, circumcised, matures, and dies segregated socially and spatially in his community. Equally

this ontology recognizes the biography of the stone tool as a male being with a life course. After birth (procurement) in a river gorge, a stone tool experiences circumcision (knapping), rest in the house (storage), marriage (hafting), activity in the house (use), and burial (discard) in a knapper's garden. The Boreda ontology through which many perceive stone as alive can be subsumed under neither animism, vitalism, or relational ontologies; it is a unique ontology. It is imperative that we begin to advocate Indigenous ontologies as theory and concede that Western theories and tropes are not universal. As Chris Gosden wrote, "Ontology . . . designates a theory of reality. Such a view implies a thinking being who constructs a theory about how the world is and works, which can be tested or put at risk against physical reality."[10] The Boreda have a conscious explanation for the relationship between entities, such as human and stone, which is based on their observations and tested against their lived experiences in the world—a theory of reality.

Ethnoarchaeologists focusing on technologies in living communities must refuse to reframe Indigenous and descendant ontologies under Western academic theoretical traditions to encourage decolonizing history and science. I am not alone nor the first to set aside Western theories and encourage a path toward respecting and advancing Indigenous knowledge and ways of understanding the world. Eminent scholar Linda Tuhiwai Smith argues that one of the major ways in which Indigenous peoples were dehumanized in Western narratives was through failing to recognize Indigenous peoples intellect to think and create valuable knowledge, things, and cultures.[11] South Americanists,[12] North Americanists,[13] and Africanists[14] concur and assert that Western scholarship tends to describe the ontologies of former colonized peoples as worldviews and perspectives, subsuming them under academic theories rather than acknowledging them as autonomous valid theories of being. As community archaeologists contend, it is our ethical responsibility to write about presents and pasts that resonate and preserve a wide range of intellectual properties.[15]

Exposure and consideration of multiple ontologies requires archaeologists and ethnoarchaeologists to conduct longitudinal research and to be *articulate* with the language, culture, and histories of descendant communities. I borrow the concept of *articulate* from Jonathan Walz, who proposed that archaeologists are "scholars of all time" who must "gain community insights and identify historical clues through their experiences."[16] In essence we must be as engaged in understanding language, myth, and oral and life histories of descendants that retain echoes of the past, as we are the tangible residues. Studies of technology within living cultural contexts are exemplified as early as the late nineteenth century, including the work of Jesse Fewkes, who first defined the term *ethnoarchaeologist*: "the identification by archaeologic methods of many sites of ancient habitations is yet to be made. This work, however, can be best done under the guidance of the Indians, by an ethno-archaeologist, who can bring as

a preparation for his work an *intimate* [sic] knowledge of the present life of the Hopi Villages."[17] Fewkes's work embodied his understanding of "intimate knowledge" proposing that descendants offer the best source of knowledge about their past, which requires the archaeologist to be immersed in a detailed understanding of present-day practices, myths, and histories. Immersion and articulation provide the substrate for understanding. Although there is wide disagreement among archaeologists concerning what impacts context (natural and human forces, etc.), normative, processual, and postprocessual archaeologists tend to agree that without contextual information, an object is inert. In the twentieth century as archaeology moved deeper toward its claim to be a science that generated universal paradigms, ethnoarchaeology became a research strategy that observed practices and behaviors in living communities either to test archaeological theories concerning the past or to understand the relationship between people and materials through a variety of academic approaches.[18] Ethnoarchaeologists distanced themselves from their participants and focused on external academically generated questions about the past that they "tested" and sought answers for largely among Indigenous societies.[19] I include here my earlier work in the late 1990s during which I went to study among Gamo lithic practitioners to test academic theories of style and function related to stone tool variation. Although I learned about Gamo historical and cultural context, I reframed what knowledge I learned in terms of academic theories of postprocessual agency.[20] Only longitudinal engagement with the Gamo allowed me to become aware that ethnoarchaeologists, myself included, were homogenizing Indigenous theories of reality, philosophies, and ideologies into Western academic theories and thereby decontextualizing the very knowledge we were trying to gain.

Ethnoarchaeologists should situate their conclusions relative to a society's ontology, not only out of respect for nonacademic ways of viewing the world, but also to better ensure we actually practice science rather than engage in tautology. Wenceslao Gonzalez refers to a scientist's attempt to universalize and thus occupy other aspects of reality as "methodological imperialism."[21] He argues that by doing so, we make science unreliable by severely limiting our ability to provide new knowledge about the world and constraining the types of knowledge we have that could provide us with solutions for future action. The social sciences, Gonzalez notes, are particularly vulnerable in their ability to make predictions because of the complexity of the situations from which they extract information. Archaeologists may not always be in the business of predicting future action, but there is extensive recognition of the complexity of drawing information from the present to understanding the past as exemplified in the extensive debates over analogy, middle range theory, and metonomy.[22] As a subdiscipline within archaeology that works with living populations, ethnoarchaeology has great potential to reveal alternative ways of knowing the world, but we have to be

willing to set aside our academic way of knowing the world to access this knowledge and provide a wider range of possibilities for understanding the present and the past. Accessing other ways of knowing requires the ethnoarchaeologist to invest in long-term relationships with a community in order for the researcher to be articulate and open his or her mind and senses to other meaningful ways of knowing the world.[23] Only then can the ethnoarchaeologist engage in onto-praxis[24] or situate technological practices and ideas in historical and ethnographic reference relative to the deepest level of a society's ontology. I argue that ethnoarchaeology should strive to reveal alternative ontologies concerning people and their relationship to their world.

OTHER WAYS OF KNOWING
LITHIC TECHNOLOGY

Acknowledging multiple ontologies concerning lithic technology requires accepting positions that challenge our own ontologies.[25] Through long-term ethnographic engagement with the Boreda Gamo, I came to acknowledge one of their alternative ways of being and knowing the world as encompassing life in all matter including stone. Stone as an organic, living, gendered being is an ontology that challenges several of our long-held Western academic theories concerning what constitutes being and life, being human, being gendered, being skilled, and being of a particular status in a community.

Archaeology is intimately impacted by how existence is defined and how existence relates to agency.[26] As Western archaeologists we generally depend on an ontology that prescribes that much of the world is inanimate. Artifacts are inert, which allows us to justify our human agency in their recovery from the earth, their storage out of their original context, and in some cases their destruction. At the same time we are constantly confronted with the existence of artifacts and features as part of a broader assemblage of natural and human transformers.[27] Who are the actants or the actors with efficacy,[28] the stones, humans, or both? Is it possible for stone and stone tools to exist outside of a substrate, environment, or context?[29] Does existence within an assemblage create agency?[30] Or as Jane Bennett questions, does the possibility of inactive matter simply "feed human hubris and our earth-destroying fantasies of conquest and consumption"?[31] To begin to answer these questions, below I review the history of lithic technology within the growing science of Western archaeology. Academic observations and documentation of Indigenous peoples engaged in lithic technology have influenced archaeological interpretation and is well documented.[32] Centuries ago, Western society virtually eliminated stone tool production from their daily cultural repertoire and began the process of subsuming the knowledge gained from

stone-tool-using societies under Western theories and gendered tropes. This book exposes the fissures that develop when we are steeped so deeply in our own understanding of the relationship between people and technology that other ontologies elude us.

THE SKILL OF INDIGENOUS KNAPPERS

The Lives of Stone Tools questions how archaeologists define skill and transfer those assumptions to lithic technology. Within the Boreda Gamo Indigenous ontology, *Etta Woga*, skill is not defined by the morphological characteristics of the final product or by evaluations of nonknappers, but rather by the status of the practitioner within his community of knappers. Western perceptions of skill and organization of technology are deeply ingrained in the industrial Fordist paradigm, which evaluates work based on standardization in form, the efficiency of the item, and the timing of the work, superceding artisans' individual skills and the meanings they imbued into their materials.[33] Since the nineteenth century, archaeologists and ethnographers have consistently judged skills in knapping based on Western perceptions of progress and capitalism. The value of a tool is assessed based on its ability to generate value, meaning, and worth other than that perceived by its producers. The final tool product and the practice of knapping are evaluated through external Western perceptions concerning what constitutes sophistication, standardization, complexity, regularity, and beauty. I argue here that it is possible with twenty-first-century sensibilities to drop our preconceptions and witness that since at least the seventeenth century there exists a tremendous body of literature that demonstrates that people living outside of Europe were skilled and knowledgeable experts about a wide variety of stone tools.[34]

Birth—Early and Active Labor of the Unskilled Knapper

Mid- to late nineteenth-century Euro-American antiquarians poured through earlier traveler, missionary, and government documents to rebirth and to bring clarity to the ambiguity of ancient stone tools.[35] Certainly there were a few antiquarians who ascribed lithic practitioners with skill, particularly individuals who themselves observed knapping and in particular the making of arrowheads, a tool form most Westerners viewed as more complex and sophisticated.[36] Many well-respected antiquarians and anthropologists, though, such as Henry Ling Roth, John Lubbock, and Frank Cushing, considered people who "flaked" stone to be less than human and their technology crude or "rude."

The rudely chipped flints of the Tasmanian aborigines are the simplest character, rarely symmetrical and are more like the earliest Paleolithic flint implements of Europe.[37]

If we wish clearly to understand the antiquities of Europe, we must compare them with the rude implements and weapons still, of until lately, used by the savage races in other parts of the world . . . the filthiest people in the world. We might go farther and say the filthiest animals.[38]

Alice Kehoe documented well that while Lubbock was touted as the preeminent prehistorian of the nineteenth century, he and others of his generation were essential in the creation and perpetuation of ideals that dehumanized non-European people under the guise of archaeological science.[39] Predominately, Euro-Americans often denigrated non-European lithic practitioners as having a childlike mentality, and antiquarians had the bravado to believe that they could learn by self-teaching and simply duplicating the artifacts that they observed.[40]

I have told this history . . . in which I discovered [as a boy] flint-flaking, by chancing all ignorantly to follow precisely the course primitive men must have necessarily followed . . . I could learn more by strenuously experiencing with savage things and arts or their like than I could have learned by actually and merely seeing and questioning savages themselves about such things and art.[41]

Virtually the only detailed study of knapping in the nineteenth century that exalted a knapper's skill is S. B. J. Skertchly's descriptions of gunflints in England: "The modern flakers excel the Neoliths in skill . . . When the gun-flint trade became a special branch of industry the workmanship rapidly improved in the hands of workmen, who devoted themselves solely to it, and is now brought to a state of perfection never before equaled."[42] Prehistorians of the era were dependent on non-European knowledge and technologies to discern and understand the past to rebirth their own knowledge. Respect for Indigenous knappers' knowledge and skill and thereby their unique histories and identities was virtually nonexistent because to respect them would undermine European *perceptions* of their own evolutionary superiority.

Birth—Separation of the Skilled European and Unskilled Indigenous Knapper

Well into the twentieth century Indigenous peoples' knowledge and skills in knapping were devalued and used to birth the perception that they lived in a separate and unchanging state of prehistory, which served to legitimize colonial rule and justified European national identities.[43] Similarities between living and historic people's flint-knapping and archaeological assemblages were aligned to reinforce ideas of culture cores and historical continuities between the Stone Age and living peoples of Australia, the Americas, and Africa.[44] Little recognition was given to the fact that colonial

administrations made it illegal for the colonized to produce and use arrows and spears.[45] Thus the very tools that archaeologists associated with skill and sophistication were rarely being made, because colonial governments restricted their production. The absence of arrows and spears was often used as a means to denigrate a people and their technology. For example, J. R. Dunn, a South African who became the Protector of Immigrants, wrote about toolmaking among the Khoisan of southern Africa: "The true or yellow Bushman [derogatory term for Khoisan speaker] has vanished. To the end he retained the use of stone implements, except in the case of the arrow. He was unprogressive, and remained little influenced by contact with civilized races."[46] Unfortunately, well into the late twentieth century anthropologists would continue to debate whether the Khoisan were living remnant populations of Stone Age hunter-gatherers.[47] In a second example from the Americas, Nels Nelson, who was president of the American Anthropological Association and worked at the American Museum of Natural History, wrote about Ishi, a member of the Yana nation of California: "The very ancient art of producing implements from flint . . . reached a really high state of perfection in only three localities, namely Egypt, Denmark . . . and the Pacific coast of the United States . . . conditioned by unlimited amounts of raw material and a grand scale of manufacture . . . [which] increases the possibility of the development of an expert—an artisan. . . . Ishi employs three distinct processes . . . Ishi works rapidly . . . Whether Ishi is an artisan is up for debate, but he is an experienced workman."[48] The hesitance in ascribing the status of skilled artisan or craftsperson to colonized lithic practitioners even when they produced tools deemed in Western society as sophisticated speaks to the depth of Euro-American mind-set that constructed and segregated racial and ethnic identities through separate historical and technological trajectories.

In the mid- to late twentieth century, many archaeologists favored empirical processual approaches, and an evaluation of skill was based on Western ideals that emphasized consistency in production, efficiency in the performance of the final product, and ability of the style of the final product to signal the identity of the maker. When the association of stone tools was used to assert the inclusion of a fossil hominid into our genus using the name *Homo habilis*, meaning handy man, stone tools became a marker of our common humanity and of humanity's universal means to adapt to the world.[49] Some ethnoarchaeological studies of the era focused on a tool's successful use in particular environments by measuring variables associated with morphology and edge wear as a marker of a knapper's skill.[50] Many of these studies were among knappers who had not made and used adzes, knives, and scrapers for more than twenty-five years.[51] Unfortunately several researchers seemed to forget that they were studying people who had not actively knapped for many decades, and based on their own unrealistic expectations, scholars unfairly levied negative criticisms when they described the technological skills of the knappers they observed.[52]

Crude flaking technique . . . copying, and trial and error, rather than explicit teaching, are certainly the methods by which young Duna men learn about flaked stone.[53]

Clumsy in their work of flint . . . no master craftsmen of stone tool making . . . No one was capable of controlling the stone medium to anywhere near the degree attained by renowned stone knappers in the Occident, such as Bordes.[54]

The assessment of knapping skill was associated no longer with just the final product, but also with the efficiency with which the tool was made and employed. Descriptions of living people's stone tool technology as crude fueled archaeologists to more rigorously turn to experimental work.[55] J. Flenniken, for example, disregarded ethnographic evidence because observations might be among knappers who were unskilled and unencultured in knapping, but he fully accepted self-taught archaeologists as a legitimate source of knowledge for lithic production because of their perceived consistency in making a particular tool in a specific way.[56]

Transformation to Skilled Enculturated Knappers

While many processualists dismissed the skills of Indigenous knappers and turned to replicative studies, other processualists demonstrated that tools were not simply engaged to adapt to the environment, but implemented as part of shared and learned behavior to signal group identity.[57] The final tool form was a result of an intentional performance that reflected the maker's shared cultural group identity. For example, Polly Wiessner argued that skill and quality were determined by the symmetry and uniformity of the final product, in this case iron arrows.[58] The increasing acceptance of the social embeddedness of technological knowledge[59] paved the way for a concerted focus on agency of the toolmaker[60] culminating in ethnoarchaeological[61] and experimental[62] studies on a knapper's skill. More recent ethnoarchaeological studies of stone adzes[63] and stone beads[64] emphasized that while knapping requires long-term practice, social reproduction, and intentional communication, skill is an utmost demonstration of the ability to solve problems. Deeply entrenched in the Western ethos of the preeminence of the human mind and thought, neither of these more recent studies of living lithic practitioners and skill ascertained how the knappers perceived skill within their own communities.

Incorporation of Other Ways of Knowing Skill

It was a significant moment when ethnoarchaeologists realized the importance of acknowledging that stone tool technology is an enculturated process that requires learning and skill and has value in the communities that practice the trade. I argue that the next step is full acceptance of other ways of knowing lithic technology and

skill. We must recognize the cultural context of learning and skill to appreciate the definition of skill relative to the culture being studied and to fully engage a culturally relative position that may stand outside that of the Western archaeologist's reality. Western archaeologists still hold tightly to their perceptions of progress and skill and neglect to realize how these ideals become embedded in reconstructions of past lithic assemblages across time and space. What does stone toolmaking mean to the people for whom the technology is part of their daily lives? What does a skillfully produced, used, and discarded tool look like to the technician, and why? How have our own ethnocentric ideals shaped what we value in technology and blinded us to the potential other truths that exist concerning skill and stone tool technology that might provide a broader spectrum of realities associated with lithic technologies in the past? Only after we realize that there are not universal perceptions concerning how skill is obtained and evaluated and what it looks like can we begin to understand a wide spectrum of how skill is defined, practiced, and realized. This book is a step in discovering alternative realities and definitions of skill that highlight the relationship of skill to the status of the practitioner both within their community of knappers and externally in the larger society.

THE STATUS OF MAN THE TOOLMAKER

The Lives of Stone Tools interrogates Western tropes and ontologies that essentialize gender roles and the assumption that men derive prestige and status from their control of lithic technology. In the Boreda Gamo Indigenous ontology, technology exists through reproduction, and a male knapper's practice of birthing stone without women is an assertion of patrimony that violates cultural law and results in their low status in society. In contrast, Western archaeologists tend to ascribe tool technology as a male invention and responsibility, and through it men are allocated higher historical visibility and status vis-à-vis women. Archaeological imagery and literature consistently illustrate that stone tool technology and weaponry are the purview of men while human reproduction is the domain of women.[65]

Birth—Early and Active Labor of Male Knappers

Historically in Western philosophies men were perceived as the sex with reason who forwarded cultural and technological progress, while women were perceived as the sex closer to nature and valued primarily for their biological roles as mothers.[66] When naturalist Carl Linnaeus introduced the term *mammalia*, he placed humans in this taxonomic group, based on women's breasts and breast-feeding aligning women more closely with nonhuman animals, in a political move to undermine women's public power through attaching them to domestic roles.[67] During the imperial and colonial periods, sexism was intertwined with scientific racism as women's bodies were

actually used to argue that non-European men and women embodied more infantile and animal-like characteristics and capabilities than Europeans.[68] In the predominant Western worldview of the era, women and all non-European peoples also were disassociated from any significant cultural contributions in technology. European categorization of non-Europeans as racially and culturally inferior was reinforced by their observations that non-European peoples made stone tools that looked like ancient tools inferior to those made by Europeans.[69]

When non-European women toolmakers were encountered, the European ethos that tended to regard women as intellectually inferior to men served to more solidly consolidate the concept that non-European peoples were less technologically sophisticated than Europeans. For example, Edward Horace Man wrote: "Although a great portion of the inhabitants of the Great Andaman have for some time past been able through us to procure iron in sufficient quantities to substitute it for stone, still they can by no means be said to have passed out of the stone age. . . . Flaking is regarded as one of the duties of women, and is usually performed by them."[70] Under nineteenth-century European ontology, stone tool technology was considered simplistic and closer to nature and solidified the low status of non-European men and women who were engaged in stone tool technology.

Birth—Full Separation of the Male-Only Nature of Knapping

In the twentieth century, stone tools became increasingly a marker of humanity and male privilege. Western narratives progressively utilized tools as benchmarks for historic time periods and for defining culture areas, and they more firmly entrenched tools as associated with male activities, power, and prestige.[71] The discovery of stone tools associated with the earliest human ancestor in our genus[72] heightened the importance of stone tools as a symbol of progress and prestige in our history. While debates arose over whether stone tools variation derived from cultural[73] or functional[74] differences, the male nature of stone tool technology was not challenged. Stone tools became a symbol of male control and dominance in their respective culture groups, when stone tool types became markers of Stone Age cultures in Africa, Europe, Australia, and the Americas.[75] Book and article titles frequently used the word *man* in association with tool types, such as *Man the Tool-Maker, Folsom Man, Men of the Old Stone Age*, and so on.[76] In *Adam's Ancestors: The Evolution of Man and His Culture*, Louis Leakey wrote, "Before we proceed to discuss the principal tool types used by Stone Age *man* and to consider their probable uses, let us briefly consider the essential requirements of a primitive hunting people. . . . A primitive hunter and *his* family need weapons for hunting and killing wild animals" (emphases added).[77] As Joan Gero rightly demanded, "Note please: 'man' is not a semantic generalization—such tools were seen, without doubt, as the products of male labor."[78] In W. H. Holmes's classic book, *Introductory the Lithic Industries*, he clearly acknowledges that women made

tools when he referenced "squaws chipping flakes into small arrow points," yet he still generalized in his book by saying: "Many of the methods have been recorded by some degree of fullness by observers, or as operated by *old men* who had knowledge of the work,"[79] and throughout the text Holmes only illustrated men working stone. Male technological innovations and products were viewed as responsible for human progress and elevated male prestige and power.[80]

Even the language we use regarding stone tool technology, like the technologies of physics and nuclear science,[81] is sexualized, emphasizing Western perceptions of male biology and activities. In Western descriptions stone tools are not birthed, circumcised, matured, and married. Our images and language emphasize that stone tools are created by striking, applying pressure, shearing, snapping, and splitting by executing a force, power, and violence that produces fractures and scars. It's a language that mimics a tool's exploits in perceived male activities in hunting and warfare as arrowhead, spear, projectile point, pick, ax, knife—all with the power to penetrate and inflict violence.[82]

Archaeological literature, illustrations, and museums commonly displayed stone tools in association with men engaged in hunting and warfare.[83] Under midcentury processualism, lithic replication techniques and experiments that tested the function and impact of stone tools during hunting, butchering, and spear throwing were predominately performed by male archaeologists, which reinforced the association of lithics with men.[84] Further, to generate "objective" cross-cultural generalities and norms in the performance of forager activities, gender roles were naturalized to equate with Western worldviews. Ethnographic research, conferences, and books focused on "Man the Hunter" studies[85] and largely neglected the historical context of their lives under patriarchal colonialism. The latter studies were directly appropriated to interpret past gender roles and tasks by archaeologists, who used them to bolster the association of men with stone tools and hunting and women with gathering.[86] Ethnoarchaeologies of hunter and gatherer societies did little to rectify this story but reinforced the position of men in butchering, hunting, or fishing activities,[87] though several researchers also argued that it would be impossible to discern male and female activity areas.[88] Researchers who focused on knapping also seemed quickly to dismiss women as toolmakers, even when they admitted they observed women knapping.

Women do not seem to use or make any type of chipped stone-tool which is unique to their sex in the Western Desert. Females will be very difficult to see archaeologically.[89]

Women use these (flake knives) at least as much as men, and women sometimes perform the final finishing of wooden bowls, using hand-held flakescrapers. So I admit to being somewhat arbitrary in referring to the use of stone-tools as a primarily male activity.[90]

Transformation to Incorporation of Men and Women Knappers

Significantly women began to dismantle Western gender tropes by exposing women's participation in hunts and as the main food providers.[91] In 1991, Joan Gero wrote a crucial piece, which reasoned that women had the strength, access, time, and necessity to make their own informal stone tools out of local resources in the household context.[92] Gero's work opened the path for archaeologists to consider women as toolmakers,[93] as well as for subsequent ethnographic research among women knappers.[94] Though women are becoming more commonly part of the archaeological narrative associated with stone toolmaking, we still have publications that argue that stone tools primarily are the products of sexual and mating networks as evolutionary forces that drive behavior and progress marking the rise of the male hominid and human intelligence.[95] Under the force of Western patriarchy, archaeology has found it difficult to move beyond extending Western gender tropes into the past.

Incorporation of Other Ways of Knowing Gender and Technology

Associating maleness with stone tools, which are the most prevalent, oldest, most recognizable form of material culture we know of, highlights the roles of men in human history vis-à-vis women. Histories that obscure and disenfranchise women and other means of understanding and practicing gendered technology alienate Indigenous cultures from their histories.[96] While we have made important strides in exploring gender, what we need now is to broaden our understanding of gender construction and practice in the world and apply it more broadly to their appropriate historical contexts. We need to more thoroughly accept that we have been essentializing and naturalizing the tasks and technologies of not only women but also men.[97] For example, Rodney Harrison recently exposed that the Australian Kimberley points were produced only in colonial contexts and not in the prehistoric past, and as such they represented the formation of new masculine identities for Indigenous Australians within a colonized context.[98] This exemplifies that in the absence of historical context for understanding the intersection of technology and gender production, archaeologists lean toward universalizing their own gendered views of technology. As ethnoarchaeologists, we need to better understand how Indigenous peoples construct gender,[99] how and if they gender their technologies, and how technology and gender is related to status. Are there other ways of knowing what it means to be masculine and feminine as associated with technology? How does the gendering of technology relate to other forms of knowing and gendering the world, including the nonhuman world? Our Western tropes and narratives that exclude women as toolmakers are part of our binary thinking that binds with our understanding that technology is cultural and prestigious and in contrast to nature. This book is a step in discovering other ways of knowing and understanding how people derive their gendered and social status in

life in relation to technology and how that connects to their perception of how life is defined for humans and nonhumans.

THE INERTNESS AND VITALITY OF STONE TOOLS

The Lives of Stone Tools investigates the general Western assumption that materials such as stone are inert and lack life and independent agency or vitality. For many Boreda, stone used in flintknapping had an innate vitality and biography, which created a sense of responsibility for the knapper in his course of proper interactions with stone tools. Until recently,[100] the vitality of "inorganic" matter in most anthropological thinking was long criticized as irrational. Artifacts such as stone tools are freely removed from the earth as objects that only have a biography under the human manipulation. Beginning in the seventeenth century the idea that stone tools were created by forces of nature was unraveling in Europe.[101]

Birth of the Inert Material

In the late seventeenth and early eighteenth centuries, European travelers and naturalists began to notice the similarities between "thunderbolts" and stone implements made and used by people in South America, North America, and Africa.[102] An eighteenth-century traveler, Lhwyd, wrote, "'I doubt not but you have often seen of those Arrow-heads they ascribe to elfs or fairies. . . . They are just the same chip'd flints the natives of New England head their aross [sic] with at this day: and there are also several stone hatchets found in this kingdom, not unlike those of the Americans.'"[103] European writings increasingly associated ancient stone tools as the products of human agency by mining travelers' accounts and observations of non-European peoples.[104] Non-European peoples' production and use of stone and their philosophies in life were perceived to be inert, to lack change and agency, and to be stuck in prehistory, whereas only Europeans had a history that was forever moving forward and progressing.[105] During Europe's Age of Enlightenment, there was an emphasis on humanity's unique ability for intellect, reason, and empiricism as a revival toward knowledge production in forwarding progress, freedom, and equality.[106] In reality this intellectual movement undermined alternative philosophies and served only to create divides that further stagnated peoples' ability to attain freedom and equality.

Some historians suggest that during the Enlightenment not all scholars followed the doctrine of mechanism, but that there were scholars who distinctly followed vitalism, advocating for the idea that all matter has agency.[107] The influence of Romanticism and vitalism may be evident in the work of late nineteenth-century archaeologists. W. H. Holmes, based on his readings of historical documents concerning Indigenous flintknapping, was perhaps the first Western scholar to recognize that

stone tool technology was complex, had a process. Holmes also depended on metaphors of biology to explain change in stone tools.

> The simpler implements of primitive peoples are often natural forms of stone, or natural forms but slightly altered by human agency. These must be distinguished where possible from natural forms never used or intended to be used. Natural processes sometimes act in such ways as to produce effects closely resembling the simpler artificial phenomena. . . . I present two diagrams, the first illustrating the evolution of a single species of implement with phenomena of shaping at successive steps of progress, and the other indicating the morphologies of specialization and differentiation of the whole group of species.[108]

Holmes's language above insinuates that perhaps stone tools had their own agency to change and experience a speciation and evolution in the absence of human agency. Lawrence Straus and Geoffrey Clark[109] argue that the vitalism of stone tools is apparent in the French Paleolithic Traditionalist Era with the work of Henri Breuil. James Sackett[110] counters that archaeologists of the era did not believe in the vitality of stone; rather, they engaged the organic analogy as a reductionistic tool to manage the complexity of their information collected with weak methodology. Archaeologists through the early twentieth century widely continued to embed Linnaean-type taxonomies to describe tools in their fossil director approach with language that included terms such as *type, modes, phase, form, class, attribute,* and *varieties.*[111]

Birth—Full Separation of Impotent Nonhuman Matter

Mid-twentieth-century archaeologists were instrumental in highlighting the importance of human agency in relationship to the processes that instigated material changes in the world. J. Otis Brew, director of Harvard's Peabody Museum, criticized the borrowing of the life sciences' taxonomic system as applicable to artifacts. "Cultural material has been thought of and discussed in terms of kinds of relationships impossible in the nature of the material . . . it is absurd to expect . . . relationships between objects which do not receive their characteristics through the transfer of genes."[112] Walter Taylor's seminal work of the era also stressed the following:

> The culture relationships which do exist have been brought about through the minds of living beings, in the present examples through human agency. Inanimate products themselves do not reproduce, modify, copy or influence one another culturally. It is the mediate agency of a mind that brings about the culture relationship between cultural products. Therefore any classification which attempts to portray the relationship of human cultural materials must do so in terms of the people who made, used or possessed

those materials[.] . . . Interpretation involves the study of archaeological data for the purpose of discovering their technique of manufacture, use, function, and the idea or ideas behind them.[113]

Taylor argued that human agency is responsible for changes in material.

In Europe, François Bordes also moved beyond the *fossile directuer* approach to what became known as the Bordesian approach, stressing hominin agency in determining material form.[114] Bordes used detailed quantitative and stratigraphic studies of Mousterian stone tool assemblages in France, examining contemporary differences rather than just chronically divergent differences in assemblages.[115] Bordes believed emphatically that tool style was learned knowledge transmitted between generations—in a specific cultural context resulting in intracultural variation. Observations of Bordes, who also was world-renowned for his flintknapping skills, stimulated the rise of André Leroi-Gourhan's *chaîne opératoire*.[116] *Chaîne opératoire* (operational sequences) focused on understanding technology as integrated with human control of resources from the raw material to final product. Leroi-Gourhan divided technique into technical facts located in the natural and social environment in specific space and time,[117] while technical tendencies were long-term processes that accounted for social (not individual) variation through transmission, diffusion, and innovation with no predetermined point.[118] It would not be until the late twentieth century that European studies of lithic technology would widely adopt Leroi-Gourhan's concept.[119] In the interim, archaeologists led by Michael Schiffer reinvigorated the work of Holmes and Taylor in the United States, culminating in life-cycle or behavioral chain studies in material procurement, manufacture, use, maintenance, and discard, which are impacted by both cultural and natural formation processes.[120] Lithicists examined technological processes in terms of human-driven behavioral chains or reduction sequences and determined the types, location, and organizations of activities performed at a site.[121] Ethnoarchaeology thrived, and researchers undertook studies of stone-tool-using societies that primarily focused on the human use of the environment and one aspect of the lithic life-cycle/behavioral chain, such as quarrying patterns, sequences of production/reduction, tool efficiency, exchange and efficiency, or storage and discard organization.[122] These processualists acknowledged the life cycle of materials, though outright rejected the vitality of materials.[123]

Transformations to Active Nonhuman Matter

Today most archaeologists incorporate concepts of life stages and relationally based material agency into studies of lithic technology. Many different Western theories organize lithic technology into life stages including *chaîne opératoire* (agency), behavioral chains (behavioralism), tool formation processes (cultural ecology), and sequence

models and analysis of variables by domain (evolutionary).[124] In these Western models an object's biographic agency is a response to human activity and directed through human intention.[125] Although Leroi-Gourhan's concept of tendencies suggested that matter did not necessarily have a directed end point,[126] it falls short of accepting the vitality of matter. The materiality of lithics emphasizes how an artifact's biography, life cycle, or operating chains relates to human intervention.[127] The focus today is on examining the lithic reduction chain or sequence as a manifestation of learning and transmission of technology and skill.[128] Other researchers recognize more biological factors through human agency; for example, Gilbert Tostevin recently wrote that "a case of high social intimacy producing cultural transmission of knowledge of how to make lithic artifacts a certain way most likely involves individuals mixing their residential and biological lives."[129] The transmission of knowledge is viewed as a mixture of historical, cultural, and biological factors.[130] According to Linda Brown and Kitty Emery,[131] material agency has been relational rather than biological. Some archaeologists are beginning to advocate recognizing the perception that nonhuman beings have agency, as a possible interpretative base for understanding past material worlds.[132]

Incorporation of Other Ways of Knowing Nonhuman Matter

Consistently through the last one hundred years of stone tool research, archaeologists invoked *reduction* or *chaîne opératoire* methodologies, a perspective we initially derived from our observations of stone-using peoples' practices. Yet we cannot really understand a technology if we do not understand a people's theory behind their technology. Consideration of the potential that stone-using peoples may hold alternative views of material culture provides space for alternative ontologies based in real world experiences. Certainly, we have a wide geographical range of people who produced a variety of stone tools from which to draw inspiration.[133] How do people who engage in lithic technology on a daily basis for their livelihood understand their work? Is it a process, and if so, what is it? Do they distinguish between animate and inanimate beings, and how and in what way? How does this shape the way and where they interact with the nonhuman world and their perspectives regarding teaching, learning, and skill? How does their reality concerning nonhumans and interaction with nonhumans shape a human's status in society? What is the known historical depth of their technology and their views concerning their technology? As I argued above, when ethnoarchaeologists neglect to learn the ontology that contextualizes technology, we decontextualize what we have learned. It is as if we were to neglect stratigraphy and the horizontal and vertical relationship of stone tools to one another and other artifacts at a site when we make our hypothesis about what they mean. Being inclusive of other ways of knowing and understanding what constitutes being will also forward relationships between archaeologists, ethnoarchaeologists, and descendant

communities and bring a better and more democratic understanding of the past to the foreground. It is time for us to release ourselves from academic towers and fully acknowledge Indigenous theories and practices as equal to our own by making space for alternative ontologies and ways of knowing existence, gender, skill, and status as related to stone tools and other technologies.

ORGANIZATION OF THE BOOK

The Lives of Stone Tools departs from conventional archaeological narratives and argues that in alternative ontologies male stone toolmakers may be highly skilled but have low statuses because of the way in which they interact with the nonhuman world in their daily technological practices. The loss of daily stone tool production from our cultural repertoire coupled with our continued application to the past of Western gendered tropes and perception of stone tools as inanimate objects requires that stone tools largely change through their interaction with skilled male technicians. Consequently, we have failed to unveil the complexity and alternative ways of knowing the world that may exist for people engaged in lithic technologies today and in the past. For the last twenty years, in southern Ethiopia the Gamo leatherworkers, who are some of the last men in the world to daily produce stone hidescrapers, shared with me their ideological and practical knowledge that redresses Western misconceptions. This book gives voice to these Indigenous lithic practitioners and privileges their view that human beings and stone beings are equally alive with the power to influence each other's life course, offering profound insights into the relationship between men and stone tools.

The Lives of Stone Tools reveals an alternative ontology for knowing and practicing lithic technology and illustrates that studies of technology must engage longitudinal, historical, ontological, and ethnographic praxis. In particular, this method is relevant for ethnoarchaeological studies that purport to generate new knowledge through the assistance of nonacademics that can be applied to understanding broader histories. If the expectation is that people will share with the researcher their deepest ontologies, histories, and technological knowledge, we must in turn expect that first we must establish trust and our position as apprentices. Longitudinal research is a necessity because developing rapport and confidence requires years of relationship building. Trust is essential for conducting ethical and respectful research with people, and as such this book represents more than twenty years of research among the Gamo. Technological research should also be historical because it is only through understanding the history of a people's technology that one can begin to decolonize our erroneous ascription of non-European technologies as equivalent to prehistoric technologies.

Therefore, in chapter 1 I provide my longitudinal research methods among the Gamo, as well as an overview of the Gamo's deeper and more recent histories. This chapter introduces knowledge derived from the Gamo language, archaeology, oral traditions, and life histories to explore the complex local, regional, and national relationships that inform the present-day status and identities of flintknappers and their perceptions of stone tools. It follows that engaging in deep ontological praxis also serves to decolonize the production of knowledge and precedent Indigenous knowledge systems. Chapter 2 provides a detailed account of a Gamo Indigenous ontology as a valid theory of being for the material world, offering that all matter has a life. To substantiate my argument, I make available Gamo narratives about being and their human and material life-cycle ritual practices. I then illustrate through ethnographic description and material studies (measurement, maps, statistics, etc.) in chapters 3, 4, and 5 how a knapper's ontology and consideration of stone as having life is entangled with and has profound implications for understanding lithic technology. Chapter 3 explores how the Gamo leatherworkers' perception that the materials they work with are alive informs their decisions and methods in birthing or procuring resources. Chapter 4 focuses on how perceiving stone hidescrapers as living impacts production-circumcision and use-maturation practices, and in turn how practice is entwined with a knapper's different identities as male, low-status, his age and life-course stage, and his skill level. In chapter 5, the dual site formation patterns of storage-rest and discard-death exhibited by Gamo leatherworkers demonstrate the presence of agency within their ontologies that structure the life course of human and stone. At the end of chapters 3, 4, and 5, I provide a comparison of the Gamo lithic knowledge and practices to other known studies of Indigenous lithic practitioners in the world to emphasize the importance of learning other ways of knowing the world. In the concluding chapter, chapter 6, I offer an alternative ontology in which highly skilled male toolmakers are conferred a low status because they birth material beings in the absence of women, which contests the widely held Western patriarchal and androcentric tropes assuming the male character of technology. Because they regard stones as living beings, many Gamo knappers treat stone with care and respect. Skilled elders oversee novices and protect the knowledge and practices associated with hidescraper production. Furthermore, once stones enter human social life, they begin to occupy different locations on the landscape that depend on their life-course stage and that vary from community to community based on the different social life of their makers. *The Lives of Stone Tools* emphasizes the importance of recognizing Indigenous knowledge systems and ontologies to construct life histories from stone.

1

A HISTORY OF KNAPPING LEATHERWORKERS IN THE GAMO HIGHLANDS

INTRODUCTION

I HAD BEEN living in the Gamo highlands for nearly ten months, and perhaps that should have been long enough to know—to break my cultural norms that accorded great status to "Man the Toolmaker." Yet, at 3:00 a.m. sleeping roughly in my tent (Figure 4), aching from the hard ground and chilled from the mountain air, I would wake and forget all I had learned. My physical discomfort that night would be superseded by my anguish the next day when I would bring shame and the threat of infertility to myself, my hosts, and the hamlet (a community without shops or markets).

It was the rainy season, and the night began with a dense fog moving in from across Lake Abaya, conveying a wet chill to the air. Deep in sleep, I heard the snarling of an animal. I just burrowed down deeper into my sleeping bag—until the voices of men yelling my name outside my tent forced me awake. My language skills were minimal, but I understood that there was a hyena and that I should sleep in the house. It did not take much convincing, and I stumbled in the house, where I passed a warm and satisfying slumber. When I next woke, the sun and voices were streaming through the front door—an argument about someone's wife. I stretched, rising from the leather hammock that served as my bed, rubbed my face, and felt large welts around my neck. Slightly concerned but without much recourse to find a mirror or a topical salve, I proceeded to my tent to get ready for the day. The knapper, whose compound in which I was staying, was outside and in a heated discussion with several elder men of the hamlet. When he saw me outside, he turned and with his eyes and body movements gestured that I should go back into the house. I realized then that the argument was

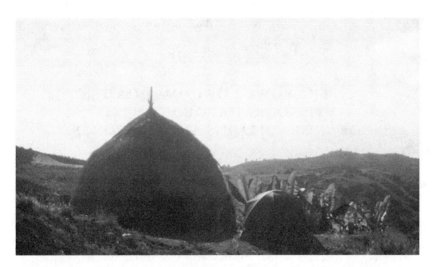

FIGURE 4 My tent next to a leatherworker household isolated on a sloped surface on the edge of a community.

about me! His wife offered me some breakfast, and I sat watching the fire and tried earnestly to listen and sort out what they were saying—what had I done? I pieced together the words *wife, sleep, hyena, Kati* (me), and *bad.* It slowly occurred to me what transgression, what cultural misstep, I had made. I had slept in the knapper's house, and I had broken one of their strictest taboos that segregated relations between those who lived with prestige and dignity, *bayira*—the *mala*-farmers—and those who were impure and stigmatized, *t'unna*—the *hilancha*-craft-specialists.

I was not of the leatherworking hereditary endogamous group, *hilancha katchea*, but as an outsider and American I was considered a person of prestige, *bayira*, and an honorary member of the *mala*-farmer group. One of the strictest Gamo taboos is segregation in sexual relations between the Gamo leatherworkers and other occupational groups. Though I knew from the last year of interviewing people across the region that the Gamo were strict about endogamy, it was not until that day that I understood the extent. I would learn that a sexual act, a flirtation, or even a perceived indiscretion—such as a sleeping in a leatherworker's house—for a nonleatherworker was not only a disgrace but could distress the ancestors, who could cause failure of crops, death of livestock, drought, and all types of havoc on the knapping leatherworker and even the community! While most all Gamo state that they are members of a Christian church, as I learned that day, many also hold to historical prescriptive behavior and practices, *Woga*, that surround propitiating ancestors. Wishing myself invisible and having little language skills to make more than a cursory apology, I did my best to resolve the issue. Our punishment was a steep fine to offer a sheep to the spirits. I would later learn that

some elders noted the welts on my neck and believed that the spirits were punishing me personally for my indiscretion.

THE POWER OF COMBINING ETHNOARCHAEOLOGY WITH ORAL TRADITIONS AND HISTORIES

The story above not only offers an example of the societal discrimination and segregation experienced by Gamo lithic practitioners, but it also points to the fact that being an ethnoarchaeologist who understands the ties between a technician, his technology, and present-day culture requires years of enculturation that must equally include understanding lithic practitioners' history. My knowledge of Gamo culture and history developed over two decades and eventually amended my Western misconceptions concerning the universal presumption of the prestigious male knapper (figure 5).

My research among the Gamo lithic practitioners began in the late 1990s and included a systematic ethnographic survey of all Gamo communities and an in-depth study of four Gamo leatherworking communities. Gamo knappers began educating

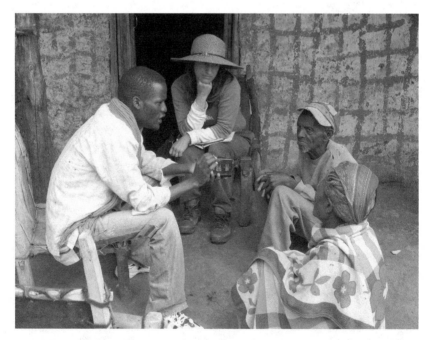

FIGURE 5 Yohannes Ethiopia Tocha, the author, leatherworker Hanicha Harengo, and his wife, Oyesa Oyso.

me in 1995, when I was a graduate student participating in a six-week survey that revealed the existence of stone-using populations and their material diversity in southern Ethiopia.[1] Subsequently, I commenced on a twenty-one-month ethnoarchaeological study with the Gamo knappers for my dissertation research between 1996 and 1998. During my first six months living among the Gamo, I conducted an ethnographic survey to locate leatherworkers, record their social and geographical relationships, and discover their stone tool and hafting types. I interviewed 180 Gamo leatherworkers and learned of another 370 living in 115 hamlets, *guta*, where there were no shops or markets and generally little infrastructure. Based on my survey, I selected four communities of leatherworkers, who primarily made and used stone hidescrapers.

The ethnoarchaeological research in this book focuses on my longitudinal research among the the stone-tool-using leatherworkers living in Patala Tsela in the district of Zada and in Mogesa Shongalay, Eeyahoo Shongalay, and Amure Dembe Chileshe in the district of Boreda (figure 6). Each community consisted of three to eleven leatherworkers with two to forty years of experience knapping chert and obsidian hidescrapers that are two to three centimeters in overall size (table 1). Depending on the historical practices of their fathers and grandfathers, they either haft their hidescrapers in the *zucano* handle with closed sockets or in the *tutuma* handle with a single open haft. During my earlier studies, I focused on a contextualized study of the relationship between local environments, individual skills, and social group memberships and stone hidescraper style, function, and technological organization.[2]

In 2006 I returned to continue my long-term ethnoarchaeological studies and enhanced this work with more in-depth historical studies to better understand changes in Gamo lithic technology and the status of the knappers. In particular I began a community archaeology project with Boreda Gamo craft-specialists and farmers that endures today,[3] after a brief study of women knappers among the Konso of southern Ethiopia.[4] I collaborated with many Boreda to record and preserve their oral traditions, life histories, and archaeologies to ascertain a narrative of the transformations in the lives of the leatherworkers and their stone tool knowledge and practices. By documenting life histories, I learned that although there are still prohibitions regarding perceived sexual relations and marriage between craftspeople and farmers, a leatherworker's stigmatized position in society does not extend infinitely back in time and has changed even in living memory.

> The Derg [militant Marxist-Leninist regime 1974–91] made big changes. Before we could not walk on the upper part of any road next to the farmers, we could not drink milk, and we had to kiss the hand of any farmer when we saw them. Before we were like slaves cleaning and removing cow manure for farmers. We could not wear clean clothes, beads, and earrings. The Derg changed many things. (craftsperson 2008)

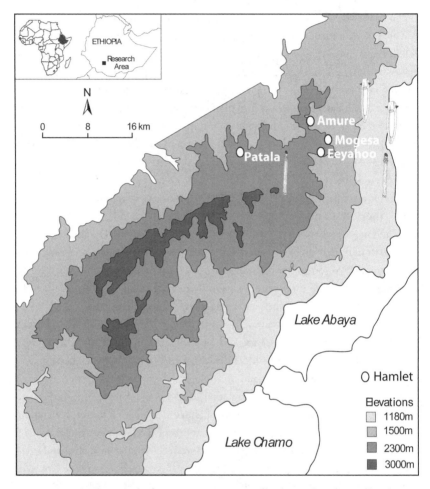

FIGURE 6 Map locating the four main communities of leatherworkers discussed in this book. Map background designed by Melanie Brandt; hamlet locations and handles added by Kathryn Weedman Arthur.

During that time [prior to Derg in 1974–91] the farmers kept their dignity, they were the seniors with prestige and leatherworkers and potters were not. . . . Another cultural rule that we kept is that farmers do not marry craft-specialists. If they marry, it is considered a transgression. If this kind of thing happens, the children die, the cattle die, and the people get sick. (farmer 2007)

Many Gamo consider leatherworkers, other craft-specialists, and craft-specialists' kin as polluted, a source of potential infertility and danger. How long ago does this perspective hold concerning the status of craftsmen, and how did and does it affect

TABLE 1 Table listing the stone-using leatherworking communities I studied with the number of leatherworkers, clan, handle type, hidescraper type, and morphology.

	MOGESA SHONGALAY BOREDA	AMURE DEMBE CHILESHE BOREDA	EEYAHOO SHONGALAY BOREDA	PATALA TSELA ZADA
No. Knappers	6	9	3	11
No. Lineages	1	1	2	1
Clans	Gezemala	Maagata	Gezemala Boloso	Zutuma
Handle Type				
Hidescraper Discard Type	End or Side	End or Side	Single edge to all edges worked	Single edge to all edges worked
Discard Hidescraper Dimensions LxWxPT cm	2.83 2.44 1.31 (n = 489)		2.67 2.38 1.06 (n = 379)	

Gamo lithic technology? If as an ethnoarchaeologist I am to create an alternative perspective for understanding lithic technology to apply to other pasts, I need an understanding of the local history of that technology. Exposing historical change related to ethnoarchaeological studies is particularly important related to stone-tool-using peoples to ensure that they are not mistaken as relics of the past Stone Ages. Engaging people through oral tradition and life histories allows for a more nuanced and historic narrative of technology, permits us to more fully acknowledge that change is fundamental in all societies, and empowers people in the construction of their status and identity in society. Furthermore, it was through Gamo historical and present-day narratives that I learned about their way of being in the world, their ontology, and their relationship to stone.

Long-term living, listening, and learning from the Gamo leatherworkers provided me with a deeper understanding of their history of stone tool technologies, which opened a landscape for decolonizing technological knowledge that can be applied to examining the history of other technologies and in implementing ethnoarchaeological research in the future. This chapter unveils the linguistic, archaeological, and oral histories of stone hidescrapers, leatherworking, and leatherworkers in Ethiopia to

contextualize our knowledge of the present-day status, gender, practices, and ontology surrounding the Gamo knapper and his lithic technology.

LEATHERWORKING IN THE MID-HOLOCENE: HISTORICAL LINGUISTICS AND ARCHAEOLOGY

HISTORICAL LINGUISTICS

The Gamo knappers live in southern Ethiopia, where deeper histories are relatively unwritten except for a small number of publications in historical linguistics and archaeology. Linguists believe the heartland of Afro-Asiatic languages, one of the four major language phyla in Africa, originated with the Omotic speakers (figure 7).[5] Today, Omotic speakers including the Gamo live primarily between the lakes of the Rift Valley and the Omo River in southern Ethiopia. Linguistic reconstructions purport that ten thousand years ago Omotic speakers were hunters and gatherers who intensively collected enset, an indigenous plant that they eventually domesticated.[6]

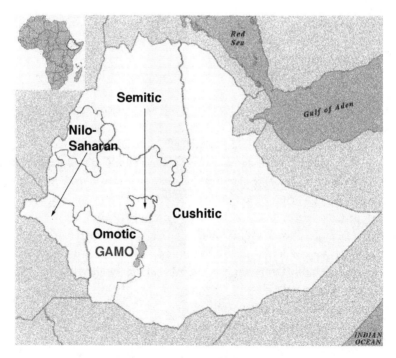

FIGURE 7 Map locating the Gamo in southwestern Ethiopia and indicating the major Afro-Asiatic language families spoken in Ethiopia. Map designed by Kathryn Weedman Arthur (language distribution adapted from Ethiopian Mapping Authority: 27).

Being conversant with Gamo vocabulary and metaphors allowed me to better comprehend their way of knowing and preserving history,[7] particularly surrounding their concept of *bayira*, as related to plant, animal, and tool technologies they deem the oldest and most important. The meaning of the word *bayira* varies situationally and may either refer to seniority as a title or be a predicate to describe a hierarchical relationship, such as elite, eldest, or first.[8] Often Boreda Gamo apply the term *bayira* when speaking of the status of particular animals such as cattle among domesticated animals and lions among wild animals. Today leatherworkers primarily process cattlehides, and in the past lion hides were of significant ritual importance. Hunting has been illegal in the Gamo region since the 1980s, and so it was with trepidation that I began to question an elder leatherworker about processing wild animal hides. When I pulled out my field guide to African wildlife, we quickly drew a crowd of men around us who were eager to chime in on the animals their fathers and grandfathers had hunted. Many returned to their homes and brought back tattered old wild animal hides that the old leatherworker or his father had processed. They identified an array of animals hunted in the past including elephants, leopards, hyenas, gazelles, dik-diks, warthogs, lions, and African buffalo. The last two caught my attention for their names in their language were *gamo* for lions and *ment'za* for African buffalo. The pronunciation of the latter word was so similar to their word for cattle, *meet'za*, that I had them repeat it several times for clarity.

The moniker of *Gamo* as applied to their culture is a recent ascription, and it reconstitutes their sense of cultural pride. The Gamo refer to their language as Gamocalay, which literally means "tongue of the lion," and many Gamo consider lions to be the most *bayira* of all animals. During the Derg regime (1974–91), the Gamo elected to be known nationally under the name *Gamo*, or lion, replacing the derogatory Amharic (national language) term *Gamu*, meaning "they stink."[9] By speaking of themselves as lions, they juxtapose the qualities of a lion including its prestige, strength, dominance, and seniority—*bayira*—with their language and culture. In the past, hunting lions and wearing their hides were associated with elite Gamo who served as lead hunters, a position that excluded craft-specialists (figure 8).

> Well there was great discrimination between potter-smiths and leatherworkers, and those who considered themselves as higher . . . except these potter-smiths and leatherworkers, all could lead the hunt. . . . Well, we hunted them [lions and leopards] just for their skins, and then we would be famous when we wore the hide. In Gamo area, in past time, people hunted animals for their hides and most of the time [we hunted] to get the title that would make us very famous. (Deha Dola 2007)

Only particularly elder men of the king's lineage were allowed to wear lion hides (figure 8), as symbols of their prestige and dignity set against the disrepute and

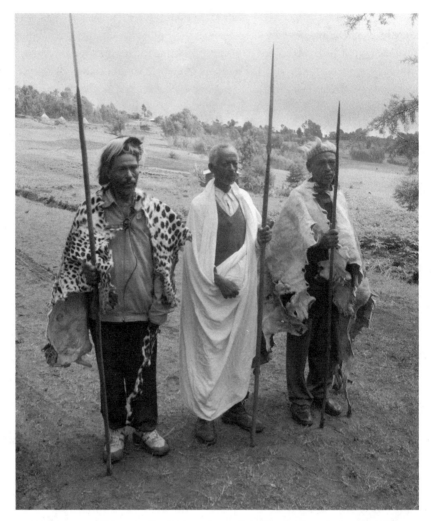

FIGURE 8 Men of the Boradamala clan, Alemayehu Gunto, Chilga Chisha, and Baredo Badeke, wearing leopard hide, cloth gabi, and lion hides of their grandfathers.

dishonor of the craft-specialist men who processed the hides of the lion into the ritual capes the elite wore. The Gamo often contrast *bayira* with the concept of *t'unna*, which means infertile, unclean, and inhuman. As one elder whispered to me, to be *t'unna* is to be less than a wild animal, and I had found out their secret that shamefully they once thought of *hila* (craft-specialists) in this way.

The primary hides processed by Gamo leatherworkers today are cattlehides rather than wild animal hides; and as a result of my interviews with Gamo, I believe that it

is highly probable that the Gamo and other Omotic speakers transferred their words for wild animals and hunting technology to domesticated animals and herding technology. Omotic speakers do not share terms for cattle, goat, and sheep with neighboring Cushitic or Semitic speakers, though it is highly likely that they acquired domesticated animals from them instead of domesticating animals themselves.[10] As stated above, the Gamo word for African buffalo is *men'za* or *men'tsa* (dialect differences), which is very similar to their words for domesticated cattle *mee'za* or *mee'tsa* (dialect differences). The Gamo word for sheep is *dorsa*, and there is no similar word to sheep/*dorsa* that was revealed relating to wild animals. However, the Gamo name for dik-dik, the smallest wild bovid in the region, is *gen'esha*, which is similar to their word for goat, *desha*. I propose that perhaps when Omotic speakers adopted pastoralism, rather than adopting the vocabulary of their neighbors, they created their own words for domesticates that were similar to the words they used for the wild animals that they believed were most akin to the domesticates they were bringing into their lives. Omotic speakers may have initially had a buffering or mutualistic exchange relationship[11] with pastoralists to create social ties and alliance that could be depended on for relief in periods of food scarcity. At the beginning, access to domestic stock may have been on a seasonal or periodic need basis that eventually led to full-time pastoralism in the highlands. This hypothesis remains to be tested and begs for further studies of Omotic terms for wild animals, domesticated animals, and technology, as well as archaeological research into the processes and timing of food production in the region.

In addition to original terminology surrounding pastoralism, Omotic speakers also have distinct terminology for their leatherworking technology. They have unique words for obsidian, chert, hidescraper, and their scraping haft when compared to the terms used by neighboring Cushitic and Semitic speakers (table 2).[12] Brandt's survey of southern Ethiopian leatherworkers indicated that many cultures utilized unique hafts (figure 9) and stone hidescrapers.[13] Cushitic is considered a derivative language of Omotic, and the two split sometime before 7000 BP.[14] Whether the Omotic and Cushitic developed these technologies separately or Cushitic peoples adopted leatherworking terms from neighbors along with pastoralism remains to be explored. The unique vocabulary for Omotic speakers' leatherworking technology suggests that they likely did not borrow this technology from Cushitic and Semitic speakers when they adopted pastoralism.

ARCHAEOLOGY

Linguistic reconstruction is still developing evidence in southern Ethiopia for the introduction of cattle and caprines, and hide processing technology and archaeological

TABLE 2 Comparison of leatherworking terminology demonstrating the uniqueness of Omotic cultures and languages. X = term unknown to author.

LANGUAGE FAMILY	OMOTIC		CUSHITIC				SEMITIC
Culture	Gamo/Oyda	Gamo/Wolayta	Konso	Sidama	Oromo	Hadiya	Gurage
Caste	Degella	Degella	Xauta	Awacho	Chawa	Faqui	Faki
Hidescraper	Depends on life cycle state	Depends on life cycle state	*paltita*	*torcho*	*chabbi*	X	*balchi*
Haft	*tutuma*	*zucano*	*tukmyatyata*	*ducancho*	*muca*	*gundagna*	*gundane*
Chert	*goshay*	*goshay*	*lingeto*	X	X	X	X
Obsidian	*solloa*	*solloa*	X	*chebbi*	*chebbi*	*bancha*	*balchi*

FIGURE 9 Drawing comparing the different hidescraper hafting types in Ethiopia. Top: Gamo/Oyda, Gamo/Wolayta, Konso, Sidama; Bottom: Oromo, Hadiya, Gurage. Drawings by Kendal Jackson.

evidence is also sparse. Once again working with the Gamo community was essential in divulging their history. In 2006, I began a community archaeology project with the Boreda Gamo with John W. Arthur and Matthew C. Curtis to facilitate a joint desire to produce a written historical text that would privilege Boreda historical knowledge and combine it with archaeological knowledge.[15] Gamo elders provided the specific locations of places of historical importance that could be investigated with archaeological methods. Most of the places identified were mountain-top sites referred to as *Bayira Deriya*, literally meaning the places of seniority, places of the ancestors, or the oldest places. Below sacred rivers and the mountaintop *Bayira Deriya*, several Boreda led me to

where they believe the earliest people came up from the soil from the cave below the earth. The cave is the womb for boys and girls. Here we used to go to make an offering to the spirits when a new child was born, at the new harvest festival, and when someone became ill. (Gigo Balgo, August 7, 2008)

Many Boreda believe the cave sites to be the homes of their earliest ancestors. Excavations of other cave sites from the landscape of present-day Omotic speakers in southern Ethiopia suggest that prior to two thousand years ago, the caves were occupied by Holocene hunter-gatherer populations utilizing Later Stone Age micro-lithic obsidian and chert points, knives, and hidescrapers to hunt and process African buffalo and other bovids.[16] Cattle herding, production of ceramic vessels and figurines, and possibly the domestication of enset and coffee likely began approximately two thousand years ago among people living to the immediate north of the present Gamo territory.[17] The mid-Holocene prevalence of African buffalo lends to the argument that it was the main hunting resource prior to domesticated cattle. The replacement of African buffalo by cattle in the archaeological record adds credence to the discussion above in which I argue that Omotic speakers may have transferred their terminology for wild animals to the introduced domesticates that replaced earlier species important in their economies.

The cave sites in the Boreda highlands also contain archaeological evidence for hunter-gatherer populations during the mid-Holocene.[18] Deposits in the caves contain wild animal bones and stone tools spanning back to the last six thousand years, and later strata include pottery and human remains. At the Boreda site Mota Cave, a nearly complete human burial is dated to circa forty-five hundred years ago (OxA29631: 3977+/1 29BP, 4524–5117 Cal BP).[19] People in the past built a cairn that cradled the man whose bones preserved the oldest known complete African genome. His genetic signature indicates that he was highland adapted and lactose intolerant, as is sup-ported by the absence of domesticated animals associated with him in the earlier strata at the site.[20] Genetics suggest that the ancient individual is most closely related to the Ari, another Omotic-speaking culture living in southern Ethiopia, supporting the idea of long-term population stability in the region. However, genetic comparison with later populations in the Horn of Africa exhibit genetic signatures that indicate that nearly three thousand years ago, during the formation of polities in the northern Horn of Africa and the Southern Arabian Peninsula,[21] peoples of the Horn tied their lives together in significant ways with populations of West Eurasia that produced future generations.[22] Significantly, this one burial in southern Ethiopia helps us to under-stand precolonial population dynamics. It provides a scientific stand against the racial categorizations that were inflicted on world populations as a colonial political tool with concrete genetic evidence of intercontinental relationships nearly three thousand

years before colonialism. Yet, the Mota Cave individual, who was buried under a cairn with obsidian stone tools in the fifth millennium BP, predates Eurasian contact during the polities in the northern Horn such as Axum. The lithic assemblage at Mota Cave indicates that people in the region produced tool types such as microlithic and backed obsidian and chert tools, including points and scrapers, that are typical in other parts of the continent. The working edges of many of the scrapers are rounded and fit into the edge angle measurements most commonly associated with hideworking. The earliest inhabitants of the cave made and used backed side hidescrapers and hidescraper cores found in the deepest deposits dating to the sixth millennium BP (figure 10). The microlithic hidescrapers may have been backed to facilitate hafting.[23] These early leatherworkers selected primarily obsidian to produce their backed and microlithic hidescrapers, which range from double to less than half the size of the hidescrapers of the living Gamo. The Mota leatherworking technology is a distinct technological tradition compared to that practiced by leatherworkers living today.

Leatherworking and knapping has a deep history among peoples who lived in the landscape that is now occupied by Omotic speakers. Clearly no matter how or from whom pastoralism was adopted, Omotic speakers chose to maintain or create a distinct terminology for their domesticates and their leatherworking processing technology. The hidescrapers produced today by the Boreda Gamo to process domesticated

FIGURE 10 Drawing of sixth millennium BP microlithic backed obsidian hidescraper (distal working edge, dorsal view, backed edge, AFN83 ST2 Level 6) from Mota Cave, Ethiopia. Drawing by Kathryn Weedman Arthur and inked by Kendal Jackson.

hides are significantly different from mid-Holocene Later Stone Age technologies associated with the processing of wild animal hides.

LEATHERWORKING AND CRAFT SPECIALIZATION IN THE THIRTEENTH TO NINETEENTH CENTURIES: ORAL TRADITION AND ARCHAEOLOGY

The low status of craft-specialists such as knapping leatherworkers likely arose in southern Ethiopia within the last millennium with the introduction of Christianity and the Gamo conscription into the state of Ethiopia (figure 11). Evidence for the presence of leatherworking specialists dates as early as AD 350 at archaeological sites in northern Ethiopia with the Axumite state, whose written texts delineate them as Ethio-Semitic speakers.[24] Several scholars postulate that either northern Ethio-Semitic speakers or eastern Cushitic speakers conquered or incorporated the south-

FIGURE 11 A Boreda Gamo Orthodox priest with his Bible and staff of authority.

ern Ethiopian hunter-gatherers and farmers and introduced social stratification and craft specialization between the thirteenth and nineteenth centuries.[25] Monumental architecture and stone stele in southern Ethiopia associated with ceramics and some obsidian lithics including hidescrapers reveal a cultural landscape of growing social complexity.[26] Unfortunately, these southern Ethiopian archaeological sites are not well studied or dated.

Three hundred years ago, households with an abundance of hidescrapers were isolated on the Boreda landscape located nearby *Bayira Deriya* or ancestral sacred landscapes. We excavated two of these sites revealing household floors, one at Ochollo Mulato dated to 170 +/− 40 BP and another at Garu Shongalay dated to 240 +/− 70 BP.[27] The eighteenth-century inhabitants chose a wide diversity of raw material types including chert, obsidian, and quartz crystal to produce end and side hidescrapers (figure 12). Furthermore, they made stone awls reinforcing the presence of leatherworking in the household, as well as other stone tools such as wood scrapers and intentionally modified flakes. Certainly the eighteenth-century stone tool assemblages confirm that there have been considerable changes in the lithic technology during the last three hundred years. The location of these leatherworking households on steep grades on the edge of *Bayira Deriya* settlements and their isolation from the main settlement allude to the possibility that some form of segregation of people engaged in leatherworking might have already been present in the region. However, another contemporary household dating from 180 +/− 50 BP to 460 +/− 40 BP at Ochollo Mulato on the peak of an adjacent mound also contains lithic debitage. In this household, we did not recover any formal stone tools; however, the presence of

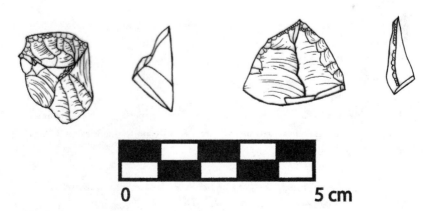

FIGURE 12 Drawing of two eighteenth-century hidescrapers from Garu, Ethiopia. Drawing by Kathryn Weedman Arthur and inked by Kendal Jackson.

lithics suggests that lithic use may have been widespread among households and may not have been associated with some of the negative attributions to which it is ascribed today.

Standing on the summit of the mountain, one can observe that hovering above the eighteenth-century leatherworking households are the *Bayira Deriya* landscapes that evoke many Boreda elder memories of oral traditions that justify the present-day segregation of the lives of farmers and craft-specialists, such as leatherworkers, iron-smiths, and potters. For many Boreda, *Bayira Deriya* literally means the "places of seniority" or the "oldest places," where the Boreda first settled, fought their enemies, and honored the spirits in sacred forests.[28] Elder men of a lineage commonly transmit oral traditions or political histories, which were performed annually in public venues to ensure a common historical narrative.

Many Boreda elders concur that Ochollo Mulato is the oldest of the *Bayira Deriya* or ancestral sacred landscapes, where their first king, Borchay, established their social order by dividing the lives of farmers and craft-specialists.[29] Boreda men were often eager to share with me the story of their founder, who had his origins in "Gergeda," among either the Cushitic Oromo peoples or Cushitic Sidama peoples. A few elders stated that Borchay was the youngest brother and therefore could not lead the Boreda people, so he had to summon his older brother, the king of the Omotic Kucha, to the north to lead. Written records document that during the sixteenth century, the Gamo paid tribute to the Omotic Kucha in 1550 and were invaded by the Cushitic Oromo in 1593.[30]

In some versions of the oral tradition, Borchay came with craft-specialists; in other versions, he selected individuals after their arrival according to their ability to be craft-specialists.[31]

> On Friday Borchay arrived from his homeland with Woreta [Amhara], Amhara, Wondo [Sidamo], Gondo [Oromo], and potter-smiths. On Saturday he made a fire at Ochollo, and then for the next days they built fires at Awesto, Barena, etc., and assembled to govern Boreda. (Kuta Kunta, May 30, 2006)

> Borchay gave names to the farmer, leatherworker, and the potter-smith castes, for all people, but the man who started the first fire was of the potter-smith caste. (Chilga Chisha, May 24, 2011)

As one elder elaborated, *the story of Borchay is more about the arrival of our culture—rather than a story of human migration* (May 26, 2012). It is clear that an important part of the Borchay tradition is to explain the division in society between farmers and craft-specialists, as well as their contact with Oromo, Sidama, and Kucha

peoples, though when is uncertain. Certainly, a few ethnographers have argued that Oromo expansionism in the sixteenth century may be responsible for introducing the current marginalization of craft-specialists by farmers in the region.[32] However, rather than taking the oral traditions literally, we might consider that the tradition may serve as a mnemonic device that conflates the period of sixteenth-century Oromo expansionism with later strife. In the nineteenth century and early twentieth century, Oromo, Sidama, and Kafa captured peoples from Gamo, Gofa, Wolayta, and Konto, subjugating them into household and agricultural slavery for their own kingdoms and those in the Near East, northern Ethiopia, and Egypt.[33] Many versions of the Borchay tradition ascribe monikers to Borchay's followers that emphasize their origin from these external polities.

> Borchay came from Mande Gergeda [Sidama and Oromiyaa], and he was the first set-
> tler at Ochollo Mulato. He came with eight other clans, including the Amhara, Gondo
> [Oromiyaa], and Woreta [Amhara]. (Kuta Kunta, July 8, 2011)

Gamo elders in our discussions markedly emphasized the strategic location of *Bayira Deriya* overlooking the Rift Valley in protective locations surrounded by stone walls, trenches, and burial grounds, evidence of past conflicts in association with tales of warfare in which they staunchly defended their people and territory.[34] Whether these external polities introduced the idea of marginalizing craft-specialists or whether the Boreda internally developed craft specialization and political complexity stimulated by defense of their homeland is clarified in other Boreda oral traditions.

Another Boreda Gamo oral tradition forwards the idea that the low status of craft-specialists, particularly leatherworkers, originated with Boreda resistance to incorporation into the northern Ethiopian state and the introduction of Christianity. The constant upheaval in the south described above probably weakened southern Ethiopian forces by the late nineteenth century, allowing for the Gamo to be formally integrated by 1897 into the northern Ethiopian empire under the rule of Menelik II, the northern Solomonic Amhara dynasty head of state.[35] Alternatively, several written records of the northern Ethiopian empire document that the Gamo and other southern nationalities experienced some form of integration into the northern state and Christianity, perhaps as early as the fifteenth century under the reign of the Zara Yaqob of the Solomonic dynasty.[36] The history of the Solomonic dynasty in Ethiopia that included nineteenth-century Menelik and fifteenth-century Zara Yaqob is outlined in the national Ethiopian epic, the *Kebra Negast*. The book touts that the first northern Ethiopian ruler, Menelik, was the son of the biblical Solomon, and as such he founded the world's first Christian state at Axum.[37] Further, the epic boasts that Menelik brought to Ethiopia the Ark of the Covenant—a gold-plated box—with two

stone tablets inscribed with the Christian Ten Commandments. Orthodox churches throughout Ethiopia, including those in the Gamo region, claim to house the coveted Ark of the Covenant.

Standing at the earliest Boreda settlement and sacred groves at the Ochollo Mulato *Baiyra Deriya*, elders pointed to an open space adjacent to the settlement indicating that the earliest Ethiopian Orthodox church once stood there. Many Boreda profess to be Orthodox and also follow their Indigenous religion, *Etta Woga* (Fig Tree Culture), honoring the Christian God, *Tossa*, and their Indigenous *Tsalahay*, spirits, and *moy-ittilletti*, ancestors. The appropriation of the *Bayira Deriya* landscape with an Orthodox church recalls an oral tradition associating the segregation of craft-specialists and farmers with the introduction of northern Amhara or Solomonic Christians and an iron rather than a gold box. The Boreda Iron Box oral tradition purports that craft-specialists were the kings, *bayira* of all of Boreda, and the first to convert to Christianity; and by misusing their technological skills, they caused their own downfall and impurity, *t'unna*. The narrative states the box served as the instigator for the present division in Gamo society between *mala*-farmers and *hilancha*-craft-specialists, such as leatherworkers. An elder and respected Gamo historical authority, Giya Fanikasha, recalled the tradition:

> Yes, I told them last time about leatherworkers and potter-smiths. In ancient times they were of the king's family. So in earlier times when the spirits lived in the world, the leatherworker and potter-smith took his son . . . they put him in a small iron box and they threw him in the water. [When the spirits learned this, they] said to them, in this world you have no authority and year after year you will live under the others. So in this case, craft-specialists and farmers do not eat together, they do not live together, and they do not marry together. (Giya Fanikasha, May 26 and 29, 2006)[38]

The craft-specialists lost their dignity, *bayira*, and became *t'unna*, impure and stigmatized. According to the Boreda tradition, the spirits punished the craft-specialists by rescinding their power as kings and insisting that they not marry, eat, or live with farmers for enclosing the king's son in an iron box. Elders stated that the northern Amhara Christians brought iron burial boxes (the caskets were not actually all iron, but held together with iron) when they settled in the Boreda region. For many Boreda, the construction of an iron casket symbolized an affront to human well-being and fertility in two ways. First, it signaled the disruption of Boreda Indigenous religious burial practices with Christian practices. For most followers of the Boreda Indigenous religion, the deceased were buried without a casket, allowing their bodies to transform into the earth and their spiritual essence to join the ancestors. When propitiated correctly, many Boreda believed that ancestors could act in concert with other

spirits to ensure the welfare of domesticated crops and animals and people. A casket would block an individual's ability to become part of the ancestral milieu and stagnate the essential process of all beings and life. Second, many Boreda believed that craft-specialists should produce iron to make farming instruments for food production, ensuring human health and fecundity. In East Africa iron is prominent in many oral traditions in association with maintaining human well-being.[39] Iron technology enlisted the skills of leatherworkers to produce hides for bellows and cattle horns for tuyeres (furnace pipes), as well as the technology of potters to make a special ceramic cover for the furnace. Thus, the technological knowledge for producing iron is intimately connected with leatherworking as well as pottery production, and all craftspersons were held responsible for the potential downfall of society. In the Iron Box tradition, the misuse of an essential product, iron, is associated with Christianity and leads to the segregation and low status of craft-specialists in Boreda society.

Gamo oral traditions likely recall and conflate the infringement of national feudal politics and Christianity between the sixteenth and nineteenth centuries and demonstrate resistance to both the state and Christianity in tandem with the formation of low-status craft-specialists. D. Freeman stated that the Gamo were quick to submit to state rule after observing the massacre of their northern neighbors.[40] Yet, other scholars argue that hereditary Gamo leaders organized and resisted Amhara settlement, rule, and taxation.[41] Boreda Gamo oral traditions claim resistance not only to Amhara rule but also to state religion. State stimulation of local economies combined with Christianity and emphasis on patrimony may have led to increased status and riches for Gamo male craft-specialists, such as leatherworkers. Written records suggest that during the late nineteenth and early twentieth centuries leather products were of considerable importance to the northern Ethiopian state,[42] and several societies were recorded using stone hidescrapers to process hides in central Ethiopia.[43] Certainly, it is not out of the realm of possibilities that the Ethiopian state would have been interested in controlling the production of leather goods that would have been highly profitable at the time. As was noted among the craft-specialists farther to the north among the Hadiya, Kambata, and Gurage, craft-specialists sided with the state against the Italians because they had better-paying opportunities and more access to land.[44] Perhaps favor of craft-specialists by the state exacerbated local tensions between craft-specialists and farmers, resulting in prohibited interactions and differences in status. Male conscription of productive resources and trade goods would have been an affront to Boreda ontology that structured male and female interaction and cooperation in productive technologies. Decisions to assign male craft-specialists to a low social status may have been a form of resistance to state patriarchy, Christian ethos, and craft-specialists economic prosperity. Boreda oral traditions infer that during incorporation into the Ethiopian Christian state, craft-specialists were once the

kings, who misused technology, transgressing Indigenous religion and sociopolitical systems, resulting in the high status of farmers and the low status of craft-specialists. According to Boreda life histories, this pattern of farmer and craft-specialists segregation continued through Haile Selassie I's feudalism (1930–36), Italian colonialism (1936–41), and Selassie's regain of the nation's independence (1941–74) until the Derg militant Marxist-Leninist regime (1974–91).

TWENTIETH- AND TWENTY-FIRST-CENTURY LIFE HISTORIES: JUSTIFYING THE SEGREGATION AND SOCIAL STIGMA OF KNAPPING LEATHERWORKERS

LIFE HISTORIES AND MEMORIES OF OPPRESSION

Boreda life histories unveiled how changes in religious affiliation and national politics transformed craft-specialists' status in society and their daily practices over the last fifty years. In the early to mid-twentieth century, for some Boreda their position in life was ascribed at birth as a member of craft-specialist occupational lineage—potter, leatherworker, or ironsmith—a status that solidified their marginalization as *t'unna*, or worthless, impure, not a full human being. During Haile Selassie's rule in Ethiopia (1941–74)

> we [leatherworkers and their families] ate separately and only poor foods. We were impure. We were considered not to be human. We worked very hard and received little. We lived close together and had no land. We could not wear nice clothing. We could only walk on the lower part of the land, sit in the lower part of the house, sit on the edge of ceremony; often we were accused of spiritual transgressions by degrading the earth. (craft-specialist 2008)

> The craft-specialists did not sit next to us; they did not share our food. They had to remove the waste products from our house. They could not sit on the upper side of the house or in sacred places. They could not enter the sacred forest. They sat on the edges for wedding, mourning, and ritual induction ceremonies. We did not marry. We still do not marry. *Mala* are senior [*bayira*] and keep rules, keep their dignity. (farmer 2007)

> We were not considered as full humans, we lived tightly together and had no land, we worked hard and got very little, we had to kiss the hand and leg of the farmer, and we washed their legs. When we would gain any wealth, the farmer would accuse us of transgressing spirits and we would be forced to give it away. (craft-specialist 2008)

Many craft-specialists and farmers agreed that in the past they had separate work groups and burial places, and craft-specialists had no access to sacred groves or the ritual market knolls. Craft-specialists recall that they felt treated with such disdain and disrespect by others that they were perceived to be inhuman and worthless, *t'unna*. Farmers substantiate their past mistreatment of craft-specialists and their past sense of seniority, superiority, and dignity, *bayira*. Craft-specialists were prohibited from entering rituals at *Bayira Deriya*, even as they played significant roles in those ceremonies. The leatherworkers would announce the beginnings of rituals with their horns, but were kept at the edge of the ceremony. Knapping leatherworkers processed the lion and leopard hides into ritual capes and made cattlehides into drums for the ceremonies. In return they only were given the head and legs of animals slaughtered for ritual consumption in compensation for their work.

Many of the elder Boreda leatherworkers recall that during this period they worked mostly full-time, processing hides and horns, transforming perceived polluted items into valuable goods. Leather clothing and shoes adorned children, men, and women. Leather saddles and bridles enabled horseback riding. Shields were made for defense in the war-torn late nineteenth to early twentieth centuries. Leatherworkers' wives were responsible for the domestic stock for milking, collecting the fodder, cleaning up the manure from households, and placing it into the fields, and for the labor-intensive processing of the indigenous staple crop enset.

> The farmers forced us to live in the swamp areas and on the edge of the mountain [Ochollo Mulato] and took the fertile lands. We did everything for them, collecting grass for their cattle and wood for their fires. We processed their enset plants, performed their circumcisions, and played music at their ceremonies. Always we were on the edge, and they gave us very little food for our effort. (craft-specialist 2011)

Leatherworkers and their wives worked almost full-time producing items that were necessary for everyone's daily existence. Their practices involving work with perceived polluted items—such as manure, animal hides, and horns, and stone as hidescrapers—reinforced perceptions that by association craft-specialists were also polluted which meant the necessity for craft-specialists segregation from those who were *bayira* or pure.

Although tensions between some farmers and craft-specialists persist today, others clearly expressed sentiments that discord began to dissipate with the onset of Derg militant Marxist-Leninist regime (1974–91). The Derg is often heralded as the great equalizer for many craft-specialists. Everyone was equal, participated together in church and in neighborhood work groups through which they built houses, helped one another in times of illness and death, and shared the meat from animals slaughtered

at annual festivals. The regime also prohibited any social or political act that redeemed any sense of ethnicity in place of nationality, and in the course of instituting these laws the government inflicted great violence. They conscripted men and women into the military to work as their local enforcers and to serve in national defense. Further, local economies were impacted when the Derg forbade the production and wearing of locally made clothing from leather that might be perceived as embodying local identities.[45] The economic and political turmoil people experienced at the hand of the Derg was noted by the mother of a leatherworker (2008).

> The ritual cape, skirt, and bed: these we made of sheep hide, also the men's clothes. The Derg came and made us stop [making these items]. They said to stop this production and use what I give you and that they need our sons for the battlefield, not for this work [leatherworking]. The Derg government was good because he made us equal with others, but later he made us cry so much. You know what he did? He took our sons like cows to the battlefield. This never leaves our mind.

Under the Derg, craft-specialists were limited in the types of hide products they could produce, but at the same time they received land in redistribution schemes and served as government officials in enforcement of equality. The widespread introduction of industrial goods beginning in the 1970s during the Derg, coupled with the forced abandonment of locally made products, meant that craft production became a part-time endeavor. Industrially made clothing, blankets, and bags were and continue to be available inexpensively and in abundance at markets and town shops and have replaced many of the items once made by leatherworkers. Leatherworkers no longer widely produced the ritual musical instruments nor the ritual clothing discussed above. Still, leatherworking with stone tools was an active occupation across the nation as evidenced by the many ethnoarchaeological studies of the era.[46] The Derg tried to instill a new ideology equalizing farmers and craft-specialists, but many farmers were resentful and complained bitterly about the loss of their land, status, and their religious practices under this regime.

> The Derg tried to teach us that all are equal, all are human beings. People said okay, but we're afraid of government so we said this, but we [mala] did not agree.... Derg said you have to drop your practices of sacrifice, priestess, priest, spirit medium, etc., and work for the government. They would give punishment for breaking rules—like going to jail, beating, or paying money. (farmer 2008)

> We practiced with our drum, the Koran, gold, and brass, but the Derg forcefully took them and there is no more Kallicha [mystical form of Islam]. The current government

today gives democracy of religion, but cannot bring back our heritage; [it] is destroyed; our ancestors' burial land is gone. (farmer 2012)

The disruption of the Gamo Indigenous religion and mystical forms of Christianity and Islam during the Derg is significant, as these practices sanctioned the segregation of craft-specialists and farmers in society.

In 1991, a new government, the Ethiopian People's Revolutionary Democratic Front (EPRDF), arose and with it many Boreda began to renew the tenets of their Indigenous religion *Etta Woga* that disenfranchised craft-specialists. Craft-specialists complain that farmers attempt to take their land away from them by prosecuting them for small crimes that require fees and force them to sell their land.

The Derg government gave us land. After the Derg, the farmer caste began requesting land back, but we refuse. (craft-specialist, June 28, 2008)

In fact, the Derg government abolished many old traditions and practices. The community was left without their culture. But later the EPRDF comes and all these traditions return. (farmer 2012)

Indignities for craft-specialists in Boreda, though lessened, continue today, as craft-specialists lose land, own land poor for agriculture, and in some places have separate burials grounds and work parties. In at least one account in the district of Doko, after the Derg, community members threatened, though failed, to remove craft-specialists away from *mala*-farmer graves because of the perception that they were causing a drain in fertility.[47] Craft-specialists' poverty and stigmatized status is widespread across southern Ethiopia as researched through a recent survey by Ethiopia's Southern Nations, Nationalities, and Peoples' Region of Ethiopia (SNNRP) Ministry of Culture and Tourism.[48]

CASTE AMONG THE GAMO? RELIGIOUS SANCTIONS, GENDER, AND TECHNOLOGY

Based on Boreda Gamo life histories, craft-specialists since the early twentieth century have experienced severe discrimination and segregation, as a result of their productive activities, which many Boreda perceived and still perceive to violate normative behavior. Anthropological debate over how we categorize societies and peoples experiencing such oppression and segregation in Ethiopia is highly contested. Several Africanists recognize caste societies as associated with endogamous ascribed occupational groups, who justify their status through concepts of pollution,[49] and it is this

definition of caste that I ascribe to in this book. Many other researchers studying the Gamo also refer to them as a caste society.[50] Historically Ethiopian scholars applied the term *caste* to describe other Ethiopian Omotic-, Cushitic-, and Semitic-speaking craftspeople, whom they recognized as endogamous, despised, polluted, ascribed to particular occupations at birth, landless, and excluded from political and social life.[51] The Boreda craft-specialists and farmers exhibit many of the characteristics of a caste society in that their religious tenets and performances hierarchically ascribe individuals according to different levels of purity into endogamous occupational groups, who often speak an argot and practice restricted interactions in their various sociopolitical-economic relationships.[52]

Many Boreda explain both their historical and present-day social and spatial segregation of craft-specialists and farmers as embedded in their Indigenous religion. The tenets of Boreda *Etta Woga* outline the hierarchical ranking and perceived level of purity-pollution of Boreda occupational groups of farmers and craft-specialists. Ascription into a particular occupational group is assigned at birth based on agnatic descent and reaffirmed during puberty rites of passage.[53] Craft-specialists interrupt their rites of passage and the life-cycle process, affecting their efficacy in social life and legitimizing their low status in society.[54] Craft-specialists did and do not complete the final phase in Boreda rites of passage, as puberty initiates were not presented in the community market ceremony commemorating their status change to fertile citizen status within society. The Boreda often state that in the past they viewed craft-specialists' failure to change as a sign that they were worthless-infertile—*t'unna*—and as such they were impure. The *mala*, on the other hand, whose ancestors were perceived to be occupational farmers, were considered to be pure and therefore were accorded with prestige and power, *bayira*, in society. As a consequence of the different hierarchical levels of purity and prestige between farmers and craft-specialists, *Etta Woga* outlined appropriate and inappropriate interaction between them. Other Gamo districts employ the terms *Bene Woga* and *Bene Ogay* to refer to their Indigenous ontology.[55] For example, craft-specialists could not sit next to a farmer or sit or stand inside farmer ritual spaces, such as weddings and funerals, or enter agricultural lands. Craft-specialists and farmers should not share food or drink or share household space, community space, or burial grounds. Further, craft-specialists and farmers should not flirt with each another, engage in sexual relations, or marry.[56] Many Boreda believed that transgressions against the prescribed rules would result in further infertility, sickness, and death.[57]

Craft-specialists not only disrupt transformation by not proceeding through all stages in rites of passage, but they also disrupt life in the way in which they practice technology. This is reinforced in the oral tradition above in which craft-specialists are stripped of their position as kings for improperly producing and using iron and

dismissing their prescribed religious burial practices. In the Boreda ontology reproduction of all forms of matter requires male and female interaction with specific gender roles. Boreda concepts of gender and how an individual manipulates the natural world informed the presence of hereditary status groups, as noted in research by Judy Sterner and Nicholas David[58] among West African cultures. *Etta Woga*, or *Bene Woga* or *Ogay Woga* in other part of the Gamo regions, delineates proper roles for men and women in daily tasks.[59] Boreda craft-specialists, whether women (potters) or men (leatherworkers and ironsmiths) were often associated with the feminine reflecting their knowledge and responsibility to mediate nature by transforming and creating raw materials into valuable goods.[60] An elder man said to me, that "in the past they had little work and the *mala* gave them food and little respect. The *mala* would say to me [the elder man]: 'You, woman, take this food'" (craft-specialist, June 5, 2008). Male craft-specialists were likened to women not only for birthing stone but because they did not own land, plant seeds, and procure their own food. One *mala* man told me that "men must plant seeds, not women, because the earth is like a patient woman; it holds on to things and gives birth" (farmer, July 5, 2007). While *mala* men farmed by planting seeds, full transformation into a plant from seed required women's labor—that is, a shared responsibility in (re)production. In contrast, craft-specialist men and women (re)produce material culture without interaction between the sexes. Craft-specialists in their practices represented an aspect of reproduction and fertility that excluded one of the sexes, often viewed as a transgression against the spirits, as were same-sex relationships. Only in ceramic production do men often help with the production of the pots.[61] This may explain why potters when not married to leatherworkers or ironsmiths may have a slightly higher and separate status. Thus, sexual relations, marriage, and other types of interaction between farmers and craft-specialists commonly were viewed as dangerous with the potential to cause infertility.

Today Boreda men and women continue to gestate into ascribed endogamous occupational groups that include *mala*-farmers and *hilancha*-craft-specialists.[62] Division of craft-specialists varies within the Gamo region. In southern districts, all historical craft-specialists were referred to as *mana*. In the central Gamo districts, craft-specialists were divided into two groups: *mana* who are historically potter-smith lineages and *degella* who were historically leatherworker and groundstone lineages. In the northern districts, however, craft-specialists lived as *chinasha* or historical potter-smith lineages and *degella* or historical leatherworker lineages. Today, craft-specialists prefer the terms *hilancha katchea*, *hilancha tugay*, and *hilancha wogatchay*, indicating professional leatherworker, potter, and ironworker respectively.

I recognize that the word *caste* is contentious and that other Ethiopian scholars prefer the phrases twofold system,[63] endogamous-hereditary groups,[64] and marginalized minorities.[65] These alternative terms to *caste* are employed in deference to recognition

that *caste* should either be only associated with a social formation embedded particularly in Hindu ideology[66] or eliminated as a tool of Euro-American "othering."[67] The term caste does not originate in Hindi and refusing to acknowledge that people live in caste-like societies fails to encourage challenges to the dominant discourse and relay a meaningful and relevant connection between peoples' experiences living today and those that they perceive of their ancestors in the past.[68] I believe that the social and economic plight experienced by most Boreda craft-specialists as described below resolutely describes a caste society and that use of other terms undermines the extent of their suffering. As demonstrated below, among the poorest of Ethiopia are the rural craftspeople, who tend to be endogamous, live segregated on the least fertile lands for agriculture, very infrequently attend school, experience dietary and ritual exclusion, and eke out a living selling their goods at local rural markets.

LEATHERWORKERS' COMMUNITIES OF PRACTICE TODAY (*HILANCHA KATCHEA*)

Gamo knapping leatherworkers are ascribed to a low-prestige occupational caste group, *hilancha katchea*, as a consequence of their perceived polluted status for violating the doctrines of *Etta Woga*. Their perceived pollution means that most leatherworkers as demonstrated below live in segregated communities based on their occupation as members of particular historical patrilineages that are and have been endogamous and segregated in use of land, diet, and in some instances access to religious, social, and political positions and rituals. Often disenfranchised and not well respected in the wider community, they are isolated, but their isolation provides an atmosphere of unity from which they develop a mutually shared knowledge and practice of knapping and leatherworking—a community of practice (figure 13).[69]

ENDOGAMY

Many of the cultural prescriptions between caste groups have relaxed since the Derg regime, but marriage, engaging in sexuality activity, or sleeping in one another's houses can still result in ostracization from the community even in households that purport to follow Christianity or Islam. Gamo marriage is restricted within the caste group and governed by a patrilineage moiety-clan system with a patrilocal postresidential pattern, which is common in Omotic societies.[70] As I narrated at the beginning of this chapter, I had firsthand experience with the strictness of the Boreda rules of endogamy. Of the hundreds of Gamo I have interviewed, I did not record one marriage between individuals of different caste groups.

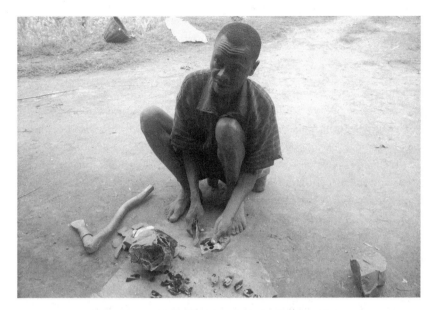

FIGURE 13 Osha Hanicha, a knapping leatherworker.

Leatherworkers are typically born and live their entire lives in the same commu-
nity, which is ensured by a marriage pattern that encourages exogamous clan marriages
and patrilocal residence. Leatherworkers living in one community often share a clan
name and descend from a common ancestor who acquired land through a historical
patron-client relationship. In return for providing a *mala*-farmer patron with "free"
leather goods, the craftsman acquired the patron's clan name and land for his house-
hold. The more than forty clans are divided into the moieties of *Dogala* and *Mala*
distinguished by oral traditions that relate the *Dogala* clans as the original settlers of
the Gamo highlands. The *Mala* clans represent immigrant populations, and the names
of each clan often reflect the name of the region they originated from followed by the
mala suffix, such as Wolaytamala. More than 60 percent of leatherworkers are mem-
bers of the *Dogala* clan, and if the *Dogala* were the original landowners, they would
have been in a better position to offer a land-labor exchange relationship with craft-
specialists. Today, fewer than 40 percent of leatherworkers adhere to the restriction of
marriage within the moiety, yet of the hundreds of leatherworkers I interviewed, only
one marriage was between individuals of the same clan. Men commonly marry women
who live outside of their natal community but within their political district. Marriages
in the previous two generations, however, more frequently included spouses from a
different political district.[71] It is uncommon for a man to move to another community,
and as such men of the same patrilineage usually inhabit the same community. Sons

live nearby their fathers, inherit their fathers' land and resources, and spend their lives acquiring technological knowledge from their fathers and patrilineage elders.

RESIDENTIAL SEGREGATION

Almost all Gamo leatherworkers recall that all their male ancestors from the last five to eight generations resided on the land on which they currently live, which is typically on a steep grade on the edge of a hamlet. Leatherworkers represent a small portion of the Gamo population and do not establish homes in all communities within the ten Gamo political districts. Generally, they live, learn their trade, and die within the same community as other members of their patrilineage. In rare cases, because of land redistribution by the Derg or disputes with parents, a leatherworker may move to another community. This includes one of the communities, Eeyahoo Shongalay, discussed in this book. The Eeyahoo leatherworkers stated that they could only move to a community with permission from leatherworkers of the same clan living in a nearby hamlet. Leatherworkers do not live in every Gamo community, and they own small amounts of farmland and household land in their resident communities.

The perceived impurity of leatherworker households accords that their households generally are distanced physically from farmer households and on small plots of infertile land with very few household structures. They tend to represent a small number of the households averaging only three to five households out of the seventy-five to eighty households in the average community. Typically, a craft-specialist household is located next to a road or on the edge of the mountainside on steep, degraded land that is extremely poor for agriculture, far from fresh springs and fertile ground (figure 14).

Detlev Karsten[72] noted in the late 1960s that the Gamo leatherworkers had no cash-crop farmland but only small gardens associated with their homes. My research in five Boreda communities indicates that leatherworkers on average own one quarter of the amount of the household land (table 3) and half of the amount of farmland compared to *mala*-farmers. Craft-specialists also tend to build smaller and fewer household structures (figure 15). While most *mala*-farmers insist on the segregation of their homes from those of craft-specialist homes, leatherworkers rarely resist as segregation of space actively encourages the continued secrecy of their trade.

DIETARY EXCLUSIONS

In the absence of abundant farmland, the average leatherworker's dietary production differs considerably from that of *mala*-farmers, which many Gamo interpret as another manifestation of their productive transgressions that relegate them as impure and eating impure foods. Leatherworkers primarily produce and consume tubers and enset

FIGURE 14 Map of the Boreda Gamo hamlet Amure indicating the clustering of leatherworking households on the northern edge of the community and on steep grades. Map designed by Kathryn Weedman Arthur.

KEY
○ Farmer Households
◉ Lineage Head Farmer Households
■ Artisan Households

TABLE 3 Comparison of caste household compounds
for five Boreda communities.

	FARMERS (N = 20 for in-depth study) (N = 126 survey)	POTTER-SMITHS (N = 21 for in-depth and survey)	LEATHERWORKERS (N = 19 for in-depth and survey)
1 Structure	50	17	14
2 Structures	57	4	5
3 Structures	17	0	0
4 Structures	2	0	0
Average size of woven grass houses	30 sq. meters (n = 18, excludes corrugated 48 sq. meters n = 2) (in-depth)	26.8 sq. meters (n = 19, excludes corrugated 32.2 sq. meters n = 2)	21.96 sq. meters (n = 18, excludes corrugated 42.6 sq. meters n = 1)
Average size of household compound	435 sq. meters (n = 126 household survey)	122.1 sq. meters	196.8 sq. meters
Average number of agricultural lands 1 plot = ¼ hectares	2.3 plots (range 1–7) (n = 126 household survey)	1.2 plots (range 0–4)	1.0 plots (range 0–3)

with very little grain, milk, butter, honey, or meat—the items necessary for proper propitiation of ancestors. My study of craft-specialist and farmer households among the Boreda Gamo and John Arthur's[73] study among the Ezo and Ochollo Gamo indicate that craft-specialist households primarily produce and consume boiled or roasted porridge and bread made from tubers (potatoes, yams, manioc, and taro) and enset. Craft-specialists eat fewer grain products (such as bread and beer) compared to *mala*-farmers. Furthermore, craft-specialists are three times less likely to grow barley and ritual red emmer wheat than farmers. Craft-specialists often do not produce surplus quantities of grains through which they could offer barley porridge and beer in propitiation to request forgiveness for transgressions to ancestors and other spirits.

Dietary practices of craft-specialists are prescribed in their religious *Etta Woga* doctrines. Only sanctioned *mala*-farmer male elders are allowed to kill animals for consumption. Many Gamo farmers state that craft-specialists are polluted because they eat "dead" meat.[74] I believe discussions over this phrase result in a misunderstanding

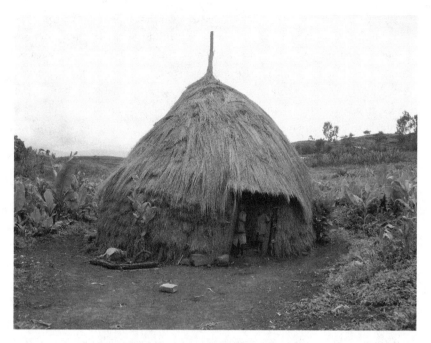

FIGURE 15 Photograph demonstrating the dilapidated house conditions of some Gamo leatherworker craft-specialists.

between what *dead* means in English and in Ethiopian languages. The Boreda do not literally just mean deceased, because of course all meat is obtained from a dead animal. Instead the statement more specifically conjures the interplay between *bayira* as purity and *t'unna* as impurity. Boreda craft-specialists are considered to be impure and do not have the transformative power necessary to instigate proper change of life course in domesticated animals from alive to their spiritual state. Thus, it is perceived that craft-specialists eat animals that have not been allowed to properly transform through ritual killing and thus they are actually dead and stagnant. In the absence of the proper rituals of transformation, "dead" animals are unchanging and impure—they are *t'unna*. Many Boreda perceive, then, that craft-specialists who eat meat are consuming meat that has been improperly prepared. While craft-specialists can purchase meat in the markets that is appropriately slaughtered by a *mala*-farmer man, it is expensive. In my recent study of the diet of thirty leatherworker households, I found that they only ate meat once a month and rarely if ever ate chicken or eggs. Leatherworkers rarely own domesticated animals, though they may keep some animals for farmers in exchange for the milk products, which they often sell instead of consuming. In contrast, *mala*-farmer households consume meat two to three times a week and eggs, butter, and milk

at least once a week. *Etta Woga* outlines that at the biannual prescribed community rituals, *mala*-farmers should freely provide craft-specialists with the impure portions of domesticated animals, such as the head, horns, entrails, tail, and feet of animals.[75] Certainly, these parts are often boiled and consumed. Craft-specialists, though, also creatively transform these same materials, as well as stone, into viable fertile items that they use to substantiate their positions in society as healers, messengers, circumcisers, and of course leatherworkers.

IMPURE RITUAL MEDIATORS AND HORN AND STONE TECHNOLOGY

Craft-specialists' impure status in society provides them with an avenue to perform rituals that mediate between people and illness, death and infertility. Leatherworkers utilize the perceived impure parts of animals (horns and tails), and in the past stone, to produce items that served their ritual mediating roles. In the past and in some communities today, leatherworkers are not allowed to enter sacred forests and ritual contexts to perform their ritual roles; instead, as farmers commonly stated, "they must stay on the edge."

From cattle horns, they produce spoons, musical horns, and healing siphons. The spoons are exchanged and sold in markets for their use in ritual feasts, particularly to serve *berbere*, the rich red pepper that accompanies most grain dishes. Leatherworkers also produce a musical bovine horn that they play to announce weddings, funerals, social and political meetings, and work parties. If the craft-specialist blows the horn within his community, he usually is not paid for this work. The craft-specialists offer that they do not mind, because "they want to get along with the people," or because they want to keep the land that the people have given them. Cattle horns also were and are used to perform *guchay*, a form of healing through incisions, for curing flesh wounds such as an abscess, insect bite, and so on (figure 16). After making an incision, the leatherworker places a cattle horn on the wound, using suction to remove the infection, and then places a secret poultice on the wound. Many Gamo believed that bad spirits and the breaking of *goma* (taboo) caused illness and injury. The appropriate rituals were in order to extinguish the effects of the violation. The leatherworkers used stone knives in the recent past, and now they use razor blades to cut open blisters or infected swellings to rid violations associated with the wounds. This act is referred to as *askatsara*, which also means "to scrape."

In some Gamo districts, leatherworkers and their wives performed male and female circumcision, *katsara*, with stone knives. An individual's circumcision was an important part of puberty rites of passage that marked an individual as proceeding to adulthood. The leatherworker was paid a small sum for this work. Today, a growing number of Gamo go to medical clinics for male circumcision. Female circumcision is prevalent

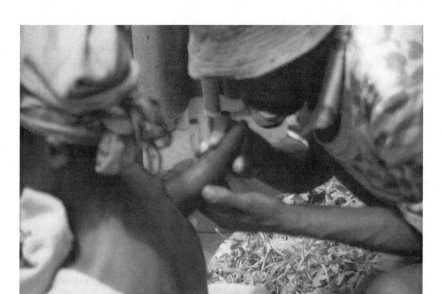

FIGURE 16 Leatherworker performing healing with a cattle horn.

in Ethiopia; estimates are that the number of females who are circumcised is as high as 73 percent of the female population, yet there are many national and international campaigns to eradicate the practice.[76]

OCCUPATION AND ECONOMIC HARDSHIP

The Boreda are extremely strict about continued occupational ascription, and although education is compulsory, it is not feasible for most children of craft-specialists. Leatherworkers earn a meager amount for their ritual occupations and for the leather goods that are an integral part of almost every Gamo household, including bedding, chairs, saddles, drums, and bridles. Since the inception of the Derg regime (1974–91), which outlawed many of the leather products and brought industrialized, globally produced clothing and blankets, leatherworkers have lost much of their income. Leatherworkers predominately process cattlehides when someone from their community or a neighboring community requests their services. *Etta Woga* outlines that craft-specialists must give the products they make, such as pots, iron, and hides, to *mala*-farmers, and in return they are to receive food or cash. The leatherworkers receive a small sum—3 ETB (Ethiopian Birr, which equaled 0.46 USD in 1996 currency) in 1996, which rose to 30 ETB in 2006 (equals 3 USD in 2006)—or grain in kind for preparing the hide. They work part-time scraping on average three hides per week. Leatherworkers do not own cattle, as they are very expensive, far exceeding the annual income of

the leatherworker. At the market, the average cost of cattle is 3,200 ETB (314 USD in 2006). Detlev Karsten[77] estimated in the 1970s that the annual income of leatherworkers at US $270 based almost exclusively on hidescraping, and I concur that the annual income for leatherworkers has not increased much beyond this point in the early twenty-first century. Leatherworkers often work hides only part-time today, although they continue to encourage their sons to learn their trade.

The social stigma against their productive activities and the economic decline for locally made hide products leads many youth I spoke with to state that they do not want to pursue their fathers' trade. The number of leatherworkers in Ethiopia is declining,[78] and of those practicing fewer and fewer engage stone to process hides. Of the 180 practicing leatherworkers I interviewed in the late 1990s, most were forty to forty-nine years old and only about 30 percent used primarily stone rather than glass. Furthermore, it is difficult for craft-specialist children to go to secondary school, opening up new career opportunities, as their parents can rarely afford the fees for the school supplies, books, and uniforms. In my studies, leatherworkers usually stated that if they do send a child to school, it is typically only through primary school, and only the oldest son may receive a complete secondary education. Although primary school attendance is compulsory, according to UNESCO 68 percent of men and 83 percent of women in southern Ethiopia are illiterate.[79] The inability to attend school severely limits the occupational choices for the children of leatherworkers. Sons of leatherworkers often move to other parts of Ethiopia and work in the service industries or work for farmers by skinning the animals and traveling to sell the hides to industrial tanning companies, and they try to work their small farms to eke out a living. A small number of men are pursing the leatherworking careers of their fathers and grandfathers, but the numbers are shrinking significantly. Maintaining a livelihood through leatherworking and knapping in Ethiopia is largely to live in a state of poverty, and while debates persist over whether Ethiopian craftspeople represent caste-like society or not, what with few exceptions tends to be missing in scholarship today is an appreciation for the technological knowledge of Ethiopian craftspeople concerning ceramic, groundstone, leatherworking, and ironworking. Demonstrating a deeper understanding of how aspects of the Gamo's historic *Woga* continue to relate to people's status and technology today could be a step toward assuaging stigmatization.

A GAMO LEATHERWORKER'S
STATUS AND IDENTITY

Material culture, linguistic reconstruction, and oral traditions and histories demonstrate tremendous changes throughout the Holocene in leatherworking practices,

technology, and the status of the leatherworkers. It is essential that ethnoarchaeologists situate technologies not only within their present-day context but also within their past practices and philosophies. Understanding history provides deeper contextual meanings that are intrinsic to present-day knowledge and practice. The technologies and cultural repertoire of leatherworkers living today who make and use stone hidescrapers are significantly different from those of their ancestors. Stone hidescrapers manifest on the Gamo landscape for more than six thousand years and resolutely express through their form and raw material types transformation in people's technological traditions and practices. Southern Ethiopian populations who initially were dependent on foraging became agropastoralists with ritualized hunting, which impacted the types of hides processed and furthermore morphed their assemblage of knowledge and practices associated with leatherworking. The memories of many Gamo indicate that by the late nineteenth century a patriarchal Christian northern government intruded and attempted to disrupt their Indigenous practices and beliefs. The Boreda Gamo historical narratives insisted that they responded to the state with resistance and conscribed craft-specialists, whom they viewed as cooperating with the state and as appropriating women's roles in "re-production," to a low-casted status in society. While the details of Gamo histories may be particularistic, the Gamo share a common experience with others who have experienced political and religious oppression and may serve as a model for understanding histories of technology that counter dominant narratives.

Today the social stigmas that physically and socially segregate craftspeople, such as the knapping leatherworkers, also serve to enhance their formation, protection, and maintenance of lineage-based communities of practice. Leatherworkers who decide to pursue their fathers' trade learn eventually the pride in being able to provide for their family and the dignity from their growing years of experience in knapping and processing hides that is recognized among other knapping leatherworkers. In a society that largely undervalues them, knapping leatherworkers derive their self-esteem from their participation in maintaining a community of practicing expert[80] knappers and leatherworkers. Knappers live segregated in their resident hamlets, creating an isolated space for them to develop a mutually shared knowledge and practice of their trade. In the remainder of this book, I demonstrate how lithic practitioners actively engage in a shared practice of maintaining their trade through enculturating a selection of youth to whom they transfer their repertoire of historical knowledge; technological language; resources; and procurement, production, use, and discard practices. Technology is learned and practiced in a social context, and while experimental studies can provide us with a basic mechanical understanding of the relationships between people and stone tool production, they cannot reproduce a person's ontological understanding of reality and how that interacts with their sense of self and with their technology.

Gamo knappers' low status and identity is entangled in their Indigenous religion and ontology, articulated through their life histories, oral traditions, and daily practices. A knapping leatherworker's perceived transgressions against spirits and inability to progress through all stages of puberty rites of passage deem them as members of a segregated, low-status, endogamous group. As explored in the next chapter, Boreda Indigenous ontology shapes not only a knapper's status in life, but how he perceives the material world and how he engages in technological practices.

2

A BOREDA ONTOLOGY
OF TECHNOLOGY

ON A RAINY DAY in early June, I met Askalay Damata, a woman who opened me to Boreda ontology, *Etta Woga*. She awoke in me an understanding of their reality that all matter, including technologies, are in existence and have the power to change throughout a life course and the power to actively capture, *oyissi*, one another. At the base of the Ochollo Mulato mountain, three elders of the king's clan led me to her small, slanted thatched house on the verge of collapse. In front of the house was a smoking pipe resting in the hollow of an old fig tree—an offering (figure 17).

Askalay held much esteem in the past as the king's spirit medium or *Maro*. By the time I met her, the Derg militant Marxist-Leninist regime (1974–91) had persecuted her as a religious leader and she had begun living in poverty. It was with great sadness to me that within months of our meeting, a woman of such stature and knowledge had died.

On the day I met Askalay, the elder men who brought me to her house called gently into her house, and when she emerged this elder woman tilted her head toward the sky and closed her eyes in reverence to the world. She said to me, "History is like a snake; it is always changing." As she whispered these words, it was the first time I had heard them, and the elder spirit medium captured my eyes in hers. Her words held thick in the air, and I was impressed that she had the power to move the three men, who brought me, off to the side of her house with their eyes averted to the ground. I was intrigued and excited by her forthrightness and the eminent power she held. She continued, testing me: "Is the sky or earth our ruler?" I replied, "The earth." Her eyes, rimmed blue and cloudy with glaucoma, locked onto mine—piercing, searching, and knowing. Then she inquired, "At night when people and all else go in, when the yellow

FIGURE 17 A Boreda spirit medium's house with her smoking pipe in the hollow of a sacred fig tree.

bird makes a sound at night, what is it?" This time she did not wait for a reply. She disclosed: "If you are good now, everything will be well. Soon the spirits will be here! In the past, stone, trees, and water had their own culture. All things change. Write it down!" I wrote it down!

Askalay taught me that in the past most Boreda believed not only that everything changes like a snake, but also that everything actually changes because the world was fully animated. Askalay often referred to *Etta Woga*—Fig Tree Culture—which she associated with eternal life. All beings start material life as fetuses who become infants, infants become youth, youth become elders, and elders become ancestral spirits. Nothing dies—it just changes its form like a snake, shedding its skin, and is in the process of continuous renewal. Everything has a life and a continuous life cycle.

> The earth is the mother of the stone. When I remove the stone from the earth, it is *yella* [birth]. The stone is an infant, and when it is living in my house it is *dume* [seclusion after birth]. When I form the *gachino* [fetus] into a young man, *pansa*, it is *katsara* [circumcision]. Then it comes together in my house with the hide, and this is *bullacha* [feast]. (Bedala Aba, leatherworker, 2012)

The life cycle and vocabulary associated with stone tool technology for many Boreda is more than symbolic; it highlights the lithic practitioner's perception of real-

ity.[1] Boreda technological knowledge emphasizes that all material beings—including crops, houses, iron, pottery, ground stones, leather, stone tools, and so on—have a life and life cycle evident in their ability to change. I learned poignantly how Boreda expressions unveil their ontologies particularly as I became more deeply enculturated into their Indigenous understanding of being in the world—*Etta Woga* or Fig Tree Culture—and how life cycle changes, or *Deetha*, were essential for all beings.

FIG TREE CULTURE: AN AFRICAN THEORY OF BEING

Understanding how the Boreda relate and understand their technology requires that we comprehend the Boreda theory of reality that is conveyed through their Indigenous religion *Etta Woga*, Fig Tree Culture (figure 18). Boreda Indigenous ontology manifests in the physical objects that they produce today by embodying their knowledge surrounding what, how, and where to produce, use, and discard their technologies. In the Boreda language, the word for "being," "life," and the "life cycle" is *Deetha*; it encompasses the meaning of the Greek-derived word *ontology*, the "logic" (λογική) of "being" (ὄντος).[2] Though the term *ontology* was not in use in ancient Greece, Western philosophies of existence originate with writings of fourth-century Aristotle, who questioned, "What is being?" and fifth-century Plato's concerns with the biographical significance of being and nonbeing.[3] *Deetha*, as the Boreda-ordered life-cycle process, created and structured the lives of the human beings or the technicians, as well as the material beings or the technology. In the Boreda ontology, a stone tool is a living entity who is birthed when procured, circumcised when knapped, rested when stored, married when hafted, active when used, and dead when discarded. When craft-specialists begin to transform through puberty rites of passage, *Asa Naʒateetha Deetha*, their low status in society is reaffirmed, and they begin to acquire technological knowledge from their elders.

A Boreda person learns proper practice through their life course "bit by bit." Even in my own instruction in learning about *Etta Woga*, elders doled out information little by little. They expected me to reflect and make connections myself. They would question me the next time we met, and when I was correct they would smile, nod their heads, and say, "Now you know our secrets!" This method has an old history in Ethiopia, as advocated by the seventeenth-century northern Ethiopian philosopher Zera Yacob. He wrote that it was best to acquire knowledge oneself "bit by bit" through questioning, reasoning, and testing, leading some scholars to argue that the northern hemisphere is not the only one with a history of reasoning and scientific process.[4] A Boreda spirit medium told me: "We have a science of religion—all this I do is science, for all answers we try and try again; it is a process based on observation" (Detcha Umo

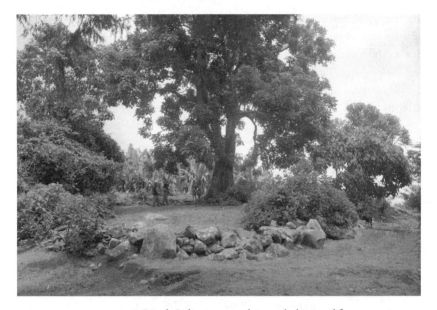

FIGURE 18 A Boreda Indigenous ritual site with the sacred fig tree.

2012). Many Boreda today argue that the tenets of their religion and their perspective of reality in which all beings are alive and part of a reproductive life-cycle process are based on their experience in life.

Western scholarship tends to merge Indigenous ontologies under worldviews and academic theories rather than acknowledging their status as pluralistic ontologies.[5] Aspects of Boreda *Etta Woga* ontology encompass vitalism, animism, and relational ontologies, though as a whole *Etta Woga* cannot be subsumed under any one of these. *Etta Woga* accepts that there are nonhuman beings that change, transform, and move outside of human interference. In this sense *Etta Woga* invigorates growing trends in philosophy, anthropology, and political ecology that have resuscitated nineteenth-century European theories of vitalism—and similar theories of *elan, bildungstrieb,* and *entelechy*.[6] Vitalism recognizes that all matter is present in a heterogeneous assemblage or a mosaic that makes it efficacious even when separate from human intervention. *Etta Woga* also is concerned with transformation of the human soul to animate nonhuman beings. Scholars are "revisiting" animism,[7] a term also coined in the nineteenth century by anthropologist Edward Burnett Tylor:

> Animism divides into two great dogmas . . . first concerning souls of individual crea-
> tures, capable of continued existence after the death or destruction of the body; sec-
> ond, concerning other spirits upward to the rank of power deities. Spiritual beings

are held to affect or control the events of the material world, and man's life here and hereafter.[8]

And more recently animism has been defined by Graham Harvey and Nurit Bird-David as

people who recognize that the world is full of persons, only some of whom are human, and that life is always lived in relationship with others.[9]

[part of] human socially biased cognitive skills and nurtures a complex articulation of skills, a double bind engagement which co-privileges utilizing and respecting animated things.[10]

Among archaeologists, the application of animism to past societies brings to the forefront debates regarding how much of the world is considered animated and which animated nonhuman entities exist as part of human social life.[11] Other archaeologists have noted that not all objects have agency, and thus animism is not the correct term because being and personhood are contingent on the presence of social relations and participating in community through ritual and are relational rather than animistic.[12] While I can appreciate postconstructionist attempts to bridge the nature-culture divide by redefining animism or employing the use of the relational ontologies in both anthropology and archaeology, I am hesitant to categorize *Etta Woga* as purely relational or as either animistic or vitalistic. Both animism and vitalism are the products of nineteenth-century othering that served to denigrate the intellect of Indigenous peoples. Importantly, continuing to fit Indigenous ontologies into Western ontologies eliminates the creation of space in which Indigenous ontologies are recognized as legitimate alternative realities. Western ontologies tend to be relational and emphasize that the human mind is how we solve the problem of how we explain the continuity and change we experience in the world.[13] In Western thought generally the human mind, spirit, or soul sets us apart from other species and all other matter in the world and is the basis for our being human[14] and our dominance over all other entities including their change. The Boreda *Etta Woga* ontology seeks to explain change in the world in all beings through reproduction. I argue that it most closely resembles other African ontologies.

Etta Woga resonates most closely with religions of other Omotic- and Cushitic-speaking peoples of southern Ethiopia[15] and with historic Maatian ontology.[16] Maat is the earliest documented African ontology present in the writings of ancient Egyptian hieroglyphics.[17] Ontologies as theories of reality are not stagnant, and they shift in time and space.[18] The *Etta Woga* that is described and practiced by living Boreda is

not eternal and should not be considered to be an exact mirror of the *Etta Woga* of their ancestors, their future descendants, or their neighbors. Omotic speakers like the Boreda and their Cushitic-speaking neighbors share threads of similar beliefs, particularly in the importance of sacred groves, the propitiation of ancestors, and the importance of the life cycle and fertility, and differ widely in their specific practices.[19] Afrocentric scholars advocate that the tenets of ancient Maatian are reverberated in many present-day African cultures.[20] The term *Maat*, for instance, is present throughout languages on the continent associated with virtue, including truth, justice, and soul.[21] In the Boreda language, *mata* or milk and *matta* or grass are items that are frequently cited to conjure the ideas of fertility, well-being, femininity, and truth. The Boreda as Omotic speakers and ancient Egyptians share a deep historic linguistic relationship as members of the Afro-Asiatic language phyla, who may have originated in southwestern Ethiopia, where present-day Omotic speakers live.[22] Maulana Karenga argues that Maat and African ontologies are unique in the world for their emphasis on the absence of separation between matter, spirit, body, and soul, which all exhibit power in being, and that being is in a constant state of existence and is manifested in movement and change, which is a process.[23] The process of existence consists of order and disorder from which the tension of movement and existence maintain being and define moral order. Together these manifest in Boreda *Etta Woga* with an emphasis on reproduction and the life cycle (*Deetha*), which instigates the inherent vitality of the earth free of human intervention; the animation of fig trees, snakes, and craft products through transformation in the souls of farmers, kings, and craft-specialists; and sets the basis for ethics and morality through outlining the proper rules of interaction and practice.

Many Boreda recognize through *Etta Woga* that all earthly materials, including those materials that serve as the mediums for human technology, transform and move outside of human social life, and thus all matter has a life, *Deetha*. *Tsalahay* are the essences, lights, sparks, or spirits that invoke biological life, *Deetha*, in all matter and nonmatter. The world is filled with animated beings that will continue to exist eternally apart from human agency and intention. *Tsalahay* are spirits of nonhumans, who are "in indefinite numbers . . . are dispersed . . . are mobile."[24] *Tsalahay* occupy all bodies of water including rivers, lakes, rain, thunder, and rainbows, as well as wind, earth as stone, soil, and caves, the sun and moon, particular animals such as lions and snakes, and certain plants such as enset, red wheat, sorghum, and fig trees. In an origin story recorded by Marc Abélès in another Gamo political district, the mountains first appeared when the sun and his wife, the moon, separated the sky from the earth that was covered with water filled with spirits.[25]

For many Boreda Gamo, essence or the agent of creation and change derives from water. *Dydanta* is a spirit that occupies water, as well as thunder, rainbows, and white

quartz, and can bring illness and misfortune or their opposites, well-being and wealth. Water is the medium for instigating change in status of all beings, and its importance is reaffirmed in ritual when humans and technologies are washed in water. *Dydanta* as river water has the power to catch, *oyissi*, people and transform them into spirit mediums that communicate with the king's ancestors. Other *Tsalahay* may also capture people causing a variety of illnesses, shaking, immobility, and dissociative disorders that can only be alleviated through the intervention of spirit mediums.[26] *Dydanta* is also present in the spring water near where women hold their annual fertility rite adjacent to large boulders, or *Chicho*, which are earth spirits under which the snake spirits as the king's ancestors live.

> There is a spring there and four boulders. They are classified into two. First, the truth boulder and second the untruth boulder. Truth boulder is female and white in color, and untruth rock is black and it can't be broken easily. (Safa Sagamo 2008)

> The old women rub the boulders with butter. This is for all of *Tsalahay*. For children's health and women for pregnancy and birth. (Badehso Tera, June 13, 2008)

Many Boreda observe that the clays and soils shift, rocks form, water flows, rain penetrates the earth, trees grow, and sunlight pierces the earth without humans interceding. Boreda often concede that the most auspicious places on earth are mountaintops and caves, where they witness the power of the earthly spirits. From the female earth, mountains grow, rise up, and expand. The male rains penetrate and mobilize the mountaintop's earth and shift the earth to form fertile valleys with lakes and rivers below, and they hollow out caves on escarpments.

> The earth gives birth to the soil and is considered female. The earth is a mother; it is patient like a woman and can hold on to anything. The rain is male because it penetrates the earth. The rain has the power to change everything. The rain is strong and active. (Gamo Tema, July 2008)

Mountaintops, caves, and rivers are in constant transformation—they are *Tsalahay* and they are being. For leatherworkers and other craft-specialists, the earth is where the resources for their trade are birthed. Potters procure red female clay and black male clay from specific sources near springs; in the past, ironsmiths collected iron ore from the earth; and leatherworkers select specific stones with a shine or light or essence created in the womb of the earth near rivers. Today most knappers use chert and obsidian, and in rare instances I recorded the use of quartz. Quartz and obsidian were associated with *Tsalahay* spirits in the past:

Quartz crystals were put in the fire and put on the body wound for healing. It is the Thunder *Tsalahay*. The black [obsidian] was only used on hoofed animals with wounds, not people. The black one, like a dead cat or rat or wood on someone's land, can cause bad things to happen; it can have a bad spirit [*Bita*]. (Badehso Tera, June 13, 2008)

At a quarry in the late 1990s, a leatherworker told me:

We always find the best chert in a gorge. The river here penetrates the earth, and we can find the chert. The river and the earth together created the chert. The best chert has a light [*tompe*], and if it has this light, we know that it is ready. It is ready to be born.

Craft-specialists' resources are always found near rivers and springs, near to one of the most powerful of the spirits—water. The earth emanating its power to change creates ideal materials at specific locations on the landscape from which people create material culture that enters their social life through a ritual process.

In Boreda *Etta Woga*, particular beings, including some human, plant, animal, and earthly entities, maintained a constant state of being, inhabiting different forms through the ritualized life-cycle transformative processes, *Deetha*. At death both humans and technologies did not cease to exist, but their essences transferred into other entities. Some beings such as snakes, fig trees, and material culture were animated by being endowed with the essence or souls of former humans, farmers, kings, and craft-specialists. Among the Boreda only some nonhuman entities were imbued with human souls through postburial rituals. When the bodies of the members of the elite *mala*-farmer group died, their bodies gestated in the ground after burial. Instigated by proper ritual nine months after burial, a person's soul departed the body and joined the ancestors (*moyittilletti*) who occupied the sacred fig trees and a man's central house post (*tussa*). Burial grounds of the elite occupy *Bayira Deriya* or the ancestral sacred grounds, and it is here that the sacred forests are filled with fig trees or the *gray hairs of the ancestors*.[27] The fig trees are both male and female beings. Fig trees penetrate the earth with their masculine roots but offer in their trunks natural hollowed womb openings, a space for descendants to offer their ritual gifts. The essences of kings were also eternal, as after the death of their bodies, their essences moved onto another physical form: the snakes. Snakes slid into the earth at *Bayira Deriya*, where snakes were propitiated by future kings, listened to by spirit mediums, and cared for by priestesses. Deceased kings and farmers lived eternally at *Bayira Deriya*, though in the past the perception that craft-specialists were polluted ensured their burial far from sacred grounds. While in the last sixty years some craft-specialists now have separate burial grounds at *Bayira Deriya*, in the deeper past they were buried in their household lands along with their lithic materials,

unsuccessful pots, and iron by-products. Pots broken or no longer required at farmers' houses were not discarded in the farmers' garden, but given back to the potters. Potters added them to new pots to infuse the new pots with life and strength. Discarded hidescrapers and all lithic waste were often buried at the base of trees in the leatherworker's household garden. When these earthly objects wandered outside the confines of the leatherworker's homestead and found themselves in a farmer's homestead, they were thought to bring harm to farmers. Farmers believed that lithics are bad polluted spirits of the craftspeople that their descendants commanded the stones to come to their homes to bring illness and death.

For many Boreda their theory of reality, based on their observations of the world, accorded that all matter was alive and "shed their skins" like snakes in an ordered ritualized life-cycle process, *Deetha,* which rationalized the moral order.[28] Similar to other African ontologies, proper practice and interaction with all beings through reproduction ensured the order of being and the continuity of being.[29] For many Boreda, the spirits had the power to impact their lives.

> There were many *Tsalahay,* who took many forms causing illness and bringing gifts. *Dydanta* [thunder] gives you wealth and health, *Gamo* [lion] brings fertility, *Aiwa* [sun] provides all nice things, *Agena* [moon] protects children and brings prosperity in the market, and *Shorsha* [snake] protects everyone. (Badheso Tera, June 11, 2011)

Tsalahay provided people with good health and fertility if they adhered to proper cultural behavior, *woga,* and punished people who transgressed proper behavior, *gome* (taboo).[30] When *Tsalahay* disturbed people and brought them trouble and misfortune, the people consulted spirit mediums (*Maroti*) to determine their transgression and to ameliorate the situation with the proper offerings.[31] Common transgressions included mistreatment of other people and improper interaction between farmers and craft-specialists, as well as regulations concerning cutting down trees and wild grasses, and specific times for hunting animals. Several Boreda elders complain that abandoning the cultural rules leads only to chaos.

> The ficus [fig] tree had its traditions. The spirits will be back when there are three signs: people cry because of drought and death, snakes leave their skins forever, frogs and insects hide. In the past, we could hear them clearly. Now they are gone, the streams are dry, the birds are crying. The hills have become flat. (Askalay Damata, June 17, 2011)

Natural disaster arises from not honoring the spirits and not engaging in proper practice. An individual within the perceptions of *Etta Woga* must always be moving toward the process of changing like a snake. Snakes are critical beings in Boreda

ontology concerning prescribed behavior. Snakes are embodied by the spirits of for-
mer kings, the most senior of all human beings, who are granted eternal life. Snakes
should never leave their skins forever, but they should keep changing and maintain
continuity of being. A common Boreda saying to youth is "*Shorsha mella photta*,"
which means "Never die, never get sick, and keep changing like a snake." This phrase
highlights the importance of change and process in Boreda life to maintain social
order and the well-being of all. Many Boreda would offer that the specific criteria
for having life is constituted in observations of whether or not the entity is created
through the reproductive life-cycle process, *Deetha*.

The way in which Boreda proceed through their own life-cycle changes and those
of other beings affects their status in social life, particularly their position as farmer
or craft-specialist, as noted in neighboring Cushitic and Omotic societies.[32] For many
Boreda, all production involving the earth must include male and female interaction.
As discussed in the previous chapter, men must plant seeds because the earth is a
female womb, and women must weed and fertilize the earth, assisting in creating the
right environment for the womb. Male birthing of resources from the earth for craft
production monopolizes women's prerogative as midwives, and men's perpetuation of
this transgression strips them of perceived purity and dignity in society. The life of all
beings serves as the foundation for the Boreda path for proper ethically and morally
profane-sacred technological practices through which they ascertain human dignity
and seniority.

Like *Etta Woga*, which defines the moral judgment under which farmers and craft-
specialists are divided, Maatian foundational principles underlie perception of moral
order, "defining and living the good life, of being a worthy member of family and
community and of creating and sustaining the just and good."[33] In Maatian ontology
there is potential and power in being for all.[34] Being is eternal and is maintained by a
creative ordered process and together these aspects manifest in Boreda *Etta Woga* with
an emphasis on the inherent vitality of the spirits, *Tsalahay*, free of human interven-
tion or endowment. For instance, the interactive assemblage of rain penetrating the
earth creates new beings, such as river valleys and chert. Some beings such as snakes,
fig trees, house posts, clay pots, iron products, and stone tools transform when infused
with the spirits of former kings, farmers, and craft-specialists. Boreda *Etta Woga* ways
of knowing also shape how humans relate with the earth through prescribed ritualized
farming and craft technologies. Elders encourage youth to be cooperative and respect-
ful in their interactions with earthly beings. Proper interaction involves gendered
specific participation in reproduction of material beings. A male knapper's practice
in birthing stone usurps the responsibilities of a female midwife, transgressing wom-
en's reproductive power and endangering the balance in the world between humans
and all other beings—material and nonmaterial. Among human beings, the lithic

practitioner incurs a low status and identity, providing a powerful and significant alternative to the Western "Male the Prestigious Toolmaker" trope.

This book privileges the Boreda philosophy *Etta Woga* and its emphasis on *Deetha*, which literally means "life" and "the life cycle" and delineates existence as constituting states of becoming, maintaining, and transforming life embodied in the human knapper as well as in the stone tool. Below I first review the human life cycle and a knapper's acquisition of technological knowledge, and then I discuss the life cycle of stone tools and hides, so that the reader may easily draw parallels between the life of a human being and a material being in the Boreda ontology. As a reminder, some Boreda today practice their Indigenous religion, *Etta Woga*; many others have abandoned it with conversion to Christianity and Islam; and still others combine the tenets of *Etta Woga* with Christianity or Islam. Since a majority of the Boreda I interviewed offered that *Deetha* and *Etta Woga* more commonly were held in reverence in the past, the narrative below is written in the past tense.

BECOMING A LITHIC PRACTITIONER: THE HUMAN LIFE CYCLE AND LEARNING TECHNOLOGICAL KNOWLEDGE

After marriage, I began learning leatherworking, before this— until this time you can watch but you do not help—you are just not ready. (Osha Hanicha 2011)

Boreda *Etta Woga* ontology prescribed that to maintain balance in the world, humans must transform like a snake, periodically shedding their skin through *Asa Na7ateetha Deetha*, the human life course, entering into other states of being to maintain their dignity and prestige, *bayira*. A Boreda human being experienced life as a fetus, infant, child, youth, married adult, mature adult, elder, and ancestor. At each of these stages in life, rituals reaffirmed the status change in life through rites[35] that mirror an infant's entrance into the material world: birth or *yella*, seclusion in household or *dume*, circumcision or *katsara*, marriage and household feast or *bullacha*, and at physical death or death of old status there was reincorporation at the market place or burial ground, *sofe*. People and things that proceeded through rites of passage correctly maintained the moral order and were *bayira*.

Craft-specialists' failure to complete their puberty rites of passage process affected their efficacy in social life and ensured the low status of craft-specialists as impure or *t'unna*. During their puberty ritual transformations, farmers and craft-specialists enacted their first formal material transformation, which legitimized the social and

political structures, as importantly exemplified among other Omotic-speaking craft-specialists.[36] While ascription to a particular endogamous hereditary group was determined at birth, a Boreda person's status and occupation as farmer or craft-specialist historically were reaffirmed and sanctioned through prescribed puberty rites of passage known as *katsara*. Human beings acquired farming and craft-specialist technological knowledge throughout *Asa Naʒateetha Deetha*, the human life course, but particularly during and after puberty rites of passage. Balance and rightness in the world were maintained by proper transformational practice, which required intensive learning that began formally during puberty rites of passage ceremonies associated with circumcision. During puberty rites, a boy, *naʒay*, became a young man or *pansa* and a girl, *naʒiya*, a young woman or *gellao*. The rites marked an individual's biological transformation into a young adult and signaled that their minds were then ready to acquire serious matters such as technological knowledge. Craft-specialist and farmer elders disclosed their technological knowledge to youth beginning during their puberty ceremonies. Like all other Boreda rituals, puberty rites that transformed youth and began their educations as craftspersons and farmers had five states: birth in the household, circumcision in the forest or garden, seclusion in the household, household feast, and a public feast at the market place. Each stage is important to review to demonstrate its similarity to the life course of hides and stone tools described in the following section and to show the intersection of the lives and statuses of stone tools and people.

YELLA: BIRTH IN THE HOUSE

At the threshold of the house, the father of a youth who was fourteen to twenty years old announced the youth's upcoming participation in the circumcision ceremony, *katsara*, an act that proclaimed the youth's rebirth (*yella*). Boreda perceive houses as the places of biological reproduction, where children are conceived and born, and places of social reproduction, where children mature and ancestral spirits reside. It is fitting that many Boreda chose the household threshold as the location for announcing the continuation of their lineage, for it is only persons who rebirth through puberty rites who become part of the ancestral spirits.

In the past, the announcement occurred typically a month before the bonfire festival, *Tompe*, in June near the summer solstice. *Tompe* included a suite of renewal rituals for many Boreda, including marriage, circumcision, and conferring ritual political leadership. Additionally, the celebration commemorated the beginning of the planting season and the history of kings, *Kawo*, and first settlements, *Bayira Deriya*. *Tompe*, as a rite of intensification, united Boreda, and as such *Tompe* was an auspicious time for youth to transition into adults.

KATSARA: CIRCUMCISION IN SACRED FORESTS AND GARDENS

In the distant past, many Boreda elders, craft-specialists and farmers alike, recall that as young men and women they were circumcised on enset leaves in a sacred forest on mountaintops, *Bayira Deriya*, where the Boreda bear witness to the transformative power of the earth in the presence of forests, caves, waterfalls, and the mountain itself. *Bayira Deriya* began to lose their significance in Boreda communities when Christian churches and government buildings appropriated these spaces. Then the Boreda began to circumcise young men in their household enset garden and young women on a grinding stone inside the household near the hearth. In the past, youth sat on enset as a symbol of their imminent fertility—the gifts of reproduction and the ability to change imbued from the spirits. Enset is the staple food of the Boreda and as such provides humans with well-being and fertility; it is the most senior and eldest of all crops and referred to as such—*uta bayira*. Today, they circumcise young boys in clinics, and the circumcision of young women is in decline. Among the southern Gamo of Bonke and of Kamba, cutting humans is considered *gome*—a taboo—and neither men nor women are cut.[37]

In the past, a Boreda craft-specialist (potter or leatherworker) performed the circumcision with a metal knife or an obsidian knife. Similar to a midwife assistant, one person held the young man or young woman around their eyes during the circumcision; this individual was a friend of the father's or mother's and referred to as *Jala Efe Awa* (eye father). The *Jala Efe Awa* and the initiate exchanged labor and gifts, and their children could not marry into each other's lineage. For most craft-specialists, the *Jala Efe Awa* was a farmer, *mala*, who often was a member of the lineage thought to provide the craftsperson's ancestors with their household land. The act of circumcision recalled the cutting of the umbilical cord and the removal of the afterbirth. The foreskin is called *shurita*, and for women the clitoris is referred to as *tora* (spear). Most Boreda consider the foreskin and the clitoris to be worthless parts that must be removed to instigate fertility. The skin was buried in the ground, just like the afterbirth, to prevent someone from collecting it to cause the individual harm. They applied to the wound butter, which when left in the cultured whey may have acted as a probiotic to encourage healing. After circumcision, the initiate proceeded to seclusion in their household.

DUME: SECLUSION IN THE HOUSEHOLD

Circumcision instigated gestation of craft-specialists and farmers, who then spent ideally nine months healing, resting, and rejuvenating, segregated from the community and one another in *dume* near their household hearth (*kolla*). Farmer and

craft-specialist youth were segregated after the rite into their separate neighborhoods and households.

A man's first small thatched oval house (figure 19), where he would spend his time in *dume*, is built just before his puberty rites with the assistance of members of his patrilineage.

> At the son's father's garden he builds a small house that is only for the boy during circumcision. No one can live here. . . . No one lives there until he marries. When he marries, his wife and he live in the house. (Doha Dola, May 31–June 1, 2008)

In this first home by the hearth, the young man secluded himself after circumcision, and his future wife secluded herself during marriage rites and after the birth of their children. Most homes were and are organized with gendered delineated space that functioned as transformative reproductive space for both people and material culture (figure 20).

Ideally, even today the household entrance faces to the east (rising, erecting sun) and opens into the male *wege* (cultural room). Today virtually all houses in the *wege* (cultural room) have a central house post (*tussa*), where sacrifices were and are made for the ancestors. Often the house post is recycled from an abandoned household of a deceased lineage member such as a grandfather, father's elder brother, and so on,

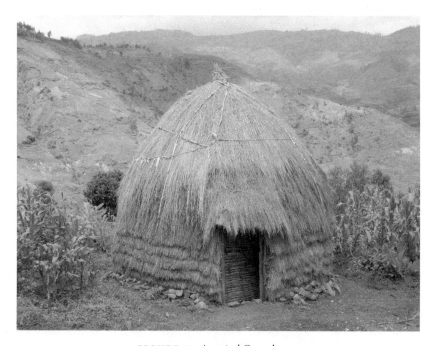

FIGURE 19 A typical Gamo house.

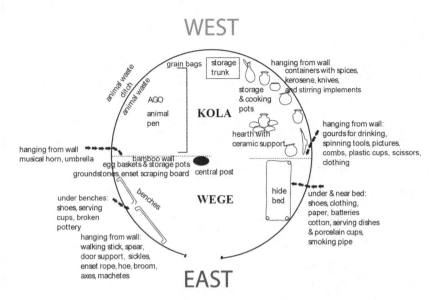

FIGURE 20 Drawing illustrating the orientation and use of space in a typical Gamo household. Drawing by Kathryn Weedman Arthur. Baseline drawing from part of figure 68 with alterations by Kathryn Weedman Arthur.

whose spirit is believed to occupy the house post. Daily, people also store noncooking items, sleep, and visit with guests in the *wege*. A bamboo wall stands between the male *wege* portion of the house and the female *kolla* areas. Bamboo represents the maturity of the male and female heads of the household.[38] The western part (setting, prostrating of the sun) of the household or *kolla* is where there is a hearth and an internal animal pen. The *kolla* is female reproductive space, and it serves as the heart of human and material transformative practices. At the hearth, women produce food to nourish their families, men and women sleep and procreate, women give birth, family members seclude themselves during puberty rites of passage, and male and female craft-specialists produce pottery and metal and stone tools. The gendered household is considered the place of biological and cultural reproduction, where men, women, and material cultural are actually born and then reborn.

In the house, an initiate was a fetus (*gachino*), who during their nine months of gestation into an adult lived secluded and did not engage in any household labor. The initiate ate special rich foods such as meat, milk, and porridges made with these products to encourage fatness and fertility. During *dume*, the initiate was a *gachino*, a fetus.

He does not cut his hair until his time is over, and his friends will come to visit him while he is in *dume*. (Shirka Hangota, May 30, 2008)

In the evenings, other youths joined the initiate, playing musical instruments and playing at conversation, and elders visited the initiate to indoctrinate them. *Dume* was the time when an initiate spent time learning their future adult tasks. Elders imparted their knowledge concerning the complex technologies such as producing and processing eldest or senior (*bayira*) crops (enset, arisaema, red wheat, sorghum, and barley), brewing beer, weaving, and pottery, leather, grindstone, and iron production. Recounting their life histories, a number of Boreda men and women emphasized that it was during these same puberty rites of passage that differentiate craft-specialists and farmers that they acquired their separate technological knowledge.

> When I was Pansa, I was circumcised. I began to stand by my father, side by side. During *dume*, I learned and practiced to scrape. I learned to produce my own hidescrapers. (Osha Hanicha, July 2012)

During social reproduction, many Boreda transmitted technological knowledge conveyed through ascribing the reproductive life-cycle process. The Boreda understanding that everything is alive meant that everything had a process, the process of reproduction.

At the end of their household seclusion, the activities of the craft-specialist and farmer youth diverged. Farmer youth entered the forest to hunt using iron spears. This *dume* practice demonstrated their eminent virility and strength. The hunt was referred to as *Kafu Shocha* (bird scaring day). After the hunt, elders placed grass and butter on the hunter's head as symbols of coolness and fertility. In some communities, the initiates proceeded to the *debusha* (male sacred forest), and there they circled the *marache* (future or divining place) four times for fertility of people, animals, soil, and children. The initiates threw the hunted bird in the *balay*, an open space where the community mourned after a human death. This marked their symbolic discard or death of their youth and their transitioning to an adult with responsibilities, including providing for his future household, as a gift to *Tsalahay*. Alternatively, craft-specialists did not participate in a community hunt or sacred forest ceremony. After *dume*, however, all male youth held feasts at their father's house.

BULLACHA: FEASTING AND COMMUNITY INCORPORATION AT THE HOUSEHOLD

After nine months of *dume*, in which youth began to gestate their technological knowledge and provisioning skills, there was a household celebration, *bullacha*. The timing of *bullacha* rituals for men and women differed significantly. Women did not experience a *bullacha* until their marriage; instead, after puberty *dume* they proceeded

directly to *sofe* (see below), where they present themselves publicly as marriageable women. In contrast, young men experienced *bullacha* after puberty *dume* and then again when they married and attained ritual-political statuses. In all instances, *bullacha* was a feast held at the initiate's or groom's father's house. Neighbors and family attended to celebrate the young man's transition to adulthood and his future prospects as a husband and father. *Bullacha* was associated with happiness and the reincorporation of the individual as an adult into the family social group. The ritual included erecting bamboo poles outside the household as symbols of male fertility, which was also practiced during marriage rituals.[39] The initiate's mother and sisters provided barley beer and feasting food in large serving pots for family and neighbors. Community leaders poured the barley beer and ox blood libations for the spirits at the households of farmer initiates. The father placed butter on the son's head, an elder woman adorned the boy with grass, and his sisters plied him with honey. At the end of the *bullacha*, the initiate's father usually gave him his first ox and spear for a farmer or first scraper handle and hide for a leatherworker.

SOFE: DISTRICT INCORPORATION AT MARKETPLACES

After *bullacha*, young farmer men rejoined society collectively in a public incorporation ceremony, *sofe*, at the district's largest marketplace, while craft-specialist youth were prohibited from attending the ceremony. *Sofe* marked the initiates' final reincorporation into society, as they had truly shed their former skin, becoming responsible men in society. First, the young men washed in *Tsalahay*'s cleansing river with other initiates from their district. Washing was reminiscent of cleansing with water a child after birth, and it was used in other rites of passages as a source of instigating change or death.[40] The men's sisters brought them fresh clothes and red feathers to place in their hair; this ritual was *Keso* (coming out). The initiates then proceeded to the market for public presentation. In a procession, the initiates circled the market *marache* (divining place) four times, as is completed in other ritual transformations for fertility of people, animals, soil, and children. As they sat on a leather blanket, an elder ritual leader sprayed beer on them and said, "You are a full man; everything will be good for you in the market." *Sofe* marked an individual's final and full shedding of the skin or transformation into a new status, such that young women became *gellao* and young men *pansi*, both eligible for marriage. The men and women of craft-specialist castes did not complete *sofe* rituals.

An individual's status change into a craft-specialist or farmer was conferred in the presence of the spirit world that inhabited water, forests, and earth, as well as pots holding food, iron knives, and leather musical instruments. In these auspicious contexts, individuals either completed their full transformation into an adult citizen

or not, which determined their authoritative knowledge and ownership over particular resources and landscapes, production techniques, and distribution of their goods. Boreda leatherworkers did not proceed through *sofe*, the last phase in the puberty rites of passage, which reinforced their low status in the *hilancha katchea* caste group. *Hilancha katchea* (professional leatherworkers) are men who acquire their technological knowledge through specific patrilineages, formerly known as the *ts'omma degella*.

For many Boreda, puberty rites of passage reaffirmed ascribed occupational statuses and assisted in the justification of the *bayira*/prestige of farmers and the *t'unna*/impurity of craft-specialists. During puberty rites, farmers and craft-specialists began to acquire the skills for reproducing technology. Craft-specialists' practice of engaging production by only one sex (potting by women, ironworking and leatherworking by men) is a transgression within their *Etta Woga* ontology. As such farmers frequently (less so today than in the past) referred to craft-specialists as *t'unna*, or infertile, and refused them the right to participate in puberty reincorporation ceremonies at the marketplace. Hence farmers generally did and do not marry, live near, share food with, or engage in ritual with craft-specialists. Rites of passage as mechanisms of social reproduction involved the transfer of technological knowledge, evoking organizational memory, practices, and techniques that also ascribed a life cycle to technology. For many Boreda, material culture has biographies. Their concept that everything has a spirit or essence and is alive means that everything has a life cycle and comes into being through the reproductive process. Stone tools, plants, animals, metal tools, groundstones, and pottery come into being and thus have life and a life course, *Deetha*.

BECOMING A STONE TOOL AND A LEATHER PRODUCT: LEATHERWORKING TECHNOLOGICAL KNOWLEDGE

The life of the stone and the male knapper's status, skill, and identity are intertwined with the Boreda understanding of being in the world, engendering a mutualistic relationship of respect. The Boreda Indigenous ontology, *Etta Woga*, shapes the life course of the human being as a male low-status craft-specialist, who is born, lives, and dies segregated socially and spatially in his community. Equally, Boreda ontology recognized the biography of the stone tool as a male being who after birth (procurement) in river gorges experiences circumcision (knapping), marriage, maturation in the household (hafting, use, storage), and burial (discard) in a knapper's garden. It is imperative that we begin to bring to the forefront Indigenous ontologies as theories and concede that

Western theories and tropes are not universal. We may consider that things, such as stone tools, have social value, life histories, and biographies that change as they interact with humans.[41] The ascription of a life cycle to nonhuman matter creates interdependent relationships between all entities. If all beings are living, then they demand our attention, respect, and care, and there are correct and incorrect ways in which to interact with other living beings. Ritualized technologies reinforce accurate memories for correct interaction with other beings and co- or reproduction that enhances survival of all.[42]

> The earth is with rock. It is the womb [*kantsa*]. The stone is like her child [*uka*]. We never go alone; it is dangerous. The water specialist [*Hatta Eka*] offers barley to the Great Spirit [*Tsalahay*] for us; he lives near the quarry. When we break the stone into pieces [*tekata*], it is circumcision [*katsara*]; storing the stone is household seclusion [*dume*]; and an old hidescraper is considered an old man [*cima* (not *baltita* for old woman)]. When the hidescraper is working, it is a household feast [*bullacha*], and when it is finished, it is reincorporated in the earth [*sofe*]. (Hanicha Harengo, 2012)

Boreda leatherworking communities embed technological knowledge in ritualized life-cycle processes that facilitate the stabilizing of their memories concerning organization, practices, and techniques. Technological knowledge draws parallels with the location and activities associated with the human life cycle and rites of passage. The life stages of a stone tool and the hide product are one and the same as those of a male human. Stone tools are male; they begin life as part of the parent raw material as a fetus (*gachino*) and proceed to become an infant (*uka*) individual piece of raw material, a boy (*na7ay*) tool blank, an unused tool youth (*pansi*), a married (*wodala*) hafted tool, and an elder (*cima*) tool ready for discard. During a stone tool's life course, it interacts with enset and butter, as well as the rejuvenating aspects of water as recurrent connections to human and nonhuman transformation. *Deetha* organizes leatherworking and lithic technology into five stages (table 4): birth (*yella*) as procurement; circumcision (*katsara*) as production; seclusion (*dume*) as storage; household interaction and feasting (*bullacha*) as use; and reincorporation (*sofe*) death as discard.

YELLA: BIRTH

Leatherworkers birth hides (*gelba*) by removing and defleshing the hide from animals at the marketplace, and they birth stone from quarries in the earth. The separation of the hide from the animal and the stone from the earth is reminiscent of the separation of infant from mother at birth or an individual from his community in the sacred forest or garden during puberty rites of passage. Birth (*yella*) creates a new hide or

TABLE 4 Table comparing the human, hide, and stone life-cycles.

LIFE CYCLE	HUMAN ACTIVITY/ LOCATION	HIDE ACTIVITY/ LOCATION	STONE ACTIVITY/ LOCATION
Yella	Birth or Separation/House-hold Hearth	Removal/Market Place	Procurement/ Quarry
Katsara	Cutting of Umbilical or Cir-cumcision/House, Garden, Sacred Forest	Scraped/House or Garden	Knapped/Quarry, House, Garden
Bullacha	Feast Celebration, Marriage/ Household Garden	Use/House or Garden	Use/House or Garden
Dume	Seclusion, Youth, Growth/ Household Hearth	Storage/House or Garden	Storage/House or Garden
Sofe	Incorporation, Death/Market, Burial Ground, Garden	Discard/Sacred Forest	Discard/Household Garden

hidescraper from a fetus (*gachino*), like a human fetus or an individual in transition to a new status.

Hide Procurement

Boreda farmers and nonleatherworking craft-specialists commission leatherworkers to birth or deflesh the hides from domesticated and wild animals. *Etta Woga* sanctioned that only *mala*-farmers could ritually kill a domesticated animal and, before hunting became illegal, lead the hunts of wild animals in the lowlands. In both instances, only leatherworkers were and are responsible for butchering meat and defleshing hides. Animals are generally defleshed with a metal knife in liminal areas between the marketplace, the sacred forest, and hunting forests. The butcher digs a hole and places the animal's carcass within, like a human infant's afterbirth and a youth's foreskin. The farmer keeps the meat for household consumption or to sell at the market. The leatherworker brings the animal's hide, with legs and skull attached to the hide, to his home. The leatherworker rolls the flat side of a metal knife over the hide to remove the upper layer of fat and does not remove the hair from the hide. He places the hide on an enset leaf, carries it to a local river, and washes it like a human infant. The leatherworker brings the hide to his home and, while it is still fresh, cuts holes along the edge of the hide. He stretches the hide out a few centimeters above the ground, and wooden stakes are set through the cut holes to keep it in place. The hide dries in this manner for one to two days, depending on the weather before scraping (figure 21).

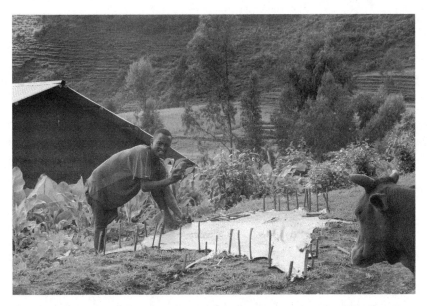

FIGURE 21 A leatherworker pegging down a cowhide to allow it to dry in the sun.

Stone Procurement

The leatherworkers I spoke to also consider the removal of the stone raw material (*goshay* [chert] or *solloa* [obsidian]) from the earth as *yella* or birth. The female earth produces the stone raw materials in her womb (*kantsa*), which are readily apparent after male rains (*era*) in the act of reproduction. The stone is *gachino* (fetus). Leatherworkers often select sources near trees and water, symbolizing auspicious places of change and transformation like sacred forests in the mountains. Leatherworkers consider quarrying to be the most dangerous aspect of technological reproduction. The birth of the stone in the absence of women places the leatherworker at risk. Leatherworkers believe that some earthly movements, in the form of landslides and floods during quarrying, are punishment for their inappropriate practice of birthing stone from the earth. They may ask ritual leaders to make offerings of barley porridge for their safety either before or after quarrying. At the quarry, the lithic practitioner washes the stone in the nearby river in an act to purify the stone, like the hide and the human infant. Stone swaddled in a cloth bag journeys to the leatherworker's household.

KATSARA: SCRAPING HIDES AND KNAPPING STONE

After procurement, hides and stone experience scraping and knapping or cutting, *katsara*, like the circumcision of humans becoming adults in society. The acts of

scraping and knapping ensue in or near the household, where some Boreda experience circumcision, and are associated with other materials such as enset leaves and bamboo that recall human rites of passage.

Scraping of Hides

The processing of raw hides into leather occurs primarily through scraping, softening, cutting, and sewing the hide. The most time-intensive and critical part of leatherworking is the removal of the inner fat of a dry hide. The Gamo do not remove the hair from the hide. The removal of the inner fatty layer of a hide, *quiche*, is referred to as *katsara* (circumcision) and implemented using stone hidescrapers.

The Boreda lay a goat, sheep, or wild animal hide over their legs and, holding the edge of the hide in one hand to create tension, use the other hand to scrape the hide. Cowhides are hung on a scraping frame. The Boreda leatherworkers' scraping frame is located in the household (figure 22). The frame consists of three bamboo poles, two of which they plant in the ground at an angle of 65–90 degrees (relative to the ground). They secure the hide on the frame by winding enset twine through the holes along the edge of the hide and around the framing poles. The leatherworkers usually place enset leaves under the hide frame. The placement of the enset leaves recalls the enset leaves that a youth sits on during circumcision or a mother sits on at birth. The enset leaves capture the afterbirth, foreskin, and the hide's dry hide shavings, all items considered *t'unna* or impure, and then are buried in the garden.

After scraping, the hide is trampled with butter or *etema* (the juice from the enset plant) to make it supple, like the butter placed on a circumcised youth to heal the wound. Leatherworkers scrape an average-sized cattlehide in approximately four hours using four and a half stone hidescrapers.[43] The hide experiences being sewn, cut, and shaped to produce various household items, such as bedding, straps, agricultural bags, and furniture within a leatherworker's household.

Knapping of Hidescrapers

The leatherworkers reduce and shape the stone material through knapping or cutting, *katsara* (figure 23). They knap the infant stone initially at the quarry at the sacred space, similar to the circumcision of young boys in sacred forests. The hidescraper boys are brought home and kept in the house. Leatherworkers use the word *tekata*, meaning "to protect," to refer to knapping. The debitage is the infertile waste, *cha-cha*. The implication is that the act of knapping, like circumcision and removing the umbilical cord after birth, is an act of protection. Cutting or knapping protects the future of the fetus or stone and allows it to develop by removing the impure infertile aspects. Newly produced unused hidescrapers are *naꞩay goshay* (boy chert). The hidescrapers are shaped again right before hafting and are called *pansa goshay* (youth

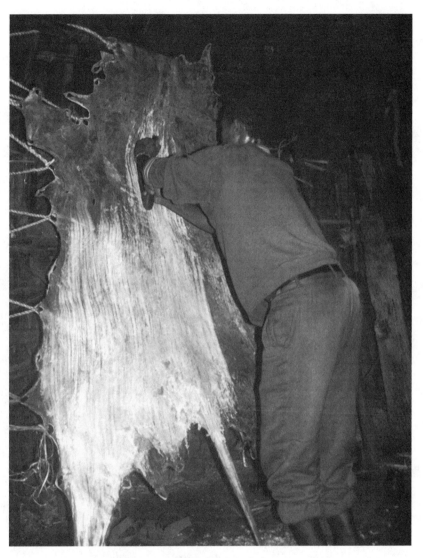

FIGURE 22 A cattlehide being scraped or circumcised.

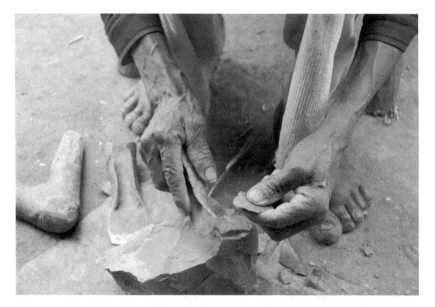

FIGURE 23 A leatherworker knapping or circumcising a new hidescraper.

chert) when they are made into formal unifacial convex hidescrapers to process the dried cattlehides.

BULLACHA: HOUSEHOLD USE OF HIDES AND LITHICS

Bullacha is a household feast celebrated at the birth of a child, at a boy's puberty circumcision, and during marriage and leadership rituals. Hides and stone are both active in the household. Several leatherworkers stated that *bullacha* is about celebration and family being together. In this sense, when leather products and stone hidescrapers are together and active in the household, they are in *bullacha*.

Leather Product Uses

When leather products are completed, they are full, mature, and ready for activity. Boreda utilize leather goods in virtually every household, where people engage them in daily use. In the past, leatherworkers produced goat- and sheep-skin clothing including men's belts (*sacke*), women's tops (*kole*) and skirts (*geetata*), and shoes (*dursa*). Today, industrially produced clothing predominately replaces leather clothing. Leatherworkers in the past also produced a variety of instruments such as straps, bridles (*pulo*), and saddles (*core*), but today most of these items are imported. In the past they also scraped sheep, leopard, and lion skins to make capes (*zito*) for ritual

FIGURE 24 A leather bench and drum.

leaders. Currently, the Boreda predominantly scrape cattlehides and most frequently produce household furniture such as bedding (*gelba arisa*), benches (*oide*), benches with a back (*zemfa oyida*), chairs (*euteta oyide*), agricultural bags (*galiba borsa*), and musical instruments such as drums (*camba*) and guitars (*getza*) (figure 24).

Active Stone Hidescrapers
A hidescraper used on a hide is a fully mature married adult, *wodala* (figure 25). To become *wodala*, a circumcised young male hidescraper is placed in the female haft—a perceived act of reproduction. The Boreda leatherworkers use a handle that requires mastic. The tree-resin gum in the handle's haft warms near the hearth to receive the

FIGURE 25 A mastic haft resting near the hearth in preparation for insertion of a hidescraper.

young hidescraper. The leatherworker places the formed hidescraper into the resin haft, sets it at the proper angle, and allows it to cool before use. The insertion of the male hidescraper into the female haft is an act of reproduction that creates a full fertile and powerful tool ready to engage in activity. The male hidescraper consummates his marriage with the female haft near the hearth, just as his human counterpart. Many leatherworkers expressed that a hidescraper is happy when it is combined with the haft and when removing the inner fatty layer from the hide; it is celebrating *bullacha* just like a human bride and groom celebrate *bullacha* in the house.

DUME: STORING HIDES AND STONE

Leatherworkers store their knapping stone and hides in their households during several periods of the leatherworking process. Human *dume* or seclusion occurs in the household, where a person experiences a period of rejuvenation, rest, and transformation during their rites. Hide and stone materials also are secluded in the household during their own transformations. First, hides and knapping stones arrive home like newborn infants to rest before their use and growth. Then each transform in the home

through scraping (hide) or knapping (stone). Lastly, both rest in the house before they are sold (hides) or placed in final discard (hidescrapers).

Hide Storage

After a leatherworker procures a hide and dries it, he brings it home and stores it in the rafters of the house or near the hearth/*kolla*, reminiscent of the resting human infant or initiate (figure 26). Other leatherworkers place the hide in the branches of trees or in enset in their garden.

FIGURE 26 Cattlehides rolled up and stored in a house.

The hide also is in *dume* when being transformed through scraping (*katsara*) in the house. Boreda scrape the hide in the symbolic male *wege* portion of the household, which is the place of cultural reproduction and activity. Leatherworkers further transform hides in the household, when they sew them into bedding and clothing or make them into furniture. The leather is stored in the household rafters or near the hearth until the leatherworker gives it to the customer.

Stone Storage

Boreda stone hidescrapers also have several stages of storage in the house. When a leatherworker first brings home the hidescraper blanks, he often stores them in a piece of cloth above his door lintel in the male *wege* portion of the household. Before hafting he removes old hidescrapers near the hearth and finalizes the shaping of young hidescrapers. Old hidescrapers may remain in preliminary discard along with small bits of debitage near the household hearth. During use, hidescrapers are continuously resharpened near the hidescraping frame in the front room of the house, thus resharpening debitage and occasionally hidescrapers broken through use remain in preliminary discard in the front room. Hidescrapers and debitage also may be swept to the edges of the household (intersection of the floor and wall) prior to final discard.

SOFE: REINCORPORATING DISCARDED HIDES AND LITHICS

When an individual dies, the *sofe* ceremony occurs at the burial ground, where the soul of the individual eventually rejoins ancestors. A deceased individual is referred to as *hayikes*, and so too are leather products and hidescrapers when they have passed through their earthly stage in life. In the past, craft-specialists were buried in their household gardens, and this is where most knappers bury their hidescrapers and debitage.

Discarding Leather Products

Leather products last up to 30 years and people reuse them as mats or other smaller items, but eventually they are deceased or *hayikes*. All Boreda people use leather products, not just the leatherworkers. Interestingly, when leather products become *hayikes*, they are not thrown in household gardens for fear that they will attract bad things such as hyenas; instead they are thrown in sacred forests, which are often human cemeteries.

Discarding Stone

Lithic materials are discarded during different phases of the lithic process: quarrying, shaping, sharpening, and after use. When a person knaps raw material producing

debitage, the debitage is *t'unna* and useless waste, *chacha*—like the skin removed from circumcision. If production occurs at the quarry, then debitage remains there near the original birthplace of the stone, reincorporating into the earth. Leatherworkers then complete final shaping at the household and bury the debitage in specific locations in the household garden, along with resharpening debitage. When a stone tool is completely exhausted, it is an elder (*cima*) near death in preliminary household discard, but eventually it is *hayikes* (deceased). Most debitage and exhausted tools appear in household gardens, reminiscent of the burial location of ancestral leatherworkers and of the afterbirth and foreskin. The dead hidescrapers' spirits return to the earth, where they rejuvenate the life-cycle process, instigating new forms of stone. They are renewable resources, like humans whose spirits are renewed entering sacred trees, snakes, and other ancestral spirit groups.

A BOREDA ONTOLOGY AND THEORY OF TECHNOLOGY

In Boreda ontology *Etta Woga*, all matter is alive and maintained through the process of reproduction, and as such has a life cycle. Leatherworkers begin to learn their theory of being, and its connection to technology, when they experience their own life course change into adults. *Deetha*, the life cycle, entwines social reproduction and biological reproduction—they are dependent on one another. The reproduction of leather, iron, and ceramic beings is a biological and social process that intertwines the lives or essence of the earth and people, demonstrating their interconnectivity and creating mutual respect. Just as proper crop production and processing are essential for human survival, so too the knowledge and technologies associated with iron tools used to plant and harvest crops, the leather bags used to store and carry crops, the leather bellows and ceramic furnace lids used in ironworking for agricultural tools, and the ceramics used to process crops are essential for human well-being. In addition, in the past many Boreda used iron spears, crowns and jewelry, hide capes and musical instruments, and ceramic jars in ceremonies as instruments of appeasement and honor of ancestors, ensuring human spiritual well-being. Thus, both farmer and craft-specialist productive technologies preserve human health and fertility (biological and spiritual).

Beyond reconstituting practices to safeguard human survival, the biography of stone tools also recalls the power of the nonhuman material to elicit change in the humans with whom they interact. Boreda farmers and craft-specialists usually are not equals in society, and it is through their different interaction with the earth and the different ways in which they proceed through rites of passage that they acquire and

legitimize their status in society. Male and female farmers work together to produce food. Men farmers most often plow and plant seeds in the earth, and women farmers tend to a plant's growth in the earth and are primarily responsible for harvesting. According to the tenets of *Etta Woga*, farmers' proper gendered interaction with the natural world instigates their high status in society. In contrast, men craft-specialists, who birth stone for grindstones, iron tools, and hidescrapers in the place of female midwives, instigate a craft-specialist's low social position in society. Female potters collect male (black) and female (red) clay from the earth in proper gendered birth, yet they tend to raise the pots themselves. In some communities, their marriage to either male ironsmiths or male leatherworkers further solidifies their impure status. There are also consequences for craft-specialists from the nonhuman world. Stones as material beings have agency to initiate harm or to call upon other earthly forces to inflict punishment on craft-specialists for their transgressions. Leatherworkers, as well as other craft-specialists, report death, injury, and illness at quarries as a result of collapsed mines, landslides, and floods. The Boreda lithic practitioners instigate reproduction and mitigate the life course of stone in their daily practices, and the interchange of agency between human and material has a profound effect on the way in which the Boreda learn and interact with stone in their technology. The Boreda theory of the material world expresses their aspirations for the world and has a substantial effect on their tangible and intangible lithic technology practices.

3

YELLA

The Birth of Knappable Stone in a Caste Society

THE PAIN WAS SHARP and immediate; a small stone hit my shoulder, then another hit my back. Yohannes, my research assistant, motioned for me to be quiet and to wedge my body against the gorge wall. Someone did not want us there—were the earth spirits forbidding us to birth her stone children, were mischievous human children playing with us, or were adults threatening us?

Yohannes and I had followed a knapper into this narrow river gorge, to procure chalcedony for his hidescraper production (figure 27). We walked for nearly two hours dropping down steep, 20–25 degree grades into the lowlands, stopping at various spots promising obsidian, yet there was none. Obsidian eluding me, I finally asked to go to the chalcedony source. We soon entered a small gorge with high walls along the Agamo River. I watched the knapper intently as he began to use his iron billet to loosen the chalcedony embedded in the basalt, letting it slide down the wall. He examined a piece and, using direct percussion with an iron billet, removed a few flakes before either discarding it or washing it in the river. After about an hour, he had a collection of fourteen cores, fifteen large flakes, and one piece of angular waste. There was no time to reduce the material further into hidescraper blanks, as it was about at that moment that it began to rain stones from above, and we took shelter, easing our way along the gorge wall to find an exit point. Yohannes and the knapper were clearly concerned and insisted that we clamber up the scree slope rather than risk the walking path where we might encounter our foe. When we arrived at the plateau, there was no one. I had been to several quarries, but it was then that the words of an elder leatherworker, Hanicha, came to me:

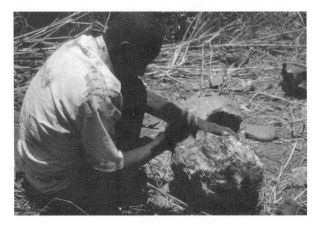

FIGURE 27 A Boreda knapper (not the knapper in the story) at a quarry working a piece of raw material.

> It can be dangerous. Always go with someone. Rocks slide down the slopes, it is dangerous, water can capture you. The earth is *kantsa*, the womb; and the stone is her child, *uka*. We are often sick afterward. Then we go to the *Hatta Eka* [water specialist]. He makes a barley offering to *Hatta Tsalahay*, then we get better. (Hanicha Harengo, June 13, 2012)

Stone, as a living entity with an essence or spirit according to the Boreda ontology *Etta Woga*, may inflict harm. The birth of human beings and stone beings alike bring joy and risk of illness and injury. Prescribed rituals at quarries ensure the safety of all; otherwise, one jeopardizes being "captured" by spirits, especially if one has committed transgressions against the nonhuman world. Although leatherworkers never ask me not to photograph a quarry, whether I took slide film or digital, virtually all the images taken within a quarry are completely black or extremely dark. Was my attempt to capture the essence of these places also thwarted by the spirits? Many Gamo perceive leatherworkers to be impure and therefore more susceptible to misfortune inflicted by spirits, such as when they birth stone. Our threatened injury that day was a reminder of the dangers leatherworkers experience. In my observations, leatherworkers and other craft-specialists receive more respect today than described in the past or even twenty years ago when I first arrived in Ethiopia. Still, illnesses and misfortune seem to follow them. Whenever I experienced an illness, bad fortune such as losing something or forgetting something, or my daughter tripped and skinned her knee, and so on, *mala*-farmer men and women were quick to offer that it was because I spent too much time with the leatherworkers.

The danger stone inflicts on a leatherworker as he delivers the fetus stone from the earth foreshadows the complicated interaction between the human being and the stone being. Stone and knapper live their lives in the leatherworker's community interacting and affecting other beings. Leatherworking as practiced among the Gamo includes a repertoire of knowledge and techniques fostering assemblages between humans, stone, wood-scraper hafts, and hides. By *assemblage* I mean more than just items that are associated with one another in the archaeological sense; I refer to *assemblage* in the sense of political ecologist Jane Bennett.[1] Assemblages are living mosaics that together create emergent future realities in which no one body, such as the human body, has full control. Stone is a living entity created in river gorges, where the movement of the earth by water is evidence of change and life without the interference of human interlopers. Only human men endowed with their ancestors' knowledge concerning proper procurement practices enter quarries and birth stone. Quarrying is potentially dangerous, bringing harm to the male leatherworker and to fetus stone. Nodular stone is recognizable as a viable fetus when it exhibits special qualities such as particular colors and a shimmer or light. Once a stone leaves the quarry and interacts with other bodies, including humans, wood hafts, and hides, it performs activities that again make apparent its power to change others.

QUARRIES AS REPRODUCTIVE SPACES

For many Gamo, quarries are important and special places on the landscape of conception, nativity, and the spirit beings. *Tsalahay* are life essences that are a part of all matter including stone. Today the belief in *Tsalahay* is waning, and glass is quickly replacing the stone hidescrapers to process hides. In the past, Gamo leatherworkers who lived more than a one-day walk from quarries purchased chalcedonies and obsidians through the market system; today these leatherworkers mostly use glass rather than stone. Today the Boreda leatherworkers, who are some of the few Gamo leatherworkers to continue to incorporate stone hidescrapers as part of their leatherworking assemblage, directly assist in delivering chalcedonies (*goshay*) from the earth as birth.

Today most stone-using leatherworkers live in the districts of Boreda and Zada on the edge of the highlands either on the Rift Valley escarpment facing east toward Lake Abaya or near the escarpment toward the west and the Kulano River. The present-day stone-using leatherworkers live in sedentary communities and have direct access to stone through dedicated expeditions. Men procure chalcedonies by walking one to three hours for four to fifteen kilometers (9.3 miles) descending into the lowlands from their highland home. While men may stop along the way to check honey hives,

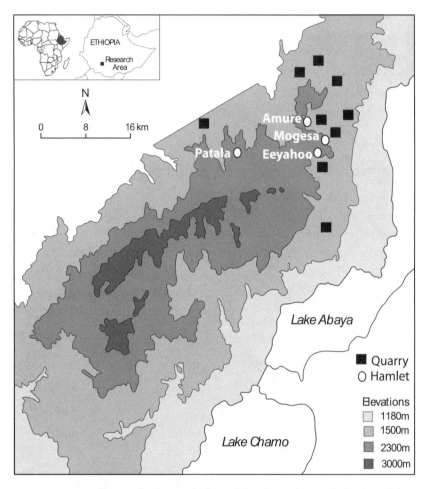

FIGURE 28 Map locating the three studied Boreda hamlets and one Zada hamlet and their quarries. Quarries are typically located at elevations between 2,300 and 1,500 meters. Map background designed by Melanie Brandt, and hamlet and quarry locations added by Kathryn Weedman Arthur.

collect wild olives, and visit with neighbors, the primary objective of the trek is to obtain stone. Currently the Boreda and Zada collect chalcedonies directly from the quarries in the Bobe, Guzeme, Dugano, and Kandala river basins at elevations of 2,300 to 1,500 meters (figure 28).

Particularly for elder Boreda leatherworkers, stone quarries are living ecosystems that reveal the movement and transformation of the earth, which bear living entities in the form of chalcedonies. Among the Boreda, quarries are more than simply acces-

sible and convenient places from which to wrest resources from the environment. For many Boreda, who follow the tenets of their Indigenous religion, *Etta Woga*, change and transformation are evidence of existence, being, and the potential of becoming. All matter exists through reproduction, which ensures and maintains balance in the world. Chalcedonies and obsidian, like all other beings, are created through reproduction. For stone this occurs when the male rains penetrate the female womb (*kantsa*) of the earth at gorges that biannually fill with rainwater.

> The earth is the mother of the stone; it is a *gachino* [fetus] when it is with her, and when it lives in your house it is an *uka* [infant] and *na7ay* [boy]. (Bedala Aba, June 21, 2012)

The depths of the earth are the source of all life, stone and human, as both initially formed from the earth. The womb of the quarries, like the caves from which the first human appeared, are associated with sacred water and sacred trees. Water emanates from the mountain springs, cresting the cave cupola as waterfalls, which are water spirits—*Hatta Tsalahay* or *Dydanta Tsalahay*—travel into quarry gorges below. The mountain springs are associated with sacred trees and serve as the Boreda *mala*-farmer ancestral sacred places or *Bayira Deriya*. It is here that a majority of the non-craft-specialist Boreda propitiated their ancestors and *Tsalahay* to maintain harmony and continued fertility for all beings. *Mala*-farmer men oversaw the annual *Tompe* (bonfire festival) summer solstice rituals, and *mala*-farmer women led the winter solstice *Asterio* (Gamo word for method of counting the phases of the moon) ceremony. Leatherworkers and their families are restricted from entering the highland sacred forests and springs, the *Bayira Deriya*. In the valleys into which the spring water mixed with rainwaters carve into the earth, the leatherworkers birth their own light (*tompe*) in the form of chalcedonies. Quarries located in river gorges with water and species of sacred trees, I argue, are a leatherworker's sacred ground.

THE EFFICACY OF STONE

For many Boreda, particularly in the past, stones were vibrant, powerful beings capable of healing, but more commonly associated with their more destructive authority. Some stones such as quartz crystal and large boulders found near springs brought reproductive relief and health to women. Quartz is referred to as thunderstone—a gift from *Dydanta Tsalahay* (rain/thunder/river spirit). The crystal was ground and heated near a hearth and then placed on the inflamed breasts of nursing women to relieve blocked mammary ducts. Stone boulders located near springs also were important during women's rites at the winter solstice, *Asterio* (figure 29). Women fed

FIGURE 29 *Asterio* ritual boulders. On the left or west is the female boulder and on the right or east is the male boulder.

butter to male (dark or black) and female (light or white) stones as an offering to serpent spirits (embodiment of a king's ancestors) next to springs to ensure women's fertility. The presence of male and female stones in women's rites is a reminder of the connection between reproduction, fertility, water, earth, and the shared essence embodied in nonhumans and humans. Though stones aid in healing, the Boreda more commonly recognize them for their power to cause physical and social harm.

Stone especially wreaks havoc on the lives of leatherworkers when they birth stone from the earth. Leatherworkers travel to quarries just after a rainfall that washes soils along the landscape, exposing the chalcedony nodules. Male leatherworkers in delivering stone from the earth are transgressing female reproductive powers as midwives. *Tsalahay* of earth and water often punish the male leatherworkers for this act. Stone may rain down from the gorge wall, severely injuring a person, as described in my narrative above. Stone may evoke the earth and river to bury, injure, or drown a male leatherworker. In particular, *Dydanta Tsalahay* (river spirit) was greatly feared by many Boreda, who generally do not know how to swim. Water instigates transformation by "capturing" a person. The Boreda use the word *capture* to emphasize a person's unwillingness to enter water—for as a result, in the past one either died or transformed into a *Maro*, or spirit medium.[2] Becoming a *Maro* incurred great costs for the individual and their family, who had to provide substantial offerings and hold

a community feast for the spirits to heal the individual. *Maroti* (plural of *Maro*) were and are often barren women or men who have a physical disability such as blindness or loss of function in one or more limbs. *Tsalahay* communicate with mediums, informing them of the transgressions of their community members and offering the means for making amends. The authority of *Tsalahay* forces in the form of stone, water, rainbows, snakes, and so on was feared by many Boreda, who believed that disruption of the *Etta Woga* tenets, including reproductive gendered roles, would cause chaos and massive drought and infertility. As discussed in the last chapter, leatherworkers also were and are socially punished for the way in which they disrupt the earth when they cross-gendered responsibility by birthing stone.[3]

Among most nonleatherworking Boreda, obsidian and chert contained a bad spirit, *Bita*, that will bring them misfortune through infertility of fields, domestic stock, and people. Chalcedonies and obsidian have the habit of wandering outside the parameters of a leatherworker's household, burying themselves in and near other households. Today, people are still anxious when speaking about *Bita*. Farmers, potters, and ironsmiths blame leatherworkers for the practice. Leatherworkers adamantly deny that they engage in such a practice and state that when a person seems to gain some small measure of wealth, they are forced to give it away. When a farmer finds obsidian or chalcedony or sometimes a rat or cat buried in their compound, they call the community to meet at the *Ya'a*, a forested meeting place.

> "They bury bad things in the yard, especially *degella*; I cannot tell who specifically did this but the group. We meet at *Ya'a* and tell all people, someone buried a bad thing in my compound. We do nothing for this person, give them nothing, separate him; he has no rights. It is almost always a man and not a woman." (farmer, June 25, 2008)

As a consequence, Boreda leatherworkers are careful about the transport and movement of lithic materials and will bury them only in their household compound. Thus, the meandering of stone outside of a leatherworker's household compound impacts social relationships negatively, affecting farmer and leatherworker alike. Stone is alive and has power, and only experienced men of the *hilancha katchea* caste group know the proper practices for birthing stone without harm.

APPEASEMENT AND ACCESS TO
STONE THROUGH MALE ANCESTORS

Stone and their places of birth, quarries, are valued as part of a leatherworker's patrimony and livelihood throughout the Gamo highlands. Leatherworkers deliver stone

from quarries that they inherited through their ancestors. Men learn where and how to quarry from their fathers, older brothers, fathers' brothers, and sometimes their fathers' fathers.

There is a stable alliance between the knapper's lineage and the stone being's lineage. Leatherworkers determine rights to access and quarrying knowledge within a hamlet patrilineage. In some communities, all members of the same patri-clan shared a quarry. For example, in Mogesa Boreda and Patala Zada (figure 28), all the leatherworkers in each community shared a single quarry on the Kandala or Guzeme rivers, respectively. In other communities, leatherworkers who are members of different lineages of the same clan use separate quarries. In the hamlet of Amure Boreda (figure 28), I worked with nine leatherworkers of the same clan, who were related to the same male ancestor three to five generations ago. They recognized three different lineages of leatherworkers who lived in three separate areas of the hamlet and attended to three different quarries in the same drainage basin along the Bobe (Agamay River, AbayaCheri River, and Guya River). I was not able to conduct a survey of the complete drainage basins associated with each of the three leatherworker hamlets, Mogesa, Patala, and Amure, to determine if there were more available quarries than those known by living leatherworkers. However, geologists who participated in my more recent research project and conducted several highland to lowland surveys stated that chalcedony was ubiquitous.

Leatherworkers are protective of their stone quarries and will not share quarry information outside of their hamlet lineage. Generally any chalcedony not collected from a man's ancestral quarry ground he considers *t'unna*—worthless and infertile. A small number of leatherworkers, though, do move far away from their natal community, and they then take up quarrying at a new location. If a leatherworker decides to move from his natal hamlet, he must obtain permission from the resident leatherworkers to move into their hamlet. In one hamlet I worked in, the immigrant leatherworkers received local permission to live there; however, the local leatherworkers did not share their quarry with the immigrants. Generally, men only accept new residents into their community when they are of the same clan. For example, approximately thirty years ago, a leatherworker moved to the community of Eeyahoo in Shongalay subdistrict of the Boreda district (figure 28). He acquired permission to live there from other leatherworkers living in another hamlet of Shongalay, Mogesa. The Mogesa leatherworkers would not share their knowledge of chalcedony sources with the new leatherworker; instead, he discovered his own source through surveying the area. When I met him he was very elderly, no longer scraped hides, and would not take me to the quarry, which he stated was very far away. Later two brothers and another young leatherworker also moved to Eeyahoo

Shongalay; they also had to find their own distinct quarry. They selected a nearby hill. The quality of the stone employed by the newly immigrant leatherworkers was poor and grainy compared to that of the leatherworkers who quarry from ancestral known places.

Each lineage of leatherworkers also arranges for gifts of atonement to *Tsalahay* and to ancestral spirits, who can communicate with *Tsalahay* to ensure protection during quarrying. Generally, to ensure the safe delivery of stone, leatherworkers ask their wives to prepare a small amount of barley or sorghum porridge or powder. Men make offerings at the quarry near a stand of sacred trees in the gorge or leave the porridge in bowls in the nooks of the trees.

> At the river, where we get the stone, we leave barley powder and roasted sorghum as an offering. After they take, I said, "Don't scare me, let me get safely to my home." (Chamo Chache, June 25, 2012)

Other leatherworkers indicated that if they discovered they did not feel well after they had traveled to a quarry, which was often, they would consult a *Maro*, a spirit medium. The *Maro* often told them to go to the nearest landowner and request that he make a barley offering. The leatherworker referred to this individual as a *Hatta Eka* [water specialists]. Propitiation of ancestors and *Tsalahay* at quarries is the responsibility of adult married men, though their unmarried circumcised sons may accompany them to the quarry.

Although a patrilineage often shares a quarry, in my travels to quarries I usually accompanied specific segments of the lineage, such as a father and his unmarried or recently married sons. When boys are fourteen to fifteen years of age, after they are circumcised, they begin to accompany their fathers, uncles, and grandfathers to quarries. At a younger age, the fathers state, they are too young and will tire and complain about being hungry, and so they do not encourage their younger sons to accompany them to the quarry. Osha Hanicha, now a leatherworker in his forties, remembers:

> When I was a *naʒay* (young boy), I watched intently. I watched my father make the mastic in a small fire he made after visiting the quarry. I followed him and watched him. After I became a *pansa* (a young man who is circumcised), I began to collect from the quarry. We usually went in the dry season right after the rains.

I never witnessed boys selecting or working with stone until they were young men or circumcised. Youths and recently married men do not travel to quarries alone, but rely on the advice of their elders for selecting the raw material.

SELECTION AND QUALITIES OF VIABLE STONE

Gamo lithic practitioners identify specific qualities of stone that are viable as fetus (*gachino*) sources for stone hidescrapers that include their nodular shape, sheen, and color. They wash the raw stone material in the water, transforming it into an infant (*uka*). Leatherworkers then bring either infants (*uka*) or hidescraper blanks/boys (*naʒay*) back to their homes.

Gamo knappers select nodular or egg-shaped stone. They generally dig for buried nodules that are just below the surface rather than selecting nodules that are on the surface. Nodular chert is preferred over banded chalcedonies, though project geologists confirm that chert sources occur in banded and nodular forms (figure 30). Chert nodules are referred to as fetuses, *gachinnotta*, and appear buried in gorge walls as a result of reproduction—after the male rains penetrate the female earth. Once a stone fetus is successfully born as an infant, *uka*, like a newborn human or an individual experiencing social transformation, the leatherworker immerses and washes the stone in *Tsalahay*'s purifying water.

Experienced leatherworkers are responsible for recognizing a viable stone fetus by its sheen or light (*tompe*). The light is evidence of the life of the stone and that it is fully formed. The stone is pliable and will have the ability to change properly. Grainy chalcedonies are considered to be not ready. The knapper removes a small flake from a piece of raw material. He places his mouth close to the stone and breathes on it. If the stone exhibits a shine, he will keep it for hidescraper production. If it does not exhibit a shine, then it is not yet ready and developed and will be left at the quarry.

Each hamlet of leatherworkers selects particular colors of raw material that they believe represent the best-quality material.[4] A variety of colors of chalcedony exists

FIGURE 30. A piece of nodular chert at a quarry.

in all the Gamo quarries, including black, brown, red, green, white, yellow, and so on. Leatherworkers in Amure predominately chose yellowish-brown, red, and gray chalcedonies. In Mogesa, they tended to select green and black chalcedony. Patala leatherworkers preferred yellowish-brown, red, and green. In Eeyahoo, where leatherworkers recently moved and selected a source not based on ancestral knowledge, gray chalcedony predominated. The predominance of the colors of red, yellow, and green are significant as colors in the Ethiopian flag, and they hold important local meaning among the Gamo concerning fertility, change, and transformation. Red is associated with blood, warfare, strength, virility, and maleness. During puberty rites of passage, youth hunted the African flycatcher and placed the red feathers in their hair during their presentation ceremony at the market. Green is cool, grass, enset, land, and fertility. Grass is handed to an individual from an elder when he is chosen to be elected for a ritual-political office, and grass is placed on people's shoulders and head during ceremonies for elected positions. Yellow is the color of lions, strength, and kingship. Elite elders and the king, *Kawo*, wear the hides of lions particularly at funerals and initiation ceremonies for youth. Red, green, and yellow are reminders of the ability of all matter to reproduce and transform. Although the leatherworkers in each of these hamlets use other colors of chalcedony, they consider other colors of stone inferior. The colors they prefer dominate their hamlet's assemblage (figure 31).

After the lithic practitioner finds a suitable viable nodular stone fetus with a sheen and the appropriate color representing his patrimony, the stone's life course proceeds as a human infant's. The knapper washes the infant stone in the river like a newborn human after birth. The stone born from the womb of the earth is male and progresses from a state of fetus or raw material in the earth (*gachino*), to infant or newly obtained raw material (*uka*), to hidescraper blank or boyhood (*naʒay*), and eventually it becomes a male elder (*cima*). However, before growing old, a stone hidescraper interacts with other materials such as the haft and the hide. Technology is a reproductive process, and as such, stone as a male being interacts with other gendered beings, and together they create their own assemblages.

MALE STONE TOOLS AND FEMALE HAFTS

BECOMING FERTILE ACTIVE YOUTH

The Gamo leatherworkers bring home stone beings and eventually insert the stone into a haft, which many Gamo consider female. The lithic practitioners only inserts the male stone into the haft after he has cut or circumcised, *katsara*, the stone, allowing it to become a fertile youth, *pansa*. The act of the male stone being penetrating the female haft is an act of reproduction, realizing the full potential of adulthood status for

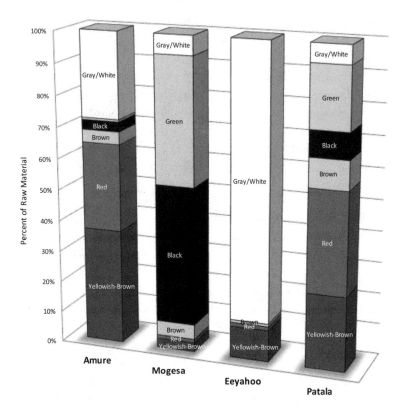

	Amure	Mogesa	Eeyahoo	Patala
☐Gray/White	115	26	201	25
☐Green	3	172	0	84
■Black	13	187	0	35
☐Brown	17	20	2	40
■Red	117	5	3	139
■Yellowish-Brown	154	12	23	101

FIGURE 31 Graph illustrating that each leatherworking community has a preference for specific colors of chalcedonies. 1996–1998 data consisting of 1,494 chalcedony unused and discarded hidescrapers. Graph created by Kathryn Weedman Arthur.

both stone and haft. In the past, male stone tools entered into female hafts for sickles, knives, hoes, and other agricultural tools, and were made into spears for hunting. Elders also recall in the not-too-distant past that they used stone circumcision knives in rites that transformed young men and women into fertile youths. Today, however, the Gamo only haft stone into handles to scrape hides. The stone and haft as fertile youths join together in marriage and like their human counterparts are considered to

be in their *bullacha* phase of celebration together. The Gamo are unique in Ethiopia for employing two styles of wood handles for hafting the stone hidescrapers. Below, I focus on the dialogue between the leatherworker, stone, and haft that together create a variety of assemblages.

Access to wood species for producing hafts is entangled with Gamo perceptions of leatherworkers as impure and polluted, as a consequence of how they acquire stone from the earth. The Gamo region is environmentally diverse, covering a region that includes lowland (*baso*, 1,500–2,300 meters) acacia and cordia woodlands, and highland (*geza*, 2,300–3,000 meters) juniper, eucalyptus, and ficus montane ecology. Most Gamo live at an elevation of 2,800 to 2,000 meters. Since the 1970s, permanent settlement in the lowlands near lakes Abaya and Chamo has increased through government resettlement plans and incentives. Certain species of trees, particularly the hardwood species of *Ficus sur* and *vasta* (figs) and *Croton macrostachys*, are sacred trees; and to cut one of these species down particularly on sacred grounds would be a grave transgression for any Gamo individual. However, these species grow in other areas such as homesteads and in the "bush," providing a context in which woodworkers use these species for making furniture, wood doors, coffee mortars, and pestles, and many households also select these species for firewood and to use for their medicinal qualities. Leatherworkers state that they should not use these species for their work on hides because of the impurity of working hides, and so they harvest other wood species to produce their hafts. The Gamo choose lowland and highland species to produce their two specific and unique hafting types, *tutuma* and *zucano*.

TUTUMA HAFTS AND STONE

Tutuma hafts made from highland tree species secure informal stone flakes, who travel to the leatherworkers' households as infant raw materials and cores (table 5). A majority of the known leatherworkers, who scrape hides with *tutuma* handles primarily live in the highland districts of Kamba, Bonke, and Ganta in the south and the central districts of Dita, Doko, Dorze, Kogo, and Zada at an elevation above 2,300 meters.[5] Most leatherworkers made their own *tutuma* handle of a tubular-shaped piece of wood. *Tutuma* users select wood from highland species, particularly *Eucalyptus*, but also *Maesa* and *Hagenia* species and *Galiniera saxifrage*. The *tutuma* handles in the central districts on average are half the length of those produced in the southern districts. Enset (an indigenous crop) rope is tied around the end of the *tutuma* haft to secure the hidescraper.

Today virtually all *tutuma* users employ glass rather than stone hidescrapers. For most *tutuma* users in the past, stone quarries were more than a day's travel located in lowlands near Lake Abaya to the east or in the Kulano River gorge to the west.[6] Many

TABLE 5 Table illustrating the interaction between the lives of stone hidescrapers and wood hafts.

OPEN HAFT	CLOSED MASTIC HAFT
62.5 cm long in southern districts (average) 35.7 cm long in central districts (average)	26.6 cm long × 7.6 cm wide in northern districts (average)
Highland wood species	Lowland wood species
No tree resin required	Lowland tree resin
Leatherworkers live in highlands (94% n = 348/370)	Leatherworkers live in highlands (42% n = 45/106) and Leatherworkers live in lowlands (68% n = 58/106)
Indirect market purchase of stone Direct quarry access usually 3 or more hours away	Direct quarry access 1 to 4 hours
Quarry raw material and cores	Quarry hidescraper blanks
Haft informal hidescrapers	Haft formal end/side hidescrapers

stated that they or their father purchased raw material through a merchant, usually at the Ezo market. Leatherworkers recall that in the past a 150 by 150 millimeter piece of stone at the Ezo market cost approximately 3 ETB (Ethiopian Birr, equivalent to USD 25 cents in the 1970s). Ezo is located within a half day's walk to lowlands with potential quarries. Leatherworkers in Birbir Ezo stated the quarry is seven hours round-trip in the Derke/Shope river basin and confirmed that their fathers traded chert at the Ezo market.

Some *tutuma* users live within a one-way, three-hour walk of stone sources and procure stone directly. At the quarry, I observed *tutuma* users often collected fourteen to twenty pieces of infant viable raw material or cores ranging in size from 40 by 40 millimeters to 200 by 200 millimeters, bringing the material home without further reducing it at the quarry (table 5). The infant stones become boys or flake blanks (*na7ay*) at the leatherworker's home and are hafted into handles without formal shaping. The open flexible haft of the *tutuma* handle accommodates a wide range

of flakes in terms of length, breadth, and thickness. Informal hidescrapers appear in households in which leatherworkers engage *tutuma* open hafts, located predominantly in the highlands far from where chalcedonies live.

ZUCANO HAFTS AND STONE

In contrast, the *zucano* closed hafts clasp formal stone hidescrapers, who journey from the quarry as boy hidescraper blanks (*naʔay*) and transform into knapped or circumcised youth (*pansa*) in the leatherworker's home. Today *zucano*-using leatherworkers predominantly live in the northern Gamo districts of Boreda, Ochollo, and Zada in the lowlands and highlands on the edge of escarpments to the lowlands (table 5).[7] The *zucano* handle has a carved central opening in a thick piece of wood, forming an open oval-shaped handle. Leatherworkers chose the lowland tree species *Olea africana*, *Cordia africana*, *Schrebrea alata*, *Combretaeceae*, and *Cupressus lusitanica* for making the hafts. Men often inherit their *zucano* haft from their father or another lineage elder. The mastic holding the hidescraper into the haft is from a resin from the lowland acacia (*brevispica* or *niolitica*) tree. Among the Zada and Boreda districts leatherworkers, the handle accommodates one hidescraper on either side of the haft, though the Ochollo district leatherworkers only haft one hidescraper on one side of the haft.

Zucano-using leatherworkers predominantly live within a half day's walk to stone quarries and usually form the stone into hidescraper blanks or boys (*naʔay*) at the quarry (table 5).[8] At the quarry, *zucano*-using leatherworkers often work at a specific location within the quarry, usually under the shade of a tree where they store their iron billets. Men frequently work squatting in a circle, reducing the raw material to blanks and placing the blanks in separate piles, which each would carry home. Each knapper had his own small shaping/sharpening iron billet. Sometimes they also kept very large pieces of raw material near their knapping space under the trees. They would take turns trying to break up large boulders by wedging rocks underneath the boulder for balance and stability and then throwing a larger rock on it from a standing position to break it up. Generally, though, men used direct hard hammer percussion with a large iron hoe tip to transform the stone and remove the cortex. The cortex of the stone is the afterbirth. A knapper leaves the cortex near a tree, as in human reproduction. *Zucano* users bring home eight to twelve boy hidescraper blanks that they further shape in their household into young men, formal hidescrapers, before hafting near the hearth. Formal hidescrapers, *pansi*, predominantly reside in lowland households with *zucano* hafts.

The current geographical distribution of handle types among Gamo leatherworkers provides the initial impression that hafting type is associated with easy access to different species of tree for wood and mastic, as well as distance to resources with readily

available stone. Thus, local availability of cherts seems to foster formal tool types, and scarce access to stone results in informal tools. *Tutuma* open hafts accommodate a wide range of hidescraper sizes, and leatherworkers bring cores and raw material back from the quarry to produce informal hidescrapers for hafting. In contrast, the *zucano* closed haft offers a restricted space for a hidescraper, and leatherworkers shape specific-sized hidescraper blanks at the quarry and bring them home for final shaping and insertion into the haft. Leatherworkers work with both handle styles to scrape cattlehides today, but in the past leatherworkers processed a wider range of hides including goat, sheep, and wild animal. Changes in leatherworking technology through time indicate that access to raw materials did not foster hidescraper morphologies.

REBIRTHING THE HIDES

The leatherworker needs his expert knowledge in concert with a well-made stone tool and haft to rebirth domesticated and, in the past, wild animal hides into a variety of household products that are soft, free of rips, and strong to ensure the satisfaction of their customers. Many leatherworkers consider that the hide, like the stone, has a life cycle. When it is freshly removed, the hide is revived or born, *yella*, washed like a human and a stone infant, and secluded in the house, stored as its period of *dume*. Then a male stone hidescraper is inserted into a female wooden haft, creating a fertile tool, and together they perform cutting or circumcision, *katsara*, on male and female cattle, goat, sheep, and, in the past, leopard, lion, and other wild animal hides (figure 32).

After circumcision, hides are plied with butter, like a human initiate. Finally, hides are often presented (sold) in the market to be reincorporated into life, just like a human during his puberty rites is presented at the marketplace in *sofe* rituals for reincorporation into society. When a hide is very, very old (more than thirty years), it is deceased, *hayikes*, and will be placed in the sacred forest. Leatherworkers do not lead hunts, and most do not own domesticated animals. Domesticated and wild animal hides are given to leatherworkers to process by *mala*-farmers as prescribed in the tenets of Boreda *Etta Woga*.

DOMESTICATED ANIMAL HIDES AND RITUAL

Another taboo would be when the *mala*-farmer kills an animal, and if he didn't give meat to the *tsoma*-craftsmen, it would be *gome* (taboo). The *mala*-farmer gives the head, the neck, the intestines, and the legs; if the *mala* didn't give these parts, it would be taboo. (Gamo Tema, July 5, 2007)

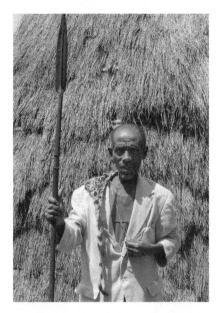

FIGURE 32 A man wearing a ceremonial leopard hide over his shoulder (left) and a man wearing a sheepskin cape (right).

Mala-farmers provide parts of the cattle, sheep, and goats for craft-specialists to consume after they have ritually slaughtered an animal, and they also have leather-workers butcher the animal and remove the hide for processing. *Mala*-farmers offer cattle, sheep, and goat blood to *Tsalahay*, ancestors, and God at annual festivals to ensure their own well-being and enhance their own prestige and status. Today, leatherworkers acquire most hides directly from their neighbors during the ritual seasons of *Masiqqalla* in September, which is the Ethiopian celebration commemorating the discovery of the True Cross, and during Easter in March/April when they offer domesticated animals in ritual feasts. Stone to process the hides also is usually available at this time, as the Gamo highlands experience two major rainy seasons a year, from March to May and July to September.[9] Hides today are primarily prepared for sleeping mats as gifts to couples who marry after these celebrations.

The hide commonly is given to the leatherworker by an elder male *mala*-farmer, whom most Gamo consider to be the only individuals sanctioned to slay animals. *Etta Woga* tenets outline that *mala*-farmers must provide leatherworkers with food in exchange for their labor processing hides. Most leatherworkers state that no one forces them to work for *mala*-farmers; however, they have very little land even today from which to derive other income, so providing quality hides is important. In particular, they are concerned with producing quality products for their *goda*—patron. Each

community lineage of leatherworkers has a clan name that is the same as their *goda*. Typically, they state that, in the past, their *goda*'s ancestors provided their ancestors with land, and in return they acquired the *goda*'s clan name. The leatherworker and his wife provide labor for the *goda* in exchange for food and his community assistance.

> We women cleaned the patron's house and processed enset. All leatherworkers worked for this family because they gave us milk and food and at *Masiqqalla* [New Year] gave us cow parts, and hides my husband scraped. (wife of a leatherworker, June 28, 2008)

A leatherworker works for his *goda* his entire life, and the leatherworker's sons work for the *goda*'s sons, creating a stable alliance through time. The *goda* helps the leatherworkers and their families if there are conflicts with other *mala*-farmers in the community and serves as the elder who arranges marriages for them. In addition, leatherworkers acquire hides from other community members, who pay them with food, products, or cash.

WILD ANIMAL HIDES AND HUNTING RITUALS

In the past, leatherworkers also revitalized wild animal hides into ritual capes worn at funerals, weddings, and other community rituals by elite *mala*-farmers. Hunting without a permit has been illegal since 1980 in Ethiopia, and license fees range from $4,600 for a leopard and up to $6,000 for Menelik's bushbuck, while lions are illegal to hunt at any time. These fees are beyond what the average Gamo household can afford to pay, and thus today they rarely engage in hunting unless an animal is attacking their community or crops, which is legal. Before the enforcement of hunting laws, wild animal hides would have been available for processing after the Gamo formal hunting rituals in January and February. The annual hunts served to transform a *mala* man from an ordinary farmer into a prestigious hunter, referred to as *Shanka, Marisha*, or *Gada Awa*.

The hunting season began with rebirth, *yella*, of the lead hunter, who called people together at his house and made barley beer to announce the instigation of his transition. Then the men went to the edge of the sacred forest and poured the blood of a sheep on the ground for *Tsalahay* and poured barley beer on all of the hunters' spears saying, "You will find the wild animal. The animal will not find you, and you will safely and luckily return from this hunt to your house!" Many men stated that two generations ago, they used stone spears, but no one knows who or how they made them. After consecrating the spears, the hunters proceeded to the forest, where they were in seclusion or *dume* for two weeks. They hunted greater kudu warthogs, vervet monkeys, colobus monkeys, gazelles, dik-diks, hartebeests, leopards, African

buffalo, lions, elephants, and hyenas. The person who struck the first spear in the animal claimed ownership of the hide and the sexual organs, breast or penis, and tied them on his right hand. They skinned the animal with an iron knife and broke the bone for marrow with an iron ax. The men consumed the meat of the animals in the forest. On return to the community, the lead hunter was ushered in with praise songs. A great feast at his home marked his private incorporation, *bullacha*, and then the next day at the market a second public ceremony indicated his public transition, *sofe*.

When the hunting party returned to their community, they brought with them teeth, horns, and hides as trophies. Commonly, wild animal teeth and fat provided relief from illness. Men crafted musical instruments from the horns of the hartebeest, while they adorned their roofs with the horns from Grant's and Thompson's gazelles as displays of their adventures. Men also carried the newly reborn, *yella*, hides of lions and leopards, carefully stowed. Leatherworkers gently transformed these hides into capes only worn by prestigious elder men at funerals, as clothing of authority.

> In the past, I scraped lion and leopard hides with either chalcedony or obsidian. I did not remove the lining of the hide [like we do for cattlehides]. I washed it [the hide] in the river, dried it, and scraped it on the frame in my house, and I used very fresh milk instead of water while scraping to make it very soft. Then I rubbed butter into the hide. (Hanicha Harengo, June 13, 2012).

Leatherworkers said they did not produce a special stone hidescraper for processing wild animal hides, though this was a task only for very experienced leatherworkers who had the ability not to rip the delicate hides.

A BIOGRAPHY OF HIDE PRODUCTS AND CHANGES IN MALE STONE TOOLS AND FEMALE HANDLES

The types of hides and the hafts engaged to scrape them have changed in the Gamo region as a consequence of widening economic markets and forced changes inflicted by national governments that forbid practicing their Indigenous religion and producing the accompanying religious regalia. According to life histories of the Gamo leatherworkers living in the central Gamo districts of Dorze, Dita, Zada, Doko/Chencha, and Ezo, they or their fathers and grandfathers

> used stone a very long time ago. My father used *zucano* and *tutuma* with chalcedony. He used *tutuma* for goat and sheep hide and *zucano* for cattlehides. He did this because

you have to hang the cattlehide to scrape and it is easier to hold the *zucano* in your hand to scrape like this. Sheep or goat hide you held in your hand, and it lay on the ground. (Gomasa Gobay, January 24, 1997)

Thus, they employed the *zucano* for cattle and *tutuma* for wild animal, sheep, and goat hides. Changes in availability of hides eventually altered this pattern.

TSALAHAY (SPIRITS) AND *TOSSA* (GOD)

The Derg forcefully took my beads, drum, and guitar. They forced me to work in the garden and told me not to waste my time with other things. (spirit medium [Maro], July 8, 2008)

Prior to the Derg (1974–91) and the conversion of many Gamo to Christianity and Islam, leatherworkers produced a wide variety of ritual clothing and musical instruments that would animate the human senses and evoke the spirits. Goat and sheep were slaughtered throughout the year at situational rituals and provided hides for clothing. Lineage elders offered goats and sheep to their ancestors or to the spirits to assuage familial transgressions and to ask for their blessing at the birth of a child. Cattle were primarily killed during two prescribed annual festivals. With forced conscription into Christianity, the Boreda *Tompe* festival was conflated with the Orthodox celebration in September, *Masiqqalla*, and the finding of the True Cross. The Boreda *Bazo Kawo Asterio* festival was conflated with the Orthodox *Marium* holiday in honor of Mary.

In June during the summer solstice after the harvest of the small-rains crops, the Boreda Gamo held an annual *Tompe* (light or bonfire festival). Leatherworkers would blow into a large cow horn announcing to all early in the morning the beginning of the festival. Elder men in each community would light a fire and slaughter an animal, allowing its blood to seep into the earth as an offering for the *Tsalahay*, or spirits, and *moylittille*, or ancestors, at *Bayira Deriya* (ancestral sacred grounds). The festival was a rite of intensification to unite communities through remembrance of their ancestors' first settlement in the highlands and the defense of their sovereignty against neighboring forces. The festival lasted several weeks and included a ceremony for uncircumcised youth to socialize, the circumcision rites for pubescent young men and women, the welcoming of new brides into a community by the elders, and ceremonies marking the ascensions of men to various ritual-political positions. The ritual capes made of sheep and wild animal hides adorned the elite farmers, whose wives provided pots full of beer, coffee, and food for feasting. The *mala* feasted, drank, inhaled incense, and chatted, sitting on leather mats made of cattlehides and given to new wives at their marriage. Meanwhile the craft-specialists were relegated to the edge of ancestral

FIGURE 33 Leather items in use today: a large ritual drum (left) and a chair (right).

grounds and festivities. The leatherworkers butchered the ritually slaughtered animals and were given their entrails, tails, legs, and head to cook and consume in their homes. The men of the potter-smith caste group were musicians, who played bugles made out of hartebeests' horns and leather drums and string instruments created from cattle-hides (figure 33). They sat on the edge of the ceremonies providing the music in return for a small amount of food at the end of the ritual.

Craft-specialists played music and slaughtered animals at a second prescribed Boreda festival, the *Bazo Kawo* (lowland king) or *Asterio* festival, held during the winter solstice in December. A male elder offered sheep to *Tsalahay*, though the ceremony mostly consisted of elder *mala* women. A woman with the high ritual-political status of *Gimuwaa* led the annual rite, in which women painted boulders with butter as offerings to the king's snake spirits for the fertility of women and the health of their children.[10] The women wore sheepskin skirts and cotton scarfs. Human ceremonies that transformed humans therefore also served to birth transformation of hides. Hides began as the coat of animals, which were slain to thank spirits for resolving human transgressions and honoring human status accession. Ultimately, the new life of the hide was a form that embraced the human body in daily life as furniture or sleeping materials, and in ritual as musical instruments and ritual capes (figure 33).

EXPANDING MARKET ECONOMIES

The types of leather products prepared declined sharply after the Derg revolution and impacted the types of hides and handles used in leatherworking. The Red Terror of the

Derg militant Marxist-Leninist regime (1974–91) forced the abandonment of Indigenous ritual practices, and the government began to mass export sheep and goat hides.

> Before we made ritual cape, skirt, and men's cover. The Derg made us stop making these items and brought items from the factory. He said if you wear hide, it smells bad. (Gigo Balgo, July 7, 2008)

Consequently, today, the Gamo leatherworkers scrape few to no sheep and goat hides, and in the central Gamo districts the use of *zucano* hafts and stone was abandoned.[11] Most leatherworkers stopped scraping sheep and goat hides because the products they made from them were outlawed and goat and sheep hides were exported out of Ethiopia. Detlev Karsten[12] noted that by the late 1960s, the leather products of the Gamo consisted of sleeping hide, leather clothing for women, furniture, and leather grain bags; however, a decade later oral histories indicate a shift away from most of these goods. In addition, there was a dramatic increase in the export of hides from Ethiopia as the value rose to US $56 million in 1974.[13] The demand for goat/sheep hides in Addis Ababa raised rural market prices. The town of Arba Minch was established in the lowland Gamo region, and a road connecting Arba Minch to Addis Ababa was completed, making transportation between the capital and the Gamo region more readily available.[14] Currently, the Ethiopian leather industry is one of the country's leading exports, resulting in US $112 million in leather and another US $122 million in raw hides.[15] A majority of the exported hides are sheepskins, which yield a high price for glove manufacture. Thus, today sheep and goat hides are very valuable as export products and too expensive and rarely available for local processing.

The Derg (1974–91) also redistributed land, offering the leatherworkers opportunities for farm work. Some leatherworkers benefited greatly from the Derg regime and acquired high government positions in their communities, while others even in the same hamlet and related to one another complained bitterly especially about military conscription.

> We had very bad time. But it was good time for *mala*. The Derg took the wealthy people's property and shared with the poor people. Because these wealthy people collected property in an illegal way. And he forced the *mala* to drink milk with us and made things better. Well, the *mala* considered me and my family as lower class and they undermined us for a century. Thanks for the Derg. He gave me a chance to tell them what they did to us. And the Derg elected me as militia, and he closed the prison house on the *mala* who had been doing bad things to us. The government gave to us, and we requested land and due to [this] he [the government] gave us their [*mala*-farmer] land. (craft specialist, June 28, 2008)

The Derg government dramatically changed the lives of many leatherworkers, who acquired land, engaged in new occupations, and were conscripted in war. Consequently, leatherworking became a part-time endeavor focused on processing only cattlehides.

Leatherworkers living in the highland regions far from stone quarries and acacia tree mastic began to rethink the effort required to acquire these resources. Many adopted Christianity under the Derg, abandoning the tenets of Woga and the use of *zucano* hafts and stone.

> In the past, we [central Gamo leatherworkers] used *zucano* to scrape cattlehide and *tutuma* to scrape the easier sheep and goat hides. Then in Derg time, people stopped bringing sheep and goat hides for us to scrape. There was not enough work, and the Derg gave us land. It is easy to use *tutuma*, and it is difficult to get the glue for the *zucano*, so why should we bother with *zucano* today? (craft-specialist 1996)

> *Zucano* and chalcedony are very strong, but the scarcity of mastic and stone forces us to use *tutuma*. (Abata Arka, May 24, 1997)

Thus, many Gamo living in the central highlands abandoned the use of *zucano* hafts, even though they had used them to scrape cattlehides, and began only to use *tutuma* hafts to scrape both cattle and caprine hides.

In only a few highland communities today, leatherworkers prefer and continue to use *zucano* hafts, and they enlist marriage networks that connect them through affines to the lowland tree sources for hafting in Boreda and Ochollo.[16] Affine kin relations and life histories concerning the preceding generations of leatherworkers before the 1970s suggests that more than half of the highland *zucano* users married women from lowland districts (figure 34). In the past, men actively chose to marry women who were members of their caste group, but who were members of lineages that lived in the lowlands, which allowed them to easily acquire the lowland resources they desired. Unfortunately, there were no individuals using both types of hafts living today from whom I could observe the types of stone brought back from the quarry. At the same time as there was an abandonment of *zucano* hafts, there were fewer leatherworkers bringing stone to the market for highland leatherworkers. Many leatherworkers stated that it was no longer worth their time to walk to quarries or to pay someone at the market for stone, when glass was readily and inexpensively available. Glass from Ambo (a brand of mineral water) bottles became the raw materials of choice among the southern and central Gamo districts. Only leatherworkers living within one to three hours of a chalcedony source continue to engage stone in transforming the life of a hide.

Thus, exploring the relationship between people, hides, hafts, and stone by engaging life histories reveals the changes incurred by the interaction of all these beings.

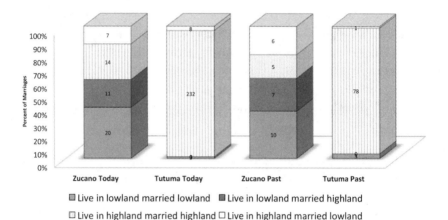

FIGURE 34 Graph illustrating that highland *zucano* users today and in the past often marry women from the lowlands, providing a social network for access to stone and hafting resources located in the lowlands. Graph created by Kathryn Weedman Arthur.

The Gamo believe that one of the most salient aspects to all matter is that it changes, and this is embodied in their Indigenous ontology *Etta Woga*. Over the last twenty years, I have also witnessed change. More and more people are either abandoning leatherworking or adopting glass in place of stone. I also observed changes in quarry activities. Although relationships between farmer and craft-specialist are better today than in the past, increased population growth means the expansion of agricultural land in the lowlands with more permanent occupation. As indicated by the story at the beginning of this chapter, compared to twenty years ago, leatherworkers are now more likely to experience threats and harm from nearby farmers, some of whom still retain the idea that leatherworkers are polluted and do not want them near their water sources for their fields.

> Before the Derg regime, the leatherworkers and potter-smiths were very neglected and oppressed by the farmers. After the Derg came, things started to get better for leather-workers and potter-smiths. In the time of Derg, he called people and taught people well. When the Derg came, he forced the *mala*-farmer men to make iron and *mala*-women to make pottery. And he strongly told them that this is no small work. He awarded all of them. However, when he stepped down from power, *mala*-farmers started neglecting them [craft-specialists] and requested their land back. (farmer 2008)

Consequently, I noted in the last few years on expeditions to the quarries that even leatherworkers, who in the recent past reduced raw material to flake blanks at

the quarries, will now quickly collect raw material and bring it back to the safety of their home to work. The raw materials the leatherworkers enlist to practice their trade continue to change, and transformation in all matter is an expected part of life under the tenets of their Indigenous religion *Etta Woga*. Stone, handles, and domesticated animal hides begin their life cycle, *Deetha*, in ritual acts that both embrace the strength and witness the weakness of human beings. Thus, the life-cycles of stone, hide, and human are inextricably linked together through ritual transformation.

A KNAPPER'S KNOWLEDGE
PROCURING RESOURCES

WHAT WE LEARN FROM INDIGENOUS LITHIC PRACTITIONERS

Among the Boreda, their Indigenous theory of *Etta Woga* and the life cycle informs decisions associated with the lives of stone for hidescrapers, wood and mastic for handles, and hides for leather products. Status of all beings is essential to understanding access, method, and selection of knapped beings. Twenty years ago, I noted in my dissertation a grave insult, at least according to some *mala*-farmers: "give birth to stone." It is only twenty years later after learning their *Etta Woga* ontology that I realize how this phrase highlights a disdain by some Gamo Christians for the concept that all matter is alive, but also contempt for male leatherworkers who birth the stone. In the last one hundred years, the Gamo experienced tremendous changes through feudalism, colonialism, and a Marxist-Leninist regime, and yet they are resilient in maintaining the importance of their Indigenous knowledge. Gamo leatherworkers persevered by altering their leatherworking and knapping technologies to accommodate national outlawing of the production of hide clothing and the hunting of wild animals, importing of industrial items that replace hide products, and issuing of land to leatherworkers. The Boreda Gamo illustrate that despite the presence of great changes in a knapper's trade and technology, his ontology *Etta Woga* persists in structuring the relationship between humans and stone. For many Boreda lithic practitioners, particularly elders, stone is a living male being who allowed only experienced elder men with the appropriate rituals and knowledge to identify and properly birth them from the earth. Leatherworkers select quarry locations based on the presence of water and sacred trees and their perceived sacredness, although other sources are readily available. They prefer cherts located less than a half day's walk that they deem fully formed in the earth, exhibited by their shine or luster and particular color—only these cherts are truly newborns or *uka*. Leatherworkers often experience danger when quarrying chert, as a result of the agency of the earth flooding gorges and landslides, as well as from farmers who perceive leatherworkers as impure and polluting the water

sources and nearby agricultural land. The Boreda lithic practitioners are not alone in their ontological perspective of stone constituting a living being.

RIVERBED QUARRIES AS SACRED SPACE: LOCATION, DISTANCE, AND ACCESS

Studies of stone-tool-using societies widely refer to quarries as sacred landscapes that embody ancestral beings, who restrict access to their birth.[17] Lithic practitioners frequently make special-purpose trips walking two to fifteen kilometers largely to riverbed quarries to obtain lithic material (table 6[18]).[19] Quarrying was often considered dangerous because of the sacredness of the quarries, and access was restricted to particular members of society. In Mexico, mining was a dangerous pursuit, because it altered the sacred gestation time of the fetus, and craft-specialists strictly controlled quarrying.[20] Among the Dene of North America, elders recalled that their ancestors made offerings at quarries in payment to earth spirits.[21]

Richard Gould and Sherry Saggers effectively argued that the perception of the sacredness of a quarry was more important than either the distance to resources or the quality of the stone.[22] Their study indicated that Indigenous Australians of the Western Desert collected lithic materials from sources that were up to forty-five kilometers away and of poorer raw material than that available locally because of the sacredness of the location. They "made trips whenever possible to locations of sacred significance, even when these trips represented detours from the primary routes of movement to water and food sources."[23] In a separate article Gould stated that "a man may have a sense of kinship with chert quarries, and he will value the stone material from them as part of his own being."[24] Brian Hayden too noted that when he brought Kimberley white flint (from a long distance) to the Cundeelee of Australia, they were hesitant to knap it because they considered the stone to be ancestral beings.[25] Furthermore, among many Indigenous Australians of the Northern Territory, cherts embodied ancestors as their petrified remains from the Dreamtime.[26] They often painted male ceremonial stone tools with female earth/ochre; because of "the ultimate life-giving powers of Ancestral Beings, it was necessary for Aborigines to unite male and female together, as with sexual intercourse," according to P. Taçon.[27] The most prestigious quarry in the Northern Territory was located in the region of Marra-larr-mirri (head/top/hair-stone flake-with/belonging to), also known as Gurrka-larr-mirri (meaning penis-stone flake-with), which was the essence of stone flakes used to make spears and associated with spiritual beings that imbue the place with major spiritual significance.[28] Here Rhys Jones and Neville White noted the difficulties they had accessing the quarries because senior Yolngu believed they as foreigners would disturb the spiritual essence, thus exposing everyone to grave illness.[29] Among Australians, access to quarries often

TABLE 6 Cross-cultural summary of lithic practitioners procurement practices.

COUNTRY CULTURE	TOOL TYPE	RAW MATERIAL TYPE AND QUALITIES	QUARRY LOCATION	LABOR	DISTANCE AND FREQUENCY	EXTRACTION METHOD
Ethiopia Gamo	hidescraper	nodular chert obsidian sheen	river gorges	elders and nuclear family village clan lineages	half day's walk after rain 5–15 km	digging trade
Ethiopia Konso	hidescraper	nodular chert quartzite shine	streams	co-lineage women affines	half day's walk after rain 5–10 km	digging surface trade
Ethiopia Oromo and Gurage	hidescraper	obsidian free of impurities	mountainside	men	half day's walk every 2–3 months	digging
Ethiopia Hadiya	hidescraper	obsidian	mountainside	men and women can also carry the material	9 km, 2-hour walk after plowing	surface occasionally digging
South Africa Namaqua	hidescraper	sandstone rough	riverbed	individual women	5–10 km 1 per year	digging surface
Namibia OvaTjimba	expedient knives choppers	quartzite	riverbed	women	not reported	not reported
West Papua Indonesia Dani Wano Langda	ax/adze ritual bundles	argillite, greenschist, andesite boulders and large glisten translucent, fossils, unusual colors	riverbed	individuals and groups of men controlled by big men and specialists, women quarry highly ritualized	Wano 15 km Dani 4 km Langda 5–17 km & traded over a 200 km sq. area	fire rock face and boulders movement with water
Papua New Guinea Hagen Wiru Tungei Wahgi	ax/adze	nodules chert banded hornsfel dark color shine	streams	communal clans 100–200 people men and adolescent boys ritual	every 2–3 years 2 km area to 300 sq. km area	digging pits fire

(continued)

TABLE 6 (*continued*)

COUNTRY CULTURE	TOOL TYPE	RAW MATERIAL TYPE AND QUALITIES	QUARRY LOCATION	LABOR	DISTANCE AND FREQUENCY	EXTRACTION METHOD
Papua New Guinea Wola Duna Toirora Auyana Awa	informal tools, no retouch with various functions reamers, boring, digging, cutting, engraving	chert nodules	quarries, streambeds, and in gardens	men and women	½ mile bartering special trips Wola free for everyone	weathered out of stream beds
Turkey Cakmak	blade for threshing sledges	nodular chert green/greenish white	hillside	local miners, men groups	October to May none harvest season	digging pits specialized workshops
Tasmania	scraper ax cutting shaving	quartz, chalcedonies, black quartz dark in color	hillside	men, women, children	not reported	smashing one boulder on another; digging pits
Mexico Lacandon Maya	tourist arrowheads	nodular chert not too grainy color important quartzite unacceptable	streambed	dry season men	half day's walk	digging pits
North America Dene	hidescraper	dark gray chert tabular	mountain river quarry site offerings	clans controlled, permission required women	limited season due to snow cover embedded strategy	not reported

Group	Tools	Material	Quality/Color	Source	Collectors	Distance	Disposal
Australia (South) north of Lake Eyre Ngadadjara Nakako Pitjandjara	gravers, drills, wood scraper, knives	chert		not reported	young men bring to old men	not reported	not reported
Australia (Northern Territory) Yolngu	spears	chert	not overcooked-white pinkish	hills	men clans moiety	more than 15 km	buried under trees and dug pits
Australia (Northern Territory) Alyawara	knives	quartzite	purity of color smooth	hill	3 older men	4-hour drive	buried using fire and surface
Australia (Western Desert) Kitja and Dajru	spears	quartz		hill	young men	not reported	not reported
Australia (Western Desert) Ngadadjara Nakako Pitjandjara	knives, spear-thrower tip circumcision knives adze/chisel	chert	white, yellowish	pulanj-pulanj mine exposed outcrop	young men	not reported	buried material
Australia (Western Desert) Ngatatjara Myatunyatjara Ngatjara	maintenance tools for wood-scraping adze knives	quartzite and chert		Waberton ranges, hills, quarries, and nonlocalized sources	small parties, special trips adult men, also women	no more than 32 km away, but distance and quality not main concerns	smashing block on block surface and buried material

was limited to men related to the quarry through either their mother's descent group among the Mudburra and Jingili speakers[30] or their father's descent group among the Ngatatjara and Pintupi in Western Australia.[31]

In communities throughout the island of New Guinea, older experienced men were responsible for naming the stone axes based on their special and symbolic qualities that included the name of an ancestor and place of origin or quarries, which often were places of spiritual significance.[32] For the Langda and Tungei, quarrying was a dangerous pursuit controlled through offerings and consultation with ancestors.[33] As O. W. Hampton wrote, "An expert understands the rocks just like a healer knows a patient. He has a keen sensitivity and knowledge of the rock that allows him to select only the proper stones for quarrying."[34] In the past, the Langda placed the skulls of their ancestors in men's houses, where a ritual specialist requested permission to quarry. Among the Tungei in Papua New Guinea, while proper stones were often identified by specific men and quarries were owned by members of specific clans, heads of these clans organized quarrying labor expeditions consisting of several hundred adolescents and adult men every three to five years—an exclusively male activity.[35] The stones were described as alive and actively seeking a pleasant place by the river when the world was made.[36] Quarrying required ritual purity, and food offerings were provided for the female river spirit and the male stone spirit. Two unmarried young men were sequestered in a house outside the community to serve the spirit sisters who produced the stone. They remained in the house during the quarrying, and the men quarrying also secluded themselves from women. At the end of the expedition, women of their community attacked the quarrying men, forcing them to leave the spirit sisters, emerge from the quarry camp, and rejoin them in the hamlet. Although cross-culturally men do not incur a negative status because of their association with quarrying stone, as the Gamo do, clearly men are disrupting earthly activities, and the pursuit is extremely dangerous, requiring ritual intervention.

In Australia and on the island of New Guinea, the birthplace of stone is often associated with male ancestors; yet, there is some evidence that people had not always thought of stone as an exclusively male activity. Ethnographic descriptions from Australia, South Africa, Tasmania, Namibia, North America, and New Guinea clearly indicate that women participated in quarrying and making and using stone tools.[37] Yet, we lack any detailed descriptions of women's lithic activities and how the practice of women engaged in birthing stone might have been perceived. However, in one ethnographic study I conducted among the Konso of southern Ethiopia, lithic production was a female activity because it involved gestating/cooking (heat treating and mastic preparation) and kneeling and grinding (scraping the hide), which many Konso perceive to be female activities in human reproduction.[38] This study is only one, and further in-depth study of women as Indigenous lithic practitioners is encouraged

to better understand variation in the ontologies surrounding women's procurement and access to stone. Cross-culturally many cultures perceived and continue to perceive that stone is a living being who commands power, particularly associated with quarrying or birthing stone, and often constraining which humans are allowed access to stone beings.

BIRTHING BURIED STONE: A SACRED PERFORMANCE

There are hints among stone-using societies that lithic practitioners preferred buried stone, that procurement was perceived as a process of birthing, and that the act of quarrying was sacred. In Mexico, for instance, historic texts indicate that some people believed the earth was gestating the fetus stone.[39] The Wola of New Guinea, meanwhile, stated that chert "grows" along watercourses.[40]

Ethnographic and ethnoarchaeological studies in Australia provide the richest comparison to the Gamo concept of stone beings conceived through reproduction.[41] Among some Indigenous Australians, stone was a living entity that moved from the earth to near human fires, which is how the "old people used to get a stone knife out of the stone," according to Robert Paton.[42] Rhys Jones and Neville White stated that in Australia usually the men "pointed at trees and said that there were usually good rocks under their roots."[43] Lewis Binford and James O'Connell were perplexed when they encountered the Alyawara procurement method and selection, indicating that their

> answers were not very satisfactory. There was an allusion to purity of color and smooth texture . . . the cores that littered the surface of the quarry had all been weathered; they were thus considered unsuitable for making tools . . . [and the men] would not select what the researchers thought were adequate materials from the surface. . . . Both men agreed that the buried boulder was the good stuff.[44]

The importance of Alyawara ontology unfortunately eluded Binford and O'Connell, though its significance in structuring the location and method of procurement that was often considered birth cannot be understated. Many Australians understood the world in terms of the Dreamtime, in which ancient beings traveled along the landscape performing acts of creation at "being wells," where their essence continued to reside.[45] The forces for growing stone resided at particular places, for instance at Ngilipitji, where stones actively manifested traits indicating when they were ready to be birthed. According to Jones and White,

> Inferior rocks with too many fine cracks or facets on their surface were referred to as yuuthu mirri- "too many small pieces"; will shatter into tiny flakes. The term literally

means "young within," i.e. a breeding stone as in the case of a pregnant woman with young inside. The stones were left and were believed in time to breed new ones. They said that stones at this place grew in the ground like living things.[46]

White stone, *miliji*, like the white hair of respected Yolngu male elders, had power to sap the energy and life out of an individual if struck by a spear made of this stone. Rhys Jones notes, "The inorganic was seen as being the quintessence of the organic containing its true being."[47]

Many other cultures considered stone a living being born from the earth, usually along watercourses, most notably at sacred locations exuding a special quality or essence. Cross-culturally, I noted that most lithic practitioners preferred buried raw material to surface material and obtained stone through digging or use of fire from the depths of the earth (table 6). In Tasmania, Turkey, Mexico, and Ethiopia lithic practitioners predominately extract raw material from within the earth by digging pits in the earth, using fire, or eroding the soil through channeling water.[48] On the island of New Guinea, ax makers always referred to the best sources as located in streams, and fire was used to break open large boulders or crack the surface of a rock face.[49] Furthermore, in at least one origin story of ax stone collected by John Burton,[50] the stones are described as alive and actively seeking a pleasant place by the river when the world was made. Importantly, cross-culturally lithic practitioners hold the perception that quarries were sacred places, where knappable lithics formed buried in the earth, requiring humans with the proper knowledge to birth them.

STONE AS VITAL GENDERED MATTER: SELECTING RAW MATERIAL

Lithic practitioners' ontology structures how they selected their quarries, their methods of stone extraction, as well as their choice of raw materials from sacred quarries. Cross-cultural accounts of lithic practitioners suggest that they perceived lithic stones to be vital living beings with an ascribed gender and that as living entities stones had the power to both heal and harm.

Cross-cultural comparison of Indigenous lithic practitioners suggests that they were very selective in the resources they procured and almost universally acknowledged that the correct stones, whether obsidian, quartz, chert, hornsfel, and so on, were of a particular color and radiated life in the form of a shimmer, bright light, or shine, which were evidence of their life force or power (table 6).[51] Lithic practitioners across the continents indicate that specific colors of chert were significant in identifying correct toolmaking stone.[52] In Mexico, different colors and translucencies of obsidian indicated the various powers of the stone.[53] For example, light color was linked to the celestial world and translucent green with water, life, and rebirth.

Among Plains Native Americans translucent, meteorite, or shiny stones were sacred with ancient knowledge of the earth and the sky uniting the world.[54] In Australia, white chalcedony stone exuded its power through its brightness or *marr*.[55] Among the Dani and Langda of Indonesia, stone tools with different uses and sacred stones are chosen for their special qualities such as unusual shapes, colors, presence of fossils, and particularly stones that are translucent, glisten, or sparkle, being imbued with "mystic spirit power."[56] In neighboring Papua New Guinea, the Hagens, Wiru, and Tungei selected dark chert and hornsfel with a sheen for the production of axes.[57] Significantly, cross-culturally lithic practitioners only recognize specific colors of raw material, and often a stone's sheen is an essential quality for identifying viable stone for toolmaking.

Studies of stone-tool-using societies widely refer to stone as male beings, though there is some indication that they were female as well. Perhaps one of the most *pointed* manifestations of the maleness of stone was a "phallic shaped obsidian stemmed tool" found during construction in New Britain Papua New Guinea, which multiple men eagerly claimed as representing their ancestors.[58] In New Guinea, Australia, and Indonesia, maleness of stone was reinforced by the selection of specific quarry locations as they related to sacred landscapes and the embodiment of male ancestral beings described above.[59] Perhaps the most direct evidence that counters a universal ascription to the male nature of stone derives from the written sources from the Tarascans and Nahuas of Mexico, who believed that obsidian knives and projectiles personified goddesses.[60] Furthermore, some Australians referred to cores as "the mother one," which when "cut" or "bled" produced *nyndurrba* (unretouched or waste flakes).[61] North American Absarokee believed that stones enticed people for inclusion into their medicine bundles for their healing potency, and the stones identified themselves as male or female to the collector.[62]

Once stone is born as vital matter, it continues to have the power to inflict illness and even death as people attempt to use them. Among the Dani of West Papua Indonesia, stone axes embody male ancestral spirits, who are revitalized in rituals performed by their descendants so that the ancestral spirits may aid in intervening with malevolent unseen spirits.[63] In Mexico Tarascan historic text announced that arrows have a divine power with the potential to bring death and chaos, and as such the royals controlled arrows as instruments of war, justice, and to honor the gods.[64] Some Australians gave stone spears and knives individual names based on their origin and color, and certain blades were used either to cure illnesses or to cause death. The power was so great in some stone that it was essential that men distribute it throughout the landscape through trade.[65] Among Lake Eyre Australians, the oldest descendant kept a pair of stones—a conical male stone and a cylindro-conical female stone—that he would anoint to intercede on behalf of the people.[66] Some Plains Native Americans offered

that stones packed in buffalo-hide bundles empowered the owner with knowledge of healing and success in war through dream visions of the future. Among the Cheyenne, obsidian in the medicine bundle takes the form of arrows. As Peter Powell records,

> It [stone] came from the Holy Mountain, and it is very powerful. It is the most danger-ous thing in the bundle. It represents the most powerful of all things; and it has power to bring knowledge to a human being.[67]

The Sacred Arrows gave Cheyenne men power over other men as well as animals. The Sacred Arrows in concert with the female Sacred Buffalo Hat joined together to bring about the renewal of the world.[68] Stone is dynamic and has the power to harm or heal, such as arrows, and the use of powerful objects requires prescriptive handling.[69] Lee Irwin stated that sacred stone is a concept shared by all Plains cultures, who asso-ciate it with the elders of the earth and ancient knowledge.[70] Stones (including arrows) often were beings that were part of sacred bundles, which self-reproduced and even produced the first humans.[71] Lee Irwin and William Wildschut write:

> Many Plains people believed that when male and female stones were wrapped in a bun-dle they could reproduce. When the bundle was later opened, it would contain smaller stones that were regarded as offspring of the male and female pair.[72]

> The Rockman [was] the living spirit of all the rocks. He wandered all over the earth in search of a mate, but could not find one.... [He] went to the tobacco plant, entered the husk and found a mate whom he married and took with him . . . they mated and from their progeny descended the people who now live on this earth.[73]

Stone as male and female commanded power and enlisted danger particularly asso-ciated with quarrying or birthing stone, constraining which humans were allowed access, but also after it was birthed, bringing potential harm or well-being to humans.

Importantly, many societies that actively produced and used stone tools adhere to different ontological perceptions of the world than that of Western archaeologists. For many Indigenous lithic practitioners, stone is perceived as a living gendered being birthed from the sacred landscape, often streambeds. The sacredness of stone and its status as a living being informs the great lengths and particularity with which lithic practitioners select quarry sites, even dismissing closer resources that archaeologists would consider better-quality raw material. Stone is an important being that demands the attention of knappers, who make special-purpose trips up to forty-five kilometers to acquire particular stone resources, though more commonly only about fifteen kilo-meters or a half day's walk. Quarries are identifiable by their association with sacred

trees and water and as part of a man's patrimony, if not actually representative of his ancestors. Stone is most often quarried from within the earth, buried in river-beds that emanate life in the interaction between earth and water—an assemblage that reproduces stone. Cryptocrystalline stone is evidence that the earth is alive with the productive power. The reality that cryptocrystalline stones and other stones uti-lized to make stone tools are living entities that have their own agency and to varying degrees acquiesce in their birth from the earth implies that humans are encroaching on other living beings and must do so in an appropriate manner. Most knappable stone is selected based on its egg-like shape, color, and sheen. Viable stones do not lie listless on the surface but form deep in the earth and must be birthed properly by individuals with the proper status and knowledge. For many lithic practitioners, quarries and knapping stone are living members of their ecosystems. Stone is a viable entity, part of the organs of the earth, and as such elders restrict access to stone. In the next chapter I will explore how the ontological perception that stone is living warrants that youth receive long-term knapping apprenticeships to ensure that the stone is respected and reaches its full potential as a living being.

4

KATSARA AND *BULLACHA*

Learning to Circumcise and Engage Stone Tools

AS I WAS WALKING in the cool early morning, fog blurred my sight of individual faces, and people moved like shadows across the landscape.[1] It was only when I entered the warmth of the house that the mist lifted, unveiling two generations of leatherworkers—a father and his sons. The eldest son anxiously asked if I would watch him scrape a hide, rather than watch his younger brother. His younger brother had married within the year, and he had little experience with producing his own hidescrapers. I had seen the younger brother scraping on my earlier visits, and I knew he was actively practicing. I persisted and explained that I wanted to observe someone who was learning.

The young leatherworker began to scrape and after several minutes stopped to sharpen the edge of his stone hidescraper with an iron billet. He worked on the hidescraper edge for several minutes, striking it many times, shifting his position frequently, and he clearly looked frustrated. When he finished, I asked him, as I asked all leatherworkers, to let me measure the length of his hidescraper. He handed me the double-sided haft, and I turned the haft to the side where I had tied a pink ribbon. The ribbon allowed me easily to keep track of which side of the haft and which tool was being used at all times. I measured the length of the protruding hidescraper being used and examined the edge of the tool. I noticed near the haft a sharp projection on the edge of the tool. I pointed to the small projection and asked the young man about it, and I received a reaction I had seen by other Gamo, who clearly wanted to express that something was not important. He flipped his hand upward and away and made a slight puffing sound.

Soon afterward, he tore the hide with the hidescraper. His older brother covered his eyes and made a ticking sound of disapproval. The younger leatherworker covered

FIGURE 35 Drawing illustrating a broken hidescraper made and used by a novice leather-worker. Drawing by Kathryn Weedman Arthur and inked by Kendal Jackson.

the hole with his hand and sighed. He then went back to working on the hide with the hidescraper, although he was not applying much pressure to the hide and thus not removing much fat. He paused and flipped the handle over, starting to scrape with the hidescraper on the opposite side of the handle. When he stopped to sharpen the new hidescraper, he broke it (figure 35). He sat quietly for a few minutes not looking at any of us. The hafted hidescrapers were both brownish-gray, a color that more-experienced lithic practitioners from this community preferred to avoid. He looked at his brother, who rubbed his hand over his face, and there were a few quick words about "borrowing" his older brother's hidescraper blanks. Then, the older brother using his own material began to shape the blanks he had into two new hidescrapers and hafted them for his younger brother.

A few days later, I witnessed their father, an elderly man, also produce a spur on a hidescraper. He was quick to replace the hidescraper, and when I pointed it out, he just

laughed and said he was an old man. His sight was failing him, and he had produced a small spur next to the haft, as he had misjudged the distance between the striking point and the haft. When I questioned his oldest son, he told me that the projection was a result of not being able to work the material well.

As evident from this recollection, a novice Gamo lithic practitioner is saturated by and melds into his community; he does not work alone. He produces and uses stone tools in his father's house, where he receives advice and technology from his father and other experts who are members of his lineage. The transition from novice to master lithic practitioner is one that proceeds over fifteen to thirty years of a man's life, beginning with his transformation into a circumcised youth. A novice becomes competent, proficient, expert, and master lithic practitioner through transformation in his perceived status in his life among other lithic practitioners, rather than grounded in evaluations of the quality of the stone tool product.

Among the Gamo, the status and prestige of a man is *not* evaluated based on the final form of what he produces, but rather based on how he interacts and transforms himself and others, human and nonhuman. In the Boreda Gamo ontology, *Etta Woga*, an individual who exhibits change in his being demonstrates an essential quality—a respect for the proper process and order of being—and bestowed on him are titles of seniority. As discussed earlier in the book, leatherworkers are perceived in the wider society as transgressing the natural order in their interactions with the nonhuman world and in human rituals and thus positioned in a low status. Lithic practitioners do not exchange or sell their hidescrapers at the market to nonleatherworkers; and the hides processed with the stone hidescrapers, although used in virtually every household, are not aesthetically evaluated. A majority of the Gamo do not tout the talent and expertise of knapping leatherworkers nor reward them with social and economic prosperity for their trade. As a low-status man, a knapper's skill is recognized only within his caste group.

A knapper's identity and status in society overlaps, intersects, and parallels with others; in essence he engages in multiple intersubjectivities. As a craftsperson, he can simultaneously recognize his endogamous, marginalized, and oppressed status in Gamo society and his renowned skill and prestige within his occupational lineage—*hilancha katchea* or professional hidescrapers. Segregated within their own physical and sociopolitical space, communities of Gamo leatherworkers express and recognize a subaltern position in which they perceive themselves as properly transforming and interacting with nonhumans. A man incurs skill, prestige, and status as a lithic practitioner within the community of leatherworkers in association with his ability to change in his life course, or *Deetha*. Status and dignity are attained through a leatherworker's growing practice, knowledge, and interaction with the nonhuman world of stone, wood, and hides, and as he himself matures and changes from a child to

an elder. The Gamo world of being ensures that the knapper as a human being and the hidescraper as a stone being mature from an infant to adult within the secluded community of *hilancha katchea*. Leatherworkers are segregated spatially and socially from other Gamo citizens, thus creating an intimate lifelong setting for learning and practicing hidescraper technology within a specific community.

CASTE, LINEAGES, LANGUAGE, AND THE TRANSFER OF KNOWLEDGE

The trade of leatherworking and the skills of knapping are restricted to a select group of men in Gamo society who tend to live, learn, and practice their trade in the same community their entire life. Men who engage in leatherworking make up a small portion of the Gamo population (fewer than 1 percent), which means that leatherworkers tend to live in only one out of every five Gamo communities. Furthermore, they are more likely to live in the smaller communities with no markets or shops—that is, hamlets—that are located off the main transportation roads. More than 90 percent of the leatherworkers I interviewed remained in their natal hamlet. Moving to another community within the Gamo region is difficult for leatherworkers, who must acquire permission from landowners in a new community and resident leatherworkers. Generally, several generations of male leatherworkers live in the same community. Leatherworker households are isolated on the edge of hamlet, often on steep slopes with poor access to fresh water. Their isolation is associated with poverty manifested in the absence of good agricultural land, small household gardens, and few household structures (see chapter 1 for details). As a consequence of their residential isolation, poverty, and shared trade, leatherworkers and their kin depend on one another, sharing their few resources in the hope of building better futures for their children.

Although leatherworkers are socially and spatially segregated from others in their community, they speak an argot to ensure the protection of their technological knowledge and social life. One of the first aspects of learning leatherworking is the vocabulary they ascribe to the technology, which are the same words used for the human life cycle and anatomy. The vocabulary serves to delineate the materials, their correct properties, and their locations. Language evokes cultural memory of the correct technological process. Argots are for the initiated only and are incomprehensive to outsiders.[2] They use the standard language and either alter the meaning of the words or transform them through repetition of the root phonetic and morphological structures. The Gamo leatherworkers stated that they developed their argot in the past to protect their social and technological secrets from their neighbors. The Gamo leatherworkers refer to their argot, or secret ritual language, as *Odetsa*, which means

to speak in a manner in which others are expected to listen intently. The implication is that when a member of *hilancha katchea* speaks in the argot, others are expected to listen closely because the information is particularly important. Leatherworking is a dying craft, particularly with stone tools, and although leatherworkers are no longer concerned about protecting their technological knowledge, they do wish to maintain some secrecy in the details of their daily social life.

Apprenticeship is restricted to male youths of the *hilancha katchea* caste group. Male leatherworkers and knappers mature in households with their elders who are actively engaged in the trade (figure 36). All of the Gamo men that I interviewed learned the skills of leatherworking from their father or from a male lineage member such as an older brother, father's brother, or father's father. Today, the demands for leather products are waning with the import of industrial goods and the export of hides essential to the national economy. Fewer men engage in knapping and leatherworking, and usually this now falls on second or third sons. Leatherworkers send their oldest sons and grandsons to school in the hope that they will graduate high school and then be able to work in a town or city outside of the Gamo region, escape their stigmas, and earn money they can send back to help support those at home. Some sons also begin to work exclusively as butchers and travel for farmers to sell the hides to industrial tanneries in larger towns to the north. Other sons will try to piece together small plots of land to eke out a life as a farmer. Generally with few opportunities for other types of work, young men are still undertaking the process of learning knapping and leatherworking.

Leatherworking and knapping knowledge and practices are shared in daily activities between boys and men of *hilancha katchea* lineages. Knappers are spatially and

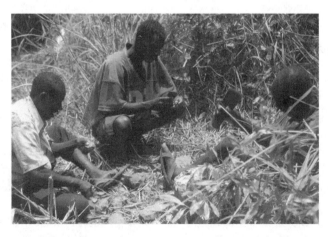

FIGURE 36 A father and his sons knapping at a quarry, illustrating that Gamo men work stone together.

socially circumscribed, which in turn serves to create small communities of practicing expert knappers, who transfer knowledge and practice through scaffolding (learning with the assistance of experienced individuals).[3] Learning occurs in the course of their daily life, through spending time with their male kin observing, questioning, imitating, and practicing, and through small moments of direct instruction. Most Gamo believe that learning is accomplished "bit by bit" and that it is acquired through an individual's life course. Though an individual's occupational trade is ascribed by birth within particular patrilineages, the Gamo realize that technological knowledge is not innately transferred. Historically and to a lesser extent today, they consummated perceived biological heritage with cultural heritage through the social practice of rites of passage that reenacted the biological life cycle, *Deetha*. A boy's transformation into an adult began sometime between the ages of fourteen and twenty with social acknowledgment through a nine-month puberty rite-of-passage ritual, *katsara*. A boy was perceived at this time in his life to have the right concentration and dexterity to pursue leatherworking and knapping. A boy's father and other male members of his lineage began to formally impart to him the details of technological knowledge concerning the production and use of stone hidescrapers during his *katsara* rituals. The boy's actions during the *katsara* rituals, in which as a male he reproduced a stone being, served to reaffirm his status, in the wider Gamo society, as a human being who was a member of the low-status caste group *degella*; today they refer to themselves as *hilancha katchea*. A Gamo boy learns knapping and leatherworking in parallel to his embodiment of his life cycle, *Deetha*. As he becomes a circumcised youth, a husband, a father, a respected adult, and an elder, with these life transformations he also becomes a novice, competent, proficient, expert, and master knapper.

STAGES OF KNAPPING AND LEATHERWORKING APPRENTICESHIP

When leatherworkers told me about how they learned their trade, they almost always recounted the process synchronizing their own life cycle with that of the hide and the stone. Among the Gamo, a man's status is determined by his power to change his life, to change his skills, and to shed the skin of his former self through *Deetha*. Individuals spend their lifetime acquiring leatherworking and knapping skills that correspond to their biological/social transformations in life marked by rituals for their birth (*yella*), puberty (*katsara*), marriage (*bullacha*), and elderhood (*sofe*) (table 7).

For many Gamo, a human and stone develop from a fetus, *gachino*, which is born (*yella*) into the world as an infant (*uka*), and then becomes a boy (*na7ay*).[4] An individual only begins knapping once he has completed his puberty rites of passage and

TABLE 7 Table comparing the life stages of Boreda
lithic practitioners and stone hidescrapers.

LIFE STAGES	LITHIC PRACTITIONER	STONE HIDESCRAPER
Uka	Infancy	Raw material, cores
Na7ay	Boyhood	Blank
Pansa	Circumcised youth	Unused hidescraper
Wodala	Married	Hafted hidescraper
Wozanota	Respected adult	Partially used hidescraper
Cima	Elder	Discard hidescraper

experienced circumcision, his own cutting between the ages of fourteen and twenty years old. As the human has cutting ability, so too does the stone, who can slash into the skin of the human, exerting its own power. The ability of stone to be a catalyst of events is one of the reasons leatherworkers insist that elders work closely with novices for at least ten years before they knap on their own. A circumcised (*katsara*) youth or hidescraper is a *pansa*. The young man begins working, learning leatherworking, and maturing in his father's household, and the young stone also matures in household *dume* (household seclusion). Both become full fertile beings. The human is a novice knapper. Once a human individual is married and a hidescraper enters into a female haft, they are *wodala*, adult men. They are both now mature, active in their work, and engage others in their own household in *bullacha* (household feasting). If the human marries soon after circumcision, he may remain a novice knapper even though his social standing has changed. Typically, though, he marries five to ten years after circumcision, when he is twenty to twenty-five years of age, becoming an adult, *wodala*, and a competent knapper. Eventually, a knapper in his mid-thirties and early forties, with many children, and with nearly ten years of leatherworking for his own clients, is considered a proficient knapper. He continues to be known by the title *wodala*, though he begins to perform knapping and all other leatherworking tasks alone in his own home without the advice of elders. After much life activity, a man becomes a respected adult with married children, and a hidescraper is matured through use on the hide, and so both are *wozanota*. As a *wozanota*, a leatherworker is an expert and is responsible for teaching novice and competent leatherworkers; he excels at all tasks and is a patient teacher. Elder leatherworkers and elder hidescrapers are *cima*. The human *cima* is a master knapper, who works closely with novice and competent

grandsons and nephews, but rarely scrapes his own hides. The *cima* hidescraper no longer scrapes hides and may rest near the hearth or in the household as an elder. Eventually, the human and the hidescraper die, *hayikes*, and are buried in the ground, and their essence transforms into new beings in *sofe* (reincorporation).

UKA, INFANCY, AND NA7AY, BOYHOOD

Born into *hilancha katchea*, a male individual proceeds from his birth (*yella*) status as a fetus (*gachino*) to an infant (*uka*). Three years after birth, an individual is recognized as a gendered human being and is no longer referred to by the gender-neutral term (*uka*), but distinguished for instance as a boy (*na7ay*). A boy of the *hilancha katchea* caste group spends much of his time in or near the household. Once an individual's gender is recognized, he is a human being with self-awareness, which allows one to become enculturated. During this time, a boy begins to observe his father and all the stages of leatherworking and the use of space (table 8). Most men explained that young boys were too impatient and did not have the stamina for long-term observation or engaging in leatherworking and knapping activities.

Leatherworkers stated that when they were boys (*na7ay*), they observed and followed their fathers around, watching them intently, observing which materials they used and where they obtained them and used them. Interestingly, men often recollected that they went to quarries with their fathers at this age, as Bedala Aba did, "When I was *na7ay* I followed my father to the quarry and watched him, and I would select my own stones." However, fathers who were actively teaching their sons, such as Chamo Chache, substantiated my observation that boys rarely went to the quarry at this age: "My ten-year-old son I rarely take to the quarry; if I did, he would complain and get hungry." I believe the inconsistency can be explained in the fact that quarrying would have been a significant event in a boy's life. It was an opportunity to venture away from home and community. It was perceived as a specifically important male task performed by older siblings, fathers, uncles, and grandfathers, in which youth pined to participate. Likely, men remember their urgency in wanting to participate in quarrying and projected it further into their youthful experience than likely allowed by their elders.

Two activities that men said their sons completed at this stage were helping to peg out the hide for drying and discarding household debitage and stone tools. Men said they remember accompanying and observing their fathers defleshing, washing, drying, and scraping hides. I occasionally observed boys in the marketplaces watching their fathers deflesh animals and sometimes watching their fathers lay out the hides to dry, though they often quickly lost interest when they spotted other children and ran off to play. Infrequently and with a bit of encouragement, a boy may help peg out

TABLE 8 A table summarizing leatherworkers' life stages and leatherworking skills, practices, and knowledge during their life.

STATUS	LEATHERWORKER	TASK	SKILLS
	Na7a 3–14 years old Father's household Observations	Materials Raw hide procurement Drying hide Lithic discard	Observing materials involved Observing procurement Cut holes along edge Insert pegs and lay on ground Observe discarding location
NOVICE 3–5 YEARS	*Pansa* 14–20 years old Circumcised Not married Father's household Assisted learning	Life cycle Hafting stone mastic production Quarrying location and time Softening hide Hanging hide Scraping hide	Process and vocabulary Proper angle of tool in haft Knowledge of location and right time of year for quarrying Trampling With correct tension Proper scraping position Proper angle of hidescraper Correct amount of pressure on hide
COMPETENT 3–8 YEARS	*Wodala* 16–25 years old Married Father's household Assisted learning	Sharpening hidescraper Quarrying Quarrying	Using the proper amount of force with iron precursor Assessing where and when the working edge of tool needs altering Identifying good striking platforms Strength and fine-tuned motor skills Angle to strike the raw material Size of tool for hafting Creating a useful working edge on tool Select quality raw material
PROFICIENT 7–14 YEARS	*Wodala* 35–45 years old Married Independent	Performs all knapping and leatherwork- ing tasks alone in household without advice of elders	Performs well at all tasks

(continued)

TABLE 8 (*continued*)

TATUS	LEATHERWORKER	TASK	SKILLS
XPERT 5–20 YEARS	*Wozanota* 45–50 years old Respected adult Married children	Performs all knapping and leatherworking tasks alone Teaches novices and competent	Excels at all tasks
ASTER 0+ YEARS	*Cima* 60+ years old Elder	Continues to knap Rarely scrapes hides Instructs novices	Excels at knapping

the hide for drying. I observed boys as young as three or four sitting near and observing their fathers, touching and playing with the stone tools and even attempting to scrape by hitting the hide with the handle. Adults often looked upon this activity with amusement. On rare occasions, I observed older boys of eight to ten mulling around watching their fathers and sometimes scraping a hide for a few minutes. I did not ever observe them engaged in stone tool production, and it was predominately wives rather than a son or the leatherworker that I observed discarding the lithic materials.

PANSA: CIRCUMCISED YOUTH AND NOVICE KNAPPERS

Novice knappers (figure 37) need intense and consistent assistance from experienced knappers. The men I interviewed indicated that they did not begin to concentrate on producing and using stone hidescrapers until after they had proceeded through rites of passage, *katsara*, between ages fourteen and twenty. Osha Hanicha told me that he began to scrape hides when he accepted that it was his future work and was in his interest.

> I learned after marriage, before this—until this time, you can watch, but you do not help—you are just not ready. In *katsara*, I learned and practiced to scrape for the first time; I stood by my father, and we worked side by side. (Osha Hanicha 2011)

> My fifteen-year-old son can break stones with advice; he can do everything but with help, and he has no customers of his own. (Chamo Chache 2012)

During puberty rites of passage, *katsara*, young men secluded themselves for up to nine months within their future marital household and begin to learn their trade. In

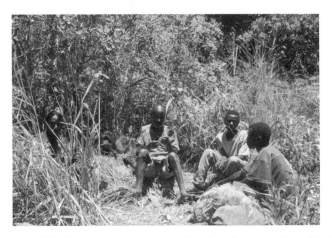

FIGURE 37 A father knapping next to his *pansa* (youth son) and recently *wodala* (married) son.

their household, friends visit, mothers and aunts bring them rich food, and fathers, uncles, and grandfathers impart to them technological knowledge. Most importantly, elder men explain that the biography of a stone tool corresponds to the youth's own life course, reinforcing their Indigenous ontology, which offers that all matter is animated through existence and the reproductive process. A stone tool is born at the quarry, is circumcised through knapping, rests and matures while stored in a house, and eventually dies to become reincorporated into the earth. A hide also has a life cycle; it is born when an animal dies, circumcised through scraping, rests and matures while stored in the house, and is discarded in death in the forest. The life-cycle vocabulary associated with the technology of knapping and leatherworking evokes the Gamo perception of reality and is an essential aspect in the transfer of knowledge to youth.

After the completion of his puberty rites of passage, a young man becomes a novice knapper. He may marry immediately or, as is more likely, marry five to ten years later. In the meantime, he is encouraged to knap and work hides with his father. He is expected to concentrate more intently on all aspects of leatherworking, but especially to focus directly on the hide—defleshing, drying, hanging, scraping, and softening. The novice does not participate full-time in the practice, nor does he have his own customers. For example, I observed a sixteen-year-old *pansa* scrape hides for his elderly father, while his father made the hidescrapers he used. Young men at this stage in their life begin to learn through practice and directed teaching how to deflesh a hide without making it too thick or thin. The novice learns how to make the mastic and to haft the tool at the proper angle. With growing experience, novices acquire the skill to hang a hide at the right tension and then to scrape a hide at the right angle. Novices

less frequently engage in stone tool production. Young men travel to the quarries and observe; however, they quickly seem to get bored and leave to do other things. While young men, *pansi*, practice, they are not yet held responsible for ensuring a hide or stone tool through its entire life cycle.

WODALA: MARRIED ADULT AND NOVICE TO COMPETENT KNAPPER

All of the men I observed knapping emphasized that a man did not begin to knap in earnest until he was married and needed to support a family with his trade through attaining his own customers. When a man marries, there is a feast at his father's house, a *bullacha*, during which they celebrate his and his wife's new status in society as married citizens. A man lives in his own house either in the same compound or in the same community as his father. He is expected to process hides for his own customers to support his household.

> After marriage, I had my own customers. A father has too much work, so he gives his son some of his customers when he is married. If you work quickly and well, then you draw in new customers to support your family. (Bedala Aba 2012)

Lineage elders anticipate that a married individual is competent or will be quickly competent in defleshing, hanging, scraping, and softening a hide, but the most difficult aspect of leatherworking is knapping, which requires more time and practice.

Generally men remain novice knappers until their mid-twenties, which means they need extensive assistance from elders. Whether a man is a novice or competent knapper at marriage depends on the amount of time spent knapping and scraping between his puberty (*katsara*) and marriage (*bullacha*) rites. The need to support a family and marriage intensifies work time. Novices all worked hides in their father's household and in the presence of more-experienced knappers, who often made their tools for them. They were expected to engage in all aspects of knapping and processing hides, including stone procurement, production, sharpening, and discard, under close supervision of more-experienced leatherworkers. Experts focus novice leatherworkers first on selecting quality raw materials, hafting the hidescraper, and sharpening the hidescraper. Learning to select the right type of stone, how to strike the stone to remove a tool with a good working edge, and how to sharpen the hidescraper take extensive practice. Novices work hides and knap in their father's home, and elders directly correct their mistakes, provide advice, and may often take over knapping a tool.

By their mid-twenties, most individuals became competent knappers, who needed little direction and support from elders. However, they continued to knap and

scrape hides in their father's household, where assistance was readily available. Competent knappers select their own raw materials and can produce their own hidescrapers with virtually little oversight. While most of the competent knappers I knew had worked stone for four to seven years, one individual had knapped for only two years and another had knapped for eight years. Both knapped and scraped hides in the presence of more-experienced knappers. The individual who had knapped for only two years was conscripted into the Derg military (1974–91) and learned leatherworking at a later age in life. Another knapper, who stated he had been working for eight years, did not process hides frequently, and he received some assistance from his older brother. Competent knappers continue to process hides in their father's house and are able to produce stone tools with little assistance from more-experienced knappers.

WODALA: MARRIED ADULT AND PROFICIENT KNAPPER

Most knappers require a total of seven to eight years of experience and usually have their own children before they are considered proficient knappers who can work independently. Some individuals became proficient at knapping more quickly than some of their cohorts. In most communities, leatherworkers in their early to midthirties begin to work hides in their own household and to engage all the stages of the hide and stone life course without the help of others and can correct mistakes. At this stage, leatherworkers often have many of their own children and may help their elders to assist younger siblings with the trade. A proficient knapper continues to knap and process hides for another eight to ten years in his household before becoming an expert.

WOZANOTA: RESPECTED WISE ADULT AND EXPERT KNAPPER

As a man matures, he becomes *wozanota*, a man who is confident, speaks well, and is respected in his community as a teacher in his trade. Typically, a *wozanota* has knapped for a total of fifteen to twenty years and is revered among other knappers as an expert. Experts are very active in instructing their circumcised sons and married sons in knapping and in the leatherworking trade. They are sought out in the leatherworking community for their knowledge of the trade and for advice on other community issues. In 1996, I met a father named Hanicha Harengo and his son Osha Hanicha. At the time, Osha was a proficient knapper, and when I returned ten years later, he had become an expert knapper. Osha had taught his oldest son to work hides and often worked hides for his elderly father, Hanicha. Today, Hanicha is in his seventies and continues to produce hidescrapers but rarely scrapes hides.

CIMA: ELDER AND MASTER KNAPPER

Eventually, an individual like Hanicha Harengo becomes a *cima*, who is a community elder and among leatherworkers known as a master knapper. In Gamo society, elderhood is marked by the birth of a grandchild and often the death of a man's father. In their elder years, leatherworkers may still produce leather goods and are usually very skilled at producing hidescrapers. However, their grandsons and sons often scrape the hide for them, even as they produce the hidescrapers for its processing. Hanicha and other elder knappers are very proud of their knapping skill well into elderhood.

The Gamo leatherworkers I observed had obtained two to forty or more years of experience and offered that knapping skills were obtained through years of guidance and practice commensurate with an individual's stage in their life course. Generally, boys begin to knap after they commence through puberty rites of passage and become competent knappers in three to four years. After marriage, a man may work another four to six years before he is proficient to knap alone and may begin to assist novice knappers in the presence of experts. A man practices another ten years before others consider him an expert knapper, at which time he usually has sons and begins to spend much of his time teaching them. Elder men who have knapped and worked hides for thirty to forty years are master knappers. A man may practice knapping for forty or fifty years, until the youngest of his children are married and are experts in the trade. Leatherworkers commented to me that the most difficult part of the trade is knapping—in particular, producing, using, and sharpening the stone tools—or the *katsara* and *bullacha* phases of a stone's life cycle.

APPRENTICE AND MASTER KNAPPERS

BIRTHING AND CIRCUMCISING STONE

In the Boreda theory of being, *Etta Woga*, stone is alive, and humans have the responsibility to care for it and ensure that it reaches its full potential in life. Apprenticing knappers are closely monitored and assisted by those with more experience. Humans birth the stone at quarries and shape them into fertile full beings through circumcision or cutting. Leatherworkers first knap a stone at its birthplace. Each quarry has a place name that is considered the *kantsa* (female womb), and the raw materials are considered *gacinnotta* or fetuses that when procured are *uka*, infants. Knappers first cut the stone from the parent material, like the umbilical cord severed between human infant and mother. They then further knap stone when they shape it at the household or sometimes at the quarry to form a mature tool, similar to circumcision that shapes a boy into a man. The word *tekata*, which the leatherworkers use to refer to knapping,

means to protect; and the debitage that is removed is referred to as the infertile waste, *chacha*. The implication is that the act of knapping, like circumcision and removing the umbilical cord, is an act of protection. Cutting or knapping protects the future of the fetus/stone and allows it to develop by removing the impure infertile aspects. Knappers have a responsibility to assist stone beings to reach their full status. Experts then carefully observe and encourage inexperienced knappers to select fully formed stone, to sit in appropriate positions for knapping, to learn to knap without overexerting force and by wasting little raw material, and to produce stone beings that resemble others in their community.

SELECTING QUALITY RAW MATERIAL FOR KNAPPING

One of the first activities that experts encourage novice knappers to pursue is selection of raw material. Leatherworkers usually travel together with novices to select cryptocrystalline stones, cherts, and obsidian. A well-developed stone, a fetus or *gachino*, will shine when someone breathes on it, exposing its essences and life. Gamo knappers generally prefer obsidian, a long-distance trade item, which is very shiny, glossy, or glasslike. More commonly, Gamo knappers use chert from a variety of local sources in the eastern and western Gamo lowlands. In addition to the sheen, each Gamo community prefers particular colors of chert that they believe are more often well-developed.

Color and stone sheen are two variables that expert and master knappers use to teach novices how to select good raw material (figure 38). In three of the communities I studied, there were two to three generations of leatherworkers. Generally, novices utilized less obsidian than others, especially master knappers. Elders noted that obsidian is very sharp and novices would likely cut themselves when using obsidian, and so they may avoid using obsidian for this reason.

In addition, as a trade good, obsidian requires a financial investment that many novices do not have. Cherts, though, are free to acquire in the nearby lowlands. All knappers seemed equally likely to select a community's preferred color of chert. However, experts and particularly master knappers always selected higher-quality glassy cherts compared to those with less experience (figure 38).

PRODUCTION POSTURES, DEBITAGE
DISPERSEMENT, AND BULBS OF PERCUSSION

Lithic practitioners rarely go alone to quarries but travel with other lineage members, who have various experience in knapping. Once a piece of raw material is selected, a Gamo knapper positions himself within a small circle of other knappers and sits in a squatting position. More-experienced knappers position themselves so that appren-

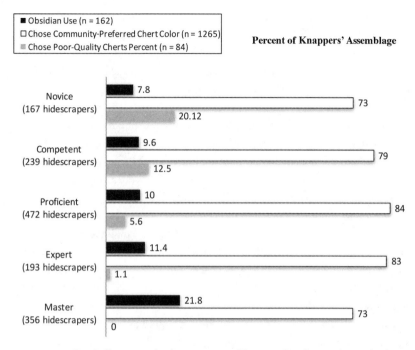

FIGURE 38 Graph illustrating that less-experienced knappers less frequently use obsidian and are more likely to select poor-quality cherts. Data based on 1,427 chalcedony and obsidian (unused and discard) ethnographic hidescrapers in my 1996 to 1998 collection, excluding hidescrapers made in Eeyahoo, a newly settled and one-generation community. Graph created by Kathryn Weedman Arthur.

tices can clearly see them knapping. Experts can easily reach over to a novice and point out good striking platforms and provide them with advice. On one quarry trek, I accompanied a master knapper; his oldest son, who was a proficient knapper; and his younger son, who was a novice knapper. The elder sat in a squatting position, selected a large piece of raw material, and broke the raw material to produce three clean pre-cores with virtually no debitage. His recently married son, who, as novice, had been knapping for three years, sat in front of him so that the novice could clearly see his striking arm technique. The novice sat on his haunches with his knees up instead of squatting. He selected one of three pieces/cores his father had just procured. He began striking at it with the small iron billet, and after many strikes he was unable to remove any flakes. His older brother, an experienced and proficient knapper, sat to his left in a cross-legged position and pointed out the edge he should strike. The proficient knapper made hidescraper blanks easily, though he produced much debitage that scattered widely. After several attempts, the novice finally removed one flake. Then he tried to

remove more and was unsuccessful. He began to take another piece of raw material, but his brother told him to continue with the flake he produced. Using direct percussion, the novice attempted to shape the flake, but he had difficulty trying to decide how to hold the flake in his hand. Eventually, the novice handed the flake to his older brother, who simply told him to work it more, and then he handed it to his father, who told him the same. After many percussive strikes with no effect, the novice handed it to his father again, and his father began to shape it and told him to try to make another.

Skilled knapping requires practice and the correct sitting position, as well as the ability to hold the material at the right angle and to recognize good striking ridges on the raw material. Sitting in a squatting position allows the knapper to position his head and eyesight directly over his working hands. Squatting is a position adopted by many Gamo when they engage in birth and in craft-specialist and agricultural activities. Sitting in a squatting position is a sign of activity. Physiologically, it serves to open the hips and strengthen the lower back muscles, which are directly connected to encouraging the strength of the upper back, arms, and wrists used in flintknapping. Usually knappers sit squatting, but they may also sit on a log and lean forward in a squatting position. Only occasionally did I observe a leatherworker stand, and this usually occurred at a quarry just to quickly test a piece of raw material. Individuals who are novice and competent knappers may sit in other positions such as squatting with one knee down or sitting on the ground with both knees up. The sitting positions exhibited by less-experienced knappers tend to hinder a direct visual perspective of the materials they are working with, and elders discourage these.

The Gamo knappers only use direct percussion and generally sit in a squatting position, allowing the debitage to fall in a small area from one to five feet in circumference on the ground, hide, or grain bag. The knapper places the raw material or core in front or slightly off to the left side. While seated in the squatting position, knees close to the chest, a right-handed knapper (figure 39) positions his left arm between his knees and takes a hold of the raw material or core in the palm of his left hand held directly in front of his body. If the piece of raw material/core is too large to hold in the left hand, then it remains on the ground and is positioned at an appropriate angle for striking. It should be clear that although the raw material/core is resting on the ground, it is positioned so that neither the striking platform nor the distal end of the flake being removed is supported by the ground—so this is *not* bipolar knapping. He then strikes the raw material/core with an iron billet held in his right hand, with the right arm wrapped around his right knee. Once the raw material is reduced to a small core or to a flake to be made into a hidescraper, the knapper uses a smaller iron billet. The knapper shapes the flake by holding it with the dorsal side to the palm of the hand and the thumb over the ventral side. An expert knapper raises the billet hand only slightly and rarely above the knee.

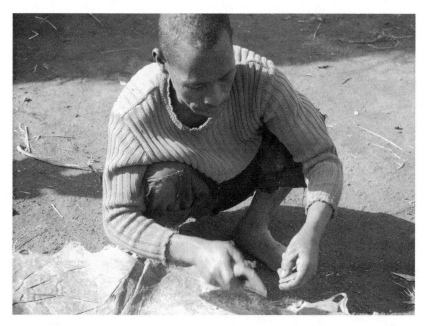

FIGURE 39 A typical body position of a right-handed knapper.

In my observations, to compensate for their lack of knowledge concerning good striking platforms, apprentices often take longer arm strokes to strike harder at the material. This may result in two observable traits in the lithic assemblage. First, it causes debitage to fall in a larger area encompassing three to five feet around the knapper rather than a small area of one by one foot directly below more-experienced knappers. Second, individuals with proficient skills and working alone for the first time without the aid of experts were most likely to produce hidescrapers with a bulb of percussion (figure 40). Less-experienced knappers tend to strike material harder, resulting in more debitage that disperses more widely and strong bulbs of percussion on their hidescrapers.

Yet, overall there are few hidescrapers that exhibit a bulb of percussion because more-experienced knappers (experts and masters) sit nearby and work closely with less-experienced knappers (novices and competent), continuously offering their advice and even sometimes taking over the knapping process themselves. Thus, sometimes the assemblages of novice and competent knappers express traits more similar to expert and masters.

Inexperienced knappers tend to shift their positions more often, sit in positions that are less effective for good sight lines to the stone, and in their inexperience, disperse debitage farther. Furthermore, proficient knappers who are working alone

Percent of Bulbs of Percussion in Knappers' Assemblage

■ Novice (167 hidescrapers)

▩ Competent (239 hidescrapers)

☐ Proficient (724 hidescrapers)

⊟ Expert (193 hidescrapers)

☐ Master (356 hidescrapers)

FIGURE 40 Graph illustrating that less-experienced knappers produce more bulbs of percussion on their hidescrapers than expert and master knappers. Data based on hidescrapers from my 1996 to 1998 ethnographic collection (unused and discard, chalcedony and obsidian, and all four communities; total 1,679). Only sixty-one hidescrapers had bulbs of percussion. Graph created by Kathryn Weedman Arthur.

for the first time tend to strike harder at the raw material, producing more frequently a distinct bulb on their tools.

PRODUCTION SEQUENCES AND SKILL PERFORMANCE

All Gamo lithic practitioners utilized the direct percussion method of producing hidescrapers. Typically, the raw material available in the Gamo region is small enough for a knapper to hold in his hand, in which case the raw material becomes the core through flake removal. Large pieces of raw material that are too large to hold in the hand are often broken into three or four smaller pieces or pre-cores. Master knappers are able to produce cores from which they directly strike off appropriate-sized flakes for hidescraper blanks. Novices and less-experienced knappers tend to exert more force, producing larger flakes that often are broken into smaller flakes to make several hidescrapers. Less-experienced knappers, therefore, produce more debitage. I attempted to quantify this by observing six knappers of varying experience each producing five hidescrapers from a chert core with a sixth knapper using an obsidian core (table 9).

I observed a novice who would soon be a competent knapper and had been knapping for eight years. His brother who has knapped for almost thirty years observed and assisted him. The novice does not often work hides and knap and had difficulty

TABLE 9 Table demonstrating that with growing experience in knapping, a knapper uses less raw material. Data is based on my observations of the production of five hidescrapers by novice- to master-level knappers in 2012.

YEARS EXPERIENCE/ AGE	CORE Original Size Reduction Size Using sphere volume cm^3	HIDESCRAPER Mean (SD) Length, Breadth, Thickness cm	PLATFORM PRESENT ON 5 TOOLS	CORTEX PRESENT ON 5 TOOLS	EDGE ANGLE Mean, SD (Range)
Novice/Competent 8/30	15.59 × 12.33 × 6.83 474.2	5.4 (0.6) 4.1 (0.8) 1.6 (0.4)	2	5	53.2, 30.45 (27–112)
Proficient 10/25	27.86 × 21.85 × 13.15 373.4	4.6 (0.4) 2.9 (0.6) 1.9 (0.2)	2	5	43.4, 12.48 (27–62)
Expert 19/40	19.49 × 15.76 × 13.76 400.8 (obsidian)	4.0 (0.9) 2.9 (0.5) 1.4 (0.5)	4	2	47.33, 14.15 (19–61)
Expert/Master 25–30/45	22.56 × 15.74 × 9.37 115.6	4.2 (0.5) 3.0 (0.3) 1.1 (0.3)	2	3	46.50, 8.41 (32–52)
Master 37/60+	15.89 × 8.99 × 3.08 100.7	3.4 (0.9) 3.0 (0.4) 0.8 (0.3)	3	2	53.25, 7.25 (42–61)
Master 55/70	20.09 × 12.7 × 10.88 209.9	3.3 (0.2) 2.8 (0.3) 0.8 (0.2)	4	1	49.4, 8.19 (36–60)

selecting platforms on the core; however, with direct instruction from his brother, he was able to produce five flakes, a very large piece of angular waste, and more than twenty small pieces of angular waste and shatter (table 9). He changed striking platforms frequently (three to five times) to remove the first three flakes, and then he continued to use the striking platform he used to remove the third flake for flakes four and five. Each time he found a striking platform, he struck it four to twelve times. His flakes were larger than those of the more-experienced knappers that I witnessed. He also had difficulty shaping his final hidescrapers, which his older brother completed.

A proficient knapper with ten years of experience was able to easily produce hidescrapers without the advice or aid of a more-experienced knapper. Proficient knappers can identify striking platforms and begin to solve problems by trimming and so on. He removed three large flakes from the core and then proceeded to produce five hidescrapers from the three larger flakes (table 9). During the reduction process, he produced less debitage than a novice or competent knapper, but still produced thirteen flakes measuring one to two centimeters, smaller flakes, and a considerable amount of angular waste material.

Expert knappers with fifteen to twenty years of knapping experience produce tools with very little waste of the raw material (table 9). They each removed one or two very large flakes from the core. From these large flakes, they produced smaller hidescraper blanks that they eventually shaped into hidescrapers. In addition to the tools, their reduction of their cores resulted in very small shatter, flakes, and angular waste.

Master knappers with thirty or more years of experience actually made flintknapping look so easy that it was as if they were cutting soft butter instead of stone (table 9). Their arm and wrist motions were smooth, small, and precise. They could produce tools by striking off five correctly sized flakes directly from the core, involving virtually no debitage in the process. Each held a large chalcedony core in their hand and deftly removed five flakes, set the core down, and then shaped the flakes into hidescrapers. They removed virtually no debitage in the process and reduced their core by very little.

Quantitative measurements of the six knappers' assemblages support the observations (table 9). Three master knappers only reduced their cores on average 142 cubic centimeters compared to the three other leatherworkers who reduced their cores an average of 416 cubic centimeters. Since master knappers directly removed correctly sized flakes from the cores for the production of hidescrapers, I expected that more of their tools would have intact platforms. This is supported by an increased presence of platforms on tools made by master knappers that I observed (figure 41, table 9). Furthermore, because master and expert often assist novice knappers and even make their hidescrapers, novices often had intact platforms on their tools. Master knapper's

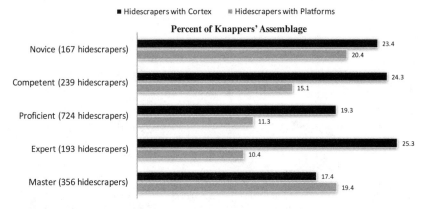

FIGURE 41 Graph illustrating that intact platforms are more commonly found in master and novice knapper assemblages, and master knappers produce fewer hidescrapers with an intact cortex than other knappers. Data based on hidescrapers from my 1996 to 1998 ethnographic collection (unused and discard, chalcedony and obsidian, and all four communities; total 1,679). Graph created by Kathryn Weedman Arthur.

hidescrapers observed in 2012 tended to be slightly smaller in length, breadth, and thickness with less variation than those with less experience (table 9). The stone hidescrapers of the Gamo leatherworkers also suggest that master knappers tend to produce fewer hidescrapers with a cortex, probably because they make better use of their raw material (figure 41). Meanwhile, all skill levels produced tools with a similar unused edge angle (figure 42, table 9).

Novice and competent knappers receive verbal and direct aid in knapping from experts. Novices tend to have much difficulty in selecting appropriate striking platforms and even shaping hidescrapers from flake blanks. They also remove a large quantity of raw material in the process of producing hidescrapers, rending a lot of debitage (figure 43). Often more-experienced knappers intercede and will work the same tool as a novice, resulting in a similar number of hidescrapers with intact platforms for master- and novice-level knappers. Proficient knappers work alone in their own households, and they continue to make mistakes, but they learn how to correct mistakes and produce hidescrapers with less debitage and in a more systematic process than novice or competent knappers. Expert knappers are able to produce hidescrapers with very little waste and are extremely good at selecting striking platforms. Experts remove two or three large flakes and reduce these flakes to produce hidescraper blanks (figure 44). In contrast, master knappers directly remove five hidescraper blanks from the raw material with little more than dust as debitage waste.

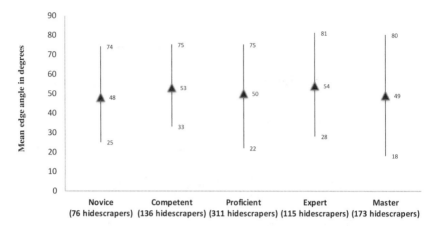

FIGURE 42 Graph illustrating that knappers with all levels of experience produce unused hidescrapers with similar edge angles. Data based on hidescrapers from my 1996 to 1998 ethnographic unused hidescraper collection (total 811). Graph created by Kathryn Weedman Arthur.

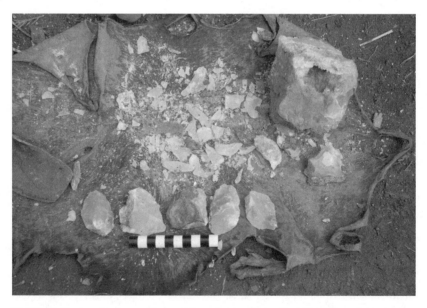

FIGURE 43 A novice knapper's assemblage after producing five hidescrapers, demonstrating an abundance of debitage.

FIGURE 44 An expert knapper's assemblage after producing five hidescrapers, demonstrating very little debitage.

COMMUNITY STANDARDS: APPRENTICE AND MASTER KNAPPER HIDESCRAPER MORPHOLOGIES

Gamo expert and master knappers feel an obligation to stone as a living entity to ensure that it becomes a full fertile being—a useable hidescraper that meets the elders' expectations in morphological form. They consistently aid less-experienced knappers and will even take over hidescraper production, resulting in a standardized hidescraper (figure 45). Fully formed and new hidescrapers are *pansi* (unused or circumcised youth). When hidescrapers age and are ready for discard, they become *cima* (old men). Leatherworkers also ascribe the same words used for human anatomy to a hidescraper's anatomy. The dorsal side is referred to as the back (*zoco*), the ventral side as the stomach (*ulo*), the laterals as the sides (*gata*), the proximal side as the anus (*dulea*), and the working edge as the eye (*iffee*). If a working edge is excellent, then it is referred to as an eye, which in Boreda culture beholds power and knowledge. One of the most important aspects of the hidescraper is the shape of the working edge. Knappers examine the ventral side of the working edge or eye of a tool to determine if it is adequate for scraping. Expert and master knappers often check the eye of a novice's hidescraper. Thus, the vocabulary associated with leatherworking and knapping serves

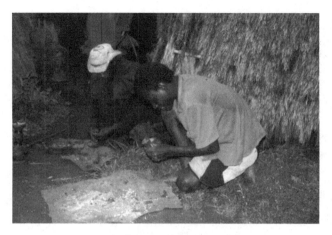

FIGURE 45. An expert father and his novice son knapping together.

to reinforce the ontology that material and human being are both alive and parallel in their existence in the world.

As a living entity, the stone is not left at the mercy of a novice knapper. As described above, fathers, uncles, and older brothers work together with novices, competent, and even occasionally proficient knappers to ensure that they are able to produce and use hidescrapers well. There is no competition or emphasis on who is the best knapper or leatherworker. There are no specific terms for a knapper with varying skill levels; instead terms used for the various stages of a man's life stages are employed. Individuals are not left alone to knap or scrape, until all feel comfortable that the individual is capable of producing a good tool; then community behavior changes and a man is allowed to begin to work alone. This is not to say that novices are not allowed to make tools, only that they are closely observed, and more skilled individuals may take the same hidescraper and work on it to help the novice. Several times I witnessed proficient or expert knappers aiding less-experienced knappers with their tools, particularly in the overall shaping of the tool, and I even witnessed experts utilizing tools made by less-experienced knappers that were left in the haft of the expert. In some communities, such as Patala, the leatherworkers all used the same scraping frames and some shared tools. For example, two brothers shared their handles, and they used a billet from an individual from another lineage in their clan. The elder brother, a proficient knapper, made a few of the hidescrapers that the younger brother, a competent knapper, used. Both the older brother and father were present while the competent knapper scraped the hide. I also made an appointment in Patala to observe an elder master knapper scrape a hide. When I arrived, his unmarried, novice son was present and proceeded to scrape and retouch tools. His father made the stone hidescrapers

and rehafted tools that the novice hafted incorrectly. In Mogesa, a competent knapper learned from his grandfather's brother (great uncle), an expert knapper. The competent knapper used an expert knapper's handle that had a hidescraper in it made by another competent knapper. Thus master, expert, novice, and competent knappers often work together and even interchange tools. A knapping community's investment in the correct production of stone tools reinforces their willingness to aid novices in producing successful fertile/useful hidescrapers.

Knapping skills are learned within community lineages, and consequently individual differences in hidescraper morphology are blurred within a community. In 2002, I reported in a small publication that among the Gamo there was little morphological variation for unused and discarded hidescrapers within a community based on the age and experience of a knapper.[5] I did not convey in the article that I had conducted blind sorting tests to determine if individuals could select their own hidescrapers out from others. When I asked leatherworkers to select their own hidescrapers from a collection of hidescrapers that I had kept for three months and then presented back to them, most declined the task. Individuals in communities, who are members of a lineage, assist novice and competent knappers through verbal guidance and directly through working their stone hidescrapers. Thus, it is difficult for individuals to select their own hidescrapers from those produced by other members of their lineage. For example, the illustrations below demonstrate the similarity in hidescraper morphology in one community, Mogesa (figures 46, 47).

However, the leatherworkers were very confident that they could select out hidescrapers made in their community vis-à-vis those made in another community based on raw material color and overall morphology, and they did so with 70–100 percent accuracy. A comparison of the unused and discard hidescrapers (figures 48, 49, 50; table 10) from the four hamlets I studied, Mogesa, Eeyahoo, Patala, and Amure, indicates that there are significant morphological differences. The Gamo knappers do not intentionally make their hidescrapers different from those in other communities, but rather a long history of learning a trade within a specific lineage and community has resulted in specific hidescraper morphologies for each community. Expert and master knappers assist less-experienced knappers within their lineage and community; hence, unused and discarded hidescrapers are fairly similar within communities despite the skill level of the individual.

Knapping or the cutting of stone (*katsara*) is a skill developed in a close and intimate community in which experienced knappers continuously work with and advise those who are less experienced. The context of learning knapping within a lineage ensures that there is mutual engagement among all individuals of the lineage who have a shared technological repertoire. An individual's identity is infused with the identity of his lineage and community. An individual's practice is not always visible in the final

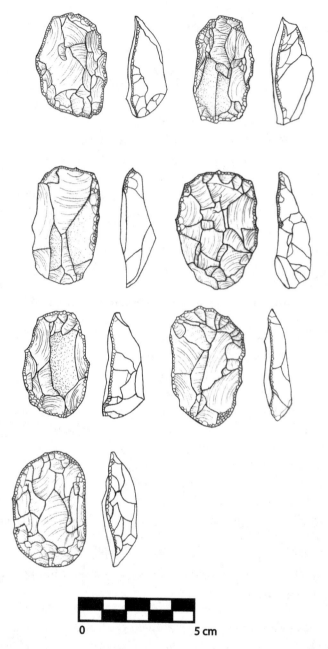

0 5 cm

FIGURE 46 Drawing of unused hidescrapers each representing a tool of different individuals belonging to one community, Mogesa, to demonstrate that there is little discernable variation based on age and skill level. Drawing by Kathryn Weedman Arthur and inked by Kendal Jackson.

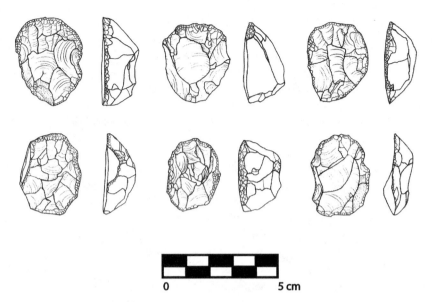

FIGURE 47 Drawing of discarded hidescrapers each representing a tool of different individuals belonging to one community, Mogesa, illustrating little discernable variation based on age and skill level. Drawing by Kathryn Weedman Arthur and inked by Kendal Jackson.

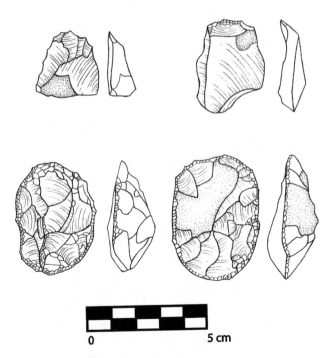

FIGURE 48 Drawing comparing the unused hidescrapers of the four communities: Patala (top left), Eeyahoo (top right), Amure (bottom left), and Mogesa (bottom right). Drawing by Kathryn Weedman Arthur and inked by Kendal Jackson.

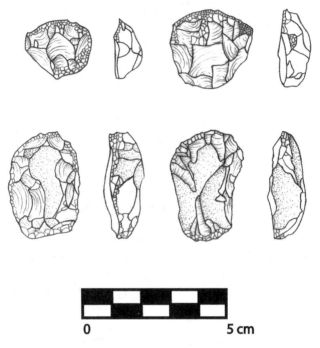

FIGURE 49 Drawing comparing the discard hidescrapers of the four communities: Patala (top left), Eeyahoo (top right), Amure (bottom left), and Mogesa (bottom right). (These are not the same hidescrapers drawn in figure 48.) Drawing by Kathryn Weedman Arthur and inked by Kendal Jackson.

stone tool, because of assistance from others in the community. Each community rather than each individual exhibits a unique hidescraper morphological style.

WORKING TOGETHER: APPRENTICE AND MASTER KNAPPERS

ENGAGING HIDESCRAPERS IN DAILY USE

After a tool is properly formed through its interaction with a human lineage, it is full, fertile, active, and ready to be with other hidescrapers, the haft, and the hide; a hidescraper being is in its *Bullacha* life stage maturing and actively engaged with others. Several hidescrapers are prepared together, stored together, hafted together, and then used together to process a hide. Human being *Bullacha* feasts occur at the household and are associated with maturation of the individual into a married adult

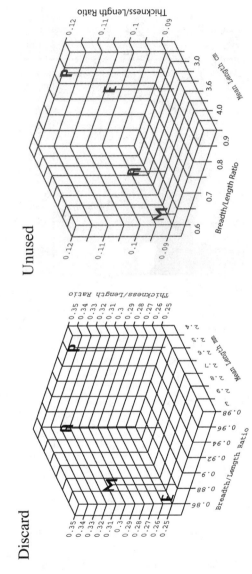

FIGURE 50 On the right a graph demonstrating the differences in unused hidescraper morphologies (811 hidescrapers) between the communities of Mogesa, Amure, Patala, and Eeyahoo from my 1996 to 1998 ethnographic collection. On the left a graph demonstrating the differences in discard hidescraper morphologies (868 hidescrapers) between the communities of Mogesa, Amure, Patala and Eeyahoo from my 1996 to 1998 ethnographic collection. Graphs created by Kathryn Weedman Arthur; similar graph in dissertation Weedman 2000.

TABLE 10 Statistical differences of the morphologies of unused (n = 811) and discarded (n = 868) hidescrapers from four communities.

UNUSED	AMURE (N = 239) MEAN (SD, VARIANCE)	MOGESA (N = 209) MEAN (SD, VARIANCE)	EEYAHOO (N = 78) MEAN (SD, VARIANCE)	PATALA (N = 285) MEAN (SD, VARIANCE)
Length	3.64 (0.67,0.45)	4.25 (0.56,0.31)	3.14 (0.81,0.66)	2.70 (0.64,0.41)
Breadth	2.41 (0.41,0.17)	2.62 (0.36,0.13)	2.56 (0.62,0.38)	2.23 (0.57,0.33)
Dthick	0.36 (0.16,0.03)	0.40 (0.14,0.02)	0.34 (0.15,0.02)	0.31 (0.12,0.01)
PThick	1.15 (0.32,0.1)	1.34 (0.32,0.10)	1.13 (0.42,0.17)	0.95 (0.44,0.19)
B/L	0.68 (0.13,0.02)	0.62 (0.10,0.01)	0.87 (0.32,0.10)	0.85 (0.22,0.05)
T/L	0.1 (0.05,0.0)	0.09 (0.3,0.0)	0.11 (0.05,0.0)	0.12 (0.05,0.0)

T-TEST	PATALA AND EEYAHOO T-TEST STAT	PATALA AND MOGESA T-TEST STAT	PATALA AND AMURE T-TEST STAT	EEYAHOO AND MOGESA T-TEST STAT	EEYAHOO AND AMURE T-TEST STAT	AMURE AND MOGESA T-TEST STAT
Length	5.03	27.91	16.35	13.06	5.42	10.33
Breadth	4.45	8.69	3.95	1.02	2.53	5.84
DThick	1.89	8.04	4.29	3.33	1.05	2.86
PThick	3.10	8.11	5.97	2.56	0.72	2.82
B/L	0.55	13.68	10.68	9.84	7.57	4.50
T/L	0.61	5.68	3.27	3.39	1.53	1.90

DISCARD	AMURE (N = 211) MEAN (SD, VARIANCE)	MOGESA (N = 278) MEAN (SD, VARIANCE)	EEYAHOO (N = 174) MEAN (SD, VARIANCE)	PATALA (N = 205) MEAN (SD, VARIANCE)
Length	2.64 (0.44,0.20)	2.97 (0.58,0.34)	2.96 (0.72,0.52)	2.43 (0.58,0.33)
Breadth	2.31 (0.33,0.11)	2.53 (0.33,0.11)	2.45 (0.54,0.29)	2.29 (0.45,0.20)
Dthick	0.90 (0.28,8.8)	0.94 (0.29,0.09)	0.73 (0.31,0.09)	0.80 (0.31,0.09)
PThick	1.10 (0.29,8.8)	1.15 (0.28,8.8)	1.09 (0.42,0.17)	1.03 (0.31,0.9)
B/L	0.89 (0.21,0.04)	0.88 (0.20,0.04)	0.86 (0.23,0.05)	0.97 (0.21,0.04)
T/L	0.35 (0.13,0.2)	0.32 (0.13,0.02)	0.25 (0.12,0.13)	0.35 (0.15,0.2)

T-TEST	PATALA AND EEYAHOO T-TEST STAT	PATALA AND MOGESA T-TEST STAT	PATALA AND AMURE T-TEST STAT	EEYAHOO AND MOGESA T-TEST STAT	EEYAHOO AND AMURE T-TEST STAT	AMURE AND MOGESA T-TEST STAT
Length	8.05	10.29	3.87	0.18	5.25	6.78
Breadth	4.06	9.67	0.76	1.89	3.10	7.17
DThick	2.36	4.73	3.12	7.14	5.52	1.52
PThick	1.32	5.36	3.66	6.72	4.95	1.37
B/L	5.53	5.42	4.03	0.90	1.70	1.03
T/L	6.48	1.45	0.29	6.08	7.68	1.95

and then into various senior adult statuses. Leatherworkers scrape hides in or just outside the *wega* or male public household space. Individually, a hidescraper matures and changes from an unused tool or youth (*pansa*), to a married or hafted (*wodala*) tool, to a respected or used (*wozanota*) tool, and then to an old tool or old man (*cima*). Guided by elders, youth select a similar number of hidescrapers to process a hide hung at a particular angle and processed in the same amount of time as their elders. Experienced leatherworkers encourage apprentices to work alone hafting, using, and sharpening their hidescrapers, and it is during use that we see distinctions in hidescraper morphologies associated with age and experience.

DURATION OF SCRAPING AND NUMBER OF HIDESCRAPERS

The time that an individual spends scraping a hide, the angle at which the hide was hung, and the number of hidescrapers engaged to process a hide varied based on community membership rather than on an individual's experience. Whether a Gamo leatherworker used a closed-mastic haft (*zucano*) or an open-tied haft (*tutuma*) did not significantly influence the duration of hidescraping events.[6] An hour before the hidescraper is engaged, the hides are saturated with water and then elevated on a wooden frame at an angle of 65–90 degrees with consistency in each community (table 11). In three of the communities I worked in, men had their own scraping frame, and only in the community of Patala did men use the same outdoor frame. All novices and competent knappers scraped hides on their father's or elder brother's frame. The leatherworker, in either a squatting or standing position, holds the blade of the hidescraper against the inner fatty part of the hide and with a downward motion removes the fat from the hide and never the hair.

Generally, scraping times meet each community's expectations, though expert knappers scrape hides in the least amount of time with the least variation compared to other leatherworkers. All leatherworkers stated that it was important to scrape a hide well by scraping the entire surface of the hide and to avoid ripping the hide during scraping. In general leatherworkers are not concerned with the amount of time they spend processing hides. They often will work the hide over several days, taking breaks to visit with friends and participate in other work. To process a single hide requires approximately four hours and three minutes, with a slightly longer time for thicker lowland hides (table 11). Gamo leatherworkers believe that lowland hides are thicker and tougher than highland hides. Recent genetic study of Gamo cattle indicates that lowland and highland cattle represent two distinct breeds.[7] The amount of time scraping a hide does not vary based on the breed or handle type. Each community seems to have particular times and expectations, though not verbalized, regarding scraping time (table 12).[8] The communities of Amure and Patala expressed the least variation in

TABLE 11 Mean hide hanging angle, size, and scraping time
for 1996 to 1998 leatherworking events.

HIDE	LOWLAND (N =12)	HIGHLAND (N =17)	MEAN OVERALL
Hanging Angle	Amure 90° Eeyahoo 70° Patala 85° Mogesa 80°	Amure 90° Eeyahoo 70° Patala 85° Mogesa 80°	
Thickness	3.95 mm, 0.96 SD (range 3–6)	2.76 mm, 0.44 SD (range 2–3)	3.35 mm
Width	168.4 cm, 8.76 SD (range 160–190)	174.17 cm, 19.78 SD (range 147–208)	170. 62 cm
Length	168.41 cm, 15.17 SD (range 116–145)	140.5 cm 28.74 SD (range 110–220)	134.93 cm
Scraping Time	249.5 minutes (range 100–655)	239.8 minutes (range 100–462)	243 minutes

scraping times and generally have a diverse work level of leatherworkers and primarily scraped one breed of cattlehide. Eeyahoo is a community of inexperienced knappers and leatherworkers, and Mogesa knappers scraped two different hide types, which may explain the higher variation in scraping time. Generally, community average times for scraping indicated less variation than average time scraped based on skill level. Expert knappers scraped both lowland and highland hides in the shortest amount of time with the least variation. Master knappers often spend their time with less-experienced leatherworking knappers. They stop scraping and instruct less-experienced leather-workers who are observing, offering instruction, and even allowing them to work their hides for much of the time, which accounts for the variation in time associated with master leatherworkers.

A leatherworking community guides apprentices in the hanging of their hides and the amount of time scraping a hide, as well as the average number of hidescraper edges used to process a hide (figure 51). My direct observation of twenty-nine leath-erworkers processing hides suggests an average of 4.5 hidescrapers used per hide; however, during observations in each community I noticed that some communities seemed to use more hidescrapers than others. To increase my sample size, I asked

TABLE 12. Community standards in scraping time and the averages for leatherworkers of different skill levels.

HAMLET HAFT TYPE	SCRAPING TIME Average, SD, Range	KNAPPER EXPERIENCE	SCRAPING TIME Average, SD, Range
Amure hamlet Zucano haft	122 minutes 17 SD 100–140 minutes	Novice	232 minutes 171 SD 120–488 minutes
Mogesa hamlet Zucano haft	411.6 minutes 150 SD 196–660 minutes	Competent	218 minutes 127 SD 120–418 minutes
Patala hamlet Tutuma haft	189 minutes 52 SD 120–300 minutes	Proficient	268 minutes 190 SD 110–660 minutes
Eeyahoo hamlet Tutuma haft	453 minutes 173 SD 256–582 minutes	Expert	170 min 62 SD 100–215 minutes
		Master	320 minutes 139 SD 160–461 minutes

leatherworkers to save me discard hidescrapers from events I did not observe during a two- to four-month period and asked them to store the hidescrapers for each event separately in bags that I provided. The community of Eeyahoo in which there is a single generation of leatherworkers, who recently moved there and have a poor-quality chert source, used the largest average number of hidescrapers at 9.2 hidescrapers per hide (figure 51). Among communities with a long history of leatherworking, several generations of leatherworkers, and good-quality chert sources, the average number of hidescrapers per hide ranged between two and five. Novice, competent, and proficient knappers employed a similar number of hidescrapers as more-experienced members of their community, though they expressed a much greater range in the number of edges used (figure 51). The number of hidescrapers therefore seems more closely related to a community's custom rather than quality of chert or an individual's experience level.

Leatherworkers share hide processing space and frames with novice- and competent-level knappers to ensure the development of their skills. The time spent scraping a hide and the number of hidescrapers used to process a hide correlate to a community's expectations rather than vary based on an individual's experience.

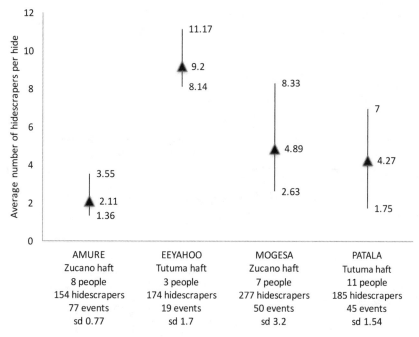

FIGURE 51 Graph illustrating that each community uses on average a different number of hidescrapers to process a hide based on 191 hidescraping events between 1996 to 1998. Graph created by Kathryn Weedman Arthur.

HAFTING AND HIDESCRAPER BREAKS

Prior to scraping, a hidescraper is hafted in a wooden handle. Learning to haft a tool correctly is essential to ensure that the tool does not fall out or break during use. Hafting is one of the first tasks that apprentices are encouraged to do alone. Different Gamo communities use different handle types to hold their hidescrapers during use: a *zucano* (double enclosed mastic haft) and a *tutuma* (single open haft). Gamo lithic practitioners occasionally break their hidescrapers during the sharpening of the working edge, as a result of improper hafting and striking force.

As I reported in an earlier publication, among the leatherworkers I studied, lithic practitioners broke approximately 5 percent of their chert and obsidian tools.[9] Breaks occur less often when associated with *tutuma* or open-hafted handles, than with mastic *zucano* handles (figure 52). This is probably because hidescrapers hafted without mastic tend to fall out of the haft rather than break. *Tutuma* hidescrapers often slip in the haft, and almost all leatherworkers had to refit their hidescrapers into their haft except for those with more than twenty years of experience. Novices with fewer than seven

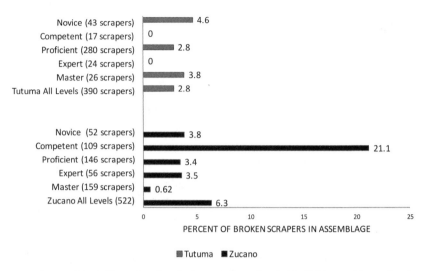

FIGURE 52 Graph illustrating that the less-experienced and older lithic practitioners break more hidescrapers. From 1996 to 1998 (868 whole and 44 broken discard hidescrapers). Graph created by Kathryn Weedman Arthur.

years of experience may refit the same hidescraper two or three times during its use. For example, one day I had an appointment with an elder leatherworker. His sixteen-year-old son hung and began to scrape what looked like an old friable hide. The elder leatherworker was at least sixty, had more than forty years of experience, and said he was too old to scrape. The novice hafted two hidescrapers, which his father had made. Soon after he began to scrape, both hidescrapers fell out. The novice attempted to sharpen and refit one of the hidescrapers, which fell out again. When he took a break after about twenty minutes, his father made and replaced new hidescrapers in the haft, and the novice did not have to again adjust or replace the hidescrapers. As a consequence of the absence of mastic, *tutuma* novices more frequently refit their tools compared to *zucano* users. I rarely observed *zucano* mastic-hafted hidescrapers falling out.

While apprenticing knappers more frequently refit or rehaft hidescrapers because they improperly hafted them, as I reported in an earlier publication, they also more frequently break hidescrapers during processing the hide (figure 53).[10] For example, I observed a competent knapper prepare three *zucano* handles with six hidescrapers to process a highland hide. In one of the hafts, he took out a hidescraper that his cousin, also a competent level knapper, had used and hafted. He used his cousin's hidescraper, rehafting the tool so that it had a longer exposed length. He began scraping the hide with one hidescraper, but soon turned the haft and began using the cousin's hidescraper. After about one hundred scrapes, the rehafted hidescraper, which was poorly hafted, snapped and in the process cut his finger.

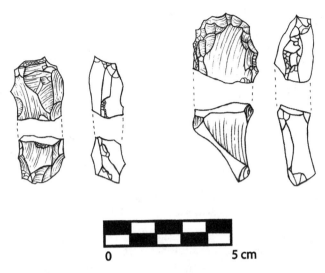

FIGURE 53 Drawings of two hidescrapers with spurs and broken by novices during use. Drawing by Kathryn Weedman Arthur and inked by Kendal Jackson.

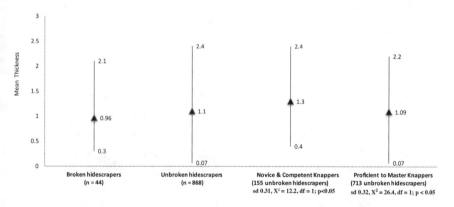

FIGURE 54 Graph illustrating that broken hidescrapers tend to be thinner than unbroken hidescrapers (data from Gamo leatherworkers 1996–1999). Graph created by Kathryn Weedman Arthur.

Novice and competent knappers tend to produce hidescrapers that break more often. Broken hidescrapers were slightly thinner than nonbroken hidescrapers. Novice and competent knappers created most of the broken hidescrapers, at least 60 percent. However, what I did not report earlier was that, statistically, younger knappers produced hidescrapers that were slightly thicker compared to experienced knappers, which is statistically significant in chi-square tests (figure 54). Although apprentices tend to make thicker hidescrapers, when they do make thinner hidescrapers, these are

the hidescrapers that are more likely to break. When experienced leatherworkers make thinner tools, they know how to properly haft and apply the correct pressure on the tool during use to prevent breakage. Elders encourage youth to haft their own tools and to scrape alone. Correctly hafting a tool that will not fall out or break during use takes time and practice. Apprentices make thicker hidescrapers than their mentors, yet apprentices are more likely to break their hidescrapers when they produce thinner hidescrapers.

SHARPENING TOOLS: FREQUENCY, DEBITAGE, AND SPURS

Hidescrapers require sharpening during use that results in changes in a hidescraper's morphology (figure 55). Sharpening is one of the first lithic tasks that novices are encouraged to complete on their own. The Gamo use an iron billet to strike the ventral side of the hidescraper to remove small flakes off the edge of the tool for sharpening. The handle is held in one hand with the ventral surface of the hidescraper facing upward. The edge is hit with a small iron billet, which removes small flakes.

Gamo hidescrapers reduce in length and increase in thickness, as a consequence of sharpening during use.[11] In a study of the Gamo hidescrapers in which I measured hidescrapers prior, during, and after use, Michael Shott statistically confirmed the reduction in the overall area (length and width) of the tool in relationship to its thickness, as well as a reduction in the overall volume ratio of a hidescraper as a result of sharpening and use.[12]

Apprentice knappers frequently sharpen their tools, producing more debitage than more-experienced leatherworkers. On average a Gamo hidescraper is sharpened six times during use, removing on average 1.7 grams of material (table 13). In my detailed

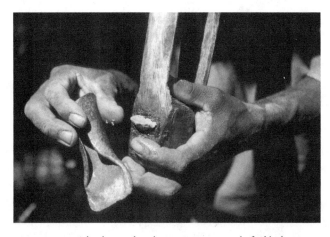

FIGURE 55. A leatherworker sharpening a *zucano*-hafted hidescraper.

TABLE 13 Comparison of sharpening data for one hide per individual. The counts for frequency and number of hard hammer strikes on a hidescraper were recorded when directly observed and then recounted when viewed by a second person watching the video.

	MEAN FREQUENCY SHARPENING A HIDESCRAPER	MEAN NUMBER OF HARD HAMMER STRIKES TO SHARPEN A HIDESCRAPER	MEAN GRAMS OF DEBITAGE REMOVED PER HIDESCRAPER
Novice	7.94	19.42	3.2
5 individuals	SD 4.86	SD 16.05	SD 1.17
13 hidescrapers	range 2,16	range 3, 128	range 2.3, 4.9
		n = 133	
Competent	5.55	25.87	0.9
5 individuals	SD 2.4	SD 33.5	SD 0.77
19 hidescrapers	range 1, 11	range 5, 213	range 0.1, 1.9
		n = 213	
Proficient	5.62	18.44	1.6
12 individuals	SD 4.01	SD 11.67	SD 1.2
43.5 hidescrapers	range 1, 14	range 3, 72	range 0.2, 1.7
		n = 333	
Expert	5.53	23.5	1.7
4 individuals	SD 4.09	SD 14.6	SD 1.9
14.5 hidescrapers	range 2, 15	range 5, 93	range 0.5, 4.5
		n = 84	
Master	5.81	14.07	1.8
4 individuals	SD 6.23	SD 7.97	SD 0.78
25.5 hidescrapers	range 1, 26	range 2, 50	range 0.9, 2.5
		n = 160	
Overall	5.94	18.85	1.7
	SD 5.00	SD, 15. 41	SD 1.3
	range 1, 16	range 3, 213	range 0.1, 4.5

study of sharpening tools, novices tend to sharpen their tools more frequently and remove more material during sharpening per tool. Competent knappers tend to strike the tool more often in sharpening than others, and the range in the number of strikes to sharpening enacted by both novices and competent knappers greatly exceeds that of other knappers. For example, I witnessed both novices and competent knappers strike their tools more than one hundred times to sharpen, shifting positions frequently and

becoming visibly frustrated with the working edge. Rarely did an expert or master knapper interfere or sharpen a tool, though they may replace a tool or make a new tool for the individual.

In 2002 I published a report in *American Antiquity* that was the first ethnoarchaeological publication of its kind, concerning skill, age, and lithic technology.[13] I announced that archaeological hidescraper spurs, beaks, or becs likely represented accidents in production by less-experienced knappers, and the presence and absence of spurs in conjunction with breaks may assist with rebuilding our knowledge of population dynamics. Gamo hidescrapers exhibit up to three spurs on a hidescraper, though single spurs are most common (figures 56, 57). Expert and master leatherworkers stated that either spurs on hidescrapers need to be removed or the tool needs to be discarded because the spur will cause a rip in the hide. In my observations of thirty leatherworkers, it was individuals who were primarily novice and competent knappers and leatherworkers with three to nine years of experience who more frequently ripped their hides, produced spurs, and broke their tools. Spurs commonly

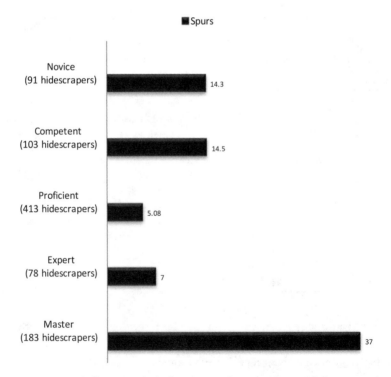

FIGURE 56 Graph illustrating the higher percent of spurs on the stone hidescrapers of novice, competent, and master knappers (data from 868 discard Gamo knappers from 1996 to 1998). Graph created by Kathryn Weedman Arthur.

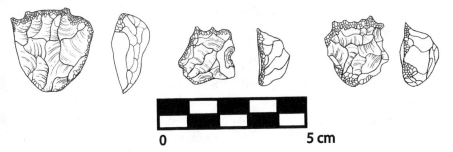

FIGURE 57 Drawing illustrating spurred hidescrapers. Drawing by Kathryn Weedman Arthur and inked by Kendal Jackson.

appear at the intersection of the tool and the haft, where novice toolmakers and elders with poor sight misjudge the appropriate striking point for removal to create a clean, smooth-working edge. Spurs also appear in more central locations on a working edge when there is change in the raw material, which may be more dense and grainy and more difficult for novice and competent knappers to remove. Thus, spurs occur more frequently on the hidescrapers of older and younger leatherworkers because they have less strength or less control over the material. A chi-square test suggests that there is a strong relationship between the presence of spurs and the experience of the leatherworkers ($X_2 = 18.34$; $df = 1$; $p < .05$).[14] Master knappers in my observations, though, were quick to replace a spurred hidescraper, knowing that it would rip the hide, while novices were more reluctant to switch out the tool and thus more commonly ripped the hide. The Gamo never use a spur on a hidescraper as a graver or for any other use.

Importantly, the experience level of the knapper affects the use-life of a hidescraper. Hidescraper beings and human beings both experience maturation or *bullacha* within the confines of the household compound and among others in their community. Experienced knappers encourage apprentices to haft, sharpen, and scrape. Consequently, hidescrapers utilized by less-experienced leatherworkers have a shorter use-life and more often break and are spurred.

A KNAPPER'S AGE, SKILL, AND EXPERIENCE

WHAT WE LEARN FROM INDIGENOUS LITHIC PRACTITIONERS

Gamo lithic practitioner perceive their technological practices as skilled, learned, and complex cultural knowledge, which require years of listening, observing, and practicing. Stone as a living entity commands respect, and as such Gamo men who interact with stone transmit their knowledge only to sons and grandsons, who acquire adult

status before engaging in long-term apprenticeships. Among the Gamo, stones are living beings that cut, *katsara* (circumcision), animal hides, and humans transform them from infertile beings, *t'unna*, to fertile full beings. Stones also experience transformation to their full fertile form through circumcision (*katsara*) or knapping. Leatherworkers use the word *tekata* to refer to the act of knapping, which literally means "to protect," and the debitage that is removed is infertile earthly debris or *chacha*. Knapping protects the future of the infant stone and allows it to develop by removing the impure infertile aspects. Knapping then is more than an intentional act to transform raw material, and it is more than technology; it is a responsibility to another being that has its own vitality and tendencies. Learning and acquiring skills in knapping begins when an individual proceeds through puberty rites of passage, part of the ordered process of life, *Deetha*. As an individual's life unfolds in each of his life stages, a knapper acquires new knowledge and skills, and his interactions with the stone transform instigating tangible differences in the stone.

Skill among the Gamo is an evaluation of a man's status in his knapping community and his demonstrated longitudinal knowledge, engagement, and dedication to his trade; it is not only a judgment based on a glance at the final product he produces. The stone tool being is a product and responsibility of community work, not individual work. A Gamo man is not evaluating skill by comparing an individual man's hidescrapers to those of other communities or other times or to other forms of stone tools in time and space.

A Gamo knapper perceives a stone tool as a living entity that demands his attention, and a knapper dedicates much of his life learning to appreciate stone and attaining the status of skilled knapper. Novice and master knapper working together reduces the presence and number of production errors, but it does not eliminate them completely. Among the Gamo, novice and competent knappers are more likely to select lower-quality raw material; strike their material harder, creating prominent bulbs of percussion; and reduce cores in a less systematic manner, removing more debitage. However, the final hidescraper morphology within a community of knappers is highly standardized regardless of skill and experience level because elders are invested in ensuring the proper maturation of a stone tool and work closely with novice and competent knappers. Significantly, this results in a tool standardization and style emblematic of each community of leatherworkers in terms of the tool's raw material color and overall morphological dimensions. The Gamo further illustrate that tool use was a less supervised activity, frequently resulting in a quicker end to the (use) life of a tool for tools used by novices. During use, Gamo novice and competent knappers tend to sharpen their tools more frequently, using more and harder strokes, and creating more retouch debitage. Less-experienced knappers also often break their tools or create spurs on the edge of the tool, ending a tool's use-life. Ethnographic studies of

other knappers demonstrate that lithic technology requires long-term apprenticeship to obtain the techniques and status required to be recognized as a skilled knapper and tool user.

APPRENTICESHIP

Most ethnographic studies reveal that knapping is a learned process that begins during adolescence and requires years of apprenticeship.[15] In one study, among the Yamana (Yagán) of Tierra del Fuego, boys at age three were encouraged to follow their fathers in producing slate and quartz arrowheads. According to Martin Gusinde, "The demands that the father makes on his son increases step by step, and he is not really finished learning until he has reached marriageable age when he develops his full physical strength."[16] Most ethnographic observations, though, offered that leatherworking and knapping began at adolescence. Sylvia Albright wrote that Tahltan Athapascan girls begin to learn the process of working hides and making hidescrapers at about the age of ten to twelve.[17] Brian Hayden[18] and Karen Hardy and Paul Sillitoe[19] noted that men and women learned knapping when they were children. Richard Gould uniquely studied an Australian society that still made and used stone tools as a regular part of behavior.[20] Formal instruction was minimal, and children watched and imitated such that verbal instruction was needed only as related to raw material selection over which "conversation was highly animated."[21] However, in a later article, Gould elaborated that fathers began to seriously teach their sons of age ten to twelve to make and use small spear-throwers with a chipped stone adze flake. At age fourteen to sixteen, the young man was circumcised, introduced to the sacred life, and began to make his own spears and spear-throwers using a variety of stone tools for scraping, incising, and sharpening.[22] New Guinea Island and Australian stone toolmakers only taught youth who had an interest, were adept, or had higher proficiency at knapping.[23] Knapping skill is a paramount demonstration of the ability to solve problems, which requires long-term practice, as well as social reproduction and intentional communication.[24]

Indigenous lithic practitioner always learn their trade through adult guidance, which is called "scaffolding," and familial apprenticeships throughout their life course as they become part of a community of practice.[25] In some cultures, individuals learn by observing parents and other elders without the aid of direct teaching or language, though it should be clear that these studies were conducted among people among whom production was waning or who had not engaged in knapping as a regular daily practice for more than twenty years.[26] In contrast, in-depth studies of knappers who actively practiced the craft on a daily basis, when observed by researchers, emphasize that apprenticeships required directed learning and language with ten or more

years of practice.[27] Some archaeological interpretations grounded in refitting lithic assemblages also emphasize learning in a familial context through scaffolding[28] and institutionalized apprenticeship with directed and practical training.[29]

SKILL AND LEARNING TOOL PRODUCTION

The ontologies of many Indigenous lithic practitioners concerning the nature of stone beings, their concept of skill associated with technology, and the status of knappers are at odds with those of most archaeologists. In the Western perspective, a skilled knapper is often evaluated based on the final product and reduction strategy. Archaeologists most commonly identify three types of knapper skill: the perceived quality of his final product—*artisan skill*; his capacity to make decisions and strategize, and his dexterity to create a standardized final product—*innate skill*; and his production efficiency—*efficiency skill*.[30] We evaluate stone tool technological skill in the context of Western concepts of industrialization, standardization in form, and progress, which we combine with our knowledge about other tools present in both cross-cultural and cross-temporal contexts.

Artisan skill is exhibited generally by high-quality ceremonial prestige items primarily associated with arrowheads, spears, bifaces, blades, daggers, and stone axes.[31] Historically these tool types, particularly arrowheads, spears/blades, and daggers, were rare and outlawed by colonial administrations,[32] and the absence of these tool types in knappers' assemblages who lived under colonial rule often resulted in unfortunate descriptions of ethnographic knapping technologies as "rude" and "crude."[33] We generally elevate tool types such as projectile points and daggers as more complex technologies, likely because these tools are perceived to be weapons, which we perceive propelled humans into progressive states of being.[34] In this sense we as archaeologists are being ethnocentric; we are projecting our own evaluations of technology and skill onto the past and outside the particular cultures and times in which they are produced, rather than attempting to understand the perception of technology within its own context. Studies of living knappers demonstrate that many tool forms, including unifacial hidescrapers, axes, and beads, require long-term practice with directed teaching and are perceived by knappers to be complex tools that require skill to produce.[35]

Archaeologists also examine issues of skill as *ability* or *innate behavior* and its intersection of *connaissance knowledge* (cognition, understanding, and strategic decision making) and *savoir-faire knowledge* (practice, advice, motivation, motor ability, dexterity), particularly associated with issues of human evolution.[36] In the mid-twentieth century, several studies of Indigenous Australian lithic knappers, who had not worked stone regularly for twenty years, attempted to evaluate the efficiency (time and energy investment) and regularity of knapper reduction strategies and the final product, only

to determine that their work was "disappointing" and "crude."[37] In fact, though, in hindsight these studies importantly demonstrate that efficiency and regularity require consistent and long-term practice, which were absent in societies where a knapper no longer regularly practiced. In a later ethnographic study of bead making in India, researchers combined a study of finished products with the knappers' strategy for production, arguing that skill requires not only knowledge of the right strategy and knowing the correct movement but having the experience through long-term apprenticeship to be able to adapt to new circumstances (Roux et al. 1994).

Third, archaeologists recognize that knapping is a reductive process and has the potential to preserve variation expressed in the final tool forms and waste products.[38] Thus, we should be able to examine lithic materials for production errors to evaluate *efficiency skill* of knapper performance and proficiency.[39] Experimental studies observed individuals who ranged in age and skill from a novice child to novice adult to adult knappers with moderate and extensive experiences.[40] These studies keenly record observations of novice reduction strategies and an impressive number of visible attributes manifested in stone cores, debitage, and tools. Many archaeological studies approach discerning efficiency of individuals in terms of novice and expert knappers through implementing refitting *chaîne opératoire* analyses, particularly with assemblages from the Upper Paleolithic Europe,[41] Paleoindian,[42] Paleolithic Japan,[43] Mesolithic and Neolithic Scandinavia,[44] and a few lower Paleolithic studies.[45] Several of these studies offer a snapshot of parent-child or family units and even the age and gender of individuals.[46] Experimental studies, however, as a product of academia present contexts in which an expert knapper is self-taught or a novice has little directed learning, creating a very different context of learning than experienced by people who engage in knapping on a daily basis for their livelihood.[47] An exception is an experiment by Jeffrey Ferguson, which demonstrated that through scaffolding, novice knappers were able to produce better arrow points.[48] However, in most experimental studies, knappers receive little directed teaching and often associate novices with increased presence of cortex, stacked or hinged terminations, failure to rejuvenate, wasteful use of raw material, increased asymmetry and decreased standardization in tool form, smaller tools, and peripheral knapping locations (table 14).[49]

Many of these production errors are *not* noted in studies among Indigenous lithic practitioners, because experts work closely with novices producing tools on which their livelihood depends (table 14). Studies of Indigenous lithic practitioners reveal ontologies in which the living stone must be raised properly, which means that experienced knappers have a responsibility to guide and intervene with production sequences of the less-experienced knappers. The Langda knappers stated they needed to be careful in their shaping techniques so as not to anger the stone through their actions.[50] Among Australian knappers, N. B. Tindale noted that youth made

TABLE 14 Novice production errors, expanded from Bamforth and Finlay 2008.

ERRORS	EXPERIMENTAL/REFITTING	ETHNOGRAPHIC
Raw material selection poorer quality and size	Grimm 2000; Winton 2005	Stout 2002 (smaller rm) Gamo
Abundance of debitage		Gamo
Misfits and hammer marks	Clark 2003; Finlay 2008; Pigeot 1990; Shelley 1990	
Blows at secant angles	Geribàs et al. 2010	
More rotation of core/tool and more impacts/direct of core exploitation	Geribàs et al. 2010; Tostevin 2012	Gamo
Platforms thicker, irregular, angle, not prepared, not present. Thickness/angle ratio	Tostevin 2012; Winton 2005	Stout 2002 Gamo
Irregular blades and flakes	Bodu et al. 1990; Fischer 1990	
Cortex retention	Bodu et al. 1990; Winton 2005	
Stacked steps and hinge terminations	Ahler 1989; Andrews 2003; Clark 2003; Milne 2005; Shelley 1990; Winton 2005	
Inconsistency in production sequence	Finlay 2008; Fischer 1990; Grimm 2000; Högberg 1999, 2008; Winton 2005	Stout 2002, 2005; Roux et al. 1994 Gamo

Failure to rejuvenate or resharpen well	Pigeot 1990	Gamo; Hayden 1979
Irregular tool form, length/breadth ratio and curvature	Ferguson 2008; Tostevin 2012; Winton 2005	Roux et al. 1994
Low length/breadth flake ratio	Fischer 1990	Stout 2002, 2005
Peripheral spatial area	Bodu 1996; Bodu et al. 1990; Grimm 2000; Högberg 1999, 2008; Pigeot 1990	
Irregular working of surface of tool	Winton 2005	Stout 2002
Smaller thicker tools	Winton 2005	Gamo (thicker not smaller)
Tool breakage		Gamo Hayden 1979; Sahle 2008; Weedman 2002a
Spurs on working edge		Gamo Weedman 2002a

mistakes in selecting poorer-quality raw materials and were sent back to the quarry by elders who corrected them.[51] Dietrich Stout observed among the Langda adze makers that apprentices are given smaller cores to produce flakes that have less-steep platform angles and that more-experienced knappers produce larger tools.[52] Both Dietrich Stout and Valentine Roux et al. determined that novices use less systematic reduction strategies compared to expert knappers, who make more uniform tools.[53] Ethnographic studies of stone-using societies importantly diverge from many experimental studies, emphasizing the importance of learning a skill with much guidance from experts. Binford witnessed men of the same community working on the same stone knives among the Alyawara, arguing that this practice of multiple men working the same tool negated the idea of stone tool style and standardization in form.[54] In fact, though, it is common ethnographically for knappers to work together even the same tool to ensure standardization in form. We do not know in the Alyawara case if their work procedure was typical, since it had been more than twenty years since any of the Alyawara had made a stone tool. The tool may have been passed around to each man to complete what he remembered of the process rather than representing a real sequence of activities, or they may have been replicating the way in which they taught youth, transferring a tool between knappers. Knappers who learn through scaffolding produce fewer efficiency errors and tools that are more uniform. Thus, even novice knappers may exhibit "artisan level" skill when working closely with experts, masking the presence of novices in tool morphology, until they begin to utilize tools.

SKILL AND LEARNING TOOL USE

Most ethnographic and experimental studies of efficiency in tool use focused on examining ideal tool form and edges for particular functions rather than concentrating on the impact of the competency level of the tool user. Most studies of living lithic practitioners did not consider the skills of the user as a variable in shortening a tool's use-life.[55] Yonatan Sahle's study in Ethiopia of Hadiya hidescrapers, as my study among the Gamo, observed that youth tended to break their tools along the medial, rendering the tool to discard, while more-experienced knappers broke tools closer to the working edge, and they could be recovered for continued use.[56] Brian Hayden's study among Indigenous Australians who had not knapped in the last twenty-five years made some interesting observations.[57] For instance, he noted the knappers' inability to sharpen tools, abandonment of tools, ineffectiveness of tools, and breakage of tools.[58] The use-life of a tool is dependent not only on the type of raw material and amount of use of the tool, but also on the expertise of the human implementing the action in accordance with the tool's being!

Study of skill and learning knapping in societies where knapping is a part of every-day life suggests that the human and the stone both have life courses. Human and stone metamorphize in the presence of each other, with the potential for creating a rich mosaic assemblage. The Boreda *Etta Woga* theory of being imbues a stone with life, and therefore the humans who interact with stone do so in a manner that ensures its longevity. A community of knappers shares their knowledge and practices with apprentices, encouraging them to learn and mature into experts like themselves for more than ten years before leaving the lives of stone in their hands. Often elders directly shape the stones used by novices, which tends to blur distinctions between novice and master hidescrapers in a community. Yet, the face of a stone tool made within a community is not completely overshadowed by community norms. A stone whose life is instilled through contact with an inexperienced human being exhib-its some clear differences from the life of a stone who interacts with an experienced human being. A mature knapper selects high-quality and full-formed stone, cuts and wastes very little stone in helping to transition it to a full being, and ensures that the stone hidescraper being has a long life through properly being used and sharpened. In contrast, a young inexperienced human knapper often selects underdeveloped stone beings, creates more waste of stone while ineffectively assisting in the transformation of stone beings, and produces thinner hidescrapers that break or spurs on hidescraper beings that are prematurely discarded. Importantly, the experience level of the knapper seems directly related to the use-life of the tool with novice tool users more likely to break or harm tools, ending their use-life. As examined in the next chapter, both the human knapper and the stone hidescraper live out their lives, rest, and are buried pre-dominately within the confines of a leatherworker's home. Their spatial distribution is associated with the differing practices related to *Woga* in the different Gamo districts.

5

DUME AND *SOFE*

Rest and Death in Leatherworkers' Households

THE FOLLOWING IS a tale of two Gamo male knappers, each a craft-specialist of low socioeconomic status, evident in their meager possessions in and near their small thatched homes isolated from others on the sloped edge of a rural mountain community (figure 58). Both men learned their trade from their fathers and advanced in skill through years of knapping and scraping in their households. They scraped cattlehides of equal size and thickness using stone hidescrapers to produce sleeping mats, but here the similarity in the organization of their lithic technology ends. Their lithic storage or seclusion, *dume*, and discard, *sofe*, patterns are distinct.

In the northern Gamo highlands, a leatherworker shapes the hidescraper blank or boy (*naʒay*) at the quarry and stores (*dume*) him in a cloth bag in a niche above the house lintel. He bends down, nestling his wooden scraping handle near the edge of the household hearth to warm the haft's mastic. The mastic heats and readies to receive the new hidescraper, which the leatherworker further shapes into a young man (*pansa*). When the mastic is malleable in the haft, he removes the elder hidescraper and lays him to the side to rest near the hearth in preliminary discard (*dume*). The leatherworker then inserts the male circumcised hidescraper into the female haft in marriage. In the confines of his home (*dume*), the male leatherworker joins the hafted hidescraper with the surface of the hide (figure 58) and occasionally sharpens the edge of the hidescraper, allowing the resharpening flakes to fall and rest on the house floor (*dume*). At the end of the day, his wife sweeps the hidescrapers and debitage toward the outer edge of the house near the animal pen and toward the entrance of the house and the stone threshold. She collects some of the larger material in her hand and discards (*sofe*) it in a specific location with previously discarded lithic materials in her household garden.

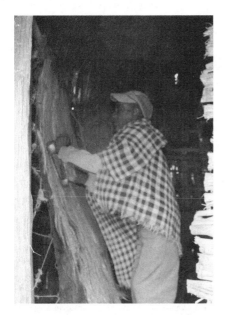
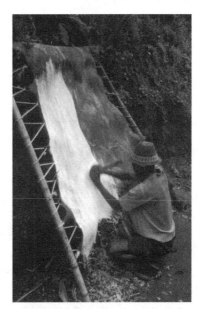

FIGURE 58 A northern Gamo leatherworker using a formal hidescraper in a closed-socket haft to scrap inside his house (left). A central Gamo leatherworker using an informal stone hidescraper in an open-socket haft to scrape outside his house (right).

In the central Gamo highlands, another male leatherworker selects a core that he has brought from the quarry. The core rests in storage (*dume*) in a bowl nested into the branches of an enset plant in his garden near his house. He removes several infant flakes from the core over the bowl. He removes an elder hidescraper from his wooden haft and places it in the bowl. Then he chooses one flake and, without shaping it further, positions the unshaped hidescraper in the slot of a wooden haft, securing it with enset twine. Outside near his home in an open area, he proceeds to use the hidescraper to process the hide (figure 58) and repeatedly sharpens the hidescraper. Occasionally his wife sweeps the area, moving small bits of debitage around, but she makes no effort to secure it and move it somewhere else. The leatherworker eventually will empty his bowl cache, disposing of debitage and discard (*sofe*) hidescrapers randomly in the household garden.

Gamo men as craft-specialists work at their homes rather than at specialized workshops, produce informal and formal hidescraping stone tools, and engage two different lithic storage and discard patterns. The narrative describing the two Gamo male knappers emphasizes that the southern and central Gamo knappers produce, use, store, and discard their informal hidescrapers in their household garden; while the northern Gamo knappers form hidescraper blanks at the quarry; shape, use, and stow

their formal hidescrapers in their homes; and then bury them in their garden. Initially, I ascribed in a publication the Gamo men's different lithic organizational patterns as entangled in their historical environmental and social-political relationships.[1] My continued investment in a longitudinal and collaborative research program with the Gamo revealed that the understanding of the low status of male lithic practitioners and the organization of their technology goes beyond their historical relationships and is deeply rooted in their way of knowing the world, their ontologies.

The Gamo Indigenous ontology, *Woga*, has several interpretations including *Etta Woga*, Fig Tree Culture, practiced by the Boreda, and *Bene Woga*, Old Culture, practiced by the Zada, Ezo, and other central Gamo peoples. The reality of change and transformation and the recognition of variation are some of the most important aspects of living in the world for most Gamo. Anthropological research among the Gamo has long focused on the tension between structure and agency in creating cultural variation.[2] Judith Olmstead described the Gamo as living in the vast watercolor of Ethiopia, where historical interactions create new colors:

> With watercolor, colors can be laid over others. A thin wash of color can cover large areas, combining in unique ways with each color already in those areas. The variation may be large or small, but it is an intrinsic part of what happened.[3]

Dena Freeman's less poetic, but equally insightful, research concerning Gamo communities states that structures "in which power is distributed fairly evenly . . . are far more sensitive to changes in local context . . . and present the anthropologists with a case of phenomenal cultural variation."[4] So too, while the Gamo Indigenous ontologies structure the spatial geographies of human beings and lithic beings, their different biographies and lineage histories offer space for agency and variation in their movement across the landscape.

The life course, *Deetha*, of stones, living in different Gamo communities, parallels the lives of their caretakers, the leatherworkers. For many Gamo the home and historic settlements that are now sacred forests were essential spaces for biological and cultural reproduction. Leatherworkers are born, secluded after circumcision, and consummate their marriages either near the household hearth or just within their household garden. In the past, Gamo commonly buried individuals who died before they completed puberty rites of passage, such as youth and craft-specialists, in their final incorporation ritual (*sofe*) in household gardens. A stone hidescraper may experience circumcision like his human counterpart at the sacred forest/quarry and then near or within the household. Some stone hidescrapers are paired with the haft also near the household hearth, and others are hafted outside the home. Stone debris, like human afterbirth and circumcision skin, as infertile waste is buried either in the animal pen

next to the hearth or outside at the base of a tree in the garden or in a sacred forest. Leatherworkers transform stone, allowing it to mature in and near their household, and eventually the hidescrapers become old and are buried in a leatherworker's household compound. Most Gamo leatherworkers store and discard their lithics within the boundaries of their household, structured through their ontologies, though nuanced differences between communities in terms of the organization of their lithic technology indicate their agency and varied historical experiences.

CRAFT-SPECIALISTS AND HOUSEHOLD SEGREGATION

Gamo lithic beings generally live out their lives and experience burial in leatherworker households segregated from the rest of the community. Leatherworkers dwell at the edge of hamlets in unfavorable areas such as near roads exposed to the dust produced from vehicles driving on the road or on steep slopes with poor agricultural soils. Historical perceptions of leatherworkers as impure and as the potential cause of danger continue to impact where they reside in communities today. Segregation of their households is effectively a permanent form of household seclusion or *dume*. *Dume* is a state of being associated also with menstruating women, women after childbirth, and men and women who are transitioning to a new ritual-political status. In this sense, leatherworker households are in permanent seclusion, tangibly emphasizing their liminal status in Gamo society.

Furthermore, in the past, many Gamo who were not leatherworkers considered that stone was alive and had the power to inflict harm. If farmer and potter-smith households found obsidian, chert, or quartz buried or lying on the surface of their fields or household gardens, they considered it *Bita*—a bad spirit. They would consult the community spirit medium, *Maro*, who prescribed the diagnosis of *Bita* practices afflicting their household. Often leatherworkers were accused of encouraging the stone to move out of the craftsman's household to bring misfortune to others and endow prosperity to themselves.

> When a craft-specialist began to gain a lot, then he was accused of *Bita* and had to give it away. (Oyeso Oyso, wife of leatherworker, June 28, 2008)

A community's punishment for *Bita* practices was to further separate the person from the community and offer him no help in the future. He must then publicly apologize with a complete account of his actions and prepare and serve beer and roasted grain for community members. The impure status and negative image of male

knapping leatherworkers ensures that they, their households, and their lithic materials are segregated from the larger community.

THE LIFE OF A LEATHERWORKING HOUSEHOLD

Among the Gamo, households are commonly perceived to be living entities with life courses and the power to intercede with the lives of other beings. Johan Normark, borrowing from the work of Manuel DeLanda and Gilles Deleuze and Félix Guattari, offered that houses are assemblages with the capacity to act with stabilizing agents that are territorial and changing agents that deterritoralize.[5] Humans, the house, and all the materials in the house are all agents and part of the assemblage of the ever-changing house.

BIRTH OF A HOUSE

Most leatherworkers occupy a single small thatched house, an *agoketsa* or living house, with an equally small household garden, and it is here that they practice most of their knapping and other leatherworker activities. The Gamo are renowned throughout Ethiopia for their unique and beautiful household architecture (*gata ketsa*), which serves as the primary draw for tourists to the Gamo Dorze district.[6] Today fewer and fewer Gamo build wood-thatched oval homes. The wild grass used for thatching is disappearing with increases in population and expansion of agricultural fields. Many Gamo are replacing their thatched houses with rectangular corrugated structures that the Derg Regime (1974–91) introduced to the region. Gamo report that corrugated roofed houses are more desirable because they have a life span of more than thirty years compared to thatched houses that live ten to twenty-five years. The high cost of a corrugated house (3,000 ETB/333 USD) compared to a thatched house (900 ETB/100 USD) means that most leatherworkers live in thatched houses, while their neighboring farmers now build corrugated roof houses with regularity.

A leatherworker builds his house with the aid of his family and members of neighborhood work groups (*seras*). Since men continue to live near their fathers, most neighborhood work groups consist of agnatic kin. Membership for men is associated with their patrilineage as well as demonstrations of participation and generosity; while women base their membership on residency. Since craft-specialist and farmer households are spatially segregated, generally *sera* membership is also segregated, though in some communities this has begun to change. Houses are typically built in the dry season, and an individual man may work several years collecting the resources for house construction.

Many Gamo consider that household construction, like the production of other types of material culture, proceeds through the *Deetha* life cycle of birth, rest, maturation, and incorporation. Men and women of *sera* groups construct the house by first leveling the ground, digging a circular trench, and filling the trench with field stones and broken sherds for the house foundation, which is considered the house's birth (*yella*). The field stones and broken sherds both embody protective spirits. Next the land is allowed to rest (*dume*) and settle. Subsequently, they construct the outside and inside walls and the roof, and men erect the central house post. This stage is considered coming together in happiness at the house (*bullacha*). Finally, men cover the house with thatching, and women construct the floor and hearth. When the house is complete and ready for incorporation (*sofe*) into the community, the owner provides a feast for neighbors and offerings for *Tsalahay*.

LIFE OF A HOUSE

Most Gamo intentionally organize their household with the entrance to the house facing toward the east and the rising sun, which is considered the direction of masculinity (figure 59). The area in front of the house, *boranda*, is used for informal gatherings of friends during warmer weather, household feasts, storage of broken pots, and sometimes weaving and other craft activities including leatherworking and knapping. In the western part and female portion of the household garden is the house, *ketsa*, and the garden, *shae*, storage pits, and in some communities discard of broken ceramic vessels.

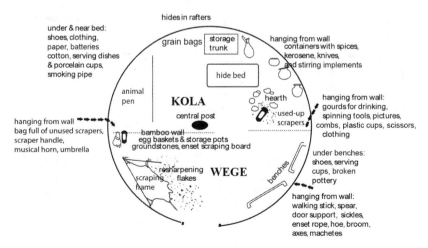

FIGURE 59 Drawing illustrating the organization of space in a typical Gamo leatherworker household (Boreda district). Baseline drawing from part of figure 68 with alterations by Kathryn Weedman Arthur.

Within a home, people erect a bamboo wall in the center of the home to represent the maturity of the male and female heads of the household, as Freeman documented the Doko Gamo do in ritual contexts.[7] Ideally, the household entrance (*pangay*) with a stone entrance marker (*guban*) faces to the east (rising erect sun) and opens into the symbolically male *wege* "cultural room" (figure 59). The *wege* is symbolic of descent groups and emphasizes cultural reproduction. Daily, people also use the room for storing noncooking items, sleeping, and visiting with guests. The *wege* houses the central house post (*tussa*) that a man recycles from his grandfather's household. The *wege* house post is where men, particularly farmer men with the means, offer daily barley porridge to their ancestors. Most of the materials in the *wege* portion of the household are similar in type and quantity among both farmers and craft-specialists and are perishable, such as bedding, clothing, furniture, and farming tools. Materials associated with transferring power and status present in the *wege* distinguish farmer from craft-specialist households. For instance, in the *wege* farmers typically keep their children's school supplies, church icons, knives for the ritual slaughter of animals, and regalia such as spears and walking sticks, while craft-specialists stow their materials associated with their ritual roles including musical instruments and ritual healing tools.

The *kolla* or hearth room ideally is located in the western part of the house in the direction of the setting sun or in the back of the household, which is considered feminine reproductive space. The *kolla* is a womb with a hearth and an internal animal pen. The *kolla* is where women cook, give birth, seclude themselves after birth and during menstruation, and experience circumcision. The *kolla* is also where elderly men and women live, who are beyond reproductive and social productivity in society. The *kolla* has several other functions as private space. It is where the adults sleep and animals are penned at night, and it is a place for cooking technology and material production. Craft-specialists, particularly leatherworkers, consume the head, lower legs, and tail of domesticated animals, and these parts are often found in the *kolla* portion of the household.[8] A craft-specialist's *kolla* often contains the products of his or her trade, such that in some communities, stone hidescrapers and handles rest in a leatherworker's *kolla*.

The Gamo fill their household gardens and homes with few nonperishable possessions. In my study of sixty households, the average number of nonperishable goods was sixty-one, and most of these were ceramic vessels and metal farming tools. Most items are kept inside the house, and generally only broken pottery and a few farming implements may be left outside in the household garden. Leatherworker households have fewer vessels and fewer types of vessels, and they tend to consume more tubers and enset than farmer households.[9] There are no community disposal areas. Most food is either consumed or fed to animals, and most ceramic pots are repurposed, recycled as grog, or used in walkways. Iron tools are often recycled into new tools by

ironworkers. The amount of industrial waste, though, is growing, particularly plastic and metal containers. Most people also own cell phones and perhaps a radio, but televisions, computers, and other electronics are nonexistent in the rural communities outside of restaurants, schools, and government offices. In addition to pottery and farming materials, leatherworkers also may store and discard materials associated with their trade. A leatherworker's household compound contains evidences of the life and death of the human being and the material being.

DEATH OF A HOUSE

A Gamo leatherworker may live in eight to ten different houses in his lifetime, while the life span of a hidescraper is much shorter and he generally occupies only one house in his lifetime. The thatched homes they occupy also have brief life spans from ten to twenty-five years based on interviews with more than sixty Gamo. Houses are susceptible to burning from household hearths and destruction by termites and rodents and rarely outlive their human occupants. When a house is abandoned due to its deterioration or burning, the owner removes all useable items and transfers them to his new home. Clothing, bedding, wood furniture, pottery, farming tools, and other household items that are burned or broken beyond further use remain where they lie to be reincorporated into the earth. When an elder dies without a living spouse, a house is rarely abandoned. The house structure is still viable and may be moved to a neighbor's property to replace a burned or deteriorated house. A farmer or craftsman may also use a former parent's home as a workhouse for weaving or a home for a newly circumcised son. Often usable materials from a parent's home are taken by sons for use in their households or more rarely given to local craftspeople. Therefore, full fertile functioning houses and material beings are seldom abandoned.

TWO PATTERNS OF LITHIC STORAGE AND DISCARD IN MALE KNAPPER HOUSEHOLDS

The Gamo leatherworkers offered that variation in their household use of space and material culture is a result of differences in their *Woga* or ontology. Historically, the Gamo recognized ten political districts that they refer to as *derre* that can be broadly divided into three regions based on cultural differences, dialect, and leatherworking technology (figure 60). In the southern districts of Kamba, Bonke, and Ganta, the leatherworkers scrape hides outside their homes with a glass hidescraper inserted into the open end of a long cylindrical wood haft that is tied shut with enset string, referred to as a *tutuma*. In the central districts of Dita, Kogo, Dorze, Doko, and Zada,

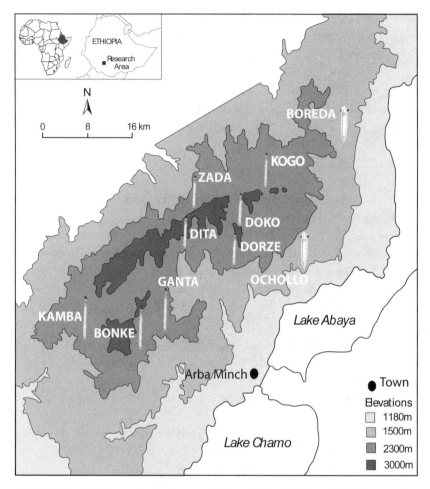

FIGURE 60 Map illustrating handle types in Gamo highland districts. Map background designed by Melanie Brandt with district and handle information added by Kathryn Weedman Arthur.

leatherworkers also scrape hides outside their homes and employ a shorter *tutuma* haft (figure 61) with a glass hidescraper, and a small number use a stone hidescraper. The leatherworkers living in the northern and the eastern lowland districts of Ochollo-Abaya and Boreda process hides inside their homes predominately with stone tools held with tree-resin mastic into sockets located on either side of a wooden haft, termed *zucano* (figure 61).

Prior to my longitudinal work and access to the deep relationship of *Woga* to their technology, I explained the variation in leatherworking technology and use of space

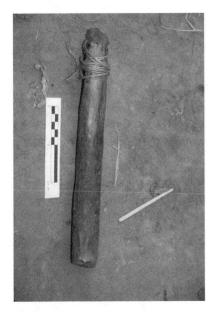 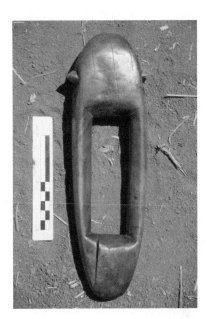

FIGURE 61 A *tutuma* haft for hidescrapers (left) and a *zucano* haft for hidescrapers (right).

through their history and present-day interactions with neighboring ethnic groups, comparing leatherworker material culture and responsibilities through the process of dialogism[10] (table 15).[11] The leatherworkers I spoke to throughout the Gamo highlands and lowlands claimed a long history of either *tutuma* or *zucano* use that extended back two to three generations. As outlined in chapter 1, although the Gamo share with neighboring language-cultural groups a similarity in leatherworking haft morphology, the Gamo maintain their own terminology and a unique ritualized technological process associated with their ontology that is yet to be recorded elsewhere in Ethiopia.

The Gamo store and discard their lithic materials in their home and household gardens in two distinct patterns, illustrating agency within the structure of their Indigenous ontologies. Like a human child that transforms and matures in and near the household, a hidescraper's life cycle is visible in the household context. In the Gamo theory of being, stone is alive and tools transform through a life cycle as a raw material fetus (*gachino*), infant hidescraper blank (*uka*), infertile waste biprod-ucts (*chacha*), boy unused hidescraper (*na7ay*), married hafted hidescraper (*wodala*), mature used hidescraper (*wozanota*), used elderly discardable male hidescraper (*cima*), and discarded dead hidescraper (*hayikes*). When cores, debitage, and tools are rest-ing between uses, leatherworkers consider them to be in a state of seclusion and rest that parallels the human practice of seclusion in or near the household during rites of passage referred to as *dume*. Eventually knappers discard debitage, raw material,

TABLE 15 Comparison of the leatherworking handle, caste group, and ritual roles among the Gamo, Oyda, and Wolayta.

	SOUTHERN GAMO	OYDA	CENTRAL GAMO	WOLAYTA	NORTHERN GAMO
Handle Type					
Leatherworkers Groundstone	*mana*	*mana*	*degella*	*degella*	*degella*
Potters Ironsmiths	*mana*	*mana*	*mana*	*chinasha*	*chinasha*
Healing	leatherworkers	leatherworkers	leatherworkers	potters	potters
Circumcision	leatherworkers	leatherworkers	leatherworkers	potters	potters
Musician	leatherworkers	leatherworkers	ironworkers	ironworkers	ironworkers

exhausted cores, and tools in household gardens, reminiscent of the burial location of ancestral leatherworkers. The stone materials are deceased (*hayikes*) and in *sofe*, or final incorporation, and considered renewable resources.

The Gamo Indigenous ontologies manifest variation in interpretation concerning human use of space associated with household and sacred grounds that is emulated in the organization of their technological space. Among the southern and central Gamo, most knapping activities, storage, and discard of lithics primarily occurred outside their homes but within their household gardens. They all hafted their informal style hidescrapers in a *tutuma* or open-socketed handle. A second pattern of storage and discard was observed among leatherworkers among the northern Gamo. These knappers primarily produce, use, and store their lithics in their homes and then bury them outside in their gardens when they have died. Northern Gamo knappers primarily place their hidescrapers in a *zucano*-type handle, which generally accommodates two hidescrapers held in the haft with mastic.

TUTUMA PATTERN: LIFE AND DEATH OF HIDESCRAPERS IN HOUSEHOLD GARDENS

Tutuma Ontologies and Lithic Discard and Storage Pattern

Most citizens of the central highland Gamo districts including Zada refer to their historic Indigenous ontology as *Bene Woga*, Old Culture. Certainly, there is cultural

variation among these districts,[12] and more detailed study of the various districts' Indigenous ways of knowing the world would likely also demonstrate variation. I found that in the communities and districts I focused on, there is a common perception of associating human and nonhuman material "reproduction" with household space. Thus, most of the lithic production debris, whether in a state of storage or discard, is present in a *tutuma*-using household garden as this location is perceived to be the appropriate place for transformation (figure 62).

The leatherworker brings chert raw materials and cores (infants, *uka*) from the quarry to his household. Chert and obsidian sources are very far from most *tutuma*-using homes, and in the past many leatherworkers purchased raw material at the market. Today most use glass. Since a majority of the lithic reduction process occurs within the garden of *tutuma* users, there is very little evidence of the lithic reduction process or circumcision at their quarries.

The circumcision or knapping of lithics among the central Gamo in their garden mirrors many of the central Gamo's perceptions for the proper location for human circumcision, *katsara* (figure 63).[13] Very little is published concerning the Gamo circumcision practices, and I did not conduct in-depth studies in all the central Gamo districts. Recently Getaneh Mehari offered that men and women in the Dorze district in the past were circumcised in sacred forests, and among the southern Gamo in Kamba and Bonke women were not circumcised and a man's foreskin was removed with a plant material.[14] Variation exists among the Gamo central highland districts that may offer different ontologies and explanations for the connections between the human and technological rituals and use of space near households. In interviews I conducted in the Ezo and Zada districts of the central Gamo, elders indicated that in the past men and women were circumcised in groups outside the home of the leatherworker or individually at the home of the initiate.

> In old time before the Derg, a leatherworker performed circumcision. All boys did this together on one day at the leatherworker's house. . . . Every seven years we had circumcision before we went to the fire celebration during *Tompe* [bonfire festival]. (Tochona Tolba, in Ezo Tula, May 24, 2012)

Like humans, stones in *tutuma*-using households primarily experience circumcision or knapping over enset leaves in a leatherworker's garden. A leatherworker sits in a squatting position and begins to remove flakes (boy, *naʒay*) and debitage waste (infertile waste, *chacha*) from the core/raw material (infant, *uka*) to produce an appropriate hidescraper. He may reduce a primary core into several smaller cores, select one core to produce eight to ten new flakes, and set the other cores and flakes aside in a bowl for future use. Leatherworkers do not shape the laterals of the tool because the

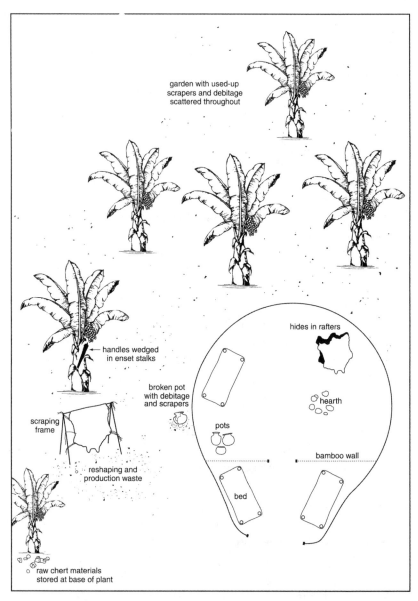

FIGURE 62 Illustration of the typical use, storage, and discard pattern at a *tutuma*-using household. From Weedman 2006, permission from *Journal of Archaeological Method and Theory*; originally designed by Melanie Brandt.

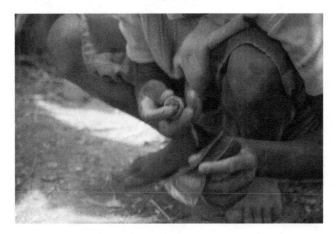

FIGURE 63 *Tutuma*-using knapper sharpening his hidescraper outside in his garden.

haft is open and unconfined; consequently, there is little shaping debitage. Once the leatherworker has produced an appropriate hidescraper, he hafts the tool and begins to scrape. Hides also are circumcised or scraped in the household garden on frames constructed of bamboo—also considered a symbol of fertility. Like humans, stone and hides are cut in the household garden marking their transition to full fertile adults.

Stone hidescrapers, cores, and debitage in *tutuma*-user households commonly rest in gourds, in broken pots, or in holes at the base of trees as storage in household gardens (figures 64, 65). In the hamlet of Patala, hidescraper production and resharpening of hidescrapers occurred near the scraping frame located outside and near the entrance to the household. While some leatherworkers knapped over an enset leaf or dried hide, some worked directly over a broken gourd or bowl where they stored their lithic materials. The bowl or gourd was kept either at the base of or in the branches of an enset plant or a tree.

Final discard of *tutuma* users' lithics also occurs within the confines of their household garden, replicating the burial location of craft-specialists, afterbirth, and foreskin (in the past). A man's removed foreskin, *shurita*, is considered infertile waste, and its removal was perceived to instigate his fertility and marked his status as a fertile young man in society. In the past, many central Gamo buried an individual's infertile parts, such as the umbilical cord after birth and circumcision skin, in his or her household garden to prevent it being taken by someone else who could then cause harm to the individual. Similarly, the debitage removed from a core is referred to as the infertile earthly waste or *chacha*. When the storage bowl becomes full of lithic waste, exhausted cores, and hidescrapers ready for discard, the leatherworker empties the bowl into his

FIGURE 64 The storage of *tutuma* lithic materials outside in a broken pot.

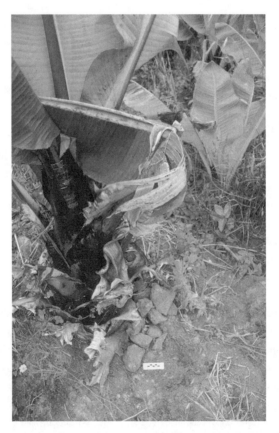

FIGURE 65 The storage of *tutuma* lithic materials on the ground at the base of an enset plant.

enset garden, usually scattered and not in a specific location. The household garden is where leatherworkers and their wives and children were buried in the past.

At *tutuma*-using households, traces of the entire life cycle of the stone beings are visible (figure 62). Cores and primary, secondary, and tertiary debitage would likely be found scattered throughout the garden. Sharpening flakes would be embedded in the outside floor or patio in front of the leatherworker's house. The products of the entire *tutuma* lithic reduction sequence, including the debitage waste and infant raw materials and cores and deceased hidescrapers, are commonly found scattered throughout their household gardens.

The unused hidescrapers that *tutuma* users produce and store resemble informal tools and formal tools when ready for discard. Unused and discardable *tutuma* hidescrapers are very distinct, since newly hafted *tutuma* hidescrapers are resharpened through use. When the utilized edge of a *tutuma* hidescraper is used up, about half of the time the leatherworker will remove the hidescraper and rehaft it to use one of the lateral edges or the proximal as the next scraping edge. Resharpening the working edge and rotating the working edge of the tool transforms an informal hidescraper into a formal end, side, double-sided, or end-side hidescraper for discard (figures 66, 67[15]).

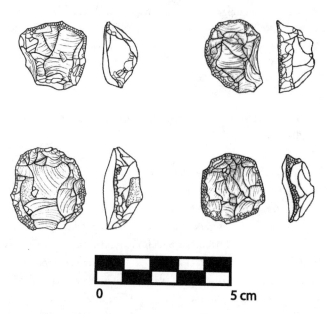

0 5 cm

FIGURE 66 Drawing of selection of *tutuma* old man (*cima*) hidescrapers ready for discard. Top row: end hidescraper and side hidescraper; bottom row: end double-sided hidescraper and hidescraper with all sides used. Drawing by Kathryn Weedman Arthur and inked by Kendal Jackson.

Percent of the different types of *tutuma* discard hidescrapers

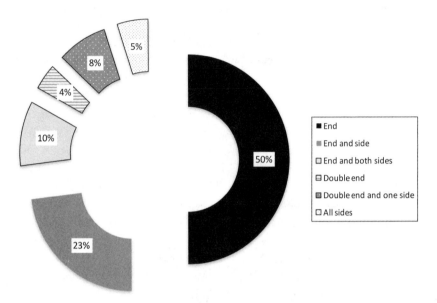

FIGURE 67　Graph illustrating that most discarded *tutuma* hidescrapers would be classified as archaeological end and end-side hidescrapers, though a wide variety of types exist (379 discard hidescrapers collected 1996–1998 from Patala and Eeyahoo communities). Graph created by Kathryn Weedman Arthur.

The most common types of *tutuma* discard hidescrapers are end hidescrapers and end-side hidescrapers.

Tutuma Households: Types and Quantity of Lithic Discard

As the entire lithic reduction sequence occurs within a *tutuma* knapper's household garden, one would expect to recover a considerable amount of lithic discard in the form of debitage, cores, hidescrapers, and resharpening flakes. I observed and collected lithic discard material from fourteen household events after processing a single hide. Today leatherworkers process hides as a part-time activity, processing two to three hides a week. They discard on average five hidescrapers and produce nine grams of resharpening debris per event (table 16). The average discard per household per year would be approximately 874 hidescrapers and 1270 grams of sharpening debitage. Unfortunately, I did not take measurements on materials during *tutuma* hidescraper production. However, *tutuma* users brought their raw materials/cores to their homes, and in measurements of caches, the average cache contained one to six

TABLE 16 Table estimating the number of hidescrapers, sharpening debitage, cores, and production debitage discarded at 14 *tutuma*-user's household events.

	SHARPENING DEBRIS PRODUCED >4 MM GRAMS	SHARPENING DEBRIS PRODUCED >2 MM GRAMS	SHARPENING DEBRIS PRODUCED >.250 MM GRAMS	SHARPENING DEBRIS PRODUCED >.063 MM GRAMS	TOTAL SHARPENING GRAMS	NUMBER OF HIDESCRAPERS
Per hide average g	5.49 g	1.40 g	0.98 g	0.12 g	8.14 g	5.6
Range	0–24.7	0.3–4.5	0–4.5	0–0.1	0.8–30.2	1–19
SD	6.64	1.42	1.23	0.16	8.75	5.06
Per year average	856.8 g	218.4 g	142.6 g	18.94 g	1270.6 g	874.7
Cache average	Flakes with no cortex	Flakes with less than 50% cortex	Flakes with more than 50% cortex	Cores		
Number	6	3.5	1	11		
Volume cm				226cm³		
Average needed per year	226 cm³ raw material/5 hidescrapers = 45.2 cm³ raw material per hidescraper	45.2 cm³ × 875 hidescrapers = 39,550 cm³ raw material per year				

flakes with eleven cores/raw material with an average volume of 226 cubic centimeters per raw material/core. With 226 cubic centimeters of raw material, a leatherworker could make at least the average five hidescrapers needed to process a hide. The average *tutuma*-using household scraping three hides per week would produce approximately 39,550 cubic centimeters per year of discarded cores and debitage at the household. Obviously someone who processed hides full-time could likely work many more hides, and considering that *tutuma* users could on average process a hide in three hours, two hides could be processed in a day, more than doubling lithic discard estimates in *tutuma* households.

Tutuma Migration and Changes in Lithic Storage and Discard Patterns

Though southern and central Gamo *tutuma* users primarily store and discard materials outside their homes, variations in the *tutuma* use and discard pattern occur particularly when they migrate to *zucano*-using districts. Only about 10 percent of the leatherworkers I interviewed lived in a community that was not their birthplace, and of these less than 1 percent had moved to the Boreda district, where leatherworkers make use of a different handle type.

Leatherworkers moved for two reasons: to acquire farmland and because they had a dispute with their parents.[16] The most common reason for leatherworkers to leave their natal community was the availability of land elsewhere. The Derg government (1974–91) redistributed land and ensured allocation to previous nonfarmers, and they particularly opened land up in areas that were previously uninhabited full-time due to malaria and tsetse fly, such as the lowlands of the Boreda and Abaya districts. The *tutuma*-using leatherworkers living in Boreda or their fathers or grandfathers moved there from the central regions of Kogo, Doko, or Zada. Half of these leatherworkers followed the activity-area pattern described above for *tutuma* users; others, though, were scraping hides in their homes, like their *zucano*-using neighbors.

The change in scraping location and discard pattern is particularly associated with *tutuma*-using lineages, who had been in the *zucano* region for many decades and even generations. For example, I conducted in-depth studies with four *tutuma*-using leatherworkers living in Eeyahoo Shongalay, Boreda, who represented three different lineages of leatherworkers originally from the central Gamo region. Eeyahoo Shongalay leatherworkers told me that in order to move to that particular community, they had to be members of the same clan as resident leatherworkers and needed their permission to live in the community. Resident Shongalay leatherworkers live in a nearby community of Mogesa and use *zucano*-handles. Of the four leatherworkers living in Eeyahoo, two were brothers who moved to the community in the last five years after a dispute with their father. Their mother and her second husband lived in Eeyahoo. The two brother leatherworkers continued the *tutuma* discard and use patterns that

they had learned from their father while living among the central Gamo. The eldest leatherworker of Eeyahoo had moved to Shongalay when land was made available by the government in the 1970s. The fourth leatherworker moved to Shongalay, Boreda, following his sister, who married a local ironsmith. These latter two Eeyahoo leatherworkers had lived there for a long time and continued to use a *tutuma* handle like their fathers, but scraped hides inside their homes and had specific lithic discard locations in their gardens. They continue to use *tutuma* handles because this is the handle of their fathers. Migrating leatherworkers closely associate themselves with their patrilineage, and the continued use of the *tutuma* actively signals their ties with their homeland. Yet, after considerable time spent in their new community, leatherworkers began to change their storage, use, and discard patterns. I found that among other *tutuma* users in Boreda, who represented second or third generations living outside the central highlands, this pattern of change in use, storage, and discard also held true. This suggests that while the style of the material culture may be slow to change even after many generations, the first observed change was in lithic storage and discard patterns. Significantly, after several generations and sometimes just decades, migrant leatherworkers from the central highlands adopted the Boreda *zucano* pattern for storage and discard of their lithics.

ZUCANO PATTERN: LIFE IN THE HOUSEHOLD AND DEATH IN THE GARDEN

Zucano Ontologies and Lithic Discard and Storage Pattern

The *zucano*-using Boreda refer to their Indigenous ontology as *Etta Woga*, Fig Tree Culture, which like *Bene Woga* among the central Gamo districts shares similarities in associating the house with production and reproduction. While *zucano* hidescraper blanks, resharpening flakes, and discarded hidescrapers are present within the leatherworker's house (figure 68), raw material production debitage and cores would only be present at quarries.

Historic Boreda circumcision practices were different from those in the southern districts and primarily occurred in sacred spaces; similarly, a Boreda knapper primarily circumcises stone at the quarry. Elder Boreda remembered circumcision was a public event in a specialized location in one of the *Bayira Deriya*, or ancestral sacred grounds, and was performed by a member of the potter-smith clan. Similarly, *zucano* hidescrapers are knapped or circumcised into hidescraper blanks at the quarry, a place leatherworkers consider sacred ground (see chapter 3). Boreda state that they never purchased chert in the market. Instead they directly procured the materials themselves. Some also claim that there are local obsidian sources, though I have been unable to locate them even with leatherworkers' guidance, and it may be that they are recycling material.

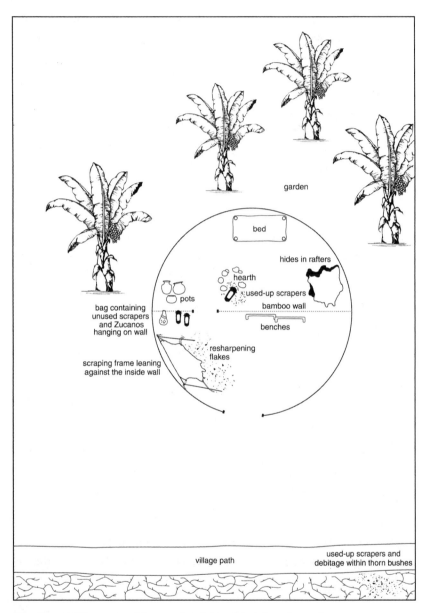

FIGURE 68 Illustration of the typical use, storage, and discard pattern in a *zucano*-using household. Weedman 2006, permission from *Journal of Archaeological Method and Theory*; original designed by Melanie Brandt.

At the quarry, the *zucano* users work within a river valley in an approximately two-meter diameter area, where evidence of production in the form of cores and debitage are clearly present. They make piles of their hidescraper blanks to bring back to their homes (figure 69).[17] Since most of the reduction process in *zucano* hidescraper technology occurs at the quarry, it would not be common to find raw material, primary or secondary debitage, or cores in *zucano*-using households.

Like the leatherworkers who experience ritual seclusion and lifelong maturation in their households, the life, storage, and preliminary discard of a *zucano* hidescraper, small shaping waste, and resharpening flakes primarily exists within a leatherworker's household. After a man's birth, circumcision, and initiation into any of the Boreda ritual-political positions, he rests in house for a period of nine months, gestating into his new social position in society. A Boreda person's afterbirth, foreskin, and clitoris are buried in the animal pen located near the household hearth. Likewise, hidescraper blanks (boys, *naꞮay*) venturing back from the quarry after circumcision find respite in the household either near the hearth or above the house lintel. When a leatherworker needs a fully fertile adult hidescraper, he selects a blank boy hidescraper from his cache and shapes it further into a circumcised youth (*pansa*), leaving small production waste (*chacha* or earthly waste) near the hearth that is swept into the animal pen. He lays his scraping handle near the hearth to warm the mastic and pries out the old hidescraper (*cima* or elder), placing him to the side of the hearth in preliminary

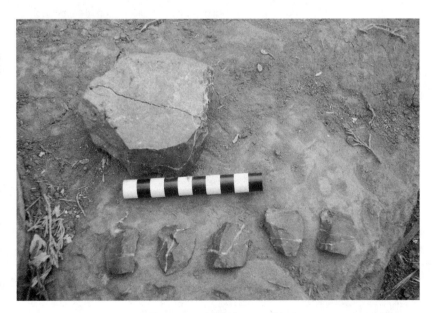

FIGURE 69 *Zucano* core and hidescraper blanks at a quarry.

discard. He then inserts a new fully fertile hidescraper (*pansa*) in the haft, forming a married tool ready to scrape the hide. *Zucano* users commonly scrape their hides and resharpen hidescrapers inside their homes in the *wege* or front portion of the house that is considered male household space. The scraping frame sits in the *wege* portion of the household, usually to the left of the entrance, which allows natural light for scraping. Most leatherworkers sharpen their hidescrapers over a dried hide and then pour the sharpening waste into their storage bowl or cloth, though pieces often fall to the floor and no effort is made to clean them up. Resharpening waste, final production waste, hidescraper blanks, partially used hidescrapers, and exhausted hidescrapers reside and rest in Boreda leatherworker households like a Boreda man experiencing household seclusion (*dume*).

The hidescrapers found within a *zucano* household are formal end hidescrapers and are morphologically distinct from *tutuma*-hafted hidescrapers. The *zucano* handles have closed hafts that require a hidescraper with a specific breadth and thickness. There is less variability and range in the breadth and thickness of *zucano*-hafted hidescrapers than there is for *tutuma*-hafted hidescrapers (figure 70).

Knappers shape *zucano* hidescrapers on the distal, proximal, and one or more lateral edges, creating unused formal tools compared to the *tutuma* hidescrapers (figure 71). *Zucano* hidescrapers are resharpened during use, resulting in exhausted formal end hidescrapers with a steeply worked single edge.

Like their human counterparts, *zucano* hidescrapers and some of their debitage find their final earthly resting place in a leatherworker's garden. Hidescraper beings arrive at *zucano* households already partially mature. Thus at *zucano*-using households, we would not expect to find raw materials, cores, or primary or secondary debitage.

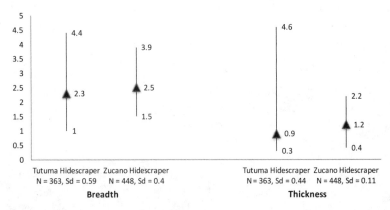

FIGURE 70 Graph illustrating the mean breadth and thickness/height of *zucano* and *tutuma* unused hidescrapers (811 hidescrapers), showing that *zucano* hidescrapers tend to be thinner to accommodate the haft. Graph created by Kathryn Weedman Arthur.

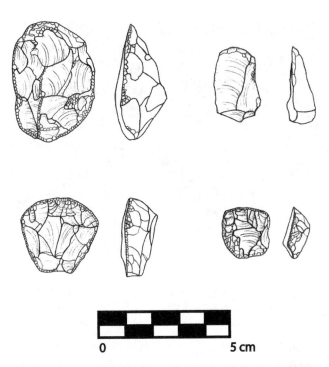

FIGURE 71 Drawing comparing unused *zucano* and *tutuma* hidescrapers (top row) to two different discard *zucano* and *tutuma* hidescrapers (bottom row); note these are drawings of four different hidescrapers, *not* two hidescrapers in different use stages. Drawing by Kathryn Weedman Arthur and inked by Kendal Jackson.

Zucano users tend to conduct the final shaping of their hidescrapers near the hearth and replace hidescrapers in this location at the hearth. Therefore, we could expect to find hidescrapers and some small shaping debris near the hearth and, as scraping occurs in the household, some sharpening debris and perhaps broken hidescrapers in the front room, or *wege*, of the household. While the leatherworkers may on occasion pick up exhausted hidescrapers removed near the hearth and select larger waste pieces for removal, more often than not they leave them where they fall and make little effort to remove any lithic materials from the household. Their wives and daughters, however, often sweep the household floors collecting the lithic waste. Both men and women place lithics in lithic-specific waste heaps located outside in the household garden at the base of a tree or near footpaths in thorny bushes between households belonging to lineage-related leatherworkers (figure 72). Members of an extended family (father-son) often share lithic waste piles. Although women swept the floors of the household, *zucano* hidescrapers and lithic waste often appeared in the household

FIGURE 72 *Zucano* hidescrapers discarded near base of tree.

near the hearth, at the edges of the household, in the household animal pen, near the threshold, or near the inside-scraping frame.

Zucano Households: Types and Quantity of Lithic Discard

In the absence of much of the production waste at a *zucano*-using household, it is likely that there would be less lithic discard present than in *tutuma*-using households. I collected resharpening material and shaping material from fourteen *zucano*-using events. Similar to *tutuma*-using households, *zucano* users process two to three hides a week. They employ an average of four and a half hidescrapers with an average of 9.6 grams of lithic waste per hide (table 17). On average they would discard per household per year approximately 690 hidescrapers and 1,469 grams of sharpening debitage. Since only hidescrapers and a small amount of shaping debris is present in *zucano* households, there would be no raw materials, cores, or primary and secondary debitage discard within household compounds. Though for interest of comparison with *tutuma* users, *zucano* users who produce specific-sized hidescrapers need only slightly more raw material. From my production study of five *zucano*-using leatherworkers reviewed in chapter 4 (table 9), *zucano* users would need 39,664 centimeters cubed raw material a year, similar to the estimates (table 16) for *tutuma* users.

Population Pressure Impact on Zucano Lithic Storage and Discard Pattern

During the last fifty years, through a combination of Derg resettlement schemes and increased population growth, there has been increased permanent settlement of the Gamo in mid-elevation and lowland zones, which is affecting the storage and discard patterns of the *zucano*-using Gamo. Previously farmers owned farmland in

TABLE 17 Estimates of lithic debitage and hidescrapers discarded at 14 *zucano* household events.

SHARPENING DEBRIS PRODUCED	>4MM GRAMS	>2MM GRAMS	>.250MM GRAMS	>.063MM GRAMS	TOTAL SHARPENING DEBITAGE GRAMS	NUMBER OF HIDESCRAPERS
Per hide average	6.00	2.11	1.28	0.06	9.42	4.43
range	0.4–22.8	0.3–7.4	0.1–4.6	0–0.1	0.86–26.7	3.5–8
SD	6.5	2.08	1.24	0.13	9.62	1.27
Per year average at 3 hides/week	936	329.8	198.9	10.02	1468.77	690.85
Cache	Flakes with no cortex	Flakes with less than 50% cortex	Flakes with more than 50% cortex	Cores		
Number average	5.5	4	0.75	0		
Average needed per year	Raw material per hidescraper: 287 cm³ raw material/5 hidescrapers = 57.4 cm³ per hidescraper	Raw material for 1 year: hidescrapers 691 × 57.4 cm³ raw material = 39663.4 cm³				

the mid-elevation and lowland areas, where they often seasonally occupied a second house. Since I began working in the Gamo highlands twenty years ago, there has been more permanent farmer (*mala*) settlement in the mid-elevation and lowland areas, and farmers do not like the leatherworkers near their land or water resources. Leatherworkers travel these elevations to gorges, where they quarry for chert materials and often face danger including direct threats from farmers, as indicated by my experience narrated at the beginning of chapter 3. Consequently, leatherworkers are spending less time at the quarry and bringing the raw material back to their homes. They continue to produce their tools in their homes near the hearth, though there is more production debris present in the household context than twenty years ago.

COMPARISON OF GAMO LITHIC STORAGE AND DISCARD PATTERNS

The lithic storage and discard practices of leatherworkers are entwined in the leatherworkers' ontologies. Change and the life cycle, *Deetha*, are essential tenets in Gamo *Woga*, or their Indigenous theories of being. As living beings, stone transforms in its life and is birthed as an infant raw material/core from its mother—the earth's womb. It then proceeds to be circumcised or shaped, is married with a haft, matures through use, and eventually is buried. Changes in a human and nonhuman being's life course are instigated by either reproduction or ritual reproduction, both of which largely occur in the household and at sacred grounds that represent ancient communities with households. Leatherworking is a trade among the Gamo transmitted through specific lineages and practiced in segregated homes in the community. In the past, if community members found lithics outside the constraints of the leatherworkers' households, they would accuse the leatherworkers of trying to harm them and enforce further seclusion. Consequently, male leatherworkers work in or near their homes, and the distribution of lithic debris in a community is restricted to the areas within and near leatherworking homes. In my walks in Gamo communities, I rarely noted the presence of lithics outside the living areas of leatherworkers.

The dual organization of hidescraper technology exhibited by Gamo *tutuma* and *zucano* leatherworkers demonstrates the presence of agency within their practices associated with their ontology that structures the life course of stone (table 18). The *tutuma* pattern exists in the southern and central Gamo districts.[18] Specifically, all stages of a *tutuma* stone being's life cycle (raw material, cores, debitage, flake blanks, partially used, and discardable hidescrapers) would be found outside in the garden of the leatherworker's household compound, paralleling the human ritual circumcision and burial practices in several of the central Gamo highlands outside the

TABLE 18 Comparison of Gamo *tutuma* and *zucano* patterns.

	TUTUMA	*ZUCANO*
Gamo Location Used	Central and Southern Gamo	Northern Gamo
Environment	Highland	Highland and Lowland
Products	Domestic Hides	Domestic Hides
Quarry Procurement Strategy	No Production Bring Raw Material Home	Produce Hidescraper Blanks Bring Hidescraper Blanks Home
Household Production	Raw Material to Discard Hidescraper	Hidescraper Blank to Discard Hidescraper
Hidescraper Production	At Home	At Home and Quarry
Hidescraper Storage	Outside Home	Inside Home
Debitage Storage	Outside Home	Inside Home
Scraping Hide	Outside Home	Inside Home
Hidescraper Hafting	Outside Home	Inside Hearth
Hidescraper Discard	Outside in Garden	Outside in Specific Locations
Unused Hidescraper Form	Informal Flakes Expedient	Formal End Hidescrapers with Shaped Laterals
Unused Hidescraper Mean cm	Length × Width × Pthick 2.80 × 2.30 × .90 n = 363	Length × Width × Pthick 3.90 × 2.50 × 1.2 n = 448
Discard Hidescraper Forms	End, End-Side, End & Double Side, Double End & Side	End Hidescraper
Discard Hidescraper Mean cm	Length × Width × Pthick 2.67 × 2.38 × 1.06 n = 379	Length x Width x Pthick 2.83 × 2.44 × 1.33 n = 489

home (table 18). Like his human counterpart, the *tutuma* hidescraper is circumcised (*katsara*) or knapped outside in the leatherworker's garden. The leatherworker conducted his trade and matured and rested after circumcision in his household garden. The unfertile waste (*chacha*) in the form of primary, secondary, and tertiary debitage falls to the ground and is collected and stored in bowls or in the earth near the base of an enset plant in a leatherworker's garden. Initially, there is very little shaping of the stone hidescraper, and it resembles an informal tool or a boy (*naɹay*). The hidescraper is shaped slightly in circumcision (*pansa*) and then hafted and becomes an adult married man (*wodala*). The hidescraper, the haft, and the hide come together in use—in household feasting or *bullacha*—outside a leatherworker's household, which is the same location for human ritual household feasts. Leatherworkers often resharpen the edge of a hidescraper during use, and it becomes mature (*wozanota*), and they rehaft tools. Multiple edges of the hidescraper engage in scraping hides, constituting a broad selection of formal hidescraper types when they become mature and old men, or *cima*. Discard morphology of *tutuma* hidescrapers is highly variable and may include end, double end, double side, end and side, and use of all edges of a hidescraper tool. Eventually all lithic materials, including the hidescraper beings, die (*hayikes*), and like the leatherworkers in the past, their bodies are dispersed into the leatherworker's household garden and reincorporated (*sofe*) into the earth. Interestingly, when leatherworkers move from a district that engages in a different material type, use, storage, and discard pattern from their natal community, storage and discard patterns are one of the first aspects of technology to incur change.

In contrast, the *zucano* closed mastic haft pattern is found in the northern Gamo districts, which is common among other Omotic-speaking peoples to the north, as well as other linguistic and cultural societies to the north and east of the Gamo.[19] Most northern Gamo in the past were circumcised in sacred grounds, not near their households. The restrictions of a closed mastic haft also encourage leatherworkers to knap hidescraper blanks at the quarry. The fetus raw material (*gachino*) stone is removed or birthed (*yella*) from the womb of the earth, and as it is removed it becomes an infant (*uka*), who is shaped or circumcised at the quarry into a young boy or hidescraper blank (*naɹay*). Most production debitage waste (*chacha*) remains at the quarry, though small amounts of tertiary debitage lie near the household hearth where final shaping is conducted before hafting. It is near the hearth or above the door on the lintel where young hidescrapers rest (*dume*) when they come from the quarry. Leatherworkers rest and recover after circumcision within their house mostly near the hearth, and as they mature they practice their trade of leatherworking within the front room of their home. In *zucano* households, the final shaping or circumcision of the hidescraper is near the hearth, transforming the young boy into a youth (*pansa*). This small debitage remains near the hearth like the foreskin or afterbirth of humans

that is buried in the animal pen adjacent to the hearth. The hidescrapers represent formal end hidescrapers often with shaped laterals. Near the hearth the youth is bound with the female haft in marriage, becoming a married man (*wodala*), where many Gamo consummate their marriage. Together they work to process the hide in the *wege* front room of the household. Leatherworkers state that the coming together of haft, stone, and hide represents *bullacha* or feasting. Through resharpening, the stone hidescraper matures and becomes a respected man (*wozanota*). When a tool is completely exhausted through use, it is an elder near death, *cima*. The *zucano* hidescrapers resemble archaeological formal end hidescrapers with extensive lateral and proximal shaping. Final discard of all *zucano* lithic materials, including their formal end hidescrapers that become dead (*hayikes*) with extensive lateral and proximal shaping, may be found in burials near trees in leatherworkers' household gardens, reincorporating (*sofe*) into the earth.

The Gamo theory of being informs a leatherworker's negative status in society and restricts the storage and discard of lithic materials to within and near their homes. Within this structure, leatherworkers actively select to stow and dispose of their lithics, contingent on the ritual practices they experience in their resident district.

MALE KNAPPERS AT HOME: STORAGE AND DISCARD PATTERNS

WHAT WE LEARN FROM INDIGENOUS LITHIC PRACTITIONERS

The Indigenous ontologies of the Gamo assign gender to beings and where and when beings occupy particular spaces. Knappers are male craft-specialists, who learn through their male relatives to produce stone hidescrapers that they employ in their part-time leatherworking household trade. In the past, knapping and processing hides provided the whole of the leatherworker's livelihood. Many Gamo perceive technology as reproduction that ideally should occur in and near the household and should involve both male and female participation to instigate proper production. During the last two centuries, male monopoly over lithic and leatherworking technology is recognized as a transgression against women with the potential to disrupt well-being and fertility. Consequently, male knapper household work spaces are segregated from their neighbors in the landscape. Structured by their ontologies, male knappers and stone generally experience seclusion or storage, *dume*, within and immediately around the leatherworker's household and at death or discard are typically buried in a household garden, *sofe*. Across the Gamo landscape there are multiple interpretations of *Woga* ontology, including *Bene Woga* and *Etta Woga*, and therefore there are at least two patterns for organizing the reproduction of technology. The biographies of the Zada

Gamo and Boreda Gamo stone hidescrapers exhibit different life courses, though both involve the use/maturation, storage/rest, and discard/death within a leatherworker's household compound.

MEN AT HOME

Indigenous men and women as lithic practitioners primarily knapped and used tools for household consumption, thus tools were often stored in or near their household and in some instances discarded in the household. Many archaeological interpretations of stone tool technology are based on Western perceptions of division of labor and space, allocating men as the primary toolmakers and the adventurers who traveled to resources and hunted outside the home. This interpretation reflects widely held Western industrial precepts of the male knapper working outside the home. In valiant attempts to bring visibility to women in the past, archaeologists commonly argued that women made informal tools within the household.[20] Joan Gero and those who followed her paved the way for examining the organization of past stone tool assemblages open to diverse interpretations of the gendered division of lithic technology labor and space.[21]

Ethnohistoric records attest a great wealth of information from travelers as well as more formal studies of knappers that demonstrate that both men and women made stone tools at or near their homes for household use.[22] Knapping usually was not the specialization of a select group or a particular sex, but conducted by the entire community and learned in a kin-based context, as part of daily activities within and near the household. Studies among historic foragers of Australia, agricultural New Guinea islanders, and the pastoral-foragers OvaTjimba of Namibia suggest that both men and women and their children were involved in lithic technology of a variety of informal and formal stone tools for household use.[23] Nearly all ethnoarchaeological and, as noted above, ethnohistoric studies of men producing axes, adzes, scrapers, spears, and arrow points and a variety of other tools indicate that men worked stone primarily near or around their homes.[24] Unfortunately, Western scholarship is so entrenched in the trope of the male knapper and toolmaker that a very close reading of the material is necessary to ascertain the location of work. Researchers often focused on male knappers or made statements about lithic and tool technology as the sole purview of men, even when they knew and described women as practicing quarrying, knapping, and composite tool production.[25] Lithic debris and tools located within the household may represent activities of both women and men, and it may be nearly impossible to discern between the two, though women are known ethnographically to primarily produce stone tools using the bipolar technique.[26] Ethnoarchaeological studies focused on household use of space widely cautioned that among foragers the presence

of localized debris near hearths represents the intermixture of male and female tasks[27] or visibility based on differences in activities.[28]

ORGANIZATION OF TECHNOLOGY AT THE HOUSE

There is strong suggestion that cross-culturally Indigenous lithic practitioners viewed lithics as living beings and lithic technology as reproduction (see above and chapter 3), and most lithic storage and discard occurs in and near households. Archaeologists generally propose several different hypotheses regarding the organization of lithic technology primarily related to distance to raw material, type of tool produced, and impact by recurrent use of or multiple activities performed in a particular area.[29] The Gamo organize their lithic technology into two broad patterns practiced according to their perceptions regarding reproductive and transformative space. In one pattern, a knapper brings cores from the quarry and within his household garden produces an informal tool, using it in an open haft and discarding all lithic waste in the household garden. In a second Gamo lithic pattern, the knapper procures stone blanks at the quarry, and within his home he shapes them into formal tools that he hafts using mastic into a closed socket handle. He then discards all lithic materials in a specific location, usually near the base of a tree in his household garden.

Among Indigenous knappers, cross-culturally the two Gamo patterns of lithic production, use, and discard at households are widely exhibited as will be demonstrated below; there are, however, some exceptions. In some instances tools were entirely produced at the quarry, such as spears, knives, and scrapers among the Yolngu of Australia,[30] and informal knives among the Duna of Papua New Guinea.[31] Other knappers in Australia and Namibia made informal tools for butchering out of surface pebbles that situationally existed near an animal that was hunted and killed.[32] These tools had an exceptionally short use-life, as they were produced, used, and discarded within minutes or hours near the kill far from homes. Furthermore, there is a wide spectrum of hafting types for stone tools that do not seem to correlate with the Gamo patterns that associate hafting type with whether a tool is informal or formal or whether a knapper brought raw material, cores, or blanks back to the household.[33]

Cross-culturally, a knapper's perception of space and the type of tool to be matriculated prior to his journey to the quarry seems to be the most important factors in the organization of the use of space related to his or her lithic technology resulting in two distinct patterns. Generally, knappers procuring raw material to produce formal tools usually bring stone blanks from the quarry to their household. Most ethnographic knappers who produce informal tool beings or acquired raw material through trade produce their tools from raw nodules or cores at their household.

Pattern 1: From Raw Material/Cores to Discard at Households

Cross-culturally, knappers who practice reducing raw materials and cores in or adjacent to their homes produce informal and formal tools from resources they received primarily through trade. Consequently, for many households the entire production sequence is visible archaeologically within or near the house (table 19).[34]

In Ethiopia and Mexico, knappers specializing in the production of a single formal tool type, hidescrapers and arrows, brought raw material to the household for shaping and use. Among the *tutuma*-using Gamo and other *zucano* users among the Wolayta, Sidama, Konso, and Oromo, raw material or cores were sometimes brought directly from the quarry but more commonly purchased at markets.[35] Most of these leatherworkers reduce their cores, shape, and resharpen their tools outside their household over bowls or hides with some debris, particularly small pieces falling to the ground, with little attempt to clean up the waste. Sometimes these leatherworkers have separate workshop structures on their property for scraping hides. Scrapers are often used and stored within a year.[36] Discard of lithic materials including exhausted scrapers is within the household garden.[37] An exception were the Konso, who live in more central areas of the tightly spaced nucleated walled hamlets, and the Wolayta, who live in the main town of Soddo; both were observed discarding their lithic material in community trash pits.[38] In Mexico, men working full-time to produce chert arrows for tourists purchased raw material.[39] These full-time knapping specialists transmitted their knowledge within their lineage, and production occurred primarily near the household hearth and within the household.

Ethnographic knappers making informal tools also frequently bring raw material and cores to the house for production and use. In the Western Desert of Australia, several works concur, the young men would bring cores to living places where the old men would make the tools.[40] In Australia, among the Alyawara, knappers brought quartzite cores from the quarry to produce informal tools such as utilized flakes, women's knives, and other tools.[41] Cores were kept at men's houses and temporary men's camps separate from nuclear families' and women's houses. They allowed small items to fall to the floor or swept them to the edges of the household, while they discarded larger items in middens or refuse areas just outside the activity area.[42] While tools were largely produced in a household or community context, efforts were made to remove the waste and place it away from households. The Wola of Papua New Guinea brought high-quality chert raw material to their household to make informal tools.[43] Importantly, the study of the Wola indicates that even materials for informal tools such as unused flakes and cores could be kept in storage for years. They stored informal tools along with cores and flakes in bowls and pieces of cloth under the eaves of houses and buried or nestled in the branches of trees near the house.

TABLE 19 Comparison of ethnographically known knappers illustrating the types of products they produce and that their storage and discard patterns are mainly within or near households.

COUNTRY CULTURE	PATTERN	TOOL TYPE CONSUMER	PRODUCTION CORE	PRODUCTION BLANK	PRODUCTION TOOL	RESHARPENING	STORAGE	DISCARD PRELIMINARY	DISCARD FINAL	ESTIMATES PER YEAR
Ethiopia Gamo-Boreda Gurage Hadiya	2	Formal hidescraper household	Quarry	Quarry	Inside house or just outside house	Inside house or next to house	Inside house, gourd, bowl, cloth, or next to house	Hearth and house floor or next to house	Household garden near tree, pit	Gamo: 691 tools, 1,468 g resharpening waste, 39,663.4 cm raw material
West Papua Indonesia Dani, Wano Langda	2	Formal ax/adze ritual bundles exchange	Riverbed	Quarry	House, field house, lineage head house		House, field house, lineage head house, forest, rock shelter		Bury at house, lose in forest	
Papua New Guinea Hagen, Wiru Tungei, Wahgi Duna	2	Formal ax/adze exchange	Streams	Quarry	House, field house, lineage head house		House, field house, lineage head house, forest, rock shelter		Bury at house lose in forest	Duna owned 22–44 axes per man per his lifetime
Australia (Northern Territory) Alyawara	2	Knives, maintenance tools for wood scraping adze knives	Quarry	Quarry or men's camp	Men's camp		Brush by shelter		Debris raked and swept away	

(continued)

TABLE 19 (*continued*)

COUNTRY CULTURE	PATTERN	TOOL TYPE CONSUMER	PRODUCTION CORE	PRODUCTION BLANK	PRODUCTION TOOL	RESHARPENING	STORAGE	DISCARD PRELIMINARY	DISCARD FINAL	ESTIMATES PER YEAR
Australia (South) Pitjandjara Ngadadjara Nakako	2	Knives, spear-thrower tip, circumcision knives, adze/chisel	Quarry	Quarry and use of natural flakes	Camp		Camp			
Australia (South) Lake Erye	2	Formal drill, graver, wood chisel, knives, scrapers	Shelter of creek or sand hills	Shelter of creek or sand hills	Camp		Pits in house			
Australia (Northern Territory) Yolngu	Neither	Formal spears, stone ax, circumcision knives	Quarry	Quarry	Quarry					
Turkey Cakmak	2	Formal blade for threshing sledges	Quarry	Quarry	Workshop					500 tons per year
Australia (Western Desert) Ngatatjara Ngatunyatjara Ngatjara	Both	Informal tools choppers and knives	Not quarried surface pebbles and "flats"		"Instant" tools made at use location	"Instant" tools made at use location	No storage	None	Pattern 2: at production and use location	Pattern 1: 18.000 kg per year Pattern 2: average 23 per year 954 grams per year

Australia Western Desert Gugadja Pintupi	1	Woodworking adze flakes and flakescrapers	Quarry	Habitation camp and quarry	Habitation camp	Habitation camp	Habitation camp	Habitation camp	Habitation camp	
Ethiopia Gamo-Zada Wolayta Oromo Sidama	1	Formal hidescraper Gamo informal unused hidescraper, household	House compound	House compound	House compound	House compound	House compound gourd, bowl, cloth	Outside near house	In garden	Gamo 870 tools, 1,270.6 g resharpening waste 39,550 cm^3 raw material
Ethiopia Konso	1	Formal hidescraper, household	House compound	House compound	House compound and near hearth	House compound	House compound gourd, bowl, cloth	House compound	Community trash pit and over wall of household compound	
Papua New Guinea Wola	1	Informal tools no retouch boring, digging, cutting, engraving	Household compound	Household compound	Household compound	Household compound	Household compound	Household compound bowls and cloth	Household compound branches of trees or buried at base of tree	
Mexico Lacandon Maya	1	Formal tourist arrowheads	Household hearth	Household hearth	Household hearth	Household hearth	Household hearth	Gourd in house	Stream bed, tree hollow	

Pattern 2: From Tool Blanks to Discard at Households

Toolmakers producing formal tools usually create tool blanks at quarries, leaving most production waste behind and finishing, using, and discarding their tools at their households (table 19). In Ethiopia, Turkey, Indonesia, and Papua New Guinea, creation of tool blanks at the quarries leaves visible locations of production at mines. Evidence for quarry workshops in the forms of pits, stone-wall shelters, and large collections of debitage is evidenced in Turkey, where living knappers made blanks for threshing blades.[44] Blade production was a seasonal activity performed by men in communities living near the quarry. Men made the blanks at specialized workshops at the quarries and sold them to thresh makers, who finalized the shaping of the blades at their workshops before selling the final product. Some Ethiopian leatherworking knappers using mastic hafts also brought back hidescraper blanks, such as among the Gamo, Gurage, and Hadiya.[45] These leatherworkers tend to finalize tool production and use their tools inside their homes or near the house door and haft their tools near their hearth. They occasionally clean up or sweep debitage to the edge of household structures or dispose of it away from areas where people work; however, it is clearly visible in garden patios and household floors. Attempts are made only to collect the larger debitage and exhausted hidescrapers within or near their household, discarding the material in pits and tree hollows within the household garden.[46]

In Indonesia and Papua New Guinea, knappers living near the quarry made ax and adze blanks at the quarry and finished them near their community home, near the home of the lineage head, or at their agricultural field home, allowing debitage to fall in situ.[47] Some adze and ax stones obtained through exchange are profane and used for war payments, marriage transfer, and trading and once traded may become sacred.[48] They were displayed and stored against the interior walls of men's houses in Indonesia, while men in Papua New Guinea stored their axes in their households, in a rock shelter near their field, or near the base of tree, and loss of axes in household gardens and forests was common.[49] The average life of an ax was ten to twenty years. Men stated that they felt sorry for their farming stone axes when they broke in the forest and brought them back to their homes for burial.[50] Other axes were part of ceremonial use in ancestor propitiation and were stored in a ritual cabinet in men's houses.[51]

In Australia, men made blanks at quarries or at shelters away from the camp and finalized the shaping of their formal tools, such as men's circumcision knives, spearthrowers, adze/chisel, drills, and gravers, at their camp and stored them in pits in their homes.[52] In Australia and Ethiopia, if mastic secured the tool in the hafting, then commonly a knapper worked and stored his stone tool near the household hearth.[53] Formal tools such as spears and circumcision knives were buried in the household for future use and trade and frequently had long use-lives and could be kept for up to ten years.[54] Debris was often raked and swept away.[55] Ethnographic studies of knappers

indicate that when a person has a preconception of the tool he or she intends to produce, that person often produces a tool blank at the quarry and finalizes his or her work at their home.

ONTOLOGIES CONCERNING KNAPPED STONE AND USE OF SPACE

How did knappers perceive the spaces in which they interacted with stone during use, storage, and discard? John Clark, in his review of the lithic discard among ethnographic knappers, concluded that cultural understanding of what constitutes trash is important.[56] There is some evidence that corroborates that in Mexico, Australia, Indonesia, and Papua New Guinea—that some communities' ontologies expressed that knapping stone was more than a nonliving entity that simply became trash or refuse at discard. Instead, in many ethnohistoric and ethnographic descriptions, knapped stone was a living being with power to inflict harm and well-being, and as such it is likely that it occupied significant care during its placement in life and death.

Recent Mesoamerican studies focus on the meaning of community and forest spaces,[57] and ethnohistoric research discusses ontological perceptions of obsidian and chert.[58] The only present-day description of stone knapping in Central America is for tourists in Mexico among arrow makers, who discard their lithic waste in ravines[59]—the same feature on the landscape from which they obtain the stone. Ethnohistoric documents from the Tarascans (CE 1100–1422) state that historically obsidian and chert were sacred and associated with the subterranean world.[60] The earth mother gave birth to stone and to masculine stone implements that transformed into clouds and were associated with water, rain, and hot springs and had power to extract "precious water" or blood from humans. Tarascans associated obsidian with healing; cutting human hair for ritual purposes as a rite of transformation into another state; and human incision for blood offerings, human sacrifice, warfare, and hunting. On the landscape, obsidian was associated with volcanoes, mountains, and thermal springs. Forest or mountain space where obsidian sources exist were places of danger and where people built shrines to request permission to hunt and request forgiveness afterward.[61] In central Mexico, miners believed that they were disturbing the earth's entrails, and mining was accompanied by rites that included lullabies to appease the fetuses in the earth.[62] Ethnographic research among the present-day Maya also suggests that they designated household and community space as social space that validated inheritance and ancestors.[63] At households, obsidian blades were kept in bowls of water near household doors or courtyards to protect the house. The sound of flooding mines and hailstorms beating down on obsidian in mines was associated with harm from the gods. Ethnohistoric documents from parts of Central America suggest that ontologies

existed in which knapping stone was imbued with power to harm, heal, and protect and was therefore likely handled, stored, and discarded with care.

In the New Guinea highlands, stone contained the spirits of the ancestors, and adze and ax knappers stored and discarded tools near and within men's houses, separate from family houses.[64] In some communities quarrying required ritual purity, and food offerings were provided for the female river spirit and the male stone spirit.[65] Adzes and axes also became wands with woven handles, which were carried by men to enforce social etiquette, as amulets to find good quarry stone, and as part of men's healing bundles.[66] Other adzes and axes were identified with supernatural power, embodying the spirit beings of ancestors. They resided in the lineage head men's house in the sacred cabinet at the back of the house. It was important to orient the sacred stones properly, so as not to cause discomfort, in a prone position face upward, to be maintained in the sacred cabinet. Unaltered stones and small adzes and knives may be kept by women in bags in their households to ensure pig health and human well-being. Axes and adzes were living entities that men felt sorry for at their death and returned them to be buried near their homes.[67] Also living in New Guinea are the Wola who knap informal stone tools and discard them outside in their household gardens as knapping inside the house is taboo.[68] The Wola have a proverb that if one were to work inside, someone would demand the repayment of a pearl shell. Although the authors do not explain, we can assume this would incur a grave misstep and shame, as according to other sources pearl shells are primarily obtained through bridewealth exchange and associated with female fertility.[69] Perhaps the implication is that the stone had the power to disrupt human fertility; certainly more research along this line is needed.

In Australia, too, ethnographic knappers primarily use, store, and discard their lithic materials near their homes. In the Western Desert men brought from the quarries cores or "the mother ones," who bled at the living places to produce flakes.[70] In his study of archaeological sites in the Western Desert, Scott Cane enlisted the assistance and interpretation of elders at archaeological sites. He noted that they "treated some sites with extreme care," and after Cane picked up a tool, an elder would pick it up again and place it down again.[71] Unfortunately, he did not ask why they engaged in this behavior, though we can surmise from their classification of cores as "the mother ones" that they held some semblance of respect for stones as living entities that deserved care and respect. Yolngu of the Northern Territory procured the stone for exchange spears from a quarry literally named "head-stone-flake," and viable stones were considered "young ones."[72] In Indigenous Australian ontologies of the Dreamtime, the ancestral beings created the landscape and particular locations where creative forces were powerful—one being quarries. The power of the stone was extraordinary, and it was essential that the power or spiritual essence be distributed throughout

the landscape. Although several ethnoarchaeologists discuss the presence of lithics at habitation camps, explanations for use of space are examined in terms of activity areas and distances between residences, kinship, and predation with virtually nothing concerning how people themselves thought about household and community space.[73] Most debris was discarded near the edge or within thirty meters of the household where activity takes place.[74] Cultural anthropologists offer that historically men practiced separate but complementary rituals and use of community space.[75] If men and women worked separately as suggested, perhaps they also had different areas of lithic production and use. Clearly there are some cross-cultural indications that stone as a raw material and as part of human household assemblages were considered living beings that required care and respect often near households.

HUMAN AND STONE BEINGS IN ASSEMBLAGES OF CHANGE

While a substantial amount of male lithic technologies should be visible in household contexts, we should not forget the perception that humans, their houses, and all other beings including the land and other materials create assemblages that have the power to impact movement and change in one another.[76] As the Gamo express as one of their central tenets, life is about constant change, and all beings, material and nonmaterial, exhibit life and the capacity to change. Houses grow old and deteriorate, are eaten by other beings, and are pounded by the forces of wind and rain. The Gamo do not abandon a house even at the death of its occupants; instead, it may be moved to another location or reoccupied by descendants. At the death of a home, it is allowed for some time to reincorporate into the earth, and after an appropriate time of gestation, the space it once occupied may be rebuilt for another house, allowed to regenerate into forestland, or plowed for agricultural land. There are many activities in gardens and households that potentially disrupt the distribution of lithic materials in an archaeological assemblage. Within gardens the earth is also disturbed and moved through the actions of rodents and insects, people plowing and weeding, and people moving their houses and switching agricultural and household space. In households, floors are swept, residents often move their hearths periodically within the home, and humans and domesticated animals often trample and move lithics simply by walking on the grounds. Experimental studies offer that postdepositional activities, such as trampling, and carnivores also affect breakage, edge damage, and the spatial distribution of lithics.[77] Certainly ethnographic studies confirm that debitage may be left on the floor/ground, missed by sweeping; and other lithic items also get inadvertently lost (forest, garden, house) or abandoned with a house (fire, death of owner, or moving residence).[78] Other studies cautioned that sedentary societies tend to discard materials in specific midden areas as secondary refuse, which can easily be misidentified as

primary-use areas.[79] Seldom do houses and their human and nonhuman occupants exist in eternity together unchanged.

The biography of lithic materials on the landscape seems closely related to how a knapper perceives stone, the landscape, and his stone tools. Importantly, *male* knappers as specialists or nonspecialists tend to use, store, and discard formal and informal lithics near their homes, which contests Western industrial gender tropes filtered through evolutionary schemes that tend to emphasize the prestigious male formal toolmaker outside the home and portray women as the informal toolmaker at home.

6

THE LIVES OF STONE TOOLS

I BEGAN THIS book with a story about the disruption of my understanding of stone tools and their makers, which required longitudinally living, listening, and learning among people who conceive of the world in a markedly different way. When I asked an elder knapper if I could make a stone tool, I perceived myself as an adult who was working with inert material and speaking to a highly regarded male expert. When he scoffed at me, at first I took it as criticism that I was a woman trying to enact a male practice. After all, in my culture's dominant perspective, stone toolmaking is largely considered a male task. It did not occur to me that a man might have a low status because he made stone tools without the assistance of a woman. Furthermore, to me the stone was an inanimate object and passive in its reaction to the human knapper, who must have been held in high regard in society for his skill. Again it did not cross my mind that the stone had its own agency and could actively change my life. I was an individual conducting classic ethnoarchaeologies reaping Gamo patterns of material production, use, and discard and coating Gamo knowledge within Western archaeological theories of material culture. Over the last twenty years, I observed and listened to many Gamo men and women, punctuated by intense periods of learning. Time passed, unfolding changes—personal, political, environmental, and social. First there came a change in my status from childless to mother, which opened space for new relationships for me to develop with elders. In the view of many Gamo, as a mother, I was mature, responsible, and had a vested interest in the future. I was someone who could be trusted with knowledge of their heritage. Secondly, after nearly fifteen years, their fear of persecution for their Indigenous practices by the toppled Derg government had subsided, and Gamo elders became more comfortable with voicing their beliefs

FIGURE 73 Gamo leatherworker engaged in blowing a bovine bugle, announcing a community meeting, as part of his low status in the community.

about the world. Third, the confluence of environmental changes that include increasing periods of drought, the introduction of new crops from NGOs, and population increases has led to deforestation, soil erosion and degradation, and food shortages. Elders often suggested to me that a return to their Indigenous ways of knowing and being on the landscape was the only solution to combat these ills. Personally and professionally, I shifted, opening myself to learning about Gamo craft-specialists' way of being in the world.

ALTERNATIVE WAYS OF KNOWING
LITHIC TECHNOLOGY

Through long-term ethnographic engagement with the Gamo, I came to acknowledge their alternative way of being and knowing the world as encompassing life in all matter including stone. Arriving at this knowledge required that I set aside my Western perceptions concerning what establishes status, what constitutes skill, and what defines being alive. I engaged in longitudinal studies among the Gamo and sensitized[1] myself to their historic and present-day experiences and practices through becoming articulate[2] in their perspectives of the world. This onto-praxis[3] decolonizes the production of knowledge, respects Indigenous ways of knowing the world,[4] and ensures that we

practice science rather than tautology, opening ourselves to new paths and new futures together.[5]

By conducting long-term studies among the Gamo, I was able to ascertain the historical depth of the male monopoly of lithic technology and how it related to a knapper's status in society and the perceptions of his skill among other knappers. Archaeology suggests that leatherworking with stone tools is at least six thousand years old in the Gamo region. At this time, people produced obsidian-backed microlithic hidescrapers that are vastly different compared with the hidescrapers of living knappers. By the eighteenth century, end and side hidescrapers associated with household floors at local open-air sites were made of a wide variety of raw materials rather than primarily of chert as is the practice today. Furthermore, lithic materials were found in other eighteenth-century household contexts without hidescrapers, suggesting perhaps a different perspective concerning the restriction of lithics to leatherworker households. Gamo oral traditions infer that the male conscription of lithic technology began with the introduction of Christianity and the Gamo's incorporation into the northern Ethiopian state between the fifteenth and the late nineteenth centuries. Studies in Australia also demonstrate that masculinization of lithic technology is likely recent and corresponds to colonialism.[6] Under colonial influence, Indigenous Australian men achieved status and prestige for their association with stone spear production. In contrast, the Gamo male knappers, in reproducing stone beings without women, were perceived by many Gamo to be transgressing the tenets of their Indigenous ontology, *Woga*. Consequently, they, their wives, and their children were socially, economically, and spatially segregated from others in society. Our Western presumptions concerning lithic technology as part of male patrimony and a means through which *only* men earned prestige and status in society are beginning to erode with more in-depth studies of the histories of living knappers and their Indigenous ontologies.

The Gamo ontology, *Woga*, is similar to other African modes of thought that recognize life and a life cycle in all beings. African ontologies express that the power of being is evident in its fluidity and there is no separation in species and matter because all consist of the same essence.[7] African ontologies are unique and combine aspects of vitalism,[8] animism,[9] and relationalism,[10] and they are often revitalized in Western discourse from Enlightenment ideals. Because of the latter, I concur with Afrocentrists that African modes of thought are unique and not borrowed from Europe, nor can they be subsumed under any Western philosophy or theory. For most Gamo knappers, stone is a living being, is gendered male, and has a biography. Stone has power outside of human agency and intention; it exists stirring within an assemblage and formed by the movement and interaction of the earth and rain. In some instances, humans birth stone from the earth, and once a stone enters human social life, it proceeds along a life course that is vastly different than if it had remained in the earth. The life course of

the stone tool parallels that of its caretaker, and both are structured by the Gamo ontology, *Woga*, and its emphasis on *Deetha*, a ritualized life cycle. Within Gamo ontology, *Woga*, there are multiple interpretations, including *Bene Woga* and *Etta Woga*, that create variation in the life cycle of the stone and human, their practices, and their places on the landscape. A knapper and a stone are fetuses (*gatchinnotta*) in wombs and are birthed (*yella*) in a sacred forest or in the home, becoming infants (*uka*), and then they mature in seclusion (*dume*) in the household and become boys (*naꝫay*). Eventually, both stone and knapper are circumcised (*katsara*) again either in a sacred forest or in the home, becoming circumcised youth (*pansi*). Each is married/hafted (*bullacha* feast), consummating the relationship in a house or just outside a house, and each becomes a married man (*wodala*). After maturation within or near the house, the hidescraper and the knapper become respected adults (*wozanota*). An elder knapper and hidescraper (*cima*) are buried after death in the knapper's garden. Among the Gamo, stone, like humans and all other matter, is *Deetha*—life, being—and exists because of the continuous transformative process of reproduction; each stone embodies its own gender assignment, efficacy, and life course. Within the Gamo ontology, *Woga*, male knappers have a low status in society and yet attain value as highly skilled among their community of knappers through lifelong apprenticeships with male lineage elders. They work and discard their stone tools within and adjacent to their households. The Gamo ontology related to lithic technology overturns long-held Western gendered tropes that assign lithic technology to high-status men who can be largely self-taught and work outside of the household.

MALE KNAPPERS: PRIVILEGED OR TRANSGRESSORS? BIRTHING (*YELLA*) STONE BEINGS

The Gamo Indignous ontology, *Woga*, proclaims that stone exists through earthly reproduction. Particular places on earth embody life transformation processes and produce viable stone identified by their sheen, shape, and color by skilled individuals, who can mitigate the dangers of quarrying. *Woga* then is a disruption to Western tropes and ontologies that stress stone as an inanimate resource that is symbolic of masculinity—the male mind, ingenuity, industry, virility, strength, and authority.[11] Extraction of resources, such as stone from the earth, in many Western narratives is a given right of men, who embed or consider this practice within their other male activities, particularly subsistence hunting activities to fulfill his needs in specific environments.[12] Western archaeological reconstructs tend to be humancentric, focusing on how men efficiently use their stone resources, what they quarry, how much they

quarry, what is taken away, how far the resources are from human habitation, how well they use their tools, and how men move across the landscape.[13]

In contrast, ethnographic studies of Indigenous lithic practitioners emphasize that people have a responsibility to the earth as a living entity rather than a right to reap her resources at their convenience and without end. Rather than being concerned with finding the nearest suitable resources, the Gamo Indigenous ontology locates appropriate stone near trees in river gorges, which witness the earthly activity of male rains filling female gorges. Only men of particular *hilancha katchea* lineages, whose ancestors transmit their lithic technology knowledge, make dedicated expeditions traversing as far as fifteen kilometers in the mountainous environment to specific quarries. Stone fetuses (*gachinnotta*) are ready to procure/birth when they exhibit a shine and essence of being and are infants (*uka*), and each lineage selects particular colors of stone that they believe are viable. Generally, it is only expert and master knappers, elder respected men, who can appropriately distinguish "good" stone ready to be born and who attend to the spirits appropriately through offerings to prevent harm during and after procurement. When humans interact with stone, it is birth. Stones may evoke the earth to bury or injure a male leatherworker, who oversteps the female prerogative as midwife. The negative status of male knappers arose most likely when the Ethiopian state incorporated the Gamo into their territory and began conscripting their resources and proselytizing Christian views of patrimony. Prior to this period, there is evidence that women had been more active as leaders in their communities.[14] The Gamo ontological understanding of stone as beings created through a reproductive process highlights the power of both stone and humans to confer a low status to male knappers, providing a powerful and significant alternative to the Western "Male the Prestigious Toolmaker" trope.

In virtually every account of stone-using societies, procuring stone is birth and consequently a dangerous activity for male practitioners. The perils of women quarrying is untenable as the Western-assumed patrimony of lithic technology renders scant mentioning of women at quarries,[15] even when women were acknowledged as toolmakers.[16] Hints, though, exist of the presence of female knappers, and it is likely that male conscription of lithic technology similar to other technologies was the result of colonial and Christian infringement and destruction of more diversity in gendered division of labor.[17] It is essential to recognize that our knowledge of lithic technology derives principally from societies that were living under colonial conditions of missionization and ideological patriarchy. Studies of lithic technology among living knappers tend to emphasize male dominance with toolmaking resources and production. Yet there is also clear ontological perception among many Indigenous knappers that stone is a living entity that is birthed[18] and that women are associated with quarrying, or access was restricted through matrilineal descent and required the appeasement of female

spirits.[19] Annette Hamilton argued that men excluded women in Australia from technology as "a tool of ideological dominance" that mirrored the growing historical emphasize on the importance of men's ceremonial life in the twentieth century.[20] Furthermore, Rodney Harrison's study of the historical context of Australian Kimberley points reveal that they were largely produced over the last two centuries to fulfill the desires of colonial collectors rather than produced for daily use in hunting and ritual.[21] Gamo oral traditions also signal that male control over leatherworking lithic technology likely formed between the fifteenth and nineteenth centuries. Today in Ethiopia, among the Konso, women are the primary knappers and stone-using leatherworkers, and Wolayta men and women knap and use stone in household contexts.[22] Certainly there exists a growing body of literature that suggests with European expansionism and colonialism and patriarchy, men gained greater control over a wide array of technological and economic systems.[23] Among known stone-using societies today, then, procurement primarily is the purview of men, who consequently almost universally experience illness, misfortune, sapping of one's energy, and even death.[24] We should be cautious here because many of these same sources also mention in passing that women were responsible for carrying the stone to their homes, and unfortunately no one inquired why.[25] Among studies of many Indigenous knappers, stone is living, born, grows in the earth, manifests through creation, and is able to reproduce through male and female pairing.[26] Human procurement interrupts the stone's gestation time[27] and disturbs the essence.[28] Although men in other societies do not incur a negative status because of their association with stone, clearly, they are disrupting earthly activities, which is extremely dangerous. Stone commands power and enlists danger, particularly associated with men quarrying or birthing stone. It is not unrealistic to contend that prior to the influences of colonial and Christian patriarchy, lithic technology was likely a shared re-productive endeavor between men and women.

Birthing stone is perilous, and only men who share their ancestral essence or spirit with the stone embark on dedicated expeditions to quarry gorges often within a half day's walk of their home. Importantly, the sacredness of the quarry in some instances was viewed as more important than the quality of the raw material.[29] Commonly, the stone being embodies the ancestral male spirits, who live at specific locations (quarries) in the landscape, emphasizing a continuum and shared spiritual essence between man and stone.[30] Stone reveals its birthplace to men who are related to it through either their mother's descent group[31] or their father's descent.[32] Stone as a living being is born from the earth usually near or in streams or river gorges.[33] The roots of trees penetrating deep into hilltops also produce viable stone.[34] Men will travel fifteen to twenty kilometers to obtain stone on dedicated expeditions before they enlist trade relationships.[35] Generally, men procure stone from sacred places that they are connected to through shared ancestral essence, and among these

men, only particular individuals hold entitlement to potentially escape the perils of quarrying.

Even among men born with the right to birth stone, there are certain individuals who have the ability to recognize when a stone is viable and ready to be born and how to appropriately extract stone from the depths of the earth. Procurement generally is either the purview of older men, who know how to make the appropriate offerings, or young unmarried adult men.[36] Unfortunately, there was little concern among researchers as to why young men did the quarrying, though there is some indication that young men who quarried also were of marriageable status, and it may have been this status, embodying potential fertility, that allowed them to appease spirits in a reproductive process.[37] In other cultures, it was said that elder, initiated men had the appropriate knowledge that allowed them to properly select stones for quarrying.[38] Cross-culturally, stones actively manifest their essence, indicating when they are ready to be born through their shimmer, brightness, or sheen.[39] Stones attract our attention with their special qualities such as unusual shapes (such as egg-shaped nodules), presence of fossils, and color.[40] As a living entity there were appropriate means for birthing stone from the earth that included digging pits in the earth, use of fire, or eroding the soil through channeling water; surface stone was rarely if ever considered appropriate for knapping.[41] Among most stone-using societies, stone only acquiesces to particular men who are related to the stone and who have obtained the appropriate knowledge, skill, and stage in their life course to properly extract the correct viable stone from the earth.

Interacting with living stone beings may be a male prerogative among most lithic practitioners, but it is often a dangerous one. As living beings, stones can bring great harm to a man who births the stone from the earth. Stones are quarried from locations that emanate life in the form of trees and water. A majority of knappers acquire their stone from within the earth, dismissing surface material. Quarries are more than simply accessible and convenient places from which to wrest resources from the environment. They are living ecosystems that reveal the movement and transformation of the organs of the earth. Viable stone emits specific sheens, colors, or qualities that only elder experienced men or fertile unmarried men can recognize. Who is to say that earthly processes that involve movement without human agency such as rain, heat, and so on are not evidence of the vitality of the earth? Stone has a power that is more than relational; it is inherent in its very being. Quarries are singled out as places of initial creation, where creator beings and ancestors resided, and where the ancestors of humans connected to the original creator beings. While archaeological technology has excelled at sourcing obsidians, associating past chalcedonies with particular localities on the landscape continues to elude us. Ethnographic documentation of Indigenous knappers indicates that distance to resources is of minimal importance, though rarely more than fifteen kilometers for direct procurement, and that resources that archaeologists would consider

good-quality material for knapping may be completely ignored if it was not from the correct place, nodular, buried, and embodied the correct color, sheen, and essence recognized by the knapper as a living being. The conception of stone as a gendered, living entity structures which beings entice us for procurement and who is enchanted with the power to procure and interact with stones as they mature during their life course.

MALE KNAPPERS: AUTODIDACTICS OR APPRENTICES? THE RESPONSIBILITY OF KNAPPING (*KATSARA*) AND USING STONE TOOLS (*BULLACHA*)

Recognizing stone as a living entity through their Indigenous ontologies, Gamo knappers have the responsibility to ensure that the stone lives a full fertile life course, shrouding the context of knapping apprenticeships. This ontology creates a standpoint that is completely contrary to the long-held Western tradition in which the life of a stone tool is at the mercy of the human initiator, and producing stone tools is a skill that can be easily replicated and self-taught. There is a long history of associating stone tool technology with a process or life cycle, but initiated solely through human intention.[42] The absence of studying the ontology, skill, and transmission of lithic technology in a living community means that the agency of stone eludes the researcher, as does the impact of the vitality of both human and stone as they interact to create new assemblages/living landscapes.

In the Gamo Indigenous ontology, a human and stone experience parallel life courses, *Deetha*, that include birth, circumcision, seclusion in the household, maturation in the household, and eventually death. Technology is a reproductive process with a life cycle that serves as more than a mnemonic device for correct practice. More importantly, it reminds the initiate that he is a part of a larger living system— human and nonhuman. The act of cutting or circumcising the stone and the human youth detaches their impurity and allows for their rebirth into mature and fertile beings ready to engage others. Knapping, then, is more than an intentional act to transform raw material, and it is more than technology. Knapping is a responsibility of a select group of men to ensure the longevity and life process of the stone through transmitting knowledge of proper techniques through their lineage. Leatherworkers work together knapping stone and protecting its development into a full fertile being by closely monitoring and aiding novice knappers for up to ten years. Consequently, there is great conformity in the form of hidescraper beings in each community, and among each lineage of leatherworkers a distinct style or form of hidescraper matures. During a hidescraper's growth, like a human, it experiences visible changes in its bodily

form. Often, when utilized by an inexperienced individual, the hidescraper develops spurs and breaks, rendering a tool ineffective and ready for discard early in life. It is the leatherworker's responsibility to help the stone live a long, productive, and fertile life to mature from a boy (*naꞭay*) to an elder man (*cima*).

Stone tools experience a life course like the male knapper, and Gamo ontology advocates that the humans who interact with stone do so based on learned skills. Unfortunately, most studies of stone-using societies generally undermined their skills and failed to recognize the relationship between human and stone as one of life course. For example, nineteenth-century scholars described people who use stone as simplistic and primitive, exhibiting a mind-set that was deficient, childlike, and even nonhuman.[43] Several twentieth-century archaeologists, who predominately worked with people recalling lithic technology from memory, expressed that knappers were uninterested or had little regard for their stone technology and described their knapping techniques as crude and clumsy,[44] leaving renowned flintknapper Don Crabtree with the perception that present-day "societies generally lack sophisticated skill."[45] Consequently, experimental work began to dominate our sources for information concerning lithic technology.[46] Today, the study of the skill of knappers is heavily influenced by experimental studies of people who are usually autodidactic (self-taught) knappers or receive little instruction and mentoring.[47]

The life cycle of a hidescraper is entangled with the life of the male knapper, who learns his trade through being a participant in his community. Knappers generally learn their trade as part of their enculturation within their household and lineage, whether they are hunter-gatherers, horticulturalists, or agriculturalists.[48] Men descended from the same ancestor are expected to have shared knowledge and primarily practice their trade in group settings. Predominately, ethnographic studies of knapping indicate that learning knapping occurs within the social context as a manifestation of situated knowledge or legitimate peripheral participation.[49] Even in societies that produce flake tools with no shaping—that is, informal tools—individuals learned by observing their parents and other elders in their community or "copying and trial and error."[50] Learning to knap axes, hidescrapers, beads, and a variety of other formal tools involves directed learning or scaffolding. Intentional communication is essential to the learning process through which individuals gain competence in complex problem solving.[51] Most Indigenous lithic practitioners have a specific vocabulary associated with their knapping technology and practices.[52] Technical vocabulary reinforces local understandings of correct practice and "alignment" or desire to be part of their community.[53] Although clearly the majority of ethnographic studies of Indigenous knappers indicate that learning the trade involves language, scaffolding, and community, Gilbert Tostevin recently argued that scaffolding is not essential, because the individual can never exactly replicate the gestures of his or her teacher, which allows

for variation between generations.[54] In contrast, Etienne Wenger contends that it is exactly the presence of working together and human interaction that is the nexus for diversity.[55] Variation in practice is not only related to an individual's innate ability and imagination, but enhanced and restricted by an individual's status commensurate with his or her claim to specific knowledge, resources, and techniques.[56]

Knapping is a specialized task learned through apprenticeships that begin during puberty initiation rites and proceed for more than ten years to ensure successful development of the living stone. The perception of stones as living beings might derive from human adaptive strategies to encourage motivation in correct practice.[57] Among academics there is growing understanding that the conception that everything is alive is a concern for being respectful and engaging in respectful dialogues with the wider community of all matter.[58] The latter two hypotheses are not mutually exclusive, as encouraging correct practice through apprenticeship with elders may originate from a respectful stance that humans are but one agent in a larger assemblage on Earth. In almost all descriptions of Indigenous lithic practitioners, men work together knapping and interacting with stone as a community rather than practicing as an isolated activity,[59] which means that elders continuously observe youth as they knap. Learning may begin with a child's observations of adult practices and behaviors mimicked in play.[60] Yet learning lithic technology is not child's play. When Lewis Binford told initiated, elder Alyawara men that he wanted to learn how they lived on the land, including stone knife making, they laughed at his hubris and told him what he wanted to know was what "every Alyawara boy wants to know and begins learning from responsible men when he is very young."[61] Acknowledged participation in knapping often begins at adolescence for both boys and girls between ages ten and fourteen and continues for up to ten years before an individual becomes an expert.[62] An important aspect of puberty rites of passage is beginning the formal process of transferring knowledge from elders to youth concerning adult responsibility and proper behavior, particularly during their liminal state when they are especially malleable.[63] During rites of passage, youth experience material culture through song, dance, and ritual acts. Ritual materials are often elaborated and enhanced in their status compared to profane material beings, and as such they encourage, enchant, and command the attention of youths as they transition to adults. Youths will learn to assist in transforming these same material beings as part of their responsibility as adults in society. For instance, stone knives were often engaged for scarification and circumcision of youth; stones that cut the youth mark their transition to men who will one day properly cut the stone. Individuals during their own rebirth into society are reminded of the interconnectedness of all their kin—human and nonhuman. Indigenous knappers often conceive that because stone is a living entity, people have a responsibility to ensure that it has a full life, thus novices are carefully observed and restricted in their interaction with

stone. Transfer of knowledge, access to resources, and encouragement in practice are situated and not simply cast on an individual all at once; they are contingent on the gender, status, and age of an individual.

The life stages of the human knapper and the biography of the stone tool interact to create unique assemblages. Among Indigenous lithic practitioners, generally individuals acquire knapping skills throughout their life. Commonly, youth begin lithic technology by aiding in nonknapping activities such as collecting and transporting materials (wood, mastic, water, stone, etc.) and assisting with cleaning up materials, hafting, and tool use.[64] Novices often start directly working with stone of restricted sizes or with poorer-quality materials.[65] The few ethnographic studies of learning knapping, including this one, indicate that novice knappers learn and practice knapping in the presence of experts where more-experienced individuals directly correct their mistakes. Stone is a source of danger, and improper production may anger stone.[66] Errors or lack of *"efficiency skill"*[67] is common among novice knappers, evident in their wider array of reduction strategies resulting in considerably more debitage.[68] Novices often overcompensate by striking the stone at awkward angles with tremendous force, creating tools and waste flakes that may be thicker with large platforms, less-steep platform angles, and enhanced bulbs (see table 14). Ethnographic studies including this one have a narrower range of production errors than the impressive lists derived from experimental studies.[69] Instead ethnography indicates that when working within a community of knappers, novices often achieve *artisan-level skill*,[70] producing standardized tools generally reserved among archaeologists in association with highly experienced knappers.[71] Essentially, ethnography suggests that it is important to examine a stone's offspring—particularly cores and debitage as well as changes incurred during the use of a tool to ascertain the status and skill of the maker.

The transformation and maturation of stone during its life course does not end with its productive cutting or circumcision; like for the novice knapper himself, cutting marks the rebirth into a new status, one in which it is engaged more fully with other beings, incurring more changes. Many Indigenous lithic practitioners haft stone tools before using them as sickles, knives, hoes, and other agricultural tools, as well as spears and arrows for hunting. Hafted stone tools chafe along their sides, maintain evidence of hafting residue, and can become dull through use; consequently, these tools are sharpened and become smaller.[72] A great deal of experimental and even ethnoarchaeological studies focus on a correlation between hafting, use, form, edge wear, and efficiency in adzes, axes, knives, and hidescrapers.[73]

However, there is virtually no comparative information about how the experience of the person employing the tool affects the stone tool during use. Among the Gamo, long before elders allow a novice to knap stone, they encourage him to work with

stone through scraping on a hide. Thus, it is during a tool's use and maintenance that a novice's interaction with the tool may be most obvious. Novice and competent knappers are much more likely to break a tool and create spurs, and they sharpen more frequently, creating more sharpening debitage. Since novice and competent knappers are likely to engage a master knapper's tools in use, master knappers' final tools often exhibit these traits as well. Brian Hayden's study of tool efficiency among Indigenous Australians, who had not made and used stone tools for twenty-five years, makes an interesting though unintentional comparison of skill and tool use.[74] Hayden noted that individuals who lacked daily experience in using stone tools faltered in their efficiency in sharpening tools, quickly abandoned tools, ineffectively used tools, and often broke tools.[75] Although experienced knappers closely monitor novices during knapping, they allocate to novices more leniency during the use of a stone tool, thereby impacting the tool's use-life.

Recognizing stone as a living entity to which one has an obligation evokes the importance of transmitting information concerning correct practices to novices as they assist in transforming a stone into its new statuses through knapping (circumcision) and as it matures (is used) through life. This ontology creates a standpoint that is completely contrary to the long-held Western traditions that focus on an individual's progress and archaeological traditions of experimental knapping, where individuals self-teach or novices are given a brief demonstration. Experimental assemblages denote a remarkably extensive attribute list that distinguishes the novice and the master knapper. Ethnographically, the list is much shorter, and it is the debitage or cutting waste of stone and use attributes that manifest differences between novice and master more than the final form of a tool. Stone is guarded, protected, and respected, and elder master knappers work closely with youth to ensure a full fertile tool. Knappers are the caretakers responsible for nurturing stone beings. Neither an individual stone nor a human tends to be the focus in stone-using societies; instead, the focus is on their entire assemblage—all matter as living.

MALE KNAPPERS: WORLDLY TOOLMAKERS OR HOUSEHOLD CRAFTSMEN? STORAGE (*DUME*) AND DISCARD (*SOFE*)

The Gamo ontology, *Woga*, informs the storage and discard of lithics within or near the household and at quarries/sacred forests. Once a stone enters human social life, its residence on the landscape resembles the differential use of space by its human caretakers during ritual performances. The Gamo leatherworking knappers—who are lineage-based, part-time community craft-specialists—live within communities

in isolated households; and it is here that the stone beings predominately live, rest, mature, and are buried. Archaeologically, we are caught in our Western ontologies that often presume lithic technology to be a part of male patrimony associated with his sexual mating roles as provider, hunter, and protector outside of the house; these ontologies are embedded in evolutionary forces that drive behavior and progress, marking the rise of the male hominid and human intelligence.[76] Inclusion of Indigenous ontologies in our reconstructions of the past opens new paths for understanding variation in the ascription of gender and use of space associated with lithic technology.

Gamo male knappers primarily knap, store, use, and discard their formal and informal tools in or near their households and at sacred quarries. Gamo knappers largely perceived the presence of life in stones and sacred forests/quarries, imbuing each with independent power to move and experience change free of human intention. Once stone enters human social life and their houses and gardens, they further observed that human, stone, earth, and house interact as an assemblage, impacting one another's lives. The central Gamo and the northern Gamo knappers adhere to two slightly different versions of the Indigenous ontology, *Bene Woga* and *Etta Woga*. *Woga* predominately structures the storage and discard of stone tools within the household contexts, but creates two distinct lithic biographies or technological organizations. The central Gamo bring their fetus stones as cores and raw material from the quarry to their household. Outside the household, the craftsmen slightly knap the stone into youths or unused informal scarpers, join them in marriage with female hafts, resharpen them during use into mature adult hidescrapers, and discard them at death in household gardens. Similarly, central Gamo men are often circumcised, shaped into adult men, mature and carry out their livelihood, and in the past were buried in household gardens. In contrast, the northern Gamo birth fetus stone at the quarry and perform circumcision of the infant stones, transforming them to boys, at the sacred quarry aligned with human circumcision in sacred forests. Stone boys are then brought within the knapper's house, where they rest and are shaped further into formal marriageable hidescrapers, marry near the hearth with female hafts, mature again through work in the house, and are buried in household gardens. Thus Gamo men who make informal and formal stone hidescrapers are similar to their hidescrapers in that both reside in and near the household and are buried in the household garden.

Cross-culturally, stones and stone tools are perceived to be animated beings that express their agency in healing and harm and are often associated with the reproductive house. Formal tools, as vital matter, continue to have the power to inflict illness and even death as people attempt to use them. Among the Gamo, chalcedonies and obsidian that wander outside the parameters of a leatherworker's household can bring social accusation of *Bita* practices, resulting in social isolation and giving away of any meager wealth a leatherworker might have accrued. Stone for knapping, then, is kept

close to the leatherworker's household. In Central America obsidian was associated with healing and played a role in human sacrificial and blood-letting rituals, warfare, and hunting,[77] and it was kept in bowls of water at the house to protect the house.[78] In the New Guinea highlands, stone adzes and axes were made into wands to enforce social etiquette, healing bundles, pig health, and human well-being, as well as embodying the spirits of ancestors who could intervene with malevolent spirits.[79] Among Indigenous peoples of Australia, the Americas, and New Guinea island, royals, elites, or individuals who were perceived to be related to the stone through shared spirit, often carried and stored arrows and knives in sacred bundles, which had the power either to heal or to bring death and chaos.[80] In Australia, some people considered stone so powerful that they had to give it away, dispersing their potency across the landscape.[81] In North America, ownership of particular stones often imbued the owner with sacred ancient knowledge of the earth for healing and success in war.[82] The efficacy of stones in their mature form is important when assessing how they interact with people and where people store and discard stone in the landscape.

Stones knapped into formal tools begin their maturation at quarries, and final shaping only occurs in and near households. Indigenous lithic practitioners invested in knapping formal tools, such as spears, circumcision knives, sledge blades, hidescrapers, and axes, often began their production by creating blanks, preforms, or rough-outs at the quarry.[83] However, in some rare instances, knappers committed to the entire tool production sequence at the quarry.[84] Once they procured stone and began to shape it, they carefully took care of their materials and "nested" them in padded pouches for transport, leaving behind boulders, cores, and a variety of debitage types at the quarry.[85] Knappers engaged in the specialization of formal tool forms and often also created specific workshops with walls and pits at or near quarries.[86] Thus a great deal of debitage and cores may be present at quarries associated with formal tool production. Importantly, because most knappers collect raw material from river gorges as noted above, flooding would likely leave little trace of their activities at quarries.[87] In households producing formal tools, it is likely that only tool blanks, tertiary debitage, and tools would be present.

When lithic practitioners make informal tools, a wide range of tools, or formal tools made from raw material obtained largely from markets rather than quarries, knappers usually have raw materials and cores in their households. Thus very little knapping occurs at the quarry, and most lithic debitage will appear in household contexts. Lithic specialists making informal tools or a wide range of tool forms brought home cores, pre-cores, and large chunks, and they slightly tested raw material to later shape into expedient tools.[88] In a few instances, people made informal tools away from their homes out of nonquarried stone and produced, used, and discarded it almost immediately.[89] In addition, knappers who acquired raw material from markets or who collected raw

material that forms in natural flakes frequently left large amounts of debitage in house-hold contexts. Quartzite and obsidian often do not need to be reduced in bulk prior to transport, as they often form naturally into flakes, which knappers can easily take to their homesteads.[90] Lithic practitioners who lived more than a half day's walk to a quarry tend to bring to their homes chucks or blocks of raw material that they purchase at markets through middlemen.[91] All known living stone tool–producing societies use quarried raw material and at minimum complete the final stages of tool shaping near their homes, as well as store and use their stone tools near their households.

Once produced, stone tools employed for household use usually experience storage immediately either within or near a knapper's household. In communities where spe-cific lineages specialize in stone tool production, knapping households often occupy discrete areas of a community.[92] Some Ethiopian knappers had specialized workshops in their household garden where they worked and stored stone.[93] Knappers in Aus-tralia and the New Guinea highlands often practiced and stored stone at men's houses separate from the nuclear family's or women's houses.[94] O. Hampton noted that sacred and profane stone axes and adzes were stored in men's houses, where collective ances-tral spirits reside and embody the sacred tools.[95] When hafted with mastic, these stone tools are more likely to experience some knapping and storage inside a home near hearths.[96] In other societies, the final shaping, maintaining, and storing of formal woodworking and hidescraping stone tools and informal stone tools generally occurs outside in the immediate vicinity of a knapper's house.[97] Cores, tools, and flakes were stored in bowls, in pieces of cloth under the eaves of houses, and buried or nestled in the branches of trees near the house. Ethnographically, people primarily store their stone tools just outside their households.

Ethnographically, the use-life of stone tools does not fit neatly into archaeological categories of informal-expedient tools made of poor raw material and highly curated formal tools made from long-distance resources.[98] Stone axes and spears frequently valued as beings from sacred places have long use-lives and could be kept for up to ten years.[99] People occasionally buried them in households or gardens, stored for future use.[100] Importantly, among hunter-gatherers such as in Australia, people made and used nonquarried stone, making informal knives and choppers that were used and discarded within minutes and hours for tasks that occurred outside their living com-munity.[101] A notable exception are the Wola of Papua New Guinea, who kept unused flakes and cores for years in storage near their homes to make informal tools.[102] Gen-erally, stone tools made for household activities that occur on a daily or weekly basis or tools made outside the household for situational use have a shorter life span than ritual tools or tools engaged to periodically maintain other household tools.

While stone tools may be knapped, stored, and used adjacent to or in house-holds, generally tool users discard them separately from production and use areas in

household middens. Knappers are careful to clean and sweep knapping and lithic use areas and work over bowls, gourds, and pieces of cloth to prevent people from cutting their feet.[103] Discard locations are separate from knapping and use areas. Knappers tend to discard lithics in middens within their household compound.[104] The burial of lithic materials in the household garden, like the burial of the leatherworker in the garden, ensures purity for the wider community and reinforces the spiritual link between deceased human ancestors and the spirits of stones. Similarly, the Langda of Indonesia state that they feel sorry for their stone axes when they break in the forest and bring them back to their homes for burial.[105] Less commonly, lithic materials also are returned to streams[106] or deposited outside the village.[107] Debitage may be left on the floor/ground and missed by sweeping; and other lithic items also get inadvertently lost or abandoned in a house—these are common in most ethnographic realities.[108] Yet it remains that stone tools are predominately discarded in or near household structures in middens recycling into the earth.

Stones as living beings have different life courses and geographical spaces, where they mature, rest, work, rejuvenate, and decompose; yet like a human being, once they enter human social life they primarily experience life in and near the human house. Humans may trample, move, and reuse things and space.[109] Stone tools may not even have met their demise when buried or discarded by their original caretakers; people in the future may revitalize formerly discarded lithics for use.[110] Landscapes, whether at the beckoning of human intervention or at the mercy of their own life forces, are continually changing. The earth may shift through animals, plants, water, wind, molten flows, and other nonhuman forces. Here, I am reminded of Jane Bennett's eloquent words: "Vital materiality can never really be thrown away . . . thing power rose from a pile of trash."[111] Perhaps if we focused on alternative ontologies in defining being, we might realize that trash is not really trash, a concept that archaeologists should easily grasp, for do we not rebirth humans and "their" matter from these "trash" and refuse heaps? Like humans, stones may experience some of their maturation away from their home, leaving residues of their infant selves at quarries, or they may mature in and near the household. Certainly, like humans, they are most often buried in discrete areas away from where they matured. Among Indigenous knappers, men commonly make tools at home, both formal and informal tools, discarding them separately from storage and use areas.

AN ALTERNATIVE NARRATIVE

The Lives of Stone Tools departs from conventional archaeological narratives and argues that we must consider Indigenous theories of being as equals and as alternatives to

Western theories of material culture. Engaging alternative narratives requires long-term research within a community and a commitment to becoming a student who is open to other possibilities and strives to be articulate in local meanings, experiences, practices, and histories.

I have many Gamo elders to thank for their patience and for unveiling their world and for making me stop to observe what is in front of me—to acknowledge, engage, and ingest the world filled in its totality with animated beings. The Gamo Indigenous understanding of what constitutes life organizes a knapper's technological knowledge and practices into a life cycle, *Deetha*. Stone is born from the female womb of the earth, circumcised through knapping, rejuvenated while stored in a house, matured through household activities, and eventually dies, reincorporating into the earth. The concept that stone is living underlies the importance that one procures viable stone fetuses from the correct location with the correct shape and color. A stone's life cycle is not only a mnemonic device for correct practice, but it is a reminder that stone has its own agency to bring harm to leatherworkers, who transgress female reproductive powers as midwives and birth stone from the earth. The low and impure status of Gamo knappers results in socially and spatially segregated communities of craft-specialists, who begin to transmit their knowledge and practices to a select number of young men during their puberty rites of passage. The life course of the male leatherworker and the biography of lithic material interact to produce particular signatures of moments in time, which are potentially archaeologically visible in the quality of the stone fetus (raw material), quantity of stone circumcised skin (lithic debitage), presence of standardized mature stone tool beings, and extent to which a stone being can mature without the presence of spurs or being broken. Stones as living beings have different life courses, and yet like human beings they primarily experience life resting (stored), maturing (through use activities), and dying (discard) in and near households. Accepting alternative ways of being in the world rearticulates gender assignments, material forms, and spatial distributions.

Envisioning a world in which all matter is alive brings into question our species-centric and academic-centric narratives and our ability to evaluate what constitutes value and responsibility. As stated earlier in this book, an elder leatherworker, Hanicha, asked me: "Kati, tell the people where you come from and the people in other parts of Ethiopia and even my neighbors that my work is important. It is difficult and requires many years of hard work and apprenticeship. I am worthy of respect." For twenty years locked in my Western ontology and tropes about the nature of lithic technology, I did not understand why male knappers held such a low status in Gamo society and how that related to their reality in which stone is a living entity. Meanwhile disparities in their status grew, and leatherworkers now own smaller and smaller infertile farm lands for agriculture, very infrequently attend school, and eke out a "hand

to mouth" existence selling their goods at local rural markets. Fewer leatherworkers produce stone tools and process hides, thereby losing their prerogative to interact with resources that in turn provided them with a place in the world. They are incorporated into a global world that increasingly has no space for their knowledge and skills. Global religions disrupt Indigenous perceptions of being in the world. Global advocates for animal rights encourage stricter hunting laws, encourage increased tourist venues, and limit local people's access to wild animals and their hides. Global markets increase desires for leather goods, the growth of industrial tanneries, and the export of domestic animal hides outside their nation. As Koji Mizoguchi insists, globalism fails to equalize and unite; it continues to disrupt and divide because it seeks to create a single community rather than alliances.[112] While Hanicha's story may be only one in our diverse world, it is a story that nonetheless demands respect and a deep appreciation for knappers' technological knowledge, which has been virtually erased from the memories of people in other parts of the world. International recognition and praise for their unique knowledge and skills may be a step toward developing local, regional, and national appreciation and toward assuaging their economic and social hardships in their resident communities. Furthermore, bringing to the forefront knappers' reverence for stone as a living entity opens new opportunities to create spaces for alternative futures that ally academic theories with Indigenous knowledge and experience.[113]

NOTES

INTRODUCTION

1. I use the terms *knappers* and *flintknappers* throughout the book interchangeably to describe the profession of making, using, and discarding stone tools and to extend respect to Indigenous flintknappers for their knowledge and skill. The terms *knappers* and *flint-knappers* were first used in nineteenth-century literature to describe the skilled profession of making gun-flints in England (Skertchly 1879). At the time, different terms were used to describe the daily practices of making stone tools by colonized peoples, who were often described as "chipping/chippers" or "flaking/flakers" (Cushing 1879).

2. I use the the term *lithic practitioners* to refer to people who learn knapping as an integral part of their daily lives in contrast to individuals who are self-taught and make and use stone tools for a hobby or to make replicas for sale.

3. Abélès (1983) 2012; Cartledge 1995, 116–25; Freeman 2002, 66–68.

4. Abélès 1979; Azaïs and Chambard 1931, 260–69; Bahrey (1593) 1993; Beckingham and Huntingford 1954, lxv; Borelli 1890; Bureau 1976; Cerulli 1956, 86.

5. Mihlar 2008; Tindall 2009.

6. Harvey 2006; Tylor 1871.

7. Bennett 2010; Bergson (1907) 1998.

8. Appadurai 1986b; Astor-Aguilera 2010; Gell 1998; Kopytoff 1986.

9. I use the word *Indigenous* as defined in L. Smith 1999, 146, citing M. A. Jaimes 1995, 276, "as being grounded in the alternative conceptions of world view and value systems: 'These differences provide a basis for a conceptualization of Indigenism that counters the negative connotations of its meaning in Third World countries, where it has become synonymous with the "primitive" or with backwardness.'"

10. Gosden 2008, 2003.

11. L. Smith 1999, 25–28.

12. Alberti and Marshall 2009; Henare et al. 2007; Viveiros de Castro 1998.

13. Bastien 2004; Deloria 1992; Watkins 2001; Zedeño 2008.

14. Diop 1974; Karenga 2004; Magesa 1997; Obenga 2004.

15. Atalay 2010, 2012; Boyd 2012; Crowell et al. 2001; Hollowell and Nicholas 2000; Schmidt and Mrozowski 2013; L. Smith 1999.

16. Walz 2013, 83.

17. Fewkes 1900, 579.

18. Binford 1977; N. David and Kramer 2001, 2; Gould 1977, 1978; Kent 1987; Kleindienst and Watson 1956; Schiffer and Skibo 1987.

19. Agorsah 1990; MacEachern 1996 for critical reviews.

20. Weedman 2000, 2002a, 2002b, 2006; K. Arthur 2008.

21. Gonzalez 2012, 155–70.

22. Binford 1981; Cunningham 2003; Gould and Watson 1982; Schmidt 2010; Wylie 1982, 1985.

23. Walz 2013.

24. Scott 2007, 21.

25. Mizoguchi 2015, 21.

26. Alberti et al. 2011, 897.

27. Schiffer 1972.

28. Ingold 2007; Latour 1999.

29. Whitehead 1929.

30. Deleuze and Guattari 1987.

31. Bennett 2010, xi.

32. Bird 1993; Cane 1988; Gorman 1995; Grayson 1983; Heizer 1962; Hester and Heizer 1973; Hiatt 1968, 212–13; Kamminga 1982; Orme 1981; Piggott 1976, 1–25; Slotkin 1965, 44, 96–97, 220–26; Trigger 1989.

33. Adler 1998.

34. Charlevoix 1769, 270; de Jussieu 1723 cited in Heizer 1962, 67; Dugdale 1656; Hariot 1588; Lhwyd 1713 cited in Piggott 1976, 19; Plot 1679; Rutherford 1788.

35. Barrett 1879, 177–78; Browne 1856, 257; Catlin 1844; 1868, 31, 212; Curr 1887, 156–59; 352–53; Dale 1870; Dunn 1880, 16; Evans 1872, 21–38; Eyre 1840, 310, 313; Fowke 1896; Giglioli 1889; Grey 1841a, 252; 1841b, 265–66; Holmes 1891; Man 1883a, 94; 1883b, 328, 331, 335, 376, 379, 381; Mason 1889; Murdoch 1892, 294–301; E. Nelson 1899, 112–18; J. Powell 1895; H. Roth 1899, 51, 89, 148; Sellers 1885; Snyder 1897; Stevens 1870, 68–70; Smyth 1878, 271, 340; Teit 1900, 182, 184–87; L. Turner 1894, 205–8, 293–96; Wallace 1889, 191–92.

36. Catlin 1868; Evans 1872, 34–38; Holmes 1919; C. Lyons 1860; Redding 1879; Sellers 1885.

37. Johnston cited in H. Roth 1899, 145.

38. Lubbock 1890, 429.

39. Kehoe 1998, 2013.

40. Cushing 1895, 310–13; Mercer 1895, 367, 376.

41. Cushing 1895, 310–13.

42. Skertchly 1879, 31–41.

43. S. Jones 1997, 2–3, 16, 45–51; Veit 1989.

44. Aiston 1929, 1930; Allchin 1957; Blackwood 1950; Campbell and Noone 1943; Dixon 1914; Dunn 1931; Elkin 1948; Ellis (1940) 1965; Gusinde (1937) 1962; Hambly 1936, 49; Holmes 1919; Kosambi 1967; Lothrop 1928; MacCalman and Grobbelaar 1965; Mitchell 1955, 1959; Noetling 1911; Pospisil 1963, 278–79; Pulleine 1929; Tindale and Noone 1941, 116; Towle 1934; Vial 1940.

45. Ellicott 1977, 31; Larick 1985; Riley 2012.

46. Dunn 1931, 10.

47. Solway and Lee 1990; Wilmsen and Denbow 1990; for a discussion of this debate, see also Walz 2006.

48. N. Nelson 1916, 2; also see descriptions by Robin Hood 1917; Weston 1913.

49. Leakey et al. 1965.

50. Binford 1986; J. Burton 1984, 1985; Clark and Kurashina 1981; Gould 1966, 1968b; Gould and Quilter 1972; Gould et al. 1971; Hayden 1977; Sillitoe 1979; Tindale 1965, 1985; Townsend 1969; J. P. White 1968a, 1969; J. P. White and Thomas 1972; J. P. White et al. 1977.

51. Binford 1984, 1986; Binford and O'Connell 1984; J. Burton 1984; Hayden 1977, 1979; O'Connell 1974; M. Strathern 1965, 1970; Tindale 1965; J. P. White and Thomas 1972; J. P. White et al. 1977.

52. Hayden 1977, 1979; J. P. White 1968a, 1969; J. P. White and Thomas 1972; J. P. White et al. 1977.

53. J. P. White et al. 1977, 381.

54. Hayden 1979, 26.

55. Bordes 1961a; Brink 1978; Broadbent and Knutsson 1975; Crabtree 1975, 1982; Hayden 1979, 1987; Hurcombe 1992; Jelinek 1965; Kamminga 1982; Keeley 1980; Shea 1987; Siegel 1984; Sillitoe 1979; P. Smith 1966; Tixier 1974; Toth 1985; Townsend 1969; Vaughan 1985; Wilmsen 1968; Young and Bonnichsen 1985.

56. Flenniken 1984, 188, 195–200.

57. Lechtman 1977, 1984; Lechtman and Steinburg 1979; Wobst 1977, 320. For prestige, see Paton 1994; M. Strathern 1965, 1970; Tacon 1991; Wiessner 1983, 1985. For ethnicity/linguistic group and emblemic style, see Wiessner 1983, 1985. For internal age-grade status, see Larick 1985. For kinship descent system, see J. Burton 1984; Gould 1980; Paton 1994; Shafer and Hester 1983; Taçon 1991. For individuality, see Bamforth 1991. For idial style, see Gunn 1975. For assertive style, see Wiessner 1983. For isochrestic style, see Sackett 1973, 1982a, 1982b, 1985, 1986, 1989, 1990.

58. Wiessner 1983, 261–64.

59. Keller and Keller 1990; Killick 2004; Pfaffenberger 1992; Wobst 1999.

60. Dobres and Hoffman 1999; Dobres and Robb 2000; Sassaman 2000; Sinclair 2000; Wobst 2000.

61. K. Arthur 2010; Roux et al. 1994; Stout 2002, 2005, 2010; Weedman 2002a, 2002b, 2006.

62. Akerman and Fagan 1986; Apel 2008; Bisson 2001; Bodu 1996; Bodu et al. 1990; Callahan 2006; Crabtree 1968; Eren et al. 2011; Ferguson 2008; Finlay 2008; Fischer 1990; Flenniken 1978; Geribàs et al. 2010; Grimm 2000; Högberg 2008; Karlin and Pigeot 1989; Karlin et al. 1993; Olausson 1998, 2008; Pigeot 1987, 1988, 1990; Roche et al. 1999; Sheets 1975; Shelley 1990; Stahl 2008; Winton 2005.

63. Stout 2002, 2005, 2010.

64. Roux et al. 1994.

65. Moser 1993.

66. De Beauvoir (1949) 1953; Harding 1998; Lamphere and Rosaldo 1974; Lloyd 1993; Ortner 1974; M. Strathern 1972; Weiner 1976.

67. Schiebinger 1993.

68. For history, see Lindfors 1999, 169–70; Woodward et al. 2002. See a particular example in Drennan 1957, who describes the female brain as infantile.

69. Dunn 1931; Eyre 1840; Grey 1841a, 1841b; Lothrop 1928; Lubbock 1890; Man 1883a, 94; 1883b, 362, 379–81; H. Roth 1899.

70. Man 1883b, 379–81.

71. Maynes and Waltner 2012.

72. Leakey et al. 1965.

73. Bordes 1947, 1957, 1961a, 1961b, 1972, 1973, 1977, 1979; Childe 1929; Kroeber 1916, 7–21; Kroeber and Kluckhohn 1952, 365–76.

74. Ammerman and Feldman 1974; Binford 1968, 1973, 1986, 1989; Dibble 1984, 1987; Dunnell 1978; Mellars 1970.

75. In Africa: Goodwin and van Riet Lowe 1929; Leakey 1931. In Europe: Knowles 1944; Wilson 1862. In Australia: Tindale 1941. In the Americas, cultural distinctions are just being drawn: Adams 1940; Finkelstein 1937; Heizer 1940; Johnson 1940; Krieger 1944; McCary 1947; Quimby 1958; Roberts 1936.

76. In order of titles in text: Oakley 1949; Osborn 1916; Breuil and Lantier 1965; see also Roberts 1936.

77. Leakey 1934, 56–57.

78. Gero 1991, 165.

79. Holmes 1919, 316–83.

80. See critique by S. Nelson 2004.

81. Cohn 1996.

82. Kehoe 1990.

83. K. Arthur 2010; Conkey and Gero 1991; Gifford-Gonzales 1993; Kent 1999; Moser 1993; Owen 2005.

84. Gero 1991.

85. Ingold et al. 1988; Lee 1979; Lee and Devore 1981; Linton 1955; Washburn and Lancaster 1968.

86. Binford interviewed in Fischman 1992; Isaac 1978; M. Leakey 1971, 258; Lovejoy 1981.

87. Binford 1978, 152; O'Connell 1987; O'Connell et al. 1991.

88. Chang 1988; Janes 1983; Kent 1999; Yellen 1977.

89. Hayden 1977, 185.

90. Gould 1980, 132.

91. Bodenhorn 1990; Brumbach and Jarvenpa 1997a, 1997b; Draper 1975; Estioko-Griffin and Griffin 1985; Jarvenpa and Brumbach 1995; Slocum 1975; Tanner and Zihlman 1976; Zihlman 1978.

92. Gero 1991.

93. Bruhns and Stothert 1999; Casey 1998; Finlay 1997; Frink and Weedman 2005; Owen 2005; Sassaman 1992, 1997.

94. Albright 1984; K. Arthur 2010; Beyries 2002; Beyries et al. 2001; Brandt 1996; Brandt et al. 1996; Brandt and Weedman 1997, 2002; Gorman 1995; Sillitoe and Hardy 2005; Takase 2004; Webley 1990, 2005.

95. Eren et al. 2011; Gintis et al. 2015; Kohn and Mithen 1999.

96. L. Smith 1999.

97. Alberti 2005; Connell and Messerschmidt 2005.

98. Harrison 2002, 2004.

99. K. Arthur 2010; Sterner and David 1991.

100. Bennett 2010, xi; Deleuze and Guattari 1987; Ingold 2000, 2006, 2007; Latour 1999.

101. Balfour 1929; summarized in Heizer 1962 and Slotkin 1965, 44.

102. Charlevoix 1769, 270; de Jussieu 1723 cited in Heizer 1962, 67; Dugdale 1656, 778; Dumont 1753 cited in Swanton 1946, 146–49; Rutherford 1788, 40.

103. Lhwyd 1713 as cited in Piggott 1976, 19.

104. Dunn 1880, 16; Evans 1872, 21–38; Fowke 1896; Holmes 1894, 1919; Lubbock 1890; Mason 1889; Murdoch 1892, 294–301; J. Powell 1895; Sellers 1885; Wilson 1862.

105. Schmidt and Mrozowski 2013.

106. Hankins 1985.

107. Reill 2005; Normandin and Wolfe 2010.

108. Holmes 1894, 123, 135–36; see also Shott 2003.

109. Straus and Clark 1986.

110. Sackett 1991.

111. Ford 1954; Ford and Willey 1941; Krieger 1944; McKern 1939; Rouse 1939; Steward 1942; Wissler 1923, 12–20, 47–63.

112. Brew 1946, 47.
113. Taylor (1948) 1983, 143, 193.
114. Bordes 1947, 1957, 1961a, 1961b, 1973, 1977.
115. Sackett 1991.
116. Audouze 2002.
117. Leroi-Gourhan 1942.
118. Audouze 2002; Leroi-Gourhan 1973.
119. Audouze 1987; Audouze and Enloe 1997; Bar-Yosef and Van Peer 2009; Boëda 1988, 1995; Chazan 2003; Fischer 1990; Hofman and Enloe 1992; Högberg 2008; Karlin and Pigeot 1989; Karlin et al. 1993; Pelegrin 1990; Pigeot 1987, 1988, 1990; Schlanger 1990, 1994.
120. Schiffer 1972, 1975a, 1975b, 1975c; Shott 2003.
121. Collins 1975; Dibble 1984, 1987; Epstein 1964; Flenniken 1984; Jelinek 1976.
122. Quarrying patterns: Binford and O'Connell 1984; J. Burton 1984; Chappell 1966; Gould 1980; Gould and Saggers 1985; M. Strathern 1965. Sequences of production/reduction: Binford 1986; Binford and O'Connell 1984; McCall 2012. Tool efficiency: Hayden 1979; Sillitoe 1982; Townsend 1969. Exchange and efficiency: Torrence 1986. Storage and discard organization: Clark 1991; Clark and Kurashina 1981; R. Haaland 1987, 66–69, 138–41; Pokotylo and Hanks 1989. A review of all: Andrefsky 2009.
123. Binford, for example, wrote that "vitalism . . . is an unacceptable explanation" (1968, 322).
124. Bar-Yosef and Van Peer 2009; Bleed 2001; Dobres and Hoffman 1999; Schiffer 2004.
125. Gosden 2005, 2008; Gosden and Marshall 2010; Hodder 2012; Knappett and Malafouris 2008; Leroi-Gourhan 1942, (1965) 1993; Meskell 2004; Olsen 2010; Robb 2010.
126. Leroi-Gourhan 1973.
127. Finlay 2011; Van Gijn 2010.
128. Andrews 2003; Bamforth and Finlay 2008; Clark 2003; Grimm 2000; Roche et al. 1999.
129. Tostevin 2012, 437.
130. Bettinger and Eerkens 1999; Bleed 2008; Broughton and O'Connell 1999; Eren et al. 2011; O'Brien and Lyman 2005, 8; Stout 2002; Tostevin 2012.
131. Brown and Emery 2008.
132. Alberti and Marshall 2009; Brown and Walker 2008; González-Ruibal et al. 2011; Sillar 2009; VanPool and Newsome 2012.
133. Albright 1984; K. Arthur 2008, 2010; Binford 1986; Binford and O'Connell 1984; Brandt 1996; Brandt et al. 1996; Bordaz 1969; J. Burton 1984; Clark and Kurashina 1981; Elkin 1948; Gallagher 1974, 1977a, 1977b; Gould 1966, 1968a, 1968b; Gould et al. 1971; R. Haaland 1987; Hampton 1999; Hayden 1979; Paton 1994; Sahle 2008; Sahle and Negash 2010; Sahle et al. 2012; Stout 2002, 2005; Tindale 1965, 1985; Toth et al. 1992; Webley 1990, 2005; Weedman 2002a, 2002b, 2006; J. P. White 1969; J. P. White and Modjeska 1978; J. P. White and Thomas 1972; J. P. White et al. 1977; Whittaker 2004 (although this is among recreational knappers in North America); Whittaker et al. 2009.

CHAPTER 1

1. Brandt 1996; Brandt and Weedman 1997; Brandt et al. 1996.
2. K. Arthur 2008; Shott and Weedman 2007; Weedman 2000, 2002a, 2002b, 2005, 2006.
3. K. Arthur 2013; K. Arthur et al. 2009, 2010, 2017.
4. K. Arthur 2010; Brandt and Weedman 2002; Weedman 2005.
5. Bender 2000; Blench 2006; Fleming 1973, 1976; Hayward 1998; Woldemarium 2013.
6. Blench 2006, 159–60.
7. Walz 2013.
8. Sperber 1975.
9. Woldemarium 2013.
10. Bender 1988, 152; Blench 2006, 150–52, 159–60; Blench and Dendo 2006; Blench and MacDonald 2006, 346, 359, 457–59.
11. Bailey et al. 1989; Gregg 1988, 44–46; Headland and Reid 1989; Speilmann 1991.
12. The table information is based on my field notes and the following sources. Konso: K. Arthur 2010. Oromo: Clark and Kurashina 1981; Gallagher 1977b. Hadiya: Sahle 2008. Gurage: Gallagher 1977a, 1977b. Oyda: Feyissa 1997.
13. Brandt 1996; Brandt and Weedman 1997; Brandt et al. 1996.
14. Blench 2006.
15. K. Arthur et al. 2009, 2010, 2017.
16. Bachechi 2005; Gutherz et al. 2002; Hildebrand et al. 2010; Lesur-Gebremarium 2008; Lesur-Gebremarium et al. 2010.
17. Bachechi 2005; Gutherz et al. 2002; Hildebrand et al. 2010; Lesur-Gebremarium 2008; Lesur-Gebremarium et al. 2010.
18. K. Arthur et al. 2009, 2010.
19. Llorente et al. 2015.
20. Lesur 2012.
21. Curtis 2013; Harrower et al. 2010.
22. Llorente et al. 2015.
23. Barham 2002.
24. Michels 1991; Phillipson 2000.
25. Cerulli 1956; Hallpike 1968; Jensen 1959; D. Levine 1974; Shack 1964; Straube 1963.
26. Azaïs and Chambard 1931; Joussaume 1985, 1995, 2007.
27. K. Arthur et al. 2009, 2010, 2017.
28. K. Arthur et al. 2017.
29. K. Arthur et al. 2017.
30. Bahrey (1593) 1993; see also Cerulli 1956, 86.
31. K. Arthur et al. 2017.
32. Freeman 2002; Haberland 1959, 1978, 1984, 1993.

33. Bombe 2013; Fernyhough 1994; Smidt 2010, 673–78.

34. K. Arthur et al. 2017.

35. Bureau 1979; Hodson 1929; Marcus 1994, 19–20; Olmstead 1997, 29.

36. Azaïs and Chambard 1931, 260–69; Bureau 1976; Lange 1982, 1–13; Marcus 1994, 19–29.

37. D. Levine 1974; Woldegaber and Portella 2012.

38. Oral tradition published by K. Arthur 2013 and K. Arthur 2017.

39. Schmidt 1997.

40. Freeman 2002, 31.

41. Abélès 1981; Olmstead 1997, 34–36.

42. Bartlett 1934, 92; Bruce 1790; R. Burton 1894, 170; Combes and Tamisier 1838, 77–79; Isenberg and Krapf 1843, 255–56; Johnston (1844) 1972; Lefebvre 1846, 240–43; Merab 1929; R. Pankhurst 1964; Parkyns (1853) 1966, 230–31; Paulitschke 1888, 311; Rey 1935, 225; Wylde 1888, 289–91.

43. Giglioli 1889; Johnston (1844) 1972, 370–74.

44. Gebreselassie 2003.

45. K. Arthur 2010; Ellison 2008, 2009.

46. Clark and Kurashina 1981; Gallagher 1974, 1977a, 1997b; R. Haaland 1987.

47. Freeman 2002, 146–47.

48. Lakew 2015.

49. N. David 2012; D. Lyons 2013; Sterner and David 1991; Tamari 1991; Tuden and Plotnicov 1970.

50. Abélès 1977, 1978, 1979, 1981; J. Arthur 2002, 2003, 2006, 2009, 2013, 2014a, 2014b; Bureau 1975, 1976, 1978, 1979, 1981, 1983, 1986–87; Cartledge 1995, 40–43; Fanta 1985, 30–31; Halperin and Olmstead 1976; Straube 1963, 380–84.

51. Cassiers 1975; Haberland 1984; Hallpike 1968; D. Levine 1974, 39; Lewis 1962, 1970; Shack 1964; Todd 1977, 1978.

52. Leach 1960; Tuden and Plotnicov 1970.

53. V. Turner 1969, 1974; Van Gennep 1960; and in Ethiopia: see Freeman 1997, 2002; Hamer 1996; Kassam 1999.

54. G. Haaland 2004.

55. Abélès (1983) 2012; Freeman 2002, 66–68.

56. Olmstead 1974, 31–32.

57. See also Cartledge 1995, 113.

58. Sterner and David 1991.

59. Cartledge 1995, 116–25.

60. K. Arthur 2013; quotations from participants also appear in this text.

61. J. Arthur 2006, 2013.

62. Abélès 1979; Bureau 1975; 1981, 1986–87; Straube 1963, 380–84.

63. Berhane-Sellasie 1994; Hamer 1987, 55–60.

64. Ellison 2008, 2009.
65. Freeman 2002; D. Lyons 2013; Freeman and A. Pankhurst 2001; A. Pankhurst 1999.
66. Dumont 1980; Leach 1960; Marriott and Inden 1985.
67. Appadurai 1986a; Dirks 1989; Inden 1990.
68. Boivin 2008; Gupta 2004.
69. Lave and Wenger 1991; Wenger 1998.
70. Olmstead 1975; Orent 1969; Straube 1963.
71. Weedman 2000, 2006.
72. Karsten 1972.
73. J. Arthur 2013, 2014a.
74. See also D. Lyons 2013 for a discussion on northern Ethiopia.
75. Lesur-Gebremariam 2008.
76. Dejene et al. 2006.
77. Karsten 1972, 80.
78. Lakew 2015.
79. Shenkut 2005.
80. Lave and Wenger 1991; Wenger 1998.

CHAPTER 2

1. Lakoff and Johnson 2003, 4.
2. Liddell and Scott 1984, 416, 491.
3. Seligman 1982, 18–19.
4. Sumner 1986.
5. Alberti and Marshall 2009; Bastien 2004; Deloria 1992; Diop 1974; Henare et al. 2007; Karenga 2004; Magesa 1997; Obenga 2004; Viveiros de Castro 1998; Watkins 2001; Zedeño 2008.
6. Bennett 2010; Bergson (1907) 1998; Deleuze and Guattari 1987; Latour 1999; Spinoza (1677) 1992.
7. Alberti and Marshall 2009; Barreto 2009; Brown and Walker 2008; González-Ruibal et al. 2011; Henare et al. 2007; Ingold 2007; Sillar 2009.
8. Tylor 1871, 260.
9. Harvey 2006, xi.
10. Bird-David 1999, 78–79.
11. See articles in Alberti and Marshall 2009; Brown and Walker 2008. See also Brown and Emery 2008; González-Ruibal et al. 2011; Henare et al. 2007; Hornborg 2011; Sillar 2009.
12. Astor-Aguilera 2010, 203–32.
13. Matilal 1982.
14. Viveiros de Castro 1998.

15. Amborn 2001; Gidada 1984; Hamer 1996; Lvova 1994.

16. Karenga 2004.

17. Diop 1974; Karenga 2004; Martin 2008; Obenga 2004.

18. Alberti et al. 2011; Spelman 1988.

19. Berhane-Selassie 2008; Freeman 2002; Hamer 1970, 1996; Kassam 1999; Orent 1969; Wolde 1991, 2004.

20. Diop 1974; Karenga 2004; Martin 2008; Obenga 2004.

21. Obenga 2004.

22. Blench 2006, 150–59.

23. Karenga 2004, 175–217.

24. Spelled *ts'ala/e* by Freeman 2002, 66–68; spelled *tsala'e* by Abélès 1979, 1983, 160. Quotation is from Abélès (1983) 2012, 162.

25. Abélès (1983) 2012, 164–65.

26. See K. Arthur 2013 for more details on spirit mediums and Olmstead 1997 for similar spirit possession among the Dita Boreda.

27. Tindall 2009.

28. Freeman 1997, 2002; also see other southern Ethiopian cultures in Hamer 1996; Kassam 1999.

29. Karenga 2004, 198–206.

30. Abélès (1983) 2012.

31. K. Arthur 2013.

32. G. Haaland 2004; G. Haaland et al. 2002; Hamer 1994; Kassam 1999.

33. Karenga 2004, 176.

34. Karenga 2004; Obenga 2004.

35. Freeman 1997, 2002; Hamer 1996; Kassam 1999; V. Turner 1974, 1969; Van Gennep 1960.

36. G. Haaland 2004; G. Haaland et al. 2002.

37. Mehari 2016.

38. Freeman 2002.

39. Freeman 2002.

40. K. Arthur 2013.

41. Appadurai 1986b; Gell 1998; Kopytoff 1986; Latour 1993.

42. A. Jones 2007; Malinowski 1961; Schmidt 1997; Sperber 1975.

43. Weedman 2006.

CHAPTER 3

1. Bennett 2010, 23–24.

2. K. Arthur 2013.

3. K. Arthur 2013.

4. Weedman 2000.

5. Weedman 2006.

6. Weedman 2000.

7. Weedman 2006.

8. Weedman 2000.

9. Gamachu 1977, 6–7.

10. K. Arthur 2013.

11. Weedman 2006.

12. Karsten 1972.

13. Hasen 1996.

14. Freeman 2002, 37.

15. USAID 2013.

16. Weedman 2006.

17. Cane 1992; Gould 1980, 153; Hampton 1999, 130, 156–61; Harrison 2002; Paton 1994; Taçon 1991; Torrence et al. 2013; J. P. White and Thomas 1972.

18. For table 6: In Ethiopia: Konso (K. Arthur 2010), Gurage (Gallagher 1974, 1977a, 1977b), Hadiya (Sahle 2008; Sahle and Negash 2010; Sahle et al. 2012). In South Africa: Namaqua (Webley 1990, 2005). In Namibia: OvaTjimba (MacCalman and Grobbelaar 1965). In West Papua, Indonesia: Dani, Wano, and Langda (Hampton 1999; Stout 2002, 2005; Toth et al. 1992). In Papua New Guinea: Hageners, Wiru, Tungei, and Wahgi (Blackwood 1950; J. Burton 1984, 1985; Chappell 1966; M. Strathern 1965, 1970). In Papua New Guinea: Wiru, Wola, and Duna (Hardy and Sillitoe 2003; Watson 1995; J. P. White 1968a; J. P. White and Thomas 1972; J. P. White et al. 1977). In Turkey: Cakmak (Bordaz 1969; Whittaker et al. 2009). In Tasmania: (H. Roth 1899). In Mexico: Lacandon Maya (Clark 1991). In North America: Dene (Pokotylo and Hanks 1989). In South Australia: Ngadadjara and Nakako (Tindale 1965), Lake Eyre (Aiston 1929). In Australia among Yolngu (R. Jones and N. White 1988), in Western Desert (Tindale 1965; Gould 1968a, 1968b; 1980, 123–26; Gould and Saggers 1985; Gould et al. 1971), and among the Alyawara (Binford 1986; Binford and O'Connell 1984).

19. Blackwood 1950; Bordaz 1969, 1973; J. Burton 1984; Clark 1991; Chappell 1966, 100–104; Gallagher 1977a, 1977b, 261–63; Hampton 1999; H. Roth 1899, 151; Sillitoe 1982; M. Strathern 1965; Watson 1980; Whittaker et al. 2009.

20. Pastrana and Athie 2014, 96.

21. Pokotylo and Hanks 1989.

22. Gould and Saggers 1985.

23. Gould and Saggers 1985, 122.

24. Gould 1968, 47.

25. Hayden 1979, 7–9.

26. Taçon 1991.

27. Taçon 1991, 205.

28. R. Jones and N. White 1988.

29. R. Jones and N. White 1988, 56–57.

30. Paton 1994.

31. Gould 1968a, 107; 1980, 138–56; Gould et al. 1971.

32. J. Burton 1984, 1985, 60–62; Stout 2002.

33. Hampton 1999, 257.

34. Hampton 1999, 256.

35. J. Burton 1984, 236.

36. J. Burton 1985, 260.

37. Binford 1986; Dunn 1931, 58, 72, 77–78; Gould 1980, 132; Hassell 1975, 57; Hayden 1979, 5, 29–34, 39; Holmes 1919, 316; MacCalman and Grobbelaar 1965; H. Roth 1899; Sillitoe and Hardy 2005; Toth et al. 1992, 90.

38. K. Arthur 2010.

39. Pastrana and Athie 2014, 96.

40. Hardy and Sillitoe 2003, 557–58.

41. R. Jones 1990: 27; R. Jones and N. White 1988.

42. Paton 1994, 179, for quote; for similar descriptions of using fire to quarry buried boulders, see Binford and O'Connell 1984, 410–11; Cane 1992; Elkin 1948; R. Jones 1990; R. Jones and N. White 1988; Tindale 1965.

43. R. Jones and N. White 1988, 59.

44. Binford and O'Connell 1984, 410–11.

45. R. Jones 1990, 30.

46. R. Jones and N. White 1988, 61–62.

47. R. Jones 1990, 27.

48. Bordaz 1969, 1973; J. Burton 1984; Clark 1991; Chappell 1966, 100–104; Gallagher 1977a; 1977b, 261–63; H. Roth 1899, 151; Whittaker et al. 2009.

49. Blackwood 1950; J. Burton 1984; Hampton 1999; Sillitoe 1982; M. Strathern 1965; Watson 1980.

50. J. Burton 1985, 260.

51. Hoffman 2003; Taçon 1991.

52. Binford and O'Connell 1984; J. Burton 1984; Clark 1991; Gould 1980; Gould et al. 1971; Whittaker et al. 2009.

53. Darras 2014, 66.

54. Irwin 1996, 224–25.

55. R. Jones 1990, 27.

56. Hampton 1999, 126; Stout 2002, 2005; Toth et al. 1992.

57. Blackwood 1950; J. Burton 1984; Sillitoe 1982; M. Strathern 1965; Watson 1980.

58. Torrence et al. 2013.

59. Cane 1992; Gould 1980, 153; Hampton 1999, 130, 156–61; Harrison 2002; Paton 1994; Tacon 1990; Torrence et al. 2013; J. P. White and Thomas 1972.

60. Darras 2014, 68; Pastrana and Athie 2014.

61. Cane 1992, 16.

62. Wildschut 1975, 90–91.

63. Hampton 1999, 130, 156–61.

64. Darras 2014, 66.

65. Cane 1992; Gould 1980, 142; R. Jones 1990; Paton 1994.

66. Aiston 1929, 130.

67. P. Powell 1969, 576.

68. P. Powell 1969, xxiii.

69. Irwin 1996, 159.

70. Irwin 1996, 1929.

71. P. Powell 1969.

72. Irwin 1996, 224–25.

73. Wildschut 1975, 96–97.

CHAPTER 4

1. I described this same event in much less detail in another publication: Weedman 2002a.

2. Leslau 1964.

3. Lave and Wenger 1991; Wenger 1998.

4. Our Western use of terms for the different phases of a stone tool's life cycle—raw material, blanks, tool, partially used, and discardable—render the stone being lifeless and are not terms used by the Gamo leatherworkers.

5. Weedman 2002a.

6. Weedman 2006.

7. Chebo et al. 2013.

8. Weedman 2006.

9. Weedman 2002a.

10. Weedman 2002a.

11. Weedman 2006.

12. Shott and Weedman 2007.

13. Weedman 2002a.

14. Weedman 2002a. The data for spurs including number, types, percent, and statistics are presented in this earlier article.

15. Albright 1984, 52; K. Arthur 2010; J. Burton 1984, 239; Hampton 1999, 232; Roux et al. 1994; Stout 2002, 2005, 2010.

16. Gusinde (1937) 1962, 563.

17. Albright 1984, 52.

18. Hayden 1979, 29.

19. Hayden 1979, 29; Hardy and Sillitoe 2003.

20. Gould 1968a, 1968b, 1980.

21. Gould 1968b, 48.

22. Gould 1970.

23. J. Burton 1984, 239; 1985, 93–94; Hampton 1999, 232; Hardy and Sillitoe 2003; Hayden 1979, 111; Stout 2002, 702.

24. Roux et al. 1994; Stout 2002, 2005.

25. Albright 1984; J. Burton 1985; Gould 1970; Hampton 1999; Roux et al. 1994; Stout 2002, 2005; Whittaker et al. 2009; also see Costin 1991, 1998; Kamp 2001; C. Keller and J. Keller 1990; Lave and Wenger 1991; Wendrich 2013; Wenger 1998.

26. Hardy and Sillitoe 2003, 555; J. P. White et al. 1977, 381.

27. K. Arthur 2010; Roux et al. 1994; Stout 2002, 2005; Weedman 2002a.

28. Bodu 1996; Bodu et al. 1990; Karlin and Pigeot 1989; Karlin et al. 1993; Olive and Pigeot 1992; Pigeot 1987, 1988, 1990.

29. Apel 2008.

30. Andrews 2003 outlined the differences between artisanal and efficiency.

31. Apel 2008; Bamforth 1991; Bamforth and Hicks 2008; Bisson 2001; Finlay 1997; Hirth 2003; M. Levine and Carballo 2014.

32. Ellicott 1977, 31; Larick 1985; Riley 2012; and note in Leakey 1926 that in this survey of ethnographic African bows and arrows in European museums, the author only noted the presence of stone arrows among the Khoisan in southern Africa.

33. Cushing 1985, 310–13; Dunn 1931, 10; Evans 1872; Lubbock 1890, 429; McGuire 1896; Mercer 1895; H. Roth 1899, 145; Wilson 1862.

34. Kehoe 1990.

35. K. Arthur 2010; J. Arthur 2006; Roux et al. 1994; Stout 2002, 2005.

36. Apel 2008; Delagnes and Roche 2005; Eren et al. 2011; Pelegrin 1990, 2005; Roux et al. 1994; Winton 2005.

37. Hayden 1977, 1979; J. P. White 1968a, 1969; J. P. White and Thomas 1972; J. P. White et al. 1977.

38. Sheets 1975, 1978; Young and Bonnichsen 1985.

39. See Bamforth and Finlay 2008 for a detailed summary list.

40. Akerman and Fagan 1986; Apel 2008; Bisson 2001; Callahan 2006; Crabtree 1968; Eren et al. 2011; Ferguson 2008; Finlay 2008; Fischer 1990; Flenniken 1978; Geribàs et al. 2010; Högberg 2008; Shelley 1990; Stahl 2008; Winton 2005.

41. Bodu 1996; Bodu et al. 1990; Grimm 2000; Karlin and Pigeot 1989; Karlin et al. 1993; Pigeot 1987, 1988, 1990.

42. Milne 2005.

43. Bleed 2008.

44. Finlay 2008; Fischer 1990.

45. Eren et al. 2011; Pelegrin 2005; Roche et al. 1999; Winton 2000.

46. Audouze 1987; Audouze and Enloe 1997; Boëda 1988, 1995; Bodu 1996; Bodu et al. 1990; Dibble and Bar-Yosef 1995; Fischer 1990; Hofman and Enloe 1992; Högberg 2008; Karlin and Pigeot 1989; Karlin et al. 1993; Pelegrin 1990; Pigeot 1987, 1988, 1990; Schlanger 1990, 1994.

47. Akerman and Fagan 1986; Bisson 2001; Crabtree 1968; Frison and Bradley 1982; Geribàs et al. 2010; Shelley 1990; Tixier 1967, 1978; Tostevin 2012; Winton 2005.

48. Ferguson 2008.

49. Bamforth and Finlay 2008.

50. Stout 2002.

51. Tindale 1985, 5.

52. Stout 2002, 2005.

53. Roux et al. 1994; Stout 2002.

54. Binford 1984.

55. Gould 1980; Hayden and Cannon 1984; Shott and Sillitoe 2004.

56. Sahle 2008, 42.

57. Hayden 1979.

58. Hayden 1979, 27, 31, 45, 60, 86, 95, 109.

CHAPTER 5

1. Weedman 2006.

2. Freeman 1997, 2002; Olmstead 1975; Sperber 1973.

3. Olmstead 1997, 26.

4. Freeman 1997, 2001, 165–67.

5. Normark 2009; DeLanda 2002; Deleuze and Guattari 1987, 88.

6. Olmstead 1972.

7. Freeman 1997.

8. Lesur-Gebremariam 2008.

9. J. Arthur 2002, 2003, 2006, 2009.

10. Matory 1999.

11. Weedman 2006.

12. Freeman 2002; Olmstead 1997.

13. Weedman 2006.

14. Mehari 2016.

15. Weedman 2006.

16. Weedman 2006; I discuss migration and material change but not change in use of space.

17. Weedman 2006.

18. Weedman 2006.

19. Weedman 2006.

20. Bruhns and Sothert 1999; Casey 1998; Fischman 1992; Gero 1991; Kehoe 2005; Owen 2005; Sassaman 1992.

21. Gero 1991.

22. Bird 1993; Cane 1992; Goodale 1971, 167–68; Gould 1968a, 1980; Grey 1841b, 266; Gusinde 1931, 353; Hassell 1975, 57; Hayden 1979; Holmes 1919, 316; R. Jones 1990; R. Jones and N. White 1988; Lothrop 1928; MacCalman and Grobbelaar 1965; Man 1883b, 380; Mason 1889; Murdoch 1892; E. Nelson 1899; H. Roth 1899, 151; W. Roth 1904, 19; Sellers 1885, 872; Sillitoe and Hardy 2005; Toth et al. 1992, 90; Webley 1990, 2005.

23. Gould 1968a, 1980; Hayden 1979; R. Jones 1990, 28; R. Jones and N. White 1982, 55, 61, 83; MacCalman and Grobbelaar 1965; H. Roth 1899, 151; W. Roth 1904, 19; Sillitoe and Hardy 2005; Toth et al. 1992, 90; J. P. White and Thomas 1972, 279.

24. Aiston 1929; K. Arthur 2010; Binford and O'Connell 1984; Brandt and Weedman 1997; Brandt et al. 1996; Clark 1991; Clark and Kurashina 1981; Gallagher 1974, 1977a, 1977b; R. Haaland 1987; Hampton 1999; Sahle 2008; Sahle and Negash 2010; Sahle et al. 2012; Stout 2002, 2005.

25. Binford 1984, 172, 176; Gould 1980, 132; Hayden 1977, 185; R. Jones 1990, 28; R. Jones and N. White 1982, 55, 61, 83; H. Roth 1899, 151; Sillitoe and Hardy 2005, 562; J. P. White and Thomas 1972, 279.

26. Albright 1984, 57; K. Arthur 2010; Dunn 1931, 41; Gorman 1995; Hardy and Sillitoe 2003; Holmes 1919, 216; Man 1883b, 380; Roth 1899, 151; Sellers 1885, 872.

27. Draper 1975; Gould 1968b, 110; Hayden 1979, 167; Janes 1983; Kent 1990, 1998; Yellen 1977.

28. Cooper 1994, 2000; Jarvenpa and Brumbach 1995, 2006.

29. Andrefsky 1994, 2009; Bamforth 1986; Binford 1973, 1978, 1986; Clark 1991; Gould 1980; Odell 1989.

30. R. Jones and N. White 1982.

31. J. P. White et al. 1977.

32. Gould 1980, 123–26; 1968; MacCalman and Grobbelaar 1965.

33. Informal tools (J. P. White et al. 1977; Sillitoe and Hardy 2005) and formal tools (Blackwood 1950; Hampton 1999; Sillitoe 1982) are hafted in open hafts held in place with twine. Mastic holds formal and informal tools in open hafts (Aiston 1929, 1930; Gould 1968a; 1980, 128–29; Gould et al. 1971; Tindale 1965) and in closed hafts (K. Arthur 2010; Beyries et al. 2001; Brandt et al. 1996; Brandt and Weedman 1997; Clark and Kurashina 1981; D'iatchenko and F. David 2002; Gallagher 1974, 1977a, 1977b; Haberland 1981; Mason 1889; Straube 1963; Takase 2004; L. Turner 1894, 294).

34. For table 19: In Ethiopia: K. Arthur 2010; Brandt 1996; Brandt and Weedman 1997; Clark and Kurashina 1981; Gallagher 1977, 1977a, 1977b; Sahle 2008; Sahle and Negash 2010; Sahle et al. 2012. In West Papua, Indonesia, among the Dani, Wano, and Langda: Hampton 1999; Stout 2002, 2005; Toth et al. 1992. In Papua New Guinea among the Hagen, Wiru, Tungei, and Wahgi Duna: Blackwood 1950; J. Burton 1984, 1985; Chappell 1966; M. Strathern 1965, 1970; J. P. White and Modjeska 1978. In South Australia among the Pitjandjara, Ngadadjara, and Nakako: Tindale 1965. In Lake Erye, Australia: Aiston 1929. In Australia, among the Yolngu: R. Jones and N. White 1988. In Camak, Turkey: Bordaz 1969; Whittaker et al. 2009. Among the Wola in Papua New Guinea: Sillitoe and Hardy 2005. In Mexico: Clark 1991. In Australia, among the Alyawara: Binford 1986; Binford and O'Connell 1984. In Western Desert, Australia: Gould et al. 1971; Gould 1980, 123–26; 1968; Gould and Saggers 1985. In Western Desert, Australia Gugadja, and Pintupi: Basedow 1925, 364; Cane 1984, 146; Carnegie 1897; Hayden 1977, 180.

35. K. Arthur 2010; Brandt and Weedman 1997; Brandt et al. 1996; Clark and Kurashina 1981; Gallagher 1974, 1977a, 1977b; R. Haaland 1987.

36. Gallagher 1977a, 1977b; Gould 1980, 128–30; R. Haaland 1987; Weedman 2006.

37. Brandt and Weedman 1997; Clark and Kurashina 1981; Gallagher 1977a, 1977b; R. Haaland 1987.

38. K. Arthur 2010; Brandt et al. 1996; R. Haaland 1987.

39. Clark 1991.

40. Basedow 1925, 364; Cane 1984, 146; Carnegie 1897; Hayden 1977, 180.

41. Binford 1986; Binford and O'Connell 1984.

42. O'Connell 1987.

43. Sillitoe and Hardy 2005.

44. Bordaz 1969; Whittaker et al. 2009.

45. Gallagher 1977a, 1977b; Sahle 2008; Sahle and Negash 2010; Sahle et al. 2012.

46. Brandt and Weedman 1997; Clark and Kurashina 1981; R. Haaland 1987.

47. J. Burton 1985; Hampton 1999; M. Strathern 1965, 1970; Stout 2002, 2005; Toth et al. 1992.

48. Hampton 1999, 104–23.

49. Hampton 1999; J. P. White and Modjeska 1978.

50. Toth et al. 1992, 92.

51. J. Burton 1985; Hampton 1999; M. Strathern 1965.

52. Aiston 1929; Binford 1984; Binford and O'Connell 1984; Gould 1980, 123–32 (also mentions bringing cores from quarry); Tindale 1965.

53. Aiston 1930; Binford 1984; 1986; Brandt et al. 1996; Clark and Kurashina 1981; Gallagher 1977b, 253; Gould 1970, 1978; O'Connell 1987; Weedman 2006.

54. Aiston 1929; Gould 1980, 143, 154–55.

55. Binford 1986.

56. Clark 1991.

57. Brown 2000; Brown and Emery 2008.

58. Darras 2014.

59. Clark 1991.

60. Darras 2014.

61. Brown 2000; Brown and Emery 2008.

62. Pastrana and Athie 2014.

63. Gillespie 2000.

64. J. Burton 1985; Hampton 1999; M. Strathern 1965; Toth et al. 1992, 92.

65. J. Burton 1984.

66. Hampton 1999, 187–219.

67. Toth et al. 1992.

68. Hardy and Sillitoe 2003, 4.7: locations where men work with chert tools.

69. A. Strathern and Stewart 2000.

70. Cane 1984, 150; 1992.

71. Cane 1984, 1992.

72. R. Jones 1990; R. Jones and N. White 1982.

73. Gould and Yellen 1987; O'Connell 1987.

74. O'Connell 1987.

75. Merlan 1992.

76. Bennett 2010; Deleuze and Guattari 1987.

77. Cahen et al. 1979; Gifford-Gonzales et al. 1985; McBrearty et al. 1998; Tringham et al. 1974, 192.

78. O'Connell 1987; J. P. White and Modjeska 1978.

79. Clark and Kurashina 1981.

CHAPTER 6

1. Kus 1997.

2. Walz 2013.

3. Scott 2007.

4. Atalay 2010; Hollowell and Nicholas 2000; Schmidt and Mrozowski 2013; L. Smith 1999.

5. Gonzalez 2012; Mizoguchi 2015.

6. Harrison 2002, 2004.

7. Diop 1974; Karenga 2004, 178, 186; Martin 2008; Obenga 2004.

8. Bennett 2010; Bergson (1907) 1998; Deleuze and Guattari 1987; Spinoza (1677) 1992.

9. Bird-David 199; Harvey 2006; Ingold 2007; Tylor 1871.

10. Appadurai 1986b; Astor-Aguilera 2010; Kopytoff 1986.

11. Eren et al. 2011; Gintis et al. 2015; Kohn and Mithen 1999; Laughlin 1968; Lovejoy 1981; Woodburn 1982; see also critiques: Bird 1993; Gero 1991; Kehoe 1983, 1990, 2005.

12. Bamforth 2006; Binford 1973, 1979.

13. Andrefsky 1994, 2009; Baales 2001; Braun 2005; Ericson 1984; Torrence 1986.

14. K. Arthur 2013.

15. For exceptions, see R. Jones 1990, 28; R. Jones and N. White 1982, 55, 61, 83; H. Roth 1899, 151; Toth et al. 1992, 90.

16. Binford 1986; Brandt et al. 1996; Dunn 1931, 58, 72, 77–78; Gould 1980, 132; Hassell 1975, 57; Hayden 1979, 5, 29–34, 39; Holmes 1919, 316; MacCalman and Grobbelaar 1965; Man 1883b, 380; Hardy and Sillitoe 2003.

17. Frink 2005, 2009; Habicht Mauche 2005.

18. Irwin 1996; R. Jones 1990; R. Jones and N. White 1988, 61–62; Pastrana and Athie 2014, 96; P. Powell 1969; Wildschut 1975.

19. J. Burton 1984; R. Jones and N. White 1988, 55, 61, 83 (women carried bundles of spears for trading from the quarry!); Paton 1994; H. Roth 1899, 151; Sahle 2008; Sahle and Negash 2010; Sahle et al. 2012; Toth et al. 1992, 90.

20. Hamilton 1980.

21. Harrison 2002, 2004.

22. K. Arthur 2010; Brandt 1996; Brandt and Weedman 1997, 2002.

23. Brightman 1996; Frink 2005, 2009; Leacock 1981; Spencer-Wood 1991.

24. Aiston 1929; J. Burton 1984; Cane 1992; Gould 1966, 1980, 141–46; Gould and Saggers 1985; Hampton 1999, 256; R. Jones 1990, 27; R. Jones and N. White 1988, 56; Pokotylo and Hanks 1989; Tindale 1965, 1985; Stout 2002.

25. R. Jones 1990, 28; R. Jones and N. White 1988, 55, 61, 83; H. Roth 1899, 151; Toth et al. 1992, 90.

26. Irwin 1996, 224–25; R. Jones 1990, 27–30; R. Jones and N. White 1988; Sillitoe and Hardy 2005, 557–58; Wildschut 1975, 90–97.

27. Pastrana and Athie 2014, 96.

28. R. Jones and N. White 1988, 56–57.

29. Gould and Saggers 1985.

30. Cane 1992; Gould 1966; 1980, 153; Hampton 1999, 130, 156–61; R. Jones and N. White 1988; Paton 1994; Taçon 1991; Torrence et al. 2013; J. P. White and Thomas 1972.

31. Paton 1994.

32. J. Burton 1984, 1985, 60–62; Gould 1968a, 107; 1980, 138–42; Gould et al. 1971; Stout 2002.

33. J. Burton 1984; Chappell 1966, 100–104; Clark 1991; Hampton 1999; H. Roth 1899, 151; M. Strathern 1965; Sillitoe 1982; Sillitoe and Hardy 2005, 557–58.

34. Bordaz 1969, 1973; Clark 1991; Gallagher 1977a, 1977b: 261–63; R. Jones 1990; R. Jones and N. White 1989, 59; H. Roth 1899, 151; Whittaker et al. 2009.

35. Brandt et al. 1996; Brandt and Weedman 1997; Clark 1991; Gould 1980, 124; R. Haaland 1987, 67–68; Hampton 1999; Sillitoe and Hardy 2005; J. P. White 1968a, 1968b; J. P. White and Thomas 1972; J. P. White et al. 1977; Whittaker et al. 2009.

36. Aiston 1929; J. Burton 1984, 1985, 60–62; Cane 1992; Gould and Saggers 1985; Hampton 1999; R. Jones and N. White 1988, 56–57; Pokotylo and Hanks 1989; Tindale 1965, 1985.

37. J. Burton 1984; Gould and Saggers 1985.

38. J. Burton 1984, 1985, 60–62; Hampton 1999, 256; Stout 2002.

39. Blackwood 1940; J. Burton 1984; Irwin 1996, 224–25; R. Jones 1990, 27; Sillitoe 1982; M. Strathern 1965; Taçon 1991; Watson 1990.

40. Binford and O'Connell 1984; J. Burton 1984; Clark 1991; Darras 2014, 66; Gould 1980; Gould et al. 1971; Hampton 1999, 125; R. Jones and N. White 1988; Stout 2002, 2005; Toth et al. 1992; Whittaker et al. 2009; Wildschut 1975, 90–91.

41. Binford and O'Connell 1984; Bordaz 1969, 1973; J. Burton 1984; Cane 1992; Chappell 1966, 100–104; Clark 1991; Elkin 1948; Gallagher 1977a, 1977b, 261–63; Hampton 1999; R. Jones 1990; R. Jones and N. White 1988; H. Roth 1889, 151; Tindale 1965; Whittaker et al. 2009.

42. Bleed 2001; Böeda 1988; Dobres and Hoffman 1999; Hayden et al. 1996; Leroi-Gourhan 1942, (1965) 1993; Schiffer 1975a, 1975b, 1975c, 1983; Shott 2003.

43. Cushing 1895, 310; Lubbock 1890; Mercer 1895; Wilson 1862.

44. Hayden 1977, 179; 1979; J. P. White and Thomas 1972, 289; J. P. White et al. 1977, 381.

45. Crabtree 1975, 1.

46. Bordes 1947, 1961a; Brink 1978; Crabtree 1968, 1982; Ellis (1940) 1965; Frison and Bradley 1982; Keeley 1980; Knowles 1944; Leakey 1950; Moir 1911, 1913, 1914; Tixier 1974; Warren 1905, 1913.

47. Review in Bamforth and Finlay 2008; Clark 2003; Eren et al. 2011; Sheets 1975, 1978; Winton 2000.

48. Albright 1984; J. Burton 1985, 94; Gould 1970; Hampton 1999; Stout 2002, 2005, 2010; Whittaker et al. 2009; J. P. White et al. 1977. In several studies of stone-using peoples, knappers were working from memory, and researchers had no opportunity to observe teaching and learning; see Binford 1984; Binford and O'Connell 1984; Hayden 1977, 1979.

49. Wenger 1998.

50. Gould 1968a, 48; Hardy and Sillitoe 2003; J. P. White et al. 1977, 381.

51. Ferguson 2008; Finlay 1997; Pelegrin 1990; Roux et al. 1994; Shelley 1990; Stout 2002, 2005, 2010.

52. J. Burton 1985; Cane 1992; Gallagher 1977a, 1977b; Gould 1968a, 1980, 115–40; R. Jones and N. White 1988; Stout 2002; J. P. White and Thomas 1972; J. P. White et al. 1977.

53. Stout 2002; Wenger 1998, 179–80.

54. Tostevin 2012, 94–98.

55. Wenger 1998.

56. Stout 2002.

57. Stout 2002, 704.

58. Harvey 2006; Ingold 2006.

59. But see J. P. White et al. 1977 and Sillitoe and Harding 2005 for exceptions.

60. Finlay 1997; Gould 1968a; Grimm 2000; Hardy and Sillitoe 2003; Högberg 2008; Shea 2006.

61. Binford 1984.

62. Albright 1984, 52; K. Arthur 2010; J. Burton 1984, 239; Gould 1970; Gusinde (1937) 1962, 563; Hampton 1999, 232; Roux et al. 1994; Stout 2002, 2005, 2010.

63. V. Turner 1974.

64. K. Arthur 2010; Grimm 2000; Shea 2006; Stout 2002, 2005.

65. Ethnographic: Stout 2002, 2005. Inferred experimental archaeology: Bamforth and Finlay 2008; Ferguson 2008; Grimm 2000; Shea 2006.

66. R. Jones and N. White 1988; Stout 2002.

67. E.g., Andrews 2003.

68. This study and Stout 2002, 2005.

69. Ethnographic: Roux et al. 1994; Stout 2002, 2005; Weedman 2002a; experimental: Akerman and Fagan 1986; Apel 2008; Bamforth and Finlay 2008; Bisson 2001; Callahan 2006; Crabtree 1968; Eren et al. 2011; Ferguson 2008; Finlay 2008; Fischer 1990; Flenniken 1978; Geribàs et al. 2010; Högberg 2008; Pelegrin 1990; Shelley 1990; Stahl 2008; Winton 2005.

70. E.g., Andrews 2003.

71. Apel 2008; Bamforth 1991; Bamforth and Hicks 2008; Bisson 2001; Finlay 1997; chapters in Hirth 2003; M. Levine and Carballo 2014.

72. Rots 2000.

73. Ethnoarch: Beyries and Rots 2008; Binford 1986; Clark and Kurashina 1981; Gould 1966, 1968a; Gould and Quilter 1972; Gould et al. 1971; Hayden 1977, 1979; Tindale 1965, 1985; J. P. White 1968a, 1969; J. P. White and Thomas 1972; J. P. White et al. 1977. Experimental: Bamforth 1986; Brink 1978, 97; Broadbent and Knutsson 1975; Dibble 1987; Hayden 1979, 1987; Hurcombe 1992; Kamminga 1982; Keeley 1980; Rots 2000; Shea 1987; Siegel 1984; Shott 1995; Sillitoe 1979; Toth 1985; Townsend 1979; Vaughan 1985; Wilmsen 1968.

74. Hayden 1979, 26.

75. Hayden 1979, 27, 31, 45, 60, 86, 95, 109.

76. Binford in Fischman 1992; Gintis et al. 2015; Kohn and Mithen 1999; Laughlin 1968; Lovejoy 1981; Woodburn 1982.

77. Darras 2014.

78. Pastrana and Athie 2014.

79. Hampton 1999, 130, 156–61, 187–219.

80. Cane 1992; Darras 2014, 66; Gould 1980, 142; Irwin 1996, 159; Paton 1994.

81. Gould 1980, 142–43; R. Jones 1990.

82. Irwin 1996, 224–25; P. Powell 1969, 572–76.

83. Allchin 1957; Bordaz 1969; J. Burton 1985, 110–11; Brandt et al. 1996; Elkin 1948; Gallagher 1977b, 261; Hampton 1999; Sahle 2008, 37–38; Stout 2002, 2005; Tindale 1965; Toth et al. 1992; Whittaker et al. 2009.

84. R. Jones and N. White 1988; Thomson 1939; J. P. White et al. 1977.

85. Allchin 1957; K. Arthur 2010; Binford and O'Connell 1984, 418, for use of term "nest" by knapper; Gould et al. 1971.

86. J. Burton 1985; Hampton 1999; R. Jones and N. White 1988; Stout 2002; Whittaker et al. 2009.

87. Clark 1991; Hampton 1999, 298.

88. Aiston 1929; K. Arthur 2010; Gould 1978; 1980, 123–26; Tindale 1985; Weedman 2000, 2006.

89. Gould 1968a, 1980.

90. K. Arthur 2010; Sahle 2008; Sahle and Negash 2010.

91. Brandt et al. 1996; Clark 1991; Clark and Kurashina 1981; R. Haaland 1987; Skertchly 1879.

92. Brandt et al. 1996; Clark and Kurashina 1981; Gallagher 1977a, 1977b; Weedman 2006.

93. Brandt and Weedman 1997; Brandt et al. 1996; Clark and Kurashina 1981; Gallagher 1974, 1977a, 1977b; R. Haaland 1987.

94. Binford 1984, 1986; Hampton 1999; O'Connell 1987.

95. Hampton 1999, 128–29.

96. Aiston 1930; Binford 1984, 1986; Brandt et al. 1996; Gallagher 1977a, 253; 1977b; Gould 1970, 1978; O'Connell 1987.

97. K. Arthur 2010 for women too!; Binford 1984, 1986; Deal and Hayden 1987; Gould 1978; Hampton 1999, 236, 266–68; Hardy and Sillitoe 2003; O'Connell 1987; Sillitoe and Hardy 2005; Toth et al. 1992; J. P. White et al. 1977.

98. Andrefsky 1994; Bamforth 1986; Binford 1973, 1977, 1979; Hayden 1987; Odell 1989, 1994; Parry and Kelley 1987; Shott 1986.

99. Gould 1980, 143, 154–55; J. P. White and Modjeska 1978.

100. Aiston 1929; J. P. White and Modjeska 1978. Formal and informal tools used daily in households are used and stored for less than a year; see Gallagher 1977a, 1977b; Gould 1980, 128–30; R. Haaland 1987; Weedman 2006.

101. Gould 1978, 1980.

102. Hardy and Sillitoe 2003.

103. Clark 1991; Clark and Kurashina 1981; Deal and Hayden 1987; Gallagher 1977b, 253–54; R. Haaland 1987; Hardy and Sillitoe 2003.

104. Aiston 1930; Binford 1984, 1986; Brandt and Weedman 1997; Brandt et al. 1996; Clark and Kurashina 1981; Gallagher 1977a; 1977b, 278–79; Gould 1970, 1978; Hardy and Sillitoe 2003; O'Connell 1987; Sillitoe and Hardy 2005; J. P. White et al. 1977.

105. Toth et. al 1992, 92.
106. Clark 1991; Deal and Hayden 1976.
107. K. Arthur 2010; R. Haaland 1987.
108. O'Connell 1987; J. P. White and Modjeska 1978.
109. Cahen et al. 1979; Gifford-Gonzales et al. 1985; McBrearty et al. 1998; Schiffer 1975a, 1975c; Tringham et al. 1974, 192.
110. Whyte 2014.
111. Bennett 2010, 5–6.
112. Mizoguchi 2015.
113. *Sensu* Sassaman 2012.

REFERENCES

Abélès, Marc. 1977. "La guerre vue d'Ochollo." *Revue Canadienne des Études Africaines* 11 (3): 455–71.

———. 1978. "Pouvoir et société chez les Ochollo d'Ethiopie Méridionale." *Cahiers d'Etudes Africaines* 18 (71): 293–310.

———. 1979. "Religion, Traditional Beliefs: Interaction and Changes in Southern Ethiopian Society: Ochollo (Gamu-Gofa)." In *Society and History in Ethiopia: The Southern Periphery from the 1880s to 1974*, edited by D. L. Donham and Wendy James, 184–95. Cambridge: African Studies Centre, University of Cambridge.

———. 1981. "In Search of the Monarch: Introduction of the State among the Gamo of Ethiopia." In *Modes of Production in Africa: The Precolonial Era*, edited by D. Crummey and C. Steward, 35–67. Beverly Hills, CA: Sage Publications.

———. (1983) 2012. *Placing Politics*, translated by Dominique Lussier. Oxford: Barwell Press.

Adams, Robert McCormick. 1940. "Diagnostic Flint Points." *American Antiquity* 6 (1): 72–75.

Adler, Ken. 1998. "Making Things the Same: Representation, Tolerance, and the End of the Ancien Regime in France." *Social Studies of Science* 28 (4): 499–545.

Agorsah, E. Kofi. 1990. "Ethnoarchaeology: The Search for a Self-Corrective Approach to the Study of Past Human Behavior." *The African Archaeological Review* 8: 89–208.

Ahler, Stanley A. 1989. "Mass Analysis of Flaking Debris: Studying the Forest rather than the Trees." In *Alternative Approaches to Lithic Analysis*, edited by D. Henry and G. Odell, 85–118. *Archaeological Papers of the American Anthropological Association* 1. Tulsa, OK: University of Tulsa.

Aiston, George. 1929. "Chipped Stone Tools of the Aboriginal Tribes East and North-East of Lake Eyre South Australia." *Papers & Proceedings of the Royal Society of Tasmania*, 123–31. Hobart, Tasmania: Tasmania Museum.

———. 1930. "Method of Mounting Stone Tools on Koondi." *Papers and Proceedings of the Royal Society of Tasmania*, 44–47. Hobart, Tasmania: Tasmania Museum.

Akerman, Kim, and John L. Fagan. 1986. "Fluting the Lindenmeir Folsom: A Simple and Economical Solution to the Problem, and Its Implications for Other Fluted Point Technologies." *Lithic Technology* 15: 1–7.

Alberti, Benjamin. 2005. "Archaeology, Men, and Masculinities." In *Handbook of Gender in Archaeology*, edited by Sarah Milledge Nelson, 401–34. Walnut Creek, CA: AltaMira Press.

Alberti, Benjamin, and Yvonne Marshall. 2009. "Animating Archaeology: Local Theories and Conceptually Open-Ended Methodologies." *Cambridge Archaeological Journal* 19 (3): 344–56.

Alberti, Benjamin, Severin Fowls, Martin Holbradd, Yvonne Marshall, and Christopher Witmore. 2011. "'Worlds Otherwise': Archaeology, Anthropology, and Ontological Difference." *Current Anthropology* 52 (6): 896, 912.

Albright, Sylvia. 1984. *Tahltan Ethnoarchaeology*. Vancouver, BC: Department of Archaeology, Simon Fraser University.

Allchin, Bridget. 1957. "Australian Stone Industries, Past and Present." *Journal of the Royal Anthropological Institute* 87 (1): 115–36.

Amborn, Hermann. 2001. "Soul and Personality as a Communal Bond." *Anthropos* 96: 41–57.

Ammerman, Albert J., and M. W. Feldman. 1974. "On the Making of an Assemblage of Stone Tools." *American Antiquity* 39: 610–16.

Andrefsky, William, Jr. 1994. "Raw-Material Availability and the Organization of Technology." *American Antiquity* 59: 21–35.

———. 2009. "The Analysis of Stone Tool Procurement, Production, and Maintenance." *Journal of Archaeological Research* 17 (1): 65–103.

Andrews, Bradford. 2003. "Measuring Prehistoric Craftsman Skill: Contemplating Its Application to Mesoamerican Core-Blade Research." In *Mesoamerican Lithic Technology: Experimentation and Interpretation*, edited by Kenneth G. Hirth, 208–19. Salt Lake City: University of Utah Press.

Apel, Jan. 2008. "Knowledge Know-How and Raw Material: The Production of Late Neolithic Flint Daggers in Scandinavia." *Journal of Archaeological Method and Theory* 15: 91–11.

Appadurai, Arjun. 1986a. "Is Homo Hierachicus?" *American Ethnologist* 13 (4): 745–61.

———. 1986b. *The Social Life of Things: Commodities in Cultural Perspective*. Cambridge: Cambridge University Press.

Arthur, John W. 2002. "Brewing Beer: Status, Wealth, and Ceramic Use-Alteration among the Gamo of Southwestern Ethiopia." *World Archaeology* 34: 516–28.

———. 2003. "Beer, Food, and Wealth: An Ethnoarchaeological Use-Alteration Analysis of Pottery." *Journal of Archaeological Method and Theory* 9: 331–55.

———. 2006. *Living with Pottery: Ethnoarchaeology among the Gamo of Southwest Ethiopia*. Salt Lake City: Foundations of Archaeological Inquiry, University of Utah Press.

———. 2009. "Understanding Household Population through Ceramic Assemblage Formation: Ceramic Ethnoarchaeology among the Gamo of Southwestern Ethiopia." *American Antiquity* 74 (1): 31–48.

———. 2013. "Transforming Clay: Gamo Caste, Gender, and Pottery of Southwestern Ethiopia." *Asian and African Study Monographs* 47: 5–25.

———. 2014a. "Culinary Crafts and Foods in Southwestern Ethiopia: An Ethnoarchaeological Study of Gamo Groundstones and Pottery." *Journal of African Archaeological Review* 41 (2): 131–68.

———. 2014b. "Pottery Uniformity in a Stratified Society: An Ethnoarchaeological Perspective from the Gamo of Southwestern Ethiopia." *Journal of Anthropological Archaeology* 35: 106–16.

Arthur, Kathryn Weedman. 2008. "Stone-Tool Hide Production: The Gamo of Southwestern Ethiopia and Cross-Cultural Comparisons." *Anthropozoologica* 43 (1): 67–98.

———. 2010. "Feminine Knowledge and Skill Reconsidered: Women and Flaked Stone Tools." *American Anthropologist* 112 (2): 228–43.

———. 2013. "Material Entanglements: Gender, Ritual, and Politics among the Boreda of Southern Ethiopia." *African Study Monographs (CAAS)* 47: 53–80. Kyoto, Japan.

Arthur, Kathryn Weedman, John W. Arthur, Matthew C. Curtis, Bizuayehu Lakew, Joséphine Lesur-Gebremariam, and Yohannes Ethiopia. 2009. "Historical Archaeology in the Highlands of Southern Ethiopia: Preliminary Findings." *Nyama Akuma* 72: 3–11.

———. 2010. "Fire on the Mountain: Dignity and Prestige in the History and Archaeology of the Boreda Highlands in Southern Ethiopia." *SAA Archaeological Record* 10 (1): 17–21.

Arthur, Kathryn Weedman, Yohannes Ethiopia Tocha, Matthew C. Curtis, Bizuayehu Lakew, and John W. Arthur. 2017. "Seniority Through Ancestral Landscapes: Community Archaeology in the Highlands of Southern Ethiopia." *Journal of Community Archaeology & Heritage* 3 (2): 101–14.

Astor-Aguilera, Miguel Angel. 2010. *The Maya World of Communicating Objects: Quadripartite Crosses, Trees, and Stones.* Albuquerque: University of New Mexico Press.

Atalay, Sonya. 2010. "Diba Jimooyung—Telling Our Story: Colonization and Decolonization of Archaeological Practice from an Anishinabe Perspective." In *World Archaeological Congress Handbook of Postcolonial Archaeology,* edited by Uzma Riziv and Jane Lydon, 61–72. Walnut Creek, CA: Left Coast Press.

———. 2012. *Community-Based Archaeology: Research with, by, and for Indigenous and Local Communities.* Berkeley: University of California Press.

Audouze, Françios 1987. "The Paris Basin in Magdalenian Times." In *The Pleistocene Old World: Regional Perspective,* edited by O. Soffer, 183–200. New York: Plenum Press.

———. 2002. "Leroi-Gourhan, a Philosopher of Technique and Evolution." *Journal of Archaeological Research* 10 (4): 277–306.

Audouze, Françios, and James G. Enloe. 1997. "High Resolution Archaeology at Verberie Limits and Interpretations." *World Archaeology* 29 (2): 195–207.

Azaïs, R. Pére, and Roger Chambard. 1931. *Cinq Années de Recherches Archéologiques en Éthiopié*. Paris: Librairie Orientaliste Paul Geuthner.

Baales, Michael. 2001. "From Lithics to Spatial and Social Organization: Interpreting Lithic Distribution and Raw Material Composition at the Paleolithic Site of Kettig." *Journal of Archaeological Science* 28: 127–41.

Bachechi, Luca. 2005. "Preliminary Report on the 2002 Excavation of the Harurona Cave Deposit." In *Wolayta: Una regione d'Etiopia: Studi e richercher (1995–2004)*, edited by Carlo Cavanna, 67–78. *Atti del Museo di Storia Naturale della Marema Supplemento al* 21.

Bahrey, Abba. (1593) 1993. "History of the Galla." In *History of the Galla (Oromo) of Ethiopia*, edited by D. N. Levine, 44–55. Oakland, CA: African Sun.

Bailey, Robert C., Genevieve Head, Mark Jenike, Bruce Owen, Robert Rechtman, and Elzbieta Zechenter. 1989. "Hunting and Gathering in Tropical Rain Forest: Is It Possible?" *American Anthropologists* 91 (1): 59–82.

Balfour, Henry. 1929. "Concerning Thunderbolts." *Folklore* 40 (1): 37–49.

Bamforth, Douglas. 1986. "Technological Efficiency and Tool Curation." *American Antiquity* 51: 38–50.

———. 1991. "Flintknapping Skill, Communal Hunting, and Paleoindian Projectile Point Typology." *Plains Anthropologist* 36 (137): 309–22.

———. 2006. "The Windy Ridge Quartzite Quarry: Hunter-Gatherer Mining and Hunter-Gatherer Land Use on the North American Continental Divide." *World Archaeology* 38 (3): 511–27.

Bamforth, Douglas, and Nyree Finlay. 2008. "Introduction: Archaeological Approaches to Lithic Production Skill and Craft Learning." *Journal of Archaeological Method and Theory* 15: 1–27.

Bamforth, Douglas, and Keri Hicks. 2008. "Production Skill and Paleoindian Workgroup Organization in the Medicine Creek Drainage, Southwestern Nebraska." *Journal of Archaeological Method and Theory* 15 (1): 132–53.

Barham, Lawrence. 2002. *From Hand to Handle: The First Industrial Revolution*. Oxford: Oxford University Press.

Barreto, Ana Cristina Ramirez. 2009. "Ontology and Anthropology of Interanimality: Merleau-Ponty from Tim Ingold's Perspective." *ABIR* 5 (1): 32–57.

Barrett, Samuel A. 1879. *The Material Aspects of the Pomo Culture*. Milwaukee: University of Wisconsin Board of Trustees.

Bartleet, Eustace J. 1934. *In the Land of Sheba*. Birmingham, UK: Cornish Brothers.

Bar-Yosef, Ofer, and Philip Van Peer. 2009. "The Chaîne Opératoire Approach in the Middle Paleolithic Archaeology." *Current Anthropology* 50 (1): 103–31.

Basedow, Herbert. 1925. *The Australian Aborigines*. Adelaide: Preece and Sons.

Bastien, Betty. 2004. "Blackfoot Ways of Knowing." Calgary: University of Calgary Press.

Beckingham, Charles Fraser, and George Wynn Brereton Huntingford. 1954. *Some Records of Ethiopia, 1593–1646.* London: Hakluyt Society.

Bender, M. Lionel. 1988. "Proto-Omotic: Phonology and Lexicon." In *Papers from the International Symposium on Cushitic and Omotic Languages,* edited by M. Bechaus-Gerst and F. Sezisko, 121–62. Hamburg, Germany: Helmut Buske Verlag.

———. 2000. *Comparative Morphology of Omotic Languages.* Muchen, Germany: Lincom Europa.

Bennett, Jane. 2010. *Vibrant Matter: A Political Ecology of Things.* Durham, NC: Duke University Press.

Bergson, Henri. (1907) 1998. *Creative Evolution,* translated by Arthur Mitchell. New York: Dover.

Berhane-Selassie, Tsehai. 1994. "The Wolayta Conception of Inequality." *Proceedings of the Eleventh International Conference of Ethiopian Studies* 2: 351–58.

———. 2008. "The Socio-politics of Ethiopian Sacred Groves." In *African Sacred Groves: Ecological Dynamics and Social Change,* edited by Michael J. Sheridan and Celia Nyamweru, 103–116. Oxford: James Currey.

Bettinger, Robert L., and Jelmer W. Eerkens. 1999. "Point Typologies, Cultural Transmission, and the Spread of Bow and Arrow Technology in the Prehistoric Great Basin." *American Antiquity* 64: 231–42.

Beyries, Sylvie. 2002. "Le travail du cuir chez les Tchouktches et les Athapaskans: Implications ethno-archéologiques." In *Le travail du cuir de la préhistoire à nos jours,* edited by Frédérique Audoin-Rouzeau and Sylvie Beyries, 143–48. Antibes, France: Éditions APDCA.

Beryies, Sylvie, and Veerle Rots. 2008. "The Contributions of Ethnoarchaeological Macro- and Microscopic Wear to the Understanding of Archaeological Hide-Working Processes." In *Prehistoric Technology 40 Years Later: Functional Studies and the Russian Legacy,* edited by Laura Longo and Natalia Skakun, 21–28. *BAR International Series* 1783. Oxford: BAR Publishing.

Beyries, Sylvie, Sergev A. Vasil'ev, Francine David, Vladimir I. D'iachenko, Claudine Karlin, and Youri V. Chesnokov. 2001. "Uil, a Paleolithic Site in Siberia: An Ethno-archaeological Approach." In *Ethno-archaeology and Its Transfers,* edited by Sylvie Beyries and Pierre Petrequin, 9–22. *BAR International Series* 983. Oxford: Archaeopress.

Binford, Lewis R. 1968. "Post-Pleistocene Adaptions." *New Perspectives in Archaeology,* edited by Lewis Binford and Sally R. Binford, 313–42. Chicago: Aldine.

———. 1973. "Inter-assemblage Variability—The Mousterian and the Functional Argument." In *The Explanation of Cultural Change,* edited by Colin Renfrew, 227–54. London: Duckworth.

———. 1977. "Forty-Seven Trips: A Case Study in the Character of Archaeological Formation Processes." In *Stone Tools as Cultural Markers,* edited by R. V. S. Wright, 24–36. Canberra: Australian Institute of Aboriginal Studies.

———. 1978. *Nunamiut Ethnoarchaeology.* New York: Academic Press.

———. 1979. "Galley Pond Mound." In *An Archaeological Perspective*, edited by Lewis Binford, 390–420. New York: Academic Press.

———. 1981. *Bones: Ancient Men and Modern Myths*. New York: Academic Press.

———. 1984. "An Alyawara Day: Flour, Spinfix Gum, and Shifting Perspectives." *Journal of Anthropological Research* 40: 157–82.

———. 1986. "An Alyawara Day: Making Men's Knives and Beyond." *American Antiquity* 51 (3): 547–62.

———. 1987. "Researching Ambiguity: Frames of Reference and Site Structure." In *Method and Theory for Activity Area Research*, edited by Susan Kent, 449–512. New York: Columbia University Press.

———. 1989. "Style of Styles." *Journal of Anthropological Archaeology* 8: 51–67.

Binford, Lewis R., and James F. O'Connell. 1984. "An Alyawara Day: The Stone Quarry." *Journal of Anthropological Research* 40 (3): 406–32.

Bird, Caroline F. M. 1993. "Woman the Tool-Maker: Evidence for Women's Use and Manufacture of Flaked Stone Tools in Australia and New Guinea." In *Women in Archaeology: A Feminist Critique*, edited by Hilary du Cros and Laurajane Smith, 22–30. Canberra: Australian National University.

Bird-David, Nurit. 1999. "'Animism' Revisited: Personhood, Environment, and Relational Epistemology." *Current Anthropology* 40. Special Issue: *Culture: A Second Chance?* (February): S67–S91.

Bisson, Michael. 2001. "Interview with a Neanderthal: An Experimental Approach for Reconstructing Scraper Production Rules, and Their Implications for Imposed Form in Middle Paleolithic Tools." *Cambridge Archaeological Journal* 11 (2): 165–84.

Blackwood, Beatrice. 1950. "The Technology of Modern Stone Age People in New Guinea." *Occasional Papers on Technology* 3. Oxford: Pitt Rivers Museum.

Bleed, Peter. 2001. "Trees or Chains, Links or Branches: Conceptual Alternatives for Consideration of Stone Tool Production and Other Sequential Activities." *Journal of Archaeological Method and Theory* 8 (1): 101–27.

———. 2008. "Skillful Stones: Approaches to Knowledge and Practice in Lithic Technology." *Journal of Archaeological Method and Theory* 15: 154–66.

Blench, Roger. 2006. *Archaeology, Language and the African Past*. Walnut Creek, CA: AltaMira Press.

Blench, Roger, and Mallam Dendo. 2006. "Omotic Livestock Terminology and Its Implications for the History of Afroasiatic." Cambridge Paper, November 15, 2006. http://www.rogerblench.info/Language/Afroasiatic/Omotic/Omotic%20livestock%20paper.pdf/.

Blench, Roger, and Kevin MacDonald. 2006. *Origins and Development of African Livestock; Archaeology, Genetics, Linguistics, and Ethnography*. New York: Routledge.

Bodenhorn, Barbara. 1990. "'I'm Not the Great Hunter, My Wife Is': Inupiat and Anthropological Models of Gender." *E'tudes Inuit* 14 (1–2): 55–74.

Bodu, Pierre. 1996. "Les chausseurs Magdaléniens de Pincevent." *Lithic Technology* 21 (1): 48–70.

Bodu, Pierre, Claudine Karlin, and Sylvie Ploux. 1990. "Who's Who? The Magdalenian Flint-knappers of Pincevent, France." In *The Big Puzzle: International Symposium on Refitting Stone Artefacts*, edited by E. Cziesla, S. Ecikhoff, N. Arts, and D. Winters, 143–63. *Studies in Modern Archaeology* 1. Bonn, Germany: Holos.

Boëda, Eric. 1988. "Le concept laminaire: Rupture et filiation avec le concept Levallois." In *L'homme de Néandertal: Actes due colloque international de Liège*, edited by J. K. Kozlowski, 41–59. Liege, Belgium: Université de Liège.

———. 1995. "Levallois: A Volumetric Construction, Methods, a Technique. In *The Definition and Interpretation of Levallois Technology*, edited by Harold Dibble and O. Bar-Yosef, 41–68. Madison, WI: Monographs in World Archaeology, Prehistory Press.

Boivin, Nicole. 2008. "Orientalism, Ideology, and Identity: Examining Caste in South Asian Archaeology." *Journal of Social Archaeology* 5: 225–52.

Bombe, Bosha. 2013. *Slavery in the Gamo Highlands*. Saarbruken, Germany: LAP Lambert Academic.

Bordaz, Jacques. 1969. "Flintworking in Turkey." *Natural History* 78: 73–79.

———. 1973. "Stone Knapping in Modern Turkey." University Park, PA: PCR Films in Behavioral Sciences.

Bordes, François. 1947. "Étude comparative des différentes techniques de taille du silex et des roches dures." *L'Anthropologie* 51: 1–29.

———. 1957. "Le Moustérien de Hauteroche: Comparaisons statistiques." *L'Anthropologie* 61: 436–41.

———. 1961a. *Typologie du Paléolithique ancien et moyen*. Bordeaux, France: Imprimeries Delmas.

———. 1961b. "Mousterian Cultures in France." *Science* 134: 803–10.

———. 1972. *A Tale of Two Caves*. New York: Harper & Row.

———. 1973. "On the Chronology and Contemporaneity of Different Paleolithic Cultures in France." In *The Explanation of Cultural Change*, edited by Colin Renfrew, 218–26. London: Duckworth.

———. 1977. "Time and Space Limits in the Mousterian." In *Stone Tools as Cultural Markers*, edited by R. V. S. Wright, 37–39. Canberra: Australian Institute of Aboriginal Studies.

———. 1979. *Typologie du Paléolithique ancien et moyen*. Cahiers du Quarternaire 1. Bordeaux, France: C.N.R.S.

Borelli, Jules. 1890. *Ethiopie Meridionale*. Paris: Librairies-Imprimeries Reunies.

Boyd, William. 2012. "A Frame to Hang Clouds On: Cognitive Ownership, Landscape, and Heritage Management." In *The Oxford Handbook of Public Archaeology*, edited by Robin Skeates, Carol McDavid, and John Carman, 172–97. Oxford: Oxford University Press.

Brandt, Steven. A. 1996. "The Ethnoarchaeology of Flaked Stone Tool Use in Southern Ethiopia." In *Aspects of African Archaeology: Papers from the 10th Congress of the PanAfrican Association for Prehistory and Related Studies*, 733–38. Harare: University of Zimbabwe.

Brandt, Steven A., and Kathryn Weedman. 1997. "The Ethnoarchaeology of Hideworking and Flaked Stone-Tool Use in Southern Ethiopia." In *Broader Perspective: Papers of the XIIth International Conference of Ethiopian Studies*, edited by Katsuyoshi Fukui, Eisei Kurimoto, and Masayoshi Shigeta, 351–61. Kyoto, Japan: Shokado Book Sellers.

———. 2002. "The Ethnoarchaeology of Hide Working and Stone Tool Use in Konso, Southern Ethiopia: An Introduction." In *Le travail du cuir de la préhistoire à nos jours*, edited by Frédérique Audoin-Rouzeau and Sylvie Beyries, 113–30. Antibes, France: Éditions APDCA.

Brandt, Steven A., Kathryn Weedman, and Girma Hundie. 1996. "Gurage Hide Working, Stone Tool Use, and Social Identity: An Ethnoarchaeological Perspective." In *Essays on Gurage Language and Culture: Dedicated to Wolf Leslau on the Occasion of His 90th Birthday, November 14, 1996*, edited by G. Hudson, 35–51. Wiesbaden, Germany: Verlag Harrassowitz.

Braun, David R. 2005. "Examining Flake Production Strategies: Examples from the Middle Paleolithic of Southwest Asia." *Lithic Technology* 30 (2): 107–25.

Breuil, Henri, and Raymond Lantier. 1965. *The Men of the Old Stone Age*. New York: St. Martin's Press.

Brew, J. Otis. 1946. "The Use and Abuse of Taxonomy." In *Papers of the Peabody Museum of American Archaeology and Ethnology, Harvard*, 44–66. Cambridge, MA: Harvard University Press.

Brightman, Robert. 1996. "The Sexual Division of Foraging Labor: Biology, Taboo, and Gender Politics." *Comparative Studies in Society and History* 38 (4): 687–729.

Brink, John W. 1978. *An Experimental Study of Microwear Formation on Endscrapers*. Ottawa: National Museum of Canada, National Museum of Man Mercury Series.

Broadbent, Noel D., and K. Knutsson. 1975. "An Experimental Analysis of Quartz Scrapers." *Fornavannen* 70: 113–28.

Broughton, Jack M., and James F. O'Connell. 1999. "On Evolutionary Ecology, Selectionist Archaeology, and Behavioral Archaeology." *American Antiquity* 64 (1): 153–65.

Brown, Linda A. 2000. "From Discard to Divination: Demarcating the Sacred through the Collection and Curation of Discarded Objects." *Latin American Antiquity* 11 (4): 319–33.

Brown, Linda A., and Kitty Emery. 2008. "Negotiations with the Animate Forest: Hunting Shrines in the Guatemalan Highlands." *Journal of Archaeological Method and Theory* 15 (4): 300–337.

Brown, Linda A., and William H. Walker, eds. 2008. "Prologue: Archaeology, Animism and Non-human Agents." *Journal of Archaeological Method and Theory* 15 (4): 298–99.

Browne, James. 1856. "The Aborigines of Australia." *The Canadian Journal* (May 1): 245–66.

Bruce, James. 1790. *Travels to Discover the Source of the Nile*, vols. 3, 5. Edinburgh: Archibald Constable and Company.

Bruhns, Karen, and Karen Stothert. 1999. *Women in Ancient America*. Norman: University of Oklahoma Press.

Brumbach, Hetty Jo, and Robert Jarvenpa. 1997a. "Ethnoarchaeology Subsistence, Space, and Gender: A Subarctic Dene Case." *American Antiquity* 62 (3): 414–36.

———. 1997b. "Woman the Hunter: Ethnoarchaeological Lessons from Chipewyan Life-Cycle Dynamics." In *Women in Prehistory: North America and Mesoamerica*, edited by Cheryl Claassen and Rosemary A. Joyce, 17–32. Philadelphia: University of Pennsylvania Press.

Bureau, Jacques. 1975. "Le statut des artisans en Éthiopie." *Ethiopie, la terre et les hommes* (1975): 38–44.

———. 1976. "Note sur les églises du Gamo." *Annales d'Ethiopie* 10: 295–302.

———. 1978. "Étude diachronique de deux titres Gamo." *Cahiers d'Études Africaines* 18: 279–91.

———. 1979. "Notes sur l'histoire contemporaine des Gamo d'Ethiopie Méridionale." *Abbay* 10: 201–4.

———. 1981. *Les Gamo d'Ethiopie: Étude du système politique*. Paris: Societe d'Ethnographie.

———. 1983. "La mort du serpent: Remarques à propos d'une version d'Ethiopie Méridionale." *Abbay* 12: 779–84.

———. 1986–87. "La royauté en quèstion." *Abbay* 13: 137–42.

Burton, John. 1984. "Quarrying in a Tribal Society." *World Archaeology* 16 (2): 234–47.

———. 1985. "Axe Makers of the Wahgi." PhD diss., Australian National University.

Burton, Richard F. 1894. *First Footsteps in East Africa or an Exploration of Harar*. London: Tylston and Edwards.

Cahen, Daniel, Lawrence H. Keeley, and Francis L. Van Noten. 1979. "Stone Tools, Toolkits, and Human Behavior in Prehistory." *Current Anthropology* 20 (4): 661–83.

Callahan, Errett. 2006. "Neolithic Danish Daggers: An Experimental Peek." In *Skilled Production and Social Reproduction*, edited by J. Apel and K. Knutsson, 115–37. *SAU Stone Studies* 2. Uppsala, Sweden: Societas Archaeologica Upsaliensis.

Campbell, Thomas D., and Henry V. V. Noone. 1943. "South Australian Microlithic Stone Implements." *Records of the South Australian Museum* 7: 340–59.

Cane, Scott B. 1984. "Desert Camps: A Case Study of Stone Artifacts and Aboriginal Behavior in the Western Desert." PhD diss., Australian National University.

———. 1988. "Written on Stone: A Discussion on Ethnographic and Aboriginal Perception of Stone Tools." In *Archaeology with Ethnography: An Australian Perspective*, edited by Betty Meehan and Rhys Jones, 88–90. Canberra: Department of Prehistory, Research School of Pacific Studies, Australian National University.

———. 1992. "Aboriginal Perceptions of Their Stone Tool Technology: A Case from the Western Desert, Australia." *Australian Archaeology* (35): 11–31.

Carnegie, David Wynford. 1897. *Spinifex and Sand: A Narrative of Five Years' Pioneering and Exploration in Western Australia*. London: C. Arthur Pearson Limited.

Cartledge, Dan. 1995. "Taming the Mountain: Human Ecology, Indigenous Knowledge, and Sustainable Resource Management in the Doko Gamo Society of Ethiopia." PhD diss., University of Florida.

Casey, Joanna. 1998. "Just a Formality: The Presence of Fancy Projectile Points in a Basic Tool Assemblage." In *Gender in African Prehistory*, edited by Susan Kent, 83–104. Walnut Creek, CA: AltaMira Press.

Cassiers, Anne. 1975. "Handicrafts and Technical Innovation in Ethiopia." *Cultures* 2 (3): 119–35.

Catlin, George. 1844. "Letters." In *Notes on the Manners, Customs and Conditions of the North American Indians*, 2 vols. London: Tosswill and Myers.

———. 1868. *Life among the Indians*. London: Sampson, Low, Son and Marston.

Cerulli, Enrico. 1956. *Peoples of South-West Ethiopia and Its Borderland*. London: International African Institute.

Chang, Claudia. 1988. "Nauyalik Fish Camp: An Ethnoarchaeological Study in Activity-Area Formation." *American Antiquity* 53 (1): 145–57.

Chappell, John M. A. 1966. "Stone Axe Factories in the Highlands of East New Guinea." *Proceedings of the Prehistoric Society* 32: 96–121.

Charlevoix, Pierre François Xavier de. 1769. *The History of Paraguay. Containing amongst Many Other New, Curious, and Interesting Particulars of That country*, vol. 1. London: Lockyer Davis and University of Michigan Library.

Chazan, Michael. 2003. "Generating the Middle to Upper Paleolithic Transition: A Chaine Operatoire Approach." In *More than Meets the Eye: Studies on Upper Paleolithic Diversity in the Near East*, edited by A. Nigel Goring-Morris and Anna Belfer-Cohen, 51–54. Oxford: Oxbow Books.

Chebo, Chencha, Workneh Ayalew, and Zewdu Wuletaw. 2013. "On-Farm Phenotypic Characterization of Indigenous Cattle Populations of Gamo Goffa Zone, Southern Ethiopia." *Animal Genetic Resources/Ressources génétiques animales/Recursos genéticos animales* 52 (2013): 71–82.

Childe, V. Gordon. 1929. *The Most Ancient East: The Oriental Prelude to European Prehistory*. London: Kegan Paul, Trench, Trubner and Co.

Clark, John Desmond, and H. Kurashina. 1981. "A Study of the Work of a Modern Tanner in Ethiopia and Its Relevance for Archaeological Interpretation." In *Modern Material Culture: The Archaeology of Us*, edited by R. A. Gould and M. B. Schiffer, 303–43. New York: Academic Press.

Clark, John E. 1991. "Flintknapping and Debitage Disposal among the Lacandon Maya of Chiapas, Mexico." In *The Ethnoarchaeology of Refuse Disposal*, edited by E. Staski and L. D. Sutro, 63–88. Tempe: Arizona State University.

———. 2003. "Craftsmanship and Craft Specialization." In *Mesoamerican Lithic Technology: Experimentation and Interpretation*, edited by Kenneth G. Hirth, 220–33. Salt Lake City: University of Utah Press.

Cohn, Carol. 1996. "Nuclear Language and How We Learned to Pat the Bomb." In *Feminism and Science*, edited by Evelyn Fox Keller and Helen E. Longino, 173–85. Oxford: Oxford University Press.

Collins, Michael B. 1975. "Lithic Technology as a Means of Processual Inference." In *Lithic Technology: Making and Using Stone Tools*, edited by Eric Swanson, 15–34. The Hague: Mouton.

Combes, Edmond, and Maurice Tamisier. 1838. *Voyage en Abyssinie, dans le pays des Galla, de Choa et d'Ilfat*, vol. 4. Paris: Louis Desessart.

Conkey, Margaret W., and Joan M. Gero. 1991. "Tensions, Pluralities, and Engendering Archaeology: An Introduction to Women and Prehistory." In *Engendering Archaeology Women and Prehistory*, edited by Margaret Conkey and Joan M. Gero, 3–31. Oxford: Blackwell.

Connell, Raewyn W., and James W. Messerschmidt. 2005. "Hegemonic Masculinity: Rethinking the Concept." *Gender and Society* 19 (6): 829–59.

Cooper, Zarine. 1994. "Abandoned Onge Encampments and Their Relevance in Understanding the Archaeological Record in the Andaman Islands." In *Living Traditions: Studies in the Ethnoarchaeology of South Asia*, edited by Bridget Allchin, 235–63. New Delhi: Oxford University Press and IBH.

———. 2000. "The Enigma of Gender in the Archaeological Record of the Andaman Islands. In *In Pursuit of Gender: Worldwide Archaeological Approaches*, edited by Sarah M. Nelson and Myrian Rosen-Ayalon, 173–86. Walnut Creek, CA: AltaMira Press.

Costin, Cathy Lynn. 1991. "Craft Specialization: Issues in Defining, Documenting, and Explaining the Organization of Production." *Archaeological Method and Theory* 3: 1–56.

———. 1998. "Introduction: Craft and Social Identity." In *Craft and Social Identity*, edited by Cathy Costin, 143–62. In *Archaeological Papers of the American Anthropological Association* 8 (1). Hoboken, NJ: Blackwell.

Crabtree, Don. 1968. "A Stoneworker's Approach to Analyzing and Replicating the Lindemeier Folosom." *Tebiwa* 9: 3–39.

———. 1975. "Comments on Lithic Technology and Experimental Archaeology." In *Lithic Technology: Making and Using Stone Tools*, edited by E. Swanson, 105–114. The Hague, Netherlands: Mouton.

———. 1982. *An Introduction to Flintworking*. Pocatello, ID: Idaho Museum of Natural History.

Crowell, Aron, Amy F. Steffian, and Gordon L. Pullar. 2001. *Looking Both Ways: Heritage and Identity of the Altiiq People*. Fairbanks: University of Alaska Press.

Cunningham, Jerimy J. 2003. "Transcending the 'Obnoxious Spectator': A Case for Processual Pluralism in Ethnoarchaeology." *Journal of Anthropological Archaeology*, 22 (4): 389–410.

Curr, Edward M. 1887. *The Australian Race*, vol. 3. Melbourne, Australia: John Ferres, Government Printer.

Curtis, Matthew C. 2013. "Archaeological Evidence for the Emergence of Food Production in the Horn of Africa." In *The Oxford Handbook of African Archaeology*, edited by Peter Mitchell

and Paul Lane. Oxford: Oxford Handbooks Online. http://www.oxfordhandbooks.com
/view/10.1093/oxfordhb/9780199569885.001.0001/oxfordhb-9780199569885/.

Cushing, Frank H. 1879. "Curious Discoveries in Regard to the Manner of Making Flint Imple-ments by the Aborigines and Prehistoric Inhabitants of America." *Engineering and Mining Journal* 28: 89–92.

———. 1895. "The Arrow." *American Anthropologist* 8 (4): 307–49.

Dale, Langham. 1870. "Stone Implements of South Africa." *Cape Monthly* 1: 365–66.

Darras, Véronique. 2014. "Ethnohistorical Evidence for Obsidian's Ritual and Symbolic Uses among the PostClassic Tarascans." In *Obsidian Reflections: Symbolic Dimensions of Obsidian in Mesoamerica*, edited by Marc B. Levine and David M. Carballo, 45–47. Boulder: University Press of Colorado.

David, Nicholas. 2012. *Metals in Mandara Mountains' Society and Culture*. Trenton, NE: Africa World Press.

David, Nicholas, and Carol Kramer. 2001. *Ethnoarchaeology in Action*. Cambridge: Cambridge University Press.

Deal, Michael, and Brian Hayden. 1987. "The Persistence of Pre-Columbian Lithic Technology in the Form of Glassworking." In *Lithic Studies among the Contemporary Highland Maya*, edited by Brian Hayden, 235–331. Tucson: University of Arizona Press.

de Beauvoir, Simone. (1949) 1953. *The Second Sex*, translated by H. M. Parshley. London: Jonathan Cape.

Dejene, Amare, Abebech Alemneh, Almaz Haile Selassie, Bogalech Alemu, and Fisseha Hail Meskal. 2006. *Old Beyond Imaginings: Ethiopia Harmful Traditional Practices*. Addis Ababa: National Committee on Traditional Practices of Ethiopia (NCTPE) with NORAD.

Delagnes, Anne, and Hélène Roche. 2005. "Late Pliocene Hominid Knapping Skills: The Case of Lokalalei 2C, West Turkana, Kenya." *Journal of Human Evolution* 48 (2005): 435–72.

DeLanda, Manuel. 2013. *Intensive Science and Virtual Philosophy*. London: Bloomsbury Publishing.

Deleuze, Gilles, and Félix Guattari. 1987. *A Thousand Plateaus: Capitalism and Schizophrenia*. Minneapolis: University of Minnesota Press.

Deloria, Vine, Jr. 1992. "Indians, Archaeologist, and the Future." *American Antiquity* 57 (4): 595–98.

D'iatchenko, Vladimir, and Francine David. 2002. "La préparation traditionnelle des peaux de poisons et de mammifères marins chez les populations de l'Extrême-Orient Sibérien de language toungouze." In *Le travail du cuir de la préhistoire à nos jours*, edited by Frédérique Audoin-Rouzeau and Sylvie Beyries, 175–92. Antibes, France: Éditions APDCA.

Dibble, Harold L. 1984. "Interpreting Typological Variation of Middle Paleolithic Scrapers: Function, Style, or Sequence Reduction?" *Journal of Field Archaeology* 11: 431–35.

———. 1987. "The Interpretation of Middle Paleolithic Scraper Morphology." *American Antiquity* 52: 109–17.

Dibble, Harold L., and Ofer Bar-Yosef, eds. 1995. *The Definition and Interpretation of Levallois Technology*. Madison, WI: Prehistory Press.

Diop, Cheikh Anta. 1974. *African Origin of Civilization: Myth or Reality*. Chicago: Chicago Review Press.

Dirks, Nicholas B. 1989. "The Original Caste: Power, History, and Hierarchy in South Asia." *Contributions to Indian Sociology* 23 (1): 59–77.

Dixon, Roland Burrage. 1914. "The Early Migrations of the Indians of New England and the Maritime Provinces." In *Proceedings of the American Antiquarian Society*, New Series, vol. 2, 65–76. Worcester, MA: American Antiquarian Society.

Dobres, Marcia-Anne, and Christopher R. Hoffman. 1999. "Introduction: A Context for the Present and Future of Technology Studies." In *The Social Dynamics of Technology*, edited by Marcia-Anne Dobres and Christopher R. Hoffman, 1–22. Washington, D.C.: Smithsonian Institution Press.

Dobres, Marcia-Anne, and John E. Robb. 2000. "Agency in Archaeology: Paradigm or Platitude?" In *Agency in Archaeology*, edited by Marcia-Anne Dobres and John E. Robb, 1–18. London: Routledge.

Draper, Patricia. 1975. "Kung Women: Contrasts in Sexual Egalitarianism in Foraging and Sedentary Context." In *Toward an Anthropology of Women*, edited by Rayna Reiter, 77–109. New York: Monthly Review Press.

Drennan, Matthew R. 1957. "The Principle of 'Change' in Man and Animals and the Role of 'Feminism' or Gynomorphism in It." *The South African Archaeological Bulletin* 12 (45): 3–14.

Dugdale, William. 1656. *The Antiquities of Warwickshire Illustrated: From Records, Leiger-Books, Manuscripts, Charters, Evidences, Tombes, and Armes*. London: Thomas Warren.

Dumont, Louis. 1980. *Homo Hierarchicus: The Caste System and Its Implications*. Chicago: University of Chicago Press.

Dunn, Edward. 1880. "On the Stone Implements of South Africa." *Transactions of the South African Philosophical Society* 1880: 6–22.

———. 1931. *The Bushman*. London: Charles Griffin.

Dunnell, Robert C. 1978. "Style and Function: A Fundamental Dichotomy." *American Antiquity* 43: 192–202.

Elkin, Adolphus. 1948. "Pressure Flaking in the Northern Kimberley, Australia." *Man* 48 (130): 110–13.

Ellicott, Robert James I. 1977. Law Commission Act 1973. Legal Document, Report 31. Australian Law Reform Commission. https://www.alrc.gov.au/.

Ellis, H. Holmes. (1940) 1965. "Flint-Working Techniques of the American Indians: An Experimental Study." MA thesis, Ohio State University. Reprinted by the Ohio Historical Society.

Ellison, James. 2008. "'Everyone Can Do as He Wants': Economic Liberalization and Emergent Forms of Antipathy in Southern Ethiopia." *American Ethnologist* 33 (4): 665–86.

———. 2009. "Governmentality and the Family: Neoliberal Choices and Emergent Kin Relations in Southern Ethiopia." *American Anthropologist* 11 (1): 81–92.

Epstein, Jeremiah F. 1964. "Towards the Systematic Description of Chipped Stone." *Actas y Memorias* 35: 155–69.

Eren, Metin I., Bruce A. Bradley, and C. Garth Sampson. 2011. "Middle Paleolithic Skill Level and the Individual Knapper: An Experiment." *American Antiquity* 76 (2): 229–51.

Ericson, Jonathon E. 1984. "Toward the Analysis of Lithic Production Systems." In *Prehistoric Quarries and Lithic Production*, edited by J. E. Ericson and B. A. Purdy, 1–10. Cambridge: Cambridge University Press.

Estioko-Griffin, Agnes, and Bion Griffin 1985. *The Agta of Northeastern Luzon. Humanities Series*. Cebu City, Philippines: University of San Carlos Publications.

Ethiopian Mapping Authority. 1988. *National Atlas of Ethiopia*. Addis Ababa, Ethiopian Mapping Authority.

Evans, John, Sir. 1872. *The Ancient Stone Implements, Weapons, and Ornaments of Great Britian*. New York: D. Appleton and Company.

Eyre, John Edward. 1840. *Journals of Expeditions of Discovery into Central Australia and Overland from Adelaide to King George's Sound in the Years 1840–41*, vol. 2. London: T. and W. Boone. http://gutenberg.net.au/ebooks/e00048.html.

Fanta, Fancho. 1985. "The Cultural History of Borroda in the Late Nineteenth and Early Twentieth Centuries." BA thesis, Department of History, Addis Ababa University, Addis Ababa, Ethiopia.

Ferguson, Jeffrey R. 2008. "The When, Where, and How of Novices in Craft Production." *Journal of Archaeological Method and Theory* 15: 51–67.

Fernyhough, Timothy. 1994. "Slavery and the Slave Trade in Southern Ethiopia: A Historical Overview ca. 1800–1935." *Slavery and Abolition: A Journal of Slave Post-Slave Studies* 9 (3): 103–30.

Fewkes, Jesse Walter. 1900. *Tusayan Migration Traditions*, vol. 19, no. 1. Washington, D.C.: US Government Printing Office.

Feyissa, Dereje. 1997. "The Oyda of Southwestern Ethiopia: A Study of Socio-economic Aspects of Village Inequality." MA thesis, Department of History, Addis Ababa University, Addis Ababa, Ethiopia.

Finkelstein, J. Joe. 1937. "A Suggested Projectile-Point Classification." *American Antiquity* 2 (3): 197–203.

Finlay, Nyree. 1997. "Kid Knapping: The Missing Children in Lithic Analysis." In *Invisible People and Processes*, edited by Jenny Moore and Eleanor Scott, 202–12. London: Leicester University Press.

———. 2008. "Blank Concerns: Issues of Skill and Consistency in the Replication of Scottish Later Mesolithic Blades." *Journal of Archaeological Method and Theory* 15: 68–90.

———. 2011. "Skill and the Substance of Stone: Exploring Issues of Raw Material Diversity in Scottish Arran Pitchstone." *Lithic Technology* 36 (2): 189–200.

Fischer, Anders. 1990. "On Being a Pupil of a Flintknapper of 11,000 Years Ago." In *The Big Puzzle*, edited by Erwin Cziesla, Sabine Eickhoff, Nico Arts, and Doris Winter, 143–63. Bonn, Germany: Holos.

Fischman, Joshua. 1992. "Hard Evidence: By Re-creating Stone Age Behavior, Researchers Are Learning That Neanderthals Were Nothing Like the People We Imagined (Interview with Lewis Binford)." *Discover* (February): 44–46.

Fleming, Harold C. 1973. "Recent Research in Omotic Speaking Areas." *Proceedings of the First United States Conference on Ethiopian Studies*, 261–78. East Lansing: Michigan State University, African Studies Center.

———. 1976. "Omotic Overview." In *The Non-Semitic Languages of Ethiopia*, edited by L. Bender, 299–323. East Lansing: Michigan State University, African Studies Center.

Flenniken, Jeffrey J. 1978. "Reevaluation of the Lindenmeier Folsom: A Replication Experiment in Lithic Technology." *American Antiquity* 43: 474–80.

———. 1984. "The Past, Present, and Future of Flintknapping: An Anthropological Perspective." *Annual Review of Anthropology* 13 (1984): 187–203.

Ford, James A. 1954. "On the Concept of Types." *American Anthropologist* 56 (10): 42–57.

Ford, James A., and Gordon R. Willey. 1941. "An Interpretation of the Prehistory of the Eastern United States." *American Anthropologist* 43 (3): 325–63.

Fowke, Gerard. 1896. "Stone Art." In *Thirteenth Annual Report of the Bureau of Ethnology to the Secretary of the Smithsonian Institute 1891–92*, edited by J. W. Powell, 47–178. Washington, D.C.: Government Printing Office.

Freeman, Dena. 1997. "Images of Fertility: The Indigenous Concept of Power in Doko Masho, Southwest Ethiopia." In *Ethiopia in Broader Perspectives: Papers of the XIIth International Conference of Ethiopian Studies*, vol. 2, edited by K. Fukui, E. Kurimoto, and M. Shigeta, 342–57. Kyoto, Japan: Ethiopian Studies Association.

———. 2002. *Initiating Change in Highland Ethiopia: Causes and Consequences of Cultural Transformation*. Cambridge: Cambridge University Press.

Freeman, Dena, and Alula Pankhurst, eds. 2001. *Living on the Edge: Marginalised Minorities of Craftworkers and Hunters in Southern Ethiopia*. Addis Ababa, Ethiopia: Department of Sociology and Social Administration.

Frink, Lisa. 2005. "Gender and Hide Production Process in Colonial Western Alaska." In *Gender and Hide Production*, edited by Lisa Frink and Kathryn Weedman, 89–104. Walnut Creek, CA: AltaMira.

———. 2009. "The Identity Division of Labor in Native Alaska." *American Anthropologist* 111 (1): 21–29.

Frink, Lisa, and Kathryn Weedman. 2005. *Gender and Hide Production*. Walnut Creek, CA: AltaMira Press.

Frison, George, and Bruce Bradley. 1982. "Fluting Folsom Points." In *The Agate Basin Site: A Record of Paleoindian Occupation of the Northwestern High Plains*, edited by G. Frison and D. Standford, 209–12. New York: Academic Press.

Gallagher, James P. 1974. "The Preparation of Hides with Stone Tools in South Central Ethiopia." *Journal of Ethiopian Studies* 12: 177–82.

———. 1977a. "Contemporary Stone Tool Use in Ethiopia: Implications for Archaeology." *Journal of Field Archaeology* 4: 407–14.

———. 1977b. "Ethnoarchaeological and Prehistoric Investigations in the Ethiopian Central Rift Valley." PhD diss., Southern Methodist University, Dallas, Texas.

Gamachu, Daniel. 1977. *Aspects of Climate and Water Budget in Ethiopia*. Addis Ababa, Ethiopia: Addis Ababa University.

Gebreselassie, Teclehaimanot. 2003. "The Low-Caste Fuga Occupational Group under the Italian Administration in the Horn of Africa." *Northeast African Studies* 10 (3): 33–44.

Gell, Alfred. 1998. *Art and Agency: An Anthropological Theory*. Oxford: Oxford University Press.

Geribàs, Núria, Marina Mosquera, and Josep Maria Vergès. 2010. "What Novice Knappers Have to Learn to Become Expert Stone Toolmakers." *Journal of Archaeological Science* 37 (2): 2857–70.

Gero, Joan M. 1991. "Genderlithics: Women's Roles in Stone Tool Production." In *Engendering Archaeology: Women and Prehistory*, edited by J. M. Gero and M. W. Conkey, 163–93. Oxford: Blackwell.

Gero, Joan M., and Margaret W. Conkey. 1991. "Tensions, Pluralities and Engendering Archaeology: An Introduction to Women and Prehistory." In *Engendering Archaeology: Women and Prehistory*, edited by J. M. Gero and M. W. Conkey, 3–30. Oxford: Blackwell.

Gidada, Negaso. 1984. "History of the Sayoo Oromoo of Southwestern Wallaga, Ethiopia, from about 1730 to 1886." PhD diss., Johann Wolfgang Goethe-Universitat, Frankfurt, Germany.

Gifford–Gonzalez, Diane. 1993. "You Can Hide, but You Can't Run: Representations of Women's Work in Illustrations of Palaeolithic Life." *Visual Anthropology Review* 9 (1): 22–41.

Gifford-Gonzalez, Diane P., David B. Damrosch, Debra R. Damrosch, John Pryor, and Robert L. Thunen. 1985. "The Third Dimension in Site Structure: An Experiment in Trampling and Vertical Dispersal." *American Antiquity* 50: 803–18.

Giglioli, Henry H. 1889. "On a Singular Obsidian Scraper Used at Present by Some of the Galla Tribes in Southern Shoa." *Internationales Archives für Ethnographie* 2: 212–14.

Gillespie, Susan D. 2000. "Rethinking Ancient Maya Social Organization: Replacing Lineage with House." *American Anthropologist* 102 (3): 467–84.

Gintis, Herbert, Carel van Schaik, and Christopher Boehm. 2015. "Zoon Politikon." *Current Anthropology* 56 (3): 327–53.

Goodale, Jane. 1971. *Tiwi Wives: A Study of Women of Melville Island, North Australia*. Seattle: University of Washington Press.

Goodwin, Astley John Hilary, and Clarence van Riet Lowe. 1929. *The Stone Age Cultures of South Africa*. Edinburgh: Printed for Trustees of the South African Museum.

Gonzalez, Wenceslao J. 2012. "Methodological Universalism in Science and Its Limits, Imperialism versus Complexity." In *Thinking about Provincialism in Thinking*, edited by Kryzsztof Bryzechczyn and Katarzyna Paprzychka, 155–76. Amsterdam: Rodopi.

González-Ruibal, Alfredo, Almudena Hernando, and Gustavo Politis. 2011. "Ontology of the Self and Material Culture: Arrow-Making among the Awa Hunter-Gatherers." *Journal of Anthropological Archaeology* 30 (2011): 1–16.

Gorman, Alice. 1995. "Gender, Labour, and Resources: The Female Knappers of the Andaman Islands." In *Gendered Archaeology: The Second Australian Women in Archaeology Conference*, edited by Jane Balme and Wendy Beck, 87–91. ANH Publications. Canberra, Australia: Research School of Pacific and Asian Studies, Australian National University.

Gosden, Chris. 2005. "What Do Objects Want?" *Journal of Archaeological Method and Theory* 12 (3): 193–211.

———. 2008. "Social Ontologies: Philosophical Transactions." *Biological Sciences* 363 (1499): 2003–2010.

Gosden, Chris, and Yvonne Marshall. 2010. "The Cultural Biography of Objects." *World Archaeology* 31 (2): 169–78.

Gould, Richard A. 1966. "Some Stone Artifacts of the Wonkonguru of South Australia." *American Museum Novitates* 2249: 1–9.

———. 1968a. "Chipping Stones in the Outback." *Natural History Novitates* 77 (2): 42–49.

———. 1968b. "Living Archaeology: The Ngatatjara of Western Australia." *Southwestern Journal of Anthropology* 24: 101–21.

———. 1970. "Spears and Spear-Throwers of the Western Desert Aborigines of Australia." *American Museum Novitates* 2403: 1–42.

———. 1977. "Ethno-archaeology: Or Where Do Models Come From? A Closer Look at Australian Aboriginal Lithic Technology." In *Stone Tools as Cultural Markers*, edited by R. V. S. Wright, 162–68. London: Humanities Press.

———. 1978. "Beyond Analogy in Ethnoarchaeology." In *Explanations in Ethnoarchaeology*, edited by Richard A. Gould, 249–93. Albuquerque: University of New Mexico Press.

———. 1980. *Living Archaeology*. Cambridge: Cambridge University Press.

Gould, Richard A., Dorothy A. Koster, and Anne H. L. Sontz. 1971. "The Lithic Assemblage of the Western Desert Aborigines of Australia." *American Antiquity* 36: 149–69.

Gould, Richard A., and Jeffrey Quilter. 1972. "Flat Adzes—A Class of Flaked Stone Tools in Southwestern Australia." *American Museum Novitates* 2502: 1–14.

Gould, Richard A., and Sherry Saggers. 1985. "Lithic Procurement in Central Australia: A Look at Binford's Idea of Embeddedness in Archaeology." *American Antiquity* 50 (1): 117–36.

Gould, Richard A., and Patty Jo Watson. 1982. "A Dialogue on the Meaning and Use of Analogy in Ethnoarchaeological Reasoning." *Journal of Anthropological Archaeology* 1 (4): 355–81.

Gould, Richard A., and John E. Yellen. 1987. "Man the Hunted: Determinants of Household Spacing in Desert and Tropical Foraging Societies." *Journal of Anthropological Archaeology* 6 (1): 77–103.

Grayson, Donald K. 1983. *The Establishment of Human Antiquity*. New York: Academic Press.

Gregg, Susan A. 1988. *Foragers and Farmers: Population Interaction and Agricultural Expansion in Prehistoric Europe*. Chicago: University of Chicago Press.

Grey, George. 1841a. *Journals of Two Expedition of Discovery in North-West and Western Australia, during the Years 1837, 1838, and 1839*, vol. I. London: T. and W. Boone.

———. 1841b. *Journals of Two Expedition of Discovery in North-West and Western Australia, during the Years 1837, 1838, and 1839*, vol. II. London: T. and W. Boone.

Grimm, Linda. 2000. "Apprentice Flintknapping: Relating Material Culture and Social Practice in the Upper Palaeolithic." In *Children and Material Culture*, edited by Joanna Sofaer Dervenski, 53–70. London: Routledge Press.

Gunn, Joel D. 1975. "Idiosyncratic Behavior in Chipping Style: Some Hypotheses and Preliminary Analysis." In *Lithic Technology: Making and Using Stone Tools*, edited by E. Swanson, 35–61. The Hague, Netherlands: Mouton.

Gupta, Dipankar. 2004. "The Certitudes of Caste: When Identity Trumps Hierarchy. *Contributions to Indian Sociology* 38 (1/2): v–xv.

Gusinde, Martin. 1931. *The Fireland Indians*. Vol 1, *The Selk'nam on the Life and Thought of a Hunting People of the Great Island of Tierra del Fuego*. Mödling: Verlag der Internationalen Zietschrift.

———. (1937) 1962. *The Yahgan: The Life and Thought of the Water Nomads of Cape Horn*. New Haven, CT: Human Relations Area Files.

Gutherz, Xavier, Luc Jallot, Joséphine Lesur, Guy Pouzolles, and Dominique Sordoillet. 2002. "Les fouilles de l'abri sous-rouche de Moche Borago (Soddo-Wolayta). Premier bilan." *Annales d'Ethiopie* 18 (2002): 181–90.

Haaland, Gunnar. 2004. "Smelting Iron: Caste and Its Symbolism in South-Western Ethiopia." In *Belief in the Past: The Proceedings of the 2002 Manchester Conference on Archaeology and Religion*, edited by Timothy Insoll, 75–86. *BAR International Series* 1212. Cambridge: BAR Publishing.

Haaland, Gunnar, Randi Haaland, and Suman Rijal. 2002. "The Social Life of Iron: A Cross-Cultural Study of Technological, Symbolic, and Social Aspects of Iron Making." *Anthropos* 97: 35–54.

Haaland, Randi. 1987. *Socio-economic Differentiation in the Neolithic Sudan. BAR International Series* 350. Cambridge: BAR Publishing.

Haberland, Eike. 1959. "Archaic Tribes in Southern Ethiopia." In *Altvölker Süd-Äthiopiens*, edited by A. E. Jensen, 419–430. Stuttgart, Germany: Verlag Kohlhammer.

———. 1978. "Ethnogenesis and Expansion in Southwest-Ethiopia with Special Reference to the Omotic-Speaking Peoples." *Abbay* 9: 141–43.

———. 1981. "Die Materielle Kultur de Dizi (Sudwest-Athiopien) und Ihr Kulturhistorischer Kontext." *Paideuma* 27: 121–71.

———. 1984. "Caste and Hierarchy among the Dizi." In *Proceedings of the Seventh International Conference of Ethiopian Studies*, edited by S. Rubeson, 447–50. Addis Ababa: Institute of Ethiopian Studies.

————. 1993. *Hierarchie und Kaste*. Stuttgart, Germany: Franz Steiner Verlag.

Habicht Mauche, Judith A. 2005. "The Shifting Role of Women and Women's Labor on the Protohistoric Southern High Plains." In *Gender and Hide Production*, edited by Lisa Frink and Kathryn Weedman, 37–56. Walnut Creek, CA: AltaMira Press.

Hallpike, Christopher R. 1968. "The Status of Craftsmen among the Konso of Southwest Ethiopia." *Africa* 38 (3): 258–69.

Halperin, Rhoda, and Judith Olmstead. 1976. "To Catch a Feastgiver: Redistribution among the Dorze of Ethiopia." *Africa* 46: 146–65.

Hambly, Wilfrid D. 1936. *Primitive Hunters of Australia*. Chicago: Field Museum of Natural History.

Hamer, John H. 1970. "Sidamo Generational Class Cycles: A Political Gerontocracy." *Africa* 40 (1): 50–70.

————. 1987. *Humane Development*. Tuscaloosa: University of Alabama Press.

————. 1994. "Commensality, Process, and the Moral Order: An Example from Southern Ethiopia." *Africa* 64 (1): 126–44.

————. 1996. "Inculcation of Ideology among the Sidama of Ethiopia." *Journal of the International African Institute* 66 (4): 526–51.

Hamilton, Annette. 1980. "Dual Social Systems: Technology, Labor, and Women's Secret Rites in the Eastern Western Desert of Australia." *Oceania* 51 (1): 4–19.

Hampton, O. W. "Bud". 1999. *Culture of Stone: Sacred and Profane Uses of Stone among the Dani*. College Station: Texas A&M University.

Hankins, Thomas L. 1985. *Science and the Enlightenment*. Cambridge History of Science. Cambridge: Cambridge University Press.

Harding, Sandra. 1998. *Is Science Multicultural? Postcolonialism, Feminisms, and Epistemologies*. Bloomington: Indiana University Press.

Hardy, Karen, and Paul Sillitoe. 2003. "Material Perspectives: Stone Tool Use and Material Culture in Papua New Guinea." *Internet Archaeology* 14 (3). http://intarch.ac.uk/journal /issue14/3/toc.html.

Hariot, Thomas. 1588. "A Brief and True Report of the New Found Land of Virginia." Edited by Paul Royster. *Electronic Texts in American Studies*, Paper 20. http://digitalcommons.unl .edu/etas/20/.

Harrison, Rodney. 2002. "Archaeology and the Colonial Encounter: Kimberley Spearpoints, Cultural Identity, and Masculinity in the North of Australia." *Journal of Social Archaeology*, 2 (3): 352–77.

————. 2004. "Kimberley Points and Colonial Preference: New Insights into the Chronology of Pressure Flaked Point Forms from the Southeast Kimberley, Western Australia." *Archaeology in Oceania* 39 (1): 1–11.

Harrower, Michael J., Joy McCorriston, and Catherine D'Andrea. 2010. "General/Specific, Local/Global: Comparing the Beginnings of Agriculture in the Horn of Africa (Ethiopia/ Eritrea) and Southwest Arabia (Yemen)." *American Antiquity* 75: 452–72.

Harvey, Graham. 2006. *Animism: Respecting the Living World*. New York: Columbia University Press.

Hasen, Abdulahi. 1996. *Livestock, Poultry, and Beehives: Population and Number*. Addis Ababa, Ethiopia: Office of Population and Housing Census Commission Central Statistical Authority.

Hassell, Ethel. 1975. *My Dusky Friends*. Dalkeith, WA: C. W. Hassel.

Hayden, Brian. 1977. "Stone Tool Functions in the Western Desert." In *Stone Tools as Cultural Markers*, edited by R. V. S. Wright, 178–88. Canberra: Australian Institute of Aboriginal Studies.

———. 1979. *Paleolithic Reflections*. Atlantic Highlands, NJ: Humanities Press.

———. 1987. "Use and Misuse: The Analysis of Endscrapers." *Lithic Technology* 16: 65–70.

Hayden, Brian, and Aubrey Cannon. 1984. *The Structure of Material Systems: Ethnoarchaeology in the Maya Highlands*. Society for American Archaeology Papers 3. Washington, D.C.: Society for American Archaeology.

Hayden, Brian, Nora Franco, and Jim Spafford. 1996. "Evaluating Lithic Strategies and Design Criteria." In *Stone Tools: Theoretical Insights into Human Prehistory*, edited by George H. Odell, 9–49. New York: Plenum Press.

Hayward, Richard. 1998. "The Challenge of Omotic." *Horn of Africa* 16: 1–30.

Headland, Thomas, and Lawrence A. Reid. 1989. "Hunter-Gatherers and Their Neighbors from Prehistory to the Present." *Current Anthropology* 30 (1): 43–66.

Heizer, Robert F. 1940. "A Note on Folsom and Nepesta Points." *American Antiquity* 6 (1): 79–80.

———. 1962. *Man's Discovery of His Past: Literary Landmarks in Archaeology*. Englewood Cliffs, NJ: Prentice Hall.

Henare, Amiria, Martin Holbraad, and Sari Wastell, eds. 2007. *Thinking through Things*. London: Routledge.

Hester, Thomas R., and Robert F. Heizer. 1973. *Bibliography of Archaeology I: Experiments, Lithic Technology, and Petrography*. Reading, MA: Addison-Wesley Publishing Co.

Hiatt, Betty. 1968. "The Food Quest and the Economy of the Tasmanian Aborigines." *Oceania* 38 (2): 99–106.

Hildebrand, Elisabeth Anne, Steven Andrew Brandt, and Josephine Lesur-Gebremarium. 2010. "The Holocene Archaeology of Southwest Ethiopia: New Insights from the Kafa Archaeological Project." *African Archaeological Review* 27: 255–89.

Hirth, Kenneth G., ed. 2003. *Mesoamerican Lithic Technology*. Salt Lake City: University of Utah Press.

Hodder, Ian. 2012. *Entangled: The Relationship Between Humans and Things*. Oxford: Wiley-Blackwell.

Hodson, Arnold W. 1929. "Journeys from Maji, Southwest Abyssinia." *Geographical Journal* 73: 401–28.

Hoffman, Curtiss. 2003. "Symbols in Stone, Part Two: Quartz Ceremonial Items from the Little League Site, Middleborough, MA." *Bulletin of the Massachusetts Archaeological Society* 65 (2): 63–72.

Hofman, Jack L., and James G. Enloe. 1992. *Piecing Together the Past: Applications of Refitting Studies in Archaeology. BAR International Series* 578. Oxford: BAR Publishing.

Högberg, Anders. 1999. "Child and Adult at a Knapping Area: A Technological Flake Analysis of a Manufacture of a Neolithic Square Sectioned Axe and a Child's Flintknapping Activities on an Assemblage Excavated as Part of the Öresund Fixed Link Project." *Acta Archaeologica* 70: 79–106.

———. 2008. "Playing with Flint: Tracing a Child's Imitation of Adult Work in a Lithic Assemblage." *Journal of Archaeological Method and Theory* 15 (1): 112–31.

Holmes, William H. 1891. "Manufacture of Stone Arrowpoints." *American Anthropologists* 4: 49–58.

———. 1894. "Natural History of Flaked Stone Implements." In *Memoirs of the International Congress of Anthropology*, edited by C. Staniland Wake, 120–39. Chicago: Schulte.

———. 1919. *Handbook of Aboriginal American Antiquities, Part I. Introductory, the Lithic Industries*. Smithsonian Institution Bureau of American Ethnology Bulletin 60. Washington, D.C.: Government Printing Office.

Hornborg, Alf. 2011. "Animism, Fetishism, and Objectivism as Strategies for Knowing (or Not Knowing) the World." *Ethos: Journal of Anthropology* 71 (1): 21–32.

Hollowell, Julie, and George Nicholas. 2000. "Using Ethnographic Methods to Articulate Community-Based Conceptions of Cultural Heritage Management." *Public Archaeology: Archaeological Ethnographies* 8 (2–3): 141–60.

Hurcombe, Linda M. 1992. *Use Wear Analysis and Obsidian: Theory, Experiments, and Results.* Sheffield, UK: J. R. Collis Publications, Department of Archaeology and Prehistory, University of Sheffield.

Inden, Ronald B. 1990. *Imagining India*. Oxford: Basil Blackwell.

Ingold, Tim. 2000. *The Perception of the Environment: Essays on Livelihood, Dwelling, and Skill.* Oxford: Psychology Press.

———. 2006. "Rethinking the Animate, Re-animating Thought." *Ethnos* 71 (1): 9–20.

———. 2007. "Materials against Materiality." *Archaeological Dialogues* 14 (1): 1–16.

Ingold, Tim, David Riches, and James Woodburn. 1988. *Hunters and Gatherers: History, Evolution, and Change.* London: Bloomsbury Press.

Irwin, Lee. 1996. *The Dream Seekers: Native American Visionary Traditions of the Great Plains.* Norman: University of Oklahoma Press.

Isaac, Glynn. 1978. "The Food-Sharing Behavior of Protohuman Hominids." *Scientific American* 238 (4): 90–108.

———. 1989. *The Archaeology of Human Origins.* Cambridge: Cambridge University Press.

Isenberg, Charles W., and Johann L. Krapf. 1843. *Journals of Their Proceedings in the Kingdom of Shoa.* London: Cass.

Jaimes, M. Annette. 1995. "Native American Identity and Survival: Indigenism and Environmental Ethics." In *Issues in Native American Cultural Identity*, edited by M. K. Gree, 273–96. New York: Peter Lang.

Janes, Robert R. 1983. *Archaeological Ethnography among Mackenzie Basin Dene, Canada*. Technical Paper 28. Calgary, AB: Arctic Institute of North America.

Jarvenpa, Robert, and Hetty Jo Brumbach. 1995. "Ethnoarchaeology and Gender." *Research in Economic Anthropology* 15: 39–82.

———, eds. 2006. *Circumpolar Lives and Livelihood: A Comparative Ethnoarchaeology of Gender and Subsistence*. Lincoln: University of Nebraska Press.

Jelinek, Arthur J. 1965. "Lithic Technology Conference, Les Eyzies, France." *American Antiquity* 31 (2): 277–79.

———. 1976. "Form, Function, and Style in Lithic Analysis." In *Cultural Change and Continuity*, edited by C. E. Cleland, 19–33. New York: Academic Press.

Jensen, Adolf E. 1959. *Altvöker Süd-Atheopiens*. Stuttgart, Germany: Verlag Kohlhammer.

Jones, Andrew. 2007. *Memory and Material Culture*. Cambridge: Cambridge University Press.

Jones, Rhys. 1990. "Hunters of the Dreaming: Some Ideational, Economic, and Ecological Parameters of the Australian Aboriginal Productive System." In *Pacific Production Systems: Approaches to Economic Prehistory*, edited by D. E. Yen and J. M. J. Mummery, 25–53. Canberra: Australian National University.

Jones, Rhys, and Neville White. 1988. "Point Blank: Stone Tool Manufacture at the Ngilipiji Quarry, Arnhem Land, 1981." In *Archaeology with Ethnography: An Australian Perspective*, edited by Betty Meehan and Rhys M. Jones, 51–97. Canberra: Australian National University.

Jones, Siân. 1997. *The Archaeology of Ethnicity: Constructing Identities in the Past and Present*. London: Routledge Press.

Johnson, Ernest N. 1940. "The Serrated Points of Central California." *American Antiquity* 6 (2): 167–70.

Johnston, Charles. (1844) 1972. *Travels in Southern Abyssinia through the Country of Adaal to the Kingdom of Shoa*. Freeport, NY: Books for Libraries Press.

Joussaume, Roger. 1985. *Dolmens for the Dead: Megalith-Building throughout the World*. Ithaca, NY: Cornell University Press.

———. 1995. *Tiya, L'Ethiopie des mégalithes*. Paris: CNS.

———. 2007. *Tuto Fela et les stéles du sud de l'Ethiopie*. Paris: Recherche sûr les Civilizations.

Kamminga, Johan. 1982. *Over the Edge: Functional Analysis of Australian Stone Tools. Occasional Papers in Anthropology* 12. St. Lucia, Australia: University of Queensland.

Kamp, Kathryn. 2001. "Prehistoric Children Working and Playing: A Southwestern Case Study in Learning Ceramics." *Journal of Anthropological Research* 57 (4): 427–50.

Karenga, Maulana. 2004. *Maat, The Moral Ideal in Ancient Egypt: A Studying Classical African Ethics*. Hoboken, NJ: Taylor and Francis.

Karlin, Claudine, and Nicole Pigeot. 1989. "Chasseurs-cueilleurs Magdaléniens. L'apprentissage de la taille silex." *Le Couriere du CNRS* 73: 10–12.

Karlin, Claudine, Sylvie Ploux, Pierre Bodu, and Nicole Pigeot. 1993. "Some Socio-economic Aspects of the Knapping Processes among Hunter-Gatherers in the Paris Basin Area." In *The Use of Tools by Human and Non-human Primates*, edited by A. Berthelet and J. Chavaillon, 318–40. Oxford: Oxford University Press.

Karsten, Detlev. 1972. *The Economics of Handicrafts in Traditional Societies*. Munich, Germany: Weltforum Verlag.

Kassam, Aneesa. 1999. "Ritual and Classification: A Study of the Booran Oromo Terminal Sacred Grade Rites of Passage." *Bulletin of the School of Oriental and African Studies* 62 (3): 484–503.

Keeley, Lawrence H. 1980. *Experimental Determination of Stone Tool Uses*. Chicago: University of Chicago Press.

Kehoe, Alice B. 1983. "The Shackles of Tradition." In *The Hidden Half: Studies of Plains Indian Women*, edited by Patricia Albers and Beatrice Medicine, 53–73. New York: University Press of America.

———. 1990. "Points and Lines." In *Powers of Observation: Alternative Views in Archaeology*, edited by Sarah M. Nelson and George J. Armelagos, 23–37. Ann Arbor: University of Michigan and the American Anthropological Association.

———. 1998. *The Land of Prehistory: A Critical History of American Archaeology*. New York: Routledge.

———. 2005. "Expedient Angled-Tanged Endscrapers: Glimpsing Women's Work in the Archaeological Record." In *Gender and Hide Production*, edited by Lisa Frink and Kathryn Weedman, 133–42. Walnut Creek, CA: AltaMira Press.

———. 2013. "Prehistory's History." In *Death of Prehistory*, edited by Peter R. Schmidt and Stephen A. Mrozowski, 31–46. Oxford: Oxford University Press.

Keller, Charles M., and Janet Dixon Keller 1990. *Cognition and Tool Use: The Blacksmith at Work*. Cambridge: Cambridge University Press.

Kent, Susan. 1987. *Method and Theory for Activity Area Research: An Ethnoarchaeological Approach*. New York: Columbia University Press.

———. 1990. "A Cross-Cultural Study of Segmentation, Architecture, and the Use of Space." In *Domestic Architecture and the Use of Space*, edited by Susan Kent, 127–52. Cambridge: Cambridge University Press.

———. 1999. "The Archaeological Visibility of Storage: Delineating Storage from Trash Areas." *American Antiquity* 64: 79–94.

Killick, David. 2004. "Social Constructionist Approaches to the Study of Technology." *World Archaeology* 36 (4): 571–78.

Kleindienst, Maxine R., and Patty Jo Watson. 1956. "Action Archaeology: The Archaeological Inventory of a Living Community." *Anthropology Tomorrow* 5 (1): 75–78.

Knappett, Carl, and Lambrous Malafouris, eds. 2008. *Material Agency: Toward a Non-anthropocentric Approach*. New York: Springer.

Knowles, Sir Francis H. S. 1944. *The Manufacture of a Flint Arrowhead by Quartzite Hammer-Stone*. Occasional Paper on Technology 1. Oxford: Pitt Rivers Museum, Oxford University.

Kohn, Marek, and Steven Mithen. 1999. "Handaxes: Products of Sexual Selection?" *Antiquity* 73 (10): 518–26.

Kopytoff, Igor. 1986. "The Cultural Biography of Things: Commodization as Process." In *The Social Life of Things: Commodities in Cultural Perspective*, edited by Arjun Apparuai, 64–91. Cambridge: Cambridge University Press.

Kosambi, Damodar D. 1967. "Living Prehistory in India." *Scientific American* 261 (2): 105–15.

Krieger, Alex D. 1944. "The Typological Concept." *American Antiquity* 9 (3): 271–87.

Kroeber, Alfred L. 1916. *Zuni Potsherds. Anthropological Papers of the American Museum of Natural History* 18: 7–37.

Kroeber, Alfred L., and Clyde Kluckhohn. 1952. *Culture: A Critical Review of Concepts and Definitions. Papers of the Peabody Museum of American Archaeology and Ethnology* 47. Cambridge, MA: Harvard University Press.

Kus, Susan. 1997. "Archaeologists as Anthropologists: Much Ado about Something after All?" *Journal of Archaeological Method and Theory* 4 (3–4): 199–214.

Lakew, Bizuayehu. 2015. "The Status and Distribution of Craftspeople and Their Craft Products in SNNRP. Culture History Study and the Development Core Process." Government Document of the Southern Nations and Nationalities Region of Ethiopia. Ministry of Culture and Tourism.

Lakoff, George, and Mark Johnson. 2003. *Metaphors We Live By*. Chicago: University of Chicago Press.

Lamphere, Louise, and Michelle Z. Rosaldo, eds. 1974. *Woman, Culture, and Society*. Stanford, CA: Stanford University Press.

Lange, Werner J. 1982 *History of Southern Gonga*. Wiesbaden: Franz Steiner Verlag GMBH.

Larick, Roy. 1985. "Spears, Style, and Time among Maa-Speaking Pastoralists." *Journal of Anthropological Archaeology* 4: 206–20.

Latour, Bruno. 1993. *We Have Never Been Modern*. Cambridge, MA: Harvard University Press.

———. 1999. *Pandora's Hope: Essays on the Reality of Science Studies*. Cambridge, MA: Harvard University Press.

Laughlin, William. 1968. "Hunting: An Integrative Biobehavior System and Its Evolutionary Importance." In *Man the Hunter*, edited by Richard Lee and Irven deVore, 304–20. Chicago: Aldine.

Lave, Jean, and Etienne Wenger. 1991. *Situated Learning: Legitimate Peripheral Participation*. Cambridge: Cambridge University Press.

Leach, Edmund R. 1960. "Introduction: What Should We Mean by Caste?" In *Aspects of Caste in South India, Ceylon, and North-West Pakistan*, edited by E. R. Leach, 1–10. Cambridge: Cambridge University Press.

Leacock, Eleanor. 1981. "History, Development, and the Division of Labor by Sex: Implications for Organization." *Signs* 7 (2): 474–91.

Leakey, Louis S. B. 1926. "A New Classification of the Bow and Arrow in Africa." *Journal of the Royal Anthropological Institute of Great Britain and Ireland* 56: 259–99.

———. 1931. *The Stone Age Cultures of Kenya Colony*. Cambridge: Cambridge University Press.

———. 1934. *Adam's Ancestors: The Evolution of Man and His Culture*. New York: Harper & Row.

———. 1950. "Stone Implements: How They Were Made and Used." *The South African Archaeological Bulletin* 5 (18): 71–74.

Leakey, Louis S. B., P. V. Tobias, and J. R. Napier. 1965. "A New Species of the Genus Homo from Olduvai Gorge." *Current Anthropology* 6 (4): 424–27.

Leakey, Mary D. 1971. *Olduvai Gorge*, vol. 3, *Excavations in Beds 1 and 1960–1963*. Cambridge: Cambridge University Press.

Lechtman, Heather. 1977. "Style in Technology: Some Early Thoughts." In *Material Culture: Styles, Organization, and Dynamics of Technology*, edited by Heather Lechtman and Robert Merrill, 3–20. New York: West.

———. 1984. "Andean Value Systems and the Development of Prehistoric Metallurgy." *Technology and Culture* 25 (1): 1–36.

Lechtman, Heather, and Arthur Steinberg. 1979. "The History of Technology: An Anthropological Point of View." *The History and Philosophy of Technology* 10: 135–60.

Lee, Richard B. 1979. *The !Kung San*. Cambridge: Cambridge University Press.

Lee, Richard B., and Irven Devore, eds. 1981. *Man the Hunter*. Chicago: Aldine.

Lefebvre, Théophile. 1846. *Voyage en Abyssine*. Paris: Librairie de la Societe de Geographie.

Leroi-Gourhan, André. 1942. *Evolution et techniques I—L'homme et la matière*. Paris: Albin Michel.

———. (1965) 1993. *Gesture and Speech*, translated by Anna Bostock Berger. Paris: Albin Michel.

———. 1973. *Evolution et techniques II—Milieu et techniques*. Paris: Albin Michel.

Leslau, Wolf. 1964. *Ethiopian Argots*. The Hague, Netherlands: Mouton.

Lesur, Joséphine, J.-D. Vigne, and X. Gutherz. 2007. "Exploitation of Wild Animals in Southwestern Ethiopia during the Holocene (6000 BP–1500 BP): The Data from Moche Borago Shelter (Wolayta)." *Environmental Archaeology* 12 (2): 139–59.

Lesur-Gebremarium, Joséphine. 2008. "Ethnoarchaeozoologie sur le travail du cuir: L'exemple de deux maisons de tanneurs dans le Konso (Ethiopie)." *Anthropozoologica* 43 (1): 99–116.

———. 2010. "La domestication animale en Afrique." *Les Nouvelles de l'Archaeologie* 120–21: 36–46.

———. 2012. Report on the Faunal Remains from Garu, Ochollo Mulato and Mota Cave (2012). Report unpublished and provided to the Gamo project PI Kathryn Arthur, John Arthur, and Matthew Curtis.

Levine, Donald N. 1974. *Greater Ethiopia: The Evolution of a Multiethnic Society*. Chicago: University of Chicago Press.

Levine, Marc B., and David M. Carballo. 2014. *Obsidian Reflections: Symbolic Dimensions of Obsidian in Mesoamerica*. Boulder: University Press of Colorado.

Lewis, Herbert S. 1962. "Historical Problems in Ethiopia and the Horn of Africa." *Annals of the New York Academy of Sciences* 96 (2): 504–11.

———. 1970. "Wealth, Influence, and Prestige among the Shoa Galla." In *Social Stratification in Africa*, edited by Arthur Tuden and Leonard Plotnicov, 182–85. New York: Free Press.

Liddell, Henry G., and Robert Scott. 1984. *A Lexicon Abridged from Liddell and Scott's Greek-English Lexicon*. Oxford: Clarendon Press.

Lindfors, Bernth, ed. 1999. *Africans on Stage: Studies in Ethnological Show Business*. Bloomington: Indiana University Press.

Linton, Ralph. 1955. *The Tree of Culture*. New York: Alfred A. Knopf.

Llorente, Marcos Gallego, E. R. Jones, A. Eriksson, V. Siska, K. W. Arthur, J. W. Arthur, M. C. Curtis, J. T. Stock, M. Coltorti, P. Pieruccini, S. Stretton, F. Brock, T. Higham, Y. Park, M. Hofreiter, D. G. Bradley, J. Bhak, R. Pinhasi, and A. Manica. 2015. "Ancient Ethiopian Genome Reveals Extensive Eurasian Admixture in Eastern Africa." *Science* 350 (6262): 820–22.

Lloyd, Genevieve. 1993. *The Man of Reason: "Male" and "Female" in Western Philosophy*, 2nd ed. London: Routledge.

Lothrop, Samuel. 1928. *The Indians of Tierra del Fuego*. New York: Museum of the American Indian Heye Foundation.

Lovejoy, C. Owen. 1981. "The Origin of Man." *Science* 23 (January): 341–50.

Lubbock, Sir John. 1890. *Pre-historic Times: As Illustrated by Ancient Remains and the Manners and Customs of Modern Savages*. Ithaca, NY: Cornell University Library.

Lvova, Eleonora. 1994. "Traditional Beliefs of Ethiopian Peoples: The Stages and the Tendency." In *New Trends in Ethiopian Studies: Papers of the 12th International Conference of Ethiopian Studies*. East Lansing: Michigan State University, September 5–10.

Lyons, Caleb. 1860. *Bulletin of the American Ethnological Society*, vol. 1, p. 39. New York: American Ethnological Society. Google Books, accessed August 23, 2017. http://books.google.com/books?id=8gIOAQAAMAAJ&pg=PA39&lpg=PA39&dq=Calleb+Lyon+Bulletin+American+Ethnological&source=bl&ots=aDbmJPwA5j&sig=U4vC9tygVTKL6NK24GUjSFbtDgY&hl=en&sa=X&ei=ViMrVMKsCMnCggTnt4EI&ved=0CC4Q6AEwBg#v=onepage&q=Calleb%20Lyon%20Bulletin%20American%20Ethnological&f=false.

Lyons, Diane. 2013. "Perceptions of Consumption: Constituting Potters, Farmers, and Blacksmiths in the Culinary Continuum in Eastern Tigray, Northern Highland Ethiopia." *African Archaeological Review* 31: 169–201.

MacCalman, H. Rona, and B. J. Grobbelaar. 1965. "Preliminary Report of Two Stone Working Ova Tjimba Groups in the Northern Kaokoveld of S.W. Africa." *Cimbebasia* 13: 1–39.

MacEachern, Scott. 1996. "Foreign Countries: The Development of Ethnoarchaeology in Sub-Saharan Africa." *Journal of World Prehistory* 10 (3): 243–301.

Magesa, Laurenti. 1997. *Africa Religion: The Moral Traditions of Abundant Life*. Ossining, NY: Orbis Books.

Malinowski, Bronsilaw. 1961. *Argonauts of the Western Pacific*. London: E. P. Dutton.

Man, Edward Horace. 1883a. "On the Aboriginal Inhabitants of the Andaman Islands, Part I." *Journal of the Royal Anthropological Institute of Great Britain and Ireland* 12 (i–116): 69–116.

———. 1883b. "On the Aboriginal Inhabitants of the Andaman Islands." *Journal of the Royal Anthropological Institute of Great Britain and Ireland* 12 (257–440): 327–434.

Marcus, Harold G. 1994. *A History of Ethiopia*. Berkeley: University of California Press.

Marriott, McKim, and Ronald Inden. 1985. "Social Stratification: Caste." In *Encyclopedia Britannica*, 15th ed., 37:348–56. Chicago: University of Chicago Press.

Martin, Denise. 2008. "Maat and Order in African Cosmology: A Conceptual Tool for Understanding Indigenous Knowledge." *Journal of Black Studies* 38 (6): 951–67.

Mason, Otis. 1889. *Aboriginal Skin Dressing*. Washington, D.C.: Smithsonian Institution Press.

Matilal, Bimal Krishna. 1982. "Ontological Problems in Nyaya, Buddhism, and Jainism: Comparative Analysis." In *Philosophies of Existence Ancient and Medieval*, edited by Parviz Morewedge, 96–108. New York: Fordham University Press.

Matory, J. Lorand. 1999. "Afro-Atlantic Culture: On the Live Dialogue between Africa and the Americas." In *Africana: The Encyclopedia of the African and African American Experience*, edited by Kwame Anthony Appiah and Henry Louis Gates, 36–44. New York: Basic Civitas Books.

Maynes, Mary Jo, and Ann Waltner. 2012. "Temporalities and Periodization in Deep History Technology, Gender, and Benchmarks of 'Human Development.'" *Social Science History* 36 (1): 59–83.

McBrearty, Sally, L. Bishop, T. Plummer, R. Dewar, and N. Conrad. 1998. "Tools Underfoot: Human Trampling as an Agent of Lithic Artifact Edge Modification." *American Antiquity* 63 (1): 108–29.

McCall, Grant S. 2012. "Ethnoarchaeology and the Organization of Lithic Technology." *Journal of Archaeological Research* 20: 157–203.

McCary, Ben C. 1947. "A Survey and Study of Folsom-like Points Found in Virginia." *Quarterly Bulletin of the Archaeological Society of Virginia* 2 (1): 4–34.

McGuire, Joseph D. 1896. "Classification and Development of Primitive Implements." *American Anthropologist* 9 (7): 227–36.

McKern, W. C. 1939. "The Midwestern Taxonomic Method as an Aid to Archaeology Study." *American Antiquity* 4: 301–13.

Mehari, Getaneh. 2016. "Cursed or Blessed? Female Genital Cutting in the Gamo Cultural Landscape, South Western Ethiopia." *Afhad Journal* (June): 5730 words. Online journal. https://www.thefreelibrary.com/Ahfad+Journal/2016/June/1-p52121/.

Mellars, Paul 1970. "Some Comments on the Notion of 'Functional Variability' in Stone-Tool Assemblages." *World Archaeology* 3: 74–89.

Merab, Paul. 1929. *Impressions d' Ethiopie*, vol. 3. Paris: E. Leroux.

Mercer, Henry C. 1895. "Chipped Stone Implements at the Columbian Historical Exposition at Madrid in January 1892." *Report of the United States Commission to the Columbian Historical Exposition*, 367–97. Washington, D.C.: Government Printing Office. https://archive.org /stream/reportofunitedstoouni#page/n3/mode/2up/.

Merlan, Francesca. 1992. "Male-Female Separation and Forms of Society in Aboriginal Australia." *Cultural Anthropology* 7 (2): 169–93.

Meskell, Lynn. 2004. *Object Worlds in Ancient Egypt: Material Biographies Past and Present*. London: Bloomsbury Academic.

Michels, Joseph W. 1991. "The Axumite Kingdom: A Settlement Archaeology Perspective." In *Henok*, edited by W. Yerkru, 63–78. Washington, D.C.: Ethiopian Research Council.

Mihlar, Farah 2008. "Voices That Must Be Heard: Minorities and Indigenous People Combat Climate Change." London: Minority Rights Group International Publication.

Milne, Brooke. 2005. "Paleo-Eskimo Novice Flintknapping in the Eastern Canadian Arctic." *Journal of Field Archaeology* 30 (3): 329–45.

Mitchell, Stanley R. 1955. "Comparison of the Stone Tools of the Tasmanian and Australian Aborigines." *Journal of the Royal Anthropological Institute of Great Britain and Ireland* 85 (1): 131–39.

———. 1959. "The Woodworking Tools of the Australian Aborigines." *Journal of the Royal Anthropological Institute of Great Britain and Ireland* 89 (2): 191–99.

Mizoguchi, Koji. 2015. "Archaeological Futures." *Antiquity* 89: 12–22.

Moir, J. Reid. 1911. "The Natural Fracture of Flint and Its Bearing upon Rudimentary Flint Implements." *Prehistoric Society of East Anglia Proceedings* 1: 171–84.

———. 1913. "Flint Implements of Man from the Middle Glacial Gravel and the Chalky Boulder Clay of Suffolk." *Man* 13: 36–37.

———. 1914. The Large Non-conchoidal Fracture Surfaces of Early Flint Implements." *Nature* 94: 89.

Moser, Stephanie. 1993. "Gender Stereotyping in Pictorial Reconstructions of Human Origins." In *Women in Archaeology: A Feminist Critique*, edited by Hilary du Cros and Laurajane Smith, 75–91. Canberra, Australia: The Australian National University Press.

Murdoch, John. 1892. *Ethnological Results of the Point Barrow Expedition*. Washington, D.C.: Smithsonian Institution Press.

Nelson, Edward. 1899. *The Eskimo about Bering Strait*. Washington, D.C.: Smithsonian Institution Press.

Nelson, Nels C. 1916. "Flint Working by Ishi." *Holmes Anniversary Volume, Anthropological Essays Presented to William Henry Holmes, in Honor of His Seventieth Birthday, December 1, 1916*, edited by his friends and collaborators, 397–402. Washington, D.C.: J. W. Bryan Press.

Nelson, Sarah Milledge. 2004. *Gender in Archaeology: Analyzing Power and Prestige*. Walnut Creek, CA: AltaMira Press.

Noetling, Fritz. 1911. "The Manufacture of the Tero-watta." In *Papers and Proceedings of the Royal Society of Tasmania*, 38–61. Hobart, Tasmania: Mercury Office.

Normandin, Sebastian, and Charles T. Wolfe, eds. 2010. *Vitalism and the Scientific Image in Post-Enlightenment Life Science, 1800-2010*. New York: Springer.

Normark, Johan. 2009. "The Making of a Home: Assembling Houses at Nohcacab, Mexico." *World Archaeology* 41 (3): 430–44.

Nowell, April, and Iain Davidson, eds. 2010. *Stone Tools and the Evolution of Human Cognition*. Boulder: University of Colorado Press.

Oakley, Kenneth P. 1949. *Man the Tool-Maker*. London: The Trustees of the British Museum.

Obenga, Theophile. 2004. "Egypt: Ancient History of African Philosophy." In *A Companion to African Philosophy*, edited by Kwasi Wiredu, 31–49. Oxford: Blackwell.

O'Brien, Michael J., and R. Lee Lyman. 2005. "Style, Function, Transmission: An Introduction." In *Style, Function, Transmission: Evolutionary Archaeological Perspectives*, edited by Michael J. O'Brien and R. Lee Lyman, 1–32. *Foundations of Archaeological Inquiry*. Salt Lake City: University of Utah.

O'Connell, James F. 1974. "Spoons, Knives, and Scrapers: The Function of Yilugwa in Central Australia." *Mankind* 9 (3): 189–94.

———. 1987. "Alyawara Site Structure and Its Archaeological Implications." *American Antiquity* 52 (1): 74–108.

O'Connell, James F., Kristen Hawkes, and Nicholas Blurton Jones. 1991. "Distribution of Refuse-Producing Activities at Hadza Residential Base Camps." In *Interpreting Archaeological Spatial Patterning*, edited by Ellen M. Kroll and T. Douglas Price, 61–76. New York: Plenum Press.

Odell, George H. 1989. "Fitting Analytical Techniques to Prehistoric Problems with Lithic Data." In *Alternative Approaches to Lithic Analysis*, edited by D. O. Henry and G. H. Odell, 159–82. *Archaeological Papers of the American Anthropological Association* 1. Tulsa, OK: University of Tulsa.

———. 1994. "Prehistoric Hafting and Mobility in North American Midcontinent: Examples from Illinois." *Journal of Anthropological Archaeology* 13: 51–73.

Olausson, Deborah. 1998. "Different Strokes for Different Folks: Possible Reasons for Variation in Quality of Knapping." *Lithic Technology* 23 (2): 90–115.

———. 2008. "Does Practice Make Perfect? Craft Expertise as a Factor in Aggrandizer Strategies." *Journal of Archaeological Method and Theory* 15: 28–50.

Olive, Monique, and Nicole Pigeot. 1992. "Les tailleurs de silex Magdaléniens d'Étiolles." In *La pierre préhistorique*, edited by M. Menu and P. Walter, 173–85. Paris: Laboratoire de Recherche des Musées de France.

Olmstead, Judith. 1972. "The Dorze House: A Bamboo Basket." *Journal of Ethiopian Studies* 10 (2): 27–33.

———. 1975. "Agricultural Land and Social Stratification in the Gamo Highlands of Southern Ethiopia." In *Proceedings of the First U.S. Conference on Ethiopian Studies*, edited by H. G. Marcus, 223–34. East Lansing: African Studies Center, Michigan State University.

———. 1997. *Woman between Two Worlds: Portrait of an Ethiopian Rural Leader*. Urbana: University of Illinois Press.

Olsen, Bjørnar. 2010. *In Defense of Things: Archaeology and the Ontology of Objects*. Lanham, MD: AltaMira Press.

Orent, Amnon. 1969. *Lineage Structure and the Supernatural: The Kafa of Southwest Ethiopia*. PhD diss., Boston University.

Orme, Bryony. 1981. *Anthropology for Archaeologists*. Ithaca, NY: Cornell University Press.

Ortner, Sherry B. 1974. "Is Female to Male as Nature Is to Culture?" In *Women, Culture, and Society*, edited by Michelle Z. Rosaldo and Louise Lamphere, 68–87. Stanford, CA: Stanford University Press.

Osborn, Henry Fairfield. 1916. *Men of the Old Stone Age: Their Environment, Life and Art*. New York: C. Scribner's Sons.

Owen, Linda. 2005. *Distorting the Past: Gender and the Division of Labor in the European Upper Paleolithic*. Tübingen, Germany: Kerns Verlag.

Pankhurst, Alula. 1999. "Caste in Africa: The Evidence from Southwestern Ethiopia Reconsidered." *Africa* 69: 485–509.

Pankhurst, Richard. 1964. "Ethiopia and the Red Sea and Gulf of Aden Ports in the Nineteenth and Twentieth Centuries." *Ethiopia Observer* 8: 37–104.

Parkyns, Mansfield. (1853) 1966. *Life in Abyssinia*. London: Frank Cass.

Parry, William J., and Robert L. Kelley. 1987. "Expedient Core Technology and Sedentism." In *The Organization of Core Technology*, edited by J. K. Johnson and C. A. Morrow, 285–304. Boulder, CO: Westview Press.

Pastrana, Alejandro, and Ivonne Athie. 2014. "The Symbolism of Obsidian in Postclassic Central Mexico." In *Obsidian Reflections: Symbolic Dimensions of Obsidian in Mesoamerica*, edited by Marc B. Levine and David M. Carballo, 75–110. Boulder: University Press of Colorado.

Paton, Robert. 1994. "Speaking through Stones: A Study from Northern Australia." *World Archaeology* 26 (2): 172–84.

Paulitschke, Philipp. 1888. *Harar*. Leipzig, Germany: Brockhaus.

Pelegrin, Jacques. 1990. "Prehistoric Lithic Technology: Some Aspects of Research." *Archaeological Review from Cambridge* 9 (1): 116–25.

———. 2005. "Remarks about Archaeological Techniques and Methods of Knapping: Elements of a Cognitive Approach to Stone Knapping." In *Stone Knapping: The Necessary Conditions for a Uniquely Hominin Behaviour*," edited by Valentine Roux and Blandine Bril,

23–33. McDonald Institute Monographs. Cambridge: McDonald Institute for Archaeological Research, University of Cambridge.

Pfaffenberger, Bryan. 1992. "Social Anthropology of Technology." *Annual Review of Anthropology* 21: 491–516.

Phillipson, David. 2000. *Foundations of an African Civilisation*. Addis Ababa, Ethiopia: Addis Ababa University Press and James Currey.

Pigeot, Nicole. 1987. *Magdaléniens d'Étiolles: Économie de débitage et organisation sociale*. Paris: CNRS.

———. 1988. "Apprendre à débiter des lames: Un cas d'éducation technique chez de Magdaléniens d'Étiolles." In *Techologie préhistorique*, edited by J. Tixier, 63–70. Paris: CNRS.

———. 1990. "Technological and Social Actors: Flintknapping Specialists and Apprentices at Magdalenian Etiolles." *Archaeological Review from Cambridge* 9 (1): 126–41.

Piggott, Stuart. 1976. *Ruins in a Landscape*. Edinburgh: University Press.

Plot, Robert. 1679. *Enquiries to Be Propounded to the Most Ingenious of Each Country in My Travels through England and Wales*. Oxford: n.p. Early English Books online, accessed August 23, 2017. http://lib.ugent.be/en/catalog/rug01:001615392.

Pokotylo, David L., and Christopher C. Hanks. 1989. "Variability in Curated Lithic Technologies: An Ethnoarchaeological Case Study from the Mackenzie Basin, Northwest Territories, Canada." In *Experiments in Lithic Technology,* edited by D. S. Amick and R. P. Mauldin, 49–66. *BAR International Series* 528. Cambridge: BAR Publishing.

Pospisil, Leopold J. 1963. *Kapauku Papuan Economy*. New Haven, CT: Yale University.

Powell, John W. 1895. "Stone Art in America." *American Anthropologists* 8 (1): 1–7.

Powell, Peter J. 1969. *Sweet Medicine*, vols. 1, 2. Norman: University of Oklahoma Press.

Pulleine, Robert H. 1929. "The Tasmanians and Their Stone Culture." *Australasian Association for the Advancement of Science* (Hobart, Tasmania) 19: 294–314.

Quimby, George, I. 1958. "Fluted Points and Geochronology of the Lake Michigan Basin." *American Antiquity* 23 (3): 247–54.

Redding, Benjamin B. 1879. "How Our Ancestors in the Stone Age Made Their Implements." *The American Naturalist* 13 (11): 667–74.

Reill, Peter Hanns. 2005. *Vitalizing Nature in the Enlightenment*. Berkeley: University of California Press.

Riley, Angela R. 2012. "Indians and Guns." *Georgetown Law Journal* 100: 1675–745.

Robb, John. 2010. "Beyond Agency." *World Archaeology* 42 (4): 493–520.

Roberts, Frank H. H. 1936. "Recent Discoveries of the Material Culture of Folsom Man." *The American Naturalist* 70 (729): 337–45.

Robin Hood II. 1917. "The Bow of Yew." *Forest and Stream* 2: 56.

Roche, H., A. Delagnes, J. P. Brugal, C. Feibel, M. Kibunjia, V. Mourrell, and P. J. Texier. 1999. "Early Hominid Stone Tool Production and Technical Skill 2. 34 Myr ago in West Turkana, Kenya." *Letters to Nature* 399 (May 6): 57–59.

Roth, Henry Ling. 1899. *The Aborigines of Tasmania*. Halifax, NS: F. King & Sons.

Roth, Walter E. 1904. "Domestic Implements, Arts, and Manufactures." *North Queensland Ethnography Bulletin* 7: 719.

Rots, Veerle. 2000. *Prehension and Hafting Wear on Flint Tools. A Methodology*. Leuven, Belgium: Leuven University Press.

Rouse, Irving. 1939. *Prehistory in Haiti: A Study in Method. Publications in Anthropology* 21. New Haven, CT: Yale University.

Roux, Valentine, Blandine Bril, and G. Dietrich. 1994. "Skills and Learning Difficulties Involved in Stone Knapping: The Case of Stone-Bead Knapping in Khambhat, India." *World Archaeology* 27 (1): 63–78.

Rutherford, William. 1788. "A View of Ancient History: Including the Progress of Literature and the Fine Arts." *The English Review* 11: 335–39.

Sackett, James R. 1973. "Style, Function, and Artifact Variability in Paleolithic Assemblages." In *The Explanation of Culture Change: Models in Prehistory*, edited by C. Renfrew, 317–25. Pittsburgh: University of Pittsburgh Press.

———. 1982a. "Approaches to Style in Lithic Archaeology." *Journal of Anthropological Archaeology* 1: 59–112.

———. 1982b. "The Meaning of Style in Archaeology: A General Model." *American Antiquity* 42: 369–80.

———. 1985. "Style and Ethnicity in the Kalahari, A Reply to Wiessner." *American Antiquity* 50: 154–59.

———. 1986. "Isochrestism and Style: A Clarification." *Journal of Anthropological Archaeology* 5: 266–77.

———. 1989. "Statistics, Attributes, and the Dynamics of Burin Typology." In *Alternative Approaches to Lithic Analysis*, vol. 1, edited by D. O. Henry and G. H. Odell, 51–82. *Papers of the American Anthropological Association*. Tulsa, OK: University of Tulsa.

———. 1990. "Style and Ethnicity in Archaeology: The Case for Isochrestism." In *The Uses of Style in Archaeology*, edited by M. W. Conkey and C. A. Hastorf, 32–43. Cambridge: Cambridge University Press.

———. 1991. "Straight Archaeology French Style: The Phylogenetic Paradigm in Historic Perspective." In *Perspectives on the Past: Theoretical Biases in Mediterranean Hunter-Gatherer Research*, edited by Geoffrey A. Clark, 109–39. Philadelphia: University of Pennsylvania Press.

Sahle, Yonatan. 2008. "An Ethnoarchaeological Study of Stone-Tool Use among the Hadiya Hide-Workers of Southern Ethiopia." MA thesis, Addis Ababa University, Ethiopia.

Sahle, Yonatan, and Agazi Negash. 2010. "An Ethnoarchaeology of Lithic Site-Formation Patterns amongst the Hadiya of Ethiopia: Some Initial Results." *Nyame Akuma* 74: 36–41.

Sahle, Yonatan, Agazi Negash, and David R. Braun. 2012. "Variability in Ethnographic Hide-scraper Use among the Hadiya of Ethiopia: Implications for Reduction Analysis." *African Archaeological Review* 29: 383–97.

Sassaman, Kenneth. 1992. "Gender and Technology at the Archaic-Woodland 'Transition.'" In *Exploring Gender through Archaeology: Selected Papers from the 1991 Boone Conference*, edited by Cheryl Claassen, 71–79. Madison, WI: Prehistory Press.

———. 1998. "Lithic Technology and the Hunter-Gatherer Sexual Division of Labor." In *Reader in Gender Archaeology*, edited by Kelley Hays-Gilpin and David S. Whitley, 159–72. London: Routledge.

———. 2000. "11 Agents of Change in Hunter-Gatherer Technology." In *Agency in Archaeology*, edited by Marcia Dobres and John E. Robb, 148–69. London: Routledge.

———. 2012. "Futurologists Look Back." *Archaeologies: Journal of the World Archaeological Congress* 8 (3): 250–68.

Schiebinger, Londa L. 1993. *Nature's Body: Gender in the Making of Modern Science*. New Brunswick, NJ: Rutgers University Press.

Schiffer, Michael B. 1972. "Archaeological Context and Systematic Context." *American Antiquity* 37: 156–65.

———. 1975a. "Archaeology as Behavioral Science." *American Anthropologist* 77 (4): 836–48.

———. 1975b. "Behavioral Chain Analysis: Activities, Organization, and the Use of Space." *Fieldiana, Anthropology* 65: 103–19.

———. 1975c. "Factors and Toolkits: Evaluating Multivariate Analyses." *Archaeology* 20 (67): 61–70.

———. 1983. "Toward the Identification of Formation Processes." *American Antiquity* 48: 675–706.

———. 2004. "Studying Technological Change: A Behavioral Perspective." *World Archaeology* 36 (4): 579–85.

Schiffer, Michael B., and J. Skibo. 1987. "Theory and Experiment in the Study of Technological Change." *Current Anthropology* 28 (5): 595–622.

Schlanger, Nathan. 1990. "Techniques as Human Action: Two Perspectives." *Archaeological Review from Cambridge* 9 (1): 17–26.

———. 1994. "Mindful Technology. Unleashing the Chaîne Opératoire for an Archaeology of Mind." In *The Ancient Mind: Elements of Cognitive Archaeology*, edited by Colin Renfrew and Ezra B. W. Zubrow, 143–51. *New Directions in Archaeology Series*. Cambridge: Cambridge University Press.

Schmidt, Peter. R. 1997. *Iron Technology in East Africa: Symbolism, Science, and Archaeology*. Bloomington: Indiana University Press.

———. 2010. "The Play of Tropes in Archaeology: Ethnoarchaeology as Metonymy." *Ethnoarchaeology: Journal of Archaeological, Ethnographic, and Experimental Studies* 2 (2): 131–52.

Schmidt, Peter R., and Stephen A. Mrozowski. 2013. *The Death of Prehistory*. Oxford: Oxford University Press.

Scott, Michael W. 2007. *The Severed Snake: Matrilineages, Making Place, and Melanesian Christianity in Southeast Solomon Islands*. Durham, NC: Carolina Academic Press.

Seligman, Paul. 1982. "Being and Forms in Plato." In *Philosophies of Existence, Ancient and Medieval*, edited by Parviz Morewedge, 18–32. New York: Fordham University Press.

Sellers, George. 1885. "Observations on Stone-Chipping." *Smithsonian Institute Annual Report* (1885): 871–91.

Shack, William A. 1964. "Notes on Occupational Castes among the Gurage of Southwest Ethiopia." *Man* 64: 50–52.

Shafer, Harry J., and Thomas R. Hester. 1983. "Ancient Maya Chert Workshops in Northern Belize, Central America." *American Antiquity* 48: 519–43.

Shea, John J. 1987. "On Accuracy and Relevance in Lithic Use-Wear Analysis." *Lithic Technology* 16: 44–50.

———. 2006. "Child's Play: Reflections on the Invisibility of Children in the Paleolithic Record." *Evolutionary Anthropology* 15: 212–16.

Sheets, Payson D. 1975. "Behavioral Analysis and the Structure of a Prehistoric Industry." *Current Anthropology* 16 (3): 369–91.

———. 1978. "From Craftsman to COG: Quantitative Views of Mesoamerican Lithic Technology." In *Papers on the Economy and Architecture of the Ancient Maya*, edited by Raymond Sidrys, 40–71. Boulder: University Press of Colorado.

Shelley, Phillip H. 1990. "Variation in Lithic Assemblages: An Experiment." *Journal of Field Archaeology* 17 (2): 187–93.

Shenkut, Mammo Kebbede. 2005. "Ethiopia: Where and Who Are the World's Illiterates?" *Education for All Global Monitoring Report 2006, Literacy for Life*. Paris: UNESCO.

Shott, Michael J. 1986. "Settlement Mobility and Technological Organization: An Ethnographic Examination." *Journal of Anthropological Research* 41: 15–51.

———. 1995. "How Much Is a Scraper?" *Lithic Technology* 20: 53–72.

———. 2003. "Chaîne Opératoire and Reduction Sequence." *Lithic Technology* 28 (2): 95–105.

Shott, Michael, and Paul Sillitoe. 2004. "Modeling Use-Life Distributions in Archaeology Using New Guinea Wola Ethnographic Data." *American Antiquity* 69 (2): 339–55.

Shott, Michael, and Kathryn Weedman. 2007. "Measuring Reduction in Stone Tools: An Ethnoarchaeological Study of Gamo Hidescraper Blades from Ethiopia." *Journal of Archaeological Science* 20 (2006): 1–20.

Siegel, Peter E. 1984. "Functional Variability within an Assemblage of Endscrapers." *Lithic Technology* 12: 35–51.

Sillar, Bill. 2009. "The Social Agency of Things? Animism and Materiality in the Andes." *Cambridge Archaeological Journal* 19 (3): 369–79.

Sillitoe, Paul. 1979. "Stone Versus Steel." *Mankind* 12: 151–61.

———. 1982. "The Lithic Technology of Papua New Guinea Highland People." *The Artefact* 7 (3–4): 19–38.

Sillitoe, Paul, and Karen Hardy. 2005. "Living Lithics: Ethnoarchaeology in Highland Papua New Guinea." *Antiquity* 77: 555–66.

Sinclair, Anthony. 2000. "Constellations of Knowledge: Human Agency and Material Affordance in Lithic Technology. In *Agency in Archaeology*, edited by M. A. Dobres and J. E. Robb, 196–211. London: Routledge.

Skertchly, Sydney B. J. 1879. *On the Manufacture of Gun-Flints, the Methods of Excavating for Flint, the Age of Palaeolithic Man, and the Connexion between Neolithic Art and the Gun-Flint Trade*. Memoirs of the Geological Survey. London: Her Majesty's Stationery Office.

Slocum, Sally. 1975. "Woman the Gatherer: Male Bias in Anthropology." In *Toward an Anthropology of Women*, edited by Rayna Rapp Reiter, 36–50. New York: Monthly Review Press.

Slotkin, James S. 1965. *Early Readings in Anthropology*. Aldine: Chicago.

Smidt, Wolbert. 2010. "Slavery." In *Encyclopedia Aethopica*, vol. 4, edited by Sigbert Uhlig. Wiesbaden: Harrassowitz Verlag.

Smith, Linda Tuhiwai. 1999. *Decolonizing Methodologies: Research and Indigenous Peoples*. London: Zed Books.

Smith, Philip E. L. 1966. "Conferences: Lithic Technology." *Current Anthropology* 7 (5): 591–92.

Smyth, R. Brough. 1878. *The Aborigines of Victoria with Notes Relating to the Habits of the Natives of Other Parts of Australia and Tasmania*, vol. 1. London: John Ferres Government Printer.

Snyder, J. F. 1897. "The Method of Making Stone Arrow Points." In *The Antiquarian*, vol. 1, pp. 231–34. Columbus, OH: Landon. Google Books, accessed August 23, 2017. http://books.google.com/books?id=YjoSAAAAYAAJ&pg=PP10&lpg=PP10&dq=The+Antiquarian+Snyder&source=bl&ots=PD3g97Adbz&sig=GBK5X8nLWnooLFLhKLGw3SUmyBo&hl=en&sa=X&ei=QyYrVOytJoHFggTRooLoDw&ved=0CCUQ6AEwAQ#v=onepage&q=Snyder&f=false.

Solway, Jacqueline S., and Richard B. Lee. 1990. "Foragers, Genuine, or Spurious? Situating the Kalahari San in History." *Current Anthropology* 31 (2): 109–46.

Spelman, Elizabeth. 1988. *Inessential Woman: Problems of Exclusion in Feminist Thought*. Boston: Beacon.

Spencer-Wood, Suzanne M. 1991. "Toward a Feminist Historical Archaeology of the Construction of Gender." *The Archaeology of Gender: Proceedings of the 22nd [1989] Chacmool Conference*, edited by Dale Walde and Noreen D. Willows. Calgary, AB: University of Calgary Archaeological Association.

Sperber, Dan. 1973. "Paradoxes of Seniority among the Dorze." *Proceedings of the First U.S. Conference on Ethiopian Studies*, edited by H. G. Marcus, 209–22. East Lansing: Center for African Studies, Michigan State University.

———. 1975. *Rethinking Symbolism*. Cambridge: Cambridge University Press.

Spielmann, Katherine A. 1991. *Farmers, Hunters, and Colonists: Interaction between the Southwest and the Southern Plains*. Tucson: University of Arizona Press.

Spinoza, Baruch. (1677) 1992. *Ethics: Treatise on the Emendation of the Intellect, and Selected Letters*, translated by Samuel Shirley. Indianapolis: Hackett.

Stahl, Jenny. 2008. "Who Were the Flintknappers? A Study of Individual Characteristics." *Lithic Technology* 33 (2): 161–72.

Sterner, Judy, and Nicholas David. 1991. "Gender and Caste in the Mandara Highlands: Northeastern Nigeria and Northern Cameroon." *Ethnology* 30: 355–70.

Stevens, Edward T. 1870. *Flint Chips: A Guide in Prehistoric Archaeology*. Salisbury, UK: Brown and Co. and F. A. Blake.

Steward, Julian H. 1942. "The Direct Historical Approach to Archaeology." *American Antiquity* 7: 337–43.

Stout, Dietrich. 2002. "Skill and Cognition in Stone Tool Production." *Current Anthropology* 43 (5): 693–722.

———. 2005. "The Social and Cultural Context of Stone-Knapping Skill Acquisition." In *Stone Knapping: The Necessary Conditions for a Uniquely Hominin Behavior*, edited by Valentine Roux and Blandine Bril, 331–40. McDonald Institute Monographs. Cambridge: McDonald Institute for Archaeological Research, University of Cambridge.

———. 2010. "Possible Relations between Language and Technology in Human Evolution." In *Evolution of Human Cognition*, edited by April Nowell and Ian Davidson, 159–84. Boulder: University of Colorado Press.

Straube, Helmut. 1963. *Völker Süd-Atheopiens*, vol. 3. Stuttgart, Germany: Kohlhammer Verlag.

Strathern, Andrew, and Pamela J. Stewart. 2000. *Arrow Talk. Transactions, Transition, and Contradiction in New Guinea Highlands History*. Kent, OH: Kent State University Press.

Strathern, Marilyn. 1965. "Axe Types and Quarries: A Note on the Classification of Stone Axe Blades from the Hagen Area of New Guinea." *The Journal of the Polynesian Society* 74 (2): 182–91.

———. 1970. "Stone Axes and Flake Tools: Evaluations from Two New Guinea Highlands Societies." *Proceedings of the Prehistoric Society (New Series)* 35: 311–29.

———. 1972. *Women in Between: Female Roles in a Male World: Mount Hagen, New Guinea*. London: Seminar Press.

Straus, Lawrence G., and Geoffrey A. Clark. 1986. *La Riera Cave: Stone Age Hunter-Gatherer Adaptations in Northern Spain. Arizona State University Anthropological Research Papers* 36. Tempe: Arizona State University Press.

Sumner, Claude. 1986. *The Sources of African Philosophy: The Ethiopian Philosophy of Man*. Stuttgart, Germany: Franz Steiner Verlag Wiesbaden.

Swanton, John R. 1946. "The Indians of the Southeastern United States. Smithsonian Institution, Bureau of American Ethnology." *Bulletin* 137: 34–60.

Taçon, Paul. 1991. "The Power of Stone: Symbolic Aspects of Stone Use and Tool Development in Western Arnhem Land, Australia." *Antiquity* 65: 192–207.

Takase, Katsunori. 2004. "Hide Processing of Oxen and Koryak: An Ethnoarchaeological Survey in Kamchatka Peninsula, Russia." *Material Culture (Japan)* 77: 57–84.

Tamari, Tal. 1991. "The Development of Caste Systems in West Africa." *Journal of African History* 32: 221–50.

Tanner, Nancy, and Adrienne Zihlman. 1976. "Women in Evolution. Part I: Innovation and Selection in Human Origins." *Signs: Journal of Women in Culture and Society* 1 (3): 585–608.

Taylor, Walter W. (1948) 1983. *A Study of Archaeology.* Carbondale: Southern Illinois University.

Teit, James. 1900. *The Jesup North Pacific Expedition IV: The Thompson Indians of British Columbia.* Memoirs of the American Museum of Natural History, vol. 2, Anthropology vol. 1. New York: Museum of Natural History.

Thomas, David H. 1983. "The Archaeology of Monitor Valley: 2. Gatecliff Shelter." *Anthropological Papers of the American Museum of Natural History* 59. New York: American Museum of Natural History.

Thomson, Donald F. 1939. "The Seasonal Factor in Human Society." *Proceedings of the Prehistoric Society* 5: 209–21.

Tindale, Norman B. 1941. "Antiquity of Man in Australia." *Australian Journal of Science* 3: 144–47.

———. 1965. "Stone Implement Making among the Nakako, Ngadadjara, and Pitjandjara of the Great Western Desert." *Records of the South Australian Museum* 15 (1): 131–64.

———. 1985. "Australian Aboriginal Techniques of Pressure-Flaking Stone Implements: Some Personal Observations." In *Stone Tool Analysis: Essays in Honor of Don E. Crabtree*, edited by Mark G. Plew, James C. Woods, and Max G. Pavesic, 3–34. Albuquerque: University of New Mexico Press.

Tindale, Norman B., and H. V. V. Noone. 1941. "Results of the Harvard Adelaide Universities Anthropological Expedition 1938–39: Analysis of an Australian Aboriginal's Hoard of Knapped Flint." *Transactions of the Royal Society of South Australia* 65 (1): 116–21.

Tindall, Ashley. 2009. "Gamo Highlands: Sacred Land Film Project," accessed November 3, 2014. http://www.sacredland.org/gamo-highlands/.

Tixier, Jacques. 1967. "Procédés d'analyse et questions de terminologie concernant l'étude des ensembles industriels du Paléolithique récent et de l'Épipaléolithic en Afrique du Nord-Ouest." In *Background to Evolution in Africa*, edited by Walter W. Bishop and J. Desmond Clark, 771–820. Chicago: University of Chicago Press.

———. 1974. "Glossary for the Description of Stone Tools with Special Reference to the Epipalaeolithic of the Maghreb." *Lithic Technology*, special publication 1.

———. 1978. "Notes sur le capsien typique." In *La préhistoire: Problems et tendancies*, edited by Jean Piveteau, 437–58. Paris: Éditions du Centre National de la Recherche Scientifique.

Todd, David M. 1977. "Caste in Africa." *Africa* 47 (4): 398–412.

———. 1978. "The Origins of Outcasts in Ethiopia: Reflections on an Evolutionary Theory." *Abbay* 9: 145–58.

Torrence, Robin. 1986. *Production and Exchange of Stone Tools.* Cambridge: Cambridge University Press.

Torrence, Robin, Peter White, and Nina Kononeko. 2013. "Meaningful Stones: Obsidian Stemmed Tools from Barema, New Britain, Papua New Guinea." *Australian Archaeology* 77: 1–8.

Tostevin, Gilbert B. 2012. *Seeing Lithics: A Middle-Range Theory for Testing for Cultural Transmission in the Pleistocene*. Oxford: Oxbow Books.

Toth, Nicholas. 1985. "The Oldowan Reassessed: A Close Look at Early Stone Artifacts." *Journal of Archaeological Science* 12: 101–20.

Toth, Nicholas, John Desmond Clark, and Giancarlo Ligabue. 1992. "The Last Stone Ax Makers." *Scientific American* 267 (1): 88–93.

Towle, Clifton C. 1934. "Stone Scrapers: An Inquiry Concerning Certain Conventionalized Types Found along the Coast of New South Wales." *Journal and Proceedings Royal Society New South Wales*: 117–143.

Townsend, William H. 1969. "Stone and Steel Tool Use in a New Guinea Society." *Ethnology* 8 (2): 199–205.

Trigger, Bruce G. 1989. *A History of Archaeological Thought*. Cambridge: Cambridge University Press.

Tringham, Ruth, Glenn Copper, George Odell, Barbara Voytek, and Anne Whitman. 1974. "Experimentation on the Formation of Edge Damage: A New Approach to Lithic Analysis." *Journal of Field Archaeology* 1: 171–96.

Tuden, Arthur, and Leonard Plotnicov. 1970. "Introduction." In *Social Stratification in Africa*, edited by Arthur Tuden and Leonard Plotnicov, 1–29. New York: The Free Press.

Turner, Lucien. 1894. *Ethnology of the Ungava District: Hudson Bay Territory*. Eleventh Annual Report of the Bureau of Ethnology. Washington, D.C.: Smithsonian Institute.

Turner, Victor. 1969. *The Ritual Process: Structure and Anti-structure*. Chicago: Aldine.

———. 1974. *Dramas, Fields and Metaphors: Symbolic Action in Human Society*. Ithaca, NY: Cornell University Press.

Tylor, Edward Burnett. 1871. *Primitive Culture*. London: J. Murray.

USAID, AGP-Livestock Market Development Project. 2013. "Agricultural Growth Project-Livestock Market Development: Value Analysis Chain for Ethiopia."

Van Gennep, Arnold. 1960. *The Rites of Passage*. Chicago: University of Chicago Press.

Van Gijn, Annelou. 2010. *Flint in Focus: Lithic Biographies in the Neolithic and Bronze Age*. Leiden, Netherlands: Sidestone Press.

VanPool, Christine S., and Elizabeth Newsome. 2012. "The Spirit in the Material: A Case Study of Animism in the American Southwest." *American Antiquity* 77 (2): 243–62.

Vaughan, Patrick C. 1985. *Use Wear Analysis of Flaked Stone Tools*. Tucson: University of Arizona Press.

Veit, Ulrich. 1989. "Ethnic Concepts in German Prehistory: A Case Study on the Relationship between Cultural Identity and Archaeological Objectivity." In *Archaeological Approaches to Cultural Identity*, edited by Stephen J. Shennan, 33–56. London: Routledge.

Vial, L. 1940. "Stone Axes of Mt. Hagen, New Guinea." *Oceania* 11: 158–63.

Viveiros de Castro, Eduardo. 1998. "Cosmological Deixis and Amerindian Perspectivism." *Journal of the Royal Anthropological Institute* 4 (3): 469–88.

Wallace, Alfred R. 1889. *A Narrative of Travels on the Amazon and Rio Negro*. London: Ward, Lock, and Co.

Walz, Jonathan R. 2006. "Critical Historical Archaeologies and Historical Representations." In *Critical Historical Archaeologies and Historical Representations*, edited by Peter R. Schmidt, 45–70, Lanham, MD: AltaMira Press.

———. 2013. "Routes to History: Archaeology and Being Articulate in Eastern Africa." In *Death of Prehistory*, edited by Peter R. Schmidt and Stephen A. Mrozowski, 69–92. Oxford: Oxford University Press.

Warren, S. Hazzeldine. 1905. "On the Origin of 'Eolithic' Flints by Natural Causes, Especially by the Foundering of Drifts." *The Journal of Anthropological Institute of Great Britain and Ireland* 35 (1905): 337–64.

———. 1913. "The Problems of Flint Fracture." *Man* 13: 37.

Washburn, S. L., and C. S. Lancaster. 1968. "The Evolution of Hunting." In *Man the Hunter*, edited by Richard B. Lee and Irvine De Vore, 293–303. Chicago: Aldine Publishing.

Watkins, Joe. 2001. *Indigenous Archaeology: American Indian Values and Scientific Practice*. Walnut Creek, CA: AltaMira Press.

Watson, Virginia Drew. 1980. *Perspectives, New and Old on New Guinea Stone Blades and Their Hafts. Occasional Papers in Anthropology* 10: 167–220. St. Lucia, Australia: Anthropology Museum, University of Queensland.

———. 1995. "Simple and Significant: Stone Tool Production in Highland New Guinea." *Lithic Technology* 20 (2): 89–99.

Webley, Lita. 1990. "The Use of Stone Scrapers by Semi-sedentary Pastoralist Groups in Namaqualand, South Africa." *South African Archaeological Bulletin* 45: 28–32.

———. 2005. Hideworking among Descendants of Khoekhoen Pastoralists in the Northern Cape South Africa." In *Gender and Hideworking*, edited by Lisa Frink and Kathryn Weedman, 153–74. Walnut Creek, CA: AltaMira Press.

Weedman, Kathryn J. 2000. "An Ethnoarchaeological Study of Stone Scrapers among the Gamo People of Southern Ethiopia." PhD diss., University of Florida. Ann Arbor: University Microfilms, Inc.

———. 2002a. "On the Spur of the Moment: Effects of Age and Experience on Hafted Stone Scraper Morphology." *American Antiquity* 67: 731–44.

———. 2002b. "An Ethnoarchaeological Study of Stone-Tool Variability among the Gamo Hideworkers of Southern Ethiopia." In *Le travail du cuir de la préhistoire à nos jours*, edited by Frédérique Audoin-Rouzeau and Sylvie Beyries, 131–42. Antibes, France: Éditions APDCA.

———. 2005. "Gender and Stone Tools: An Ethnographic Study of the Konso and Gamo Hide-workers of Southern Ethiopia." In *Gender and Hide Production*, edited by Lisa Frink and Kathryn Weedman, 175–96. Walnut Creek, CA: AltaMira Press.

———. 2006. "An Ethnoarchaeological Study of Hafting and Stone Tool Diversity among the Gamo of Ethiopia." *Journal of Archaeological Method and Theory* 13 (3): 188–237.

Weiner, Annette B. 1976. *Women of Value, Men of Renown: New Perspectives in Trobriand Exchange*. Austin: University of Texas Press.

Wendrich, Willeke. 2013. *Archaeology and Apprenticeship: Body Knowledge, Identity, and Communities of Practice*. Tucson: University of Arizona Press.

Wenger, Etienne. 1998. *Communities of Practice: Learning, Meaning and Identity*. Cambridge: Cambridge University Press.

Weston, Edward B. 1913. "Ishi the Archer." *Forest and Stream* 21: 658.

White, J. Peter. 1968a. "Ston Naip Bilong Tumbuna: The Living Stone Age in New Guinea." In *Le préhistoire: Problemes et tendances*, edited by Jean Piveteau, 511–16. Paris: Editions du Centre National de la Recherche Scientifique.

———. 1968b. "Fabricators, Outils Écaillés, or Scalar Cores?" *Mankind* 6 (12): 658–66.

———. 1969. "Typologies for Some Prehistoric Flaked Stone Artefacts in the Australian New Guinea Highlands." *Archaeology and Physical Anthropology in Oceania* 4: 18–46.

White, J. Peter, and Nicholas Modjeska. 1978. "Acquirers, Users, Finders, Losers: The Use Axe Blades Make of the Duna." *Mankind* 11 (1978): 276–87.

White, J. Peter., and D. H. Thomas. 1972. "What Mean These Stones? Ethno-taxonomic Models and Archaeological Interpretations in the New Guinea Highlands." In *Models in Archaeology*, edited by D. L. Clarke, 275–308. London: Methuen.

White, J. Peter., Nicholas Modjeska, and Irari Hipuya. 1977. "Group Definitions and Mental Templates: An Ethnographic Experiment." In *Stone Tools as Cultural Markers*, edited by R. V. S. Wright, 380–90. Canberra: Australian Institute of Aboriginal Studies.

Whitehead, Alfred North. 1929. *The Function of Reason*. Princeton, NJ: Princeton University Press.

Whittaker, John C. 2004. *American Flintknappers*. Austin: University of Texas Press.

Whittaker, John C., Kathryn Kamp, and Emek Yilmaz. 2009. "Cakmak Revisted: Turkish Flintknappers Today." *Lithic Technology* 34: 93–110.

Whyte, Thomas R. 2014. "Gifts of the Ancestors: Secondary Lithic Recycling in Appalachian Summit Prehistory." *American Antiquity* 79 (4): 679–96.

Wiessner, Polly. 1983. "Style and Social Information in Kalahari San Projectile Points." *American Antiquity* 48: 253–76.

———. 1985. "Style or Isochrestic Variation? A Reply to Sackett." *American Antiquity* 50: 160–66.

Wildschut, William. 1975. *Crow Indian Medicine Bundles*. New York: Museum of the American Indian Heye Foundation.

Wilmsen, Edwin N. 1968. "Functional Analysis of Flaked Stone Artifacts." *American Antiquity* 33: 156–61.

Wilmsen, Edwin N., and James R. Denbow. 1990. "Paradigmatic History of San-Speaking Peoples and Current Attempts at Revision." *Current Anthropology* 31 (5): 489–524.

Wilson, Daniel 1862. *Prehistoric Man: Researches into the Origin of Civilisation in the Old and the New World*, vol. 1. Cambridge, UK: Macmillian.

Winton, Vicky. 2005. "An Investigation of Knapping-Skill Development in the Manufacture of Palaeolithic Handaxes." In *Stone Knapping: The Necessary Conditions for a Uniquely Hominin Behaviour*, edited by Valentine Roux and Blandine Bril, 109–16. McDonald Institute Monographs. Cambridge: McDonald Institute for Archaeological Research, University of Cambridge.

Wissler, Clark. 1923. *Man and Culture*. New York: Thomas Y. Crowell Company.

Wobst, Martin. 1977. "Stylistic Behavior and Information Exchange." In *For the Director: Research Essays in Honor of James B. Griffin*, edited by C. E. Cleland, 317–42. Ann Arbor: University of Michigan Museum of Anthropology.

———. 1999. "Style in Archaeology or Archaeologists in Style." In *Material Meaning: Critical Approaches to the Interpretation of Material Culture*, edited by E. S. Chilton, 118–32. Salt Lake City: University of Utah Press.

———. 2000. "Agency in (Spite of) Material Culture." In *Agency in Archaeology*, edited by Marcia Dobres and John Robb, 40–50. London: Routledge.

Wolde, Tadesse Gossa. 1991. "Some Social and Ritual Functions of Gamo and Konso Public Places." In *Proceedings of the Eleventh International Conference of Ethiopian Studies*, edited by Bahru Zewde, Richard Pankhurst, and Taddese Beyene, 325–40. Addis Ababa: Institute of Ethiopian Studies.

———. 2004. "Having Friends Everywhere: The Case of the Gamo and Hor." In *The Perils of Face: Essays on Cultural Contact, Respect, and Self-Esteem in Southern Ethiopia*, edited by Ivo Strecker and Jean Lydall, 289–309. Berlin: Lit Verlag.

Woldegaber, Abba Abraham Buruk, and Mario Alexis Portella. 2012. *Abyssinian Christianity: The First Christian Nation*. n.p.: BP Editing.

Woldemarium, Hirut. 2013. "Revisiting Gamo: Linguists' Classification versus Self-Identification of the Community." *International Journal of Sociology and Anthropology* 5 (9): 373–80.

Woodburn, James. 1982. "Egalitarian Societies." *Man* (New Series) 17 (3): 431–51.

Woodward, Wendy, Patricia Hayes, and Gary Minkley. 2002. *Deep Histories: Gender and Colonialism in Southern Africa*. New York: Rodopi.

Wylde, Augustus B. 1888. *'83 to '87 in the Soudan, with an Account of Sir William Hewitt's Mission to King John of Abyssinia*. New York: Negro Universities Press.

Wylie, Alison. 1982. "An Analogy by Any Other Name Is Just as Analogical: A Commentary on the Gould-Watson Dialogue." *Journal of Anthropological Archaeology* 1: 382–401.

———. 1985. "The Reaction against Analogy." *Advances in Archaeological Method and Theory* 8: 63–111.

Yellen, John. 1977. *Archaeological Approaches to the Present: Models for Reconstructing the Past.* New York: Academic Press.

Young, David E., and Robson Bonnichsen. 1985. "Cognition, Behavior, and Material Culture." In *Stone Tool Analysis: Essays in Honor of Don E. Crabtree,* edited by M. G. Plew, J. C. Woods, and M. G. Pavesic, 91–131. Albuquerque: University of New Mexico Press.

Zedeño, Maria Nieves. 2008. "Bundled Worlds: The Roles and Interactions of Complex Objects from North American Plains." *Journal of Archaeological Method and Theory* 15: 362–78.

Zihlman, Adrienne. 1978. "Women in Evolution, Part II: Subsistence and Social Organization in Early Hominids." *Signs: Journal of Women in Culture and Society* 4 (1): 4–20.

INDEX

ABOUT THE AUTHOR

Kathryn Weedman Arthur received her PhD in Anthropology at the University of Florida in 2000 and is currently an associate professor of anthropology at the University of South Florida, St. Petersburg. Her research and teaching interests include religious anthropology, gender studies, stone tool technology, community archaeology, and ethnoarchaeology studies in Africa. Kathryn has conducted research among the Gamo in southern Ethiopia since 1996, funded by the National Science Foundation, the National Endowment for the Humanities, the Leakey Foundation, Fulbright, USF Research, and USFSP Research. She is responsible for cofounding the academic journal *Ethnoarchaeology* and has published more than twenty-five academic articles, a documentary film, and an edited book. Kathryn was awarded two national prestigious awards for her research and writing from the American Anthropological Association: the Gordon R. Willey Prize and the Exemplary Cross-Fields Scholarship. Most recently, her research with Gamo elders led to the discovery of a cave, resulting in a coauthored article in *Science* revealing an ancient skeleton that provided the earliest full African genetic sequence.